THE RIGHT TO LOOK

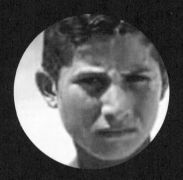

Duke University Press *Durham & London* 2011

THE RIGHT TO LOOK

A COUNTERHISTORY OF VISUALITY

Nicholas Mirzoeff

© 2011 Duke University Press

All rights reserved

Printed in the United States of America on acid-free paper ∞

Designed by Amy Ruth Buchanan

Typeset in Bembo by Tseng Information Systems, Inc.

Library of Congress Cataloging-in-Publication Data appear

on the last printed page of this book.

For **KRIS, KARIN,** *and* **KATHLEEN**

with great love and respect, and in solidarity.

And for **HANNAH** *in hope of better futures*

CONTENTS

PLATES *(Appear after page 204)*

FIGURES

Ineluctable Visualities

It's a while now that I've been tarrying with what James Joyce, in *Ulysses*, called "the ineluctable modality of the ineluctable visuality." That typically Joycean phrase could detain us for a while: why is visuality ineluctable? Who has made it so? It's a repetition with a difference of a phrase that appears earlier in *Ulysses* — "ineluctable modality of the visible" — and both are part of *Proteus*, Stephen Dedalus's interior monologue on the beach early in the day. Visuality is not, then, the visible, but it is twice ineluctable, unavoidable, inevitable. Nor, to be brief, is it a new way of thinking, any more than that currently fashionable term *modality*. By linking *visuality* with the archaic *ineluctable*, Joyce pushes us in the direction of seventeenth-century metaphysics, and behind them Aristotle, appropriate to Dedalus's concern with the "veil" between life and death as he mourns his mother and seeks the "word known to all men." So visuality is not the visible, or even the social fact of the visible, as many of us had long assumed. Nor is it one of those annoying neologisms that are so ripe a target for the book reviewer, for, as Joyce perhaps realized, the word became part of official English in 1840, in the work of Thomas Carlyle, fulminator against modernity and emancipation of all kinds. As Carlyle himself emphasized, the ability of the Hero to visualize was no innovation but "Tradition," a mighty force in the eyes of imperial apologists. To get the measure of this long Tradition and

the force of authority that renders it so ineluctable takes some time and space with no apologies. That story, the one implied by an Anglo-Celtic (Carlyle was Scottish) imperial imaginary, is the one whose counterhistory is offered here.

For in trying to come to terms with the ineluctable qualities of visuality, I have wanted to provide a critical genealogy for the resistance to the society of the spectacle and the image wars of recent decades. In turn, that genealogy would provide a framework for critical work in what has become known as visual culture, not because historicizing is necessarily always good, but because visuality both has an extensive and important history and is itself a key part of the formation of Western historiography. More precisely, visuality and its visualizing of history are part of how the "West" historicizes and distinguishes itself from its others. In this view, the "visual turn" represented academically by visual culture was not liberating in and of itself, but sought to engage the deployment of visualized authority at its points of strength. In so doing, I have crossed multiple borders, whether literally in pursuit of archives or other materials researched on three continents and in two hemispheres, or figuratively in the interface with academically discrete sets of area studies, historical periodization, and media histories. One of the early criticisms of the field of visual culture was its apparent hesitation to engage with weighty issues. The publication of such major books as W. J. T. Mitchell's *What Do Pictures Want?* (2005) and the late lamented Anne Friedberg's *The Virtual Window: From Alberti to Microsoft* (2006) has handily disposed of such objections. In this book I hope to follow in such exalted footsteps by developing a comparative decolonial framework for the field. I was impelled to do so by the questions raised in my study of the war in Iraq, *Watching Babylon: The War in Iraq and Global Visual Culture* (2005). Writing quickly, in the sadly mistaken belief that this would be a short conflict, I came up against the paradox that the immense quantity of imagery generated by the war had relatively little effect on the general public, a phenomenon I labeled the "banality of images." Nor did the Abu Ghraib photographs, disturbing as they of course were, challenge that view. The photographs were not mentioned in the U.S. elections of 2004, and no military figure above the level of the prison itself was subsequently disciplined: indeed, everyone in the chain of command leading to the Abu Ghraib scandal was promoted. Against all traditions of photojournalism and other modes of visual revelation, it seemed that visuality had become a weapon for authority, not against it. In order to make sense of the apparent

conundrum that such shocking images have had so little public effect, it is critical to locate them in the genealogy I describe here.

I am not trying to reduce the materialized visualization to a cipher. On the contrary, it seems to me that one of the major implications of W. J. T. Mitchell's famous claim, in 1994, that visual materials of all kinds are as complex and significant as print culture is that the visual image is an archive in its own right. Without extending this discussion, one issue of border crossing in this regard can be taken as an example of the issues involved. In a number of instances drawn from the plantation complex of the Atlantic world, I have used images—or sometimes even the knowledge that there were images which have been lost—as a form of evidence. When I draw inferences from enslaved, formerly enslaved, subaltern, or colonial subjects, there is often no textual support I can draw on beyond the visual image. Therefore I use the formal analysis of style, composition, and inference that is commonplace within the Western canon and its hinterlands to support my arguments. I further claim that the wider historical frame I am developing here would reinforce such interpretations, just as many cultural historians have done before me. I may be wrong, of course, but the use of the visual archive to "speak" for and about subaltern histories of this kind, as opposed to simply being illustrative of them, seems to me an important methodological question. If formal use of that visual archive is to be disallowed in, say, Puerto Rico, then I want it disqualified in Rome as well. And if that is not going to happen, then what methodological objection is operative in one place but not the other? This objection comes most often from those in the field of art history, where attribution is a central question. I do not, however, conceive of this book as art history, but rather as part of the critical interpretation of media and mediation, performing what Mitchell has usefully called "medium theory," all puns intended. In this sense, I consider visuality to be both a medium for the transmission and dissemination of authority, and a means for the mediation of those subject to that authority.

The main text will either justify these claims to readers or not. Here I would like to indicate one or two omissions that might not be self-evident. As a matter of framing and containing this project, I have used the tradition of authority that first inspired Carlyle and then was inspired, directly or indirectly, by him. That is to say, this is a genealogy of the Anglo-French imperial project that was launched in the direction of plantation colonies in the mid-seventeenth century and then diverged radically with the out-

break of the French and Haitian Revolutions (1789–1804). This legacy was disseminated to the United States in its capacity as a former British colony and by Ralph Waldo Emerson's adaptation of Carlyle, published as *Representative Men* (1850). While some scholars might question so extensive a reach, the imperial project writ large was (and is) an actively conceived zone of experience, intervention, and imagination. James Anthony Froude called it "Oceana," in imitation of James Harrington's seventeenth-century treatise. On the other hand, for some this sphere may not go far enough. I recognize the extent to which this Anglo-French-American "imagined community" was contrapuntally interfaced with the Spanish empire, and I have given this practical expression in a set of "counterpoints" from the Hispanophone Americas. These sections deal with various forms of visual imagery, not because I conceive of Spanish empire "as" an image, but because this is perhaps as far as I dare trust my knowledge and language skills. I have risked these brief moments of imperial interpenetration as a sign of my sense that a very promising direction for new research would be a collaborative exploration of the intersections of such globalizing visualities. While I certainly imagine these zones as extending to South and East Asia, it has not been within my skill-set to include them in this book, which I now conceive as simply the first step in a longer project. Would it not, then, be prudent to conceive of this current volume as several books? It is certainly true that I can imagine a book project on each of the different complexes of visuality that I describe here. If the mode of critical analysis that I promote here takes hold, then I certainly see a place for multiple books, whether written by myself or by others. Here I felt it was important to set out the framework as a whole in sufficient detail that its outlines became clear, yet without presuming that no modifications would be later necessary. Another suggestion to write a very short introduction to the topic seems to me to prioritize the current fashion in publishing over sustained argument: I do not see how a project for a reevaluation of modernity could be undertaken seriously in the hundred-page "very short" format so popular these days. Enough, then, of what this book is not, and on to what it, for all its faults, actually is.

This book has benefited from so many people's advice, insight, and material support—in part because it took me longer to finish than I would have liked—that I cannot possibly list them all. The project's first steps were taken under the auspices of a fellowship at the Humanities Research Center at the Australian National University, Canberra, in 2001, and developed at the Sterling and Francine Clark Art Institute, in Williamstown, Massachusetts, in 2002. My research into Maori history and culture was enabled when I was a visiting scholar in the department of American studies at the University of Canterbury, Aotearoa New Zealand, in 2005. Support for my research was provided by the deans of the College of Arts and Sciences at Stony Brook University and later by Dean Mary Brabeck of the Steinhardt School of Culture, Education and Human Development at New York University. I owe much to librarians and archivists at: Charlotte Amelie Public Library, St. Thomas; University of Puerto Rico, Rio Pedras; the Macmillan Brown Library–Te Puna Rakahau o Macmillan Brown, University of Canterbury, Aotearoa New Zealand; the Australian National Library; Bibliothèque Nationale, Paris; Musée Nationale de la Révolution Française, Vizille, France; the British Library; the New York Historical Society Library; Melville Memorial Library at Stony Brook University; and the Elmer Bobst Memorial Library at New York University. Of the venues where I have presented portions of this project I would like to especially thank the "Trans"

conference at University of Wisconsin, Madison, in 2006; the AUP–NYU Media and Belief conference in Paris, in 2009; the Visual Culture Conference 2010 at University of Westminster, London; the George Levitine Lecture at the University of Maryland, in 2010; as well as the Modern Language Association, College Art Association, and a variety of events at New York University and around New York City.

Among the many people that I want to thank, first place goes to the anonymous readers for Duke University Press, who extended and challenged my thinking. This was one instance of the double-blind peer review that really worked. Other readers and advisers who provided beyond-the-call-of-duty contributions were Terry Smith, Marita Sturken, and Dana Polan. I'd like to thank all my current colleagues in the department of media, culture and communication at New York University and those in the departments of art and comparative literature and cultural studies at Stony Brook University. Further, my thanks go to all those students who helped me figure this project out as I went along and experienced its growing pains. The picture research was enabled by the excellent work of first Max Liboiron and then Ami Kim, to whom special thanks are due. At Duke University Press, Ken Wissoker, Mandy Early, Jade Brooks, Tim Elfenbein, and Patricia Mickleberry have done sterling work keeping me focused and actually editing the manuscript, a rarity these days in my experience. Tara McPherson, Brian Goldfarb, Joan Saab, and Wendy Chun, my colleagues on the Alliance for Networking Visual Culture project, have had to listen to versions of these ideas many times, and for this and their inspiration and excellence, many thanks. I owe much to the friendship and intelligence of a remarkable group of people at the Hemispheric Institute for Performance and Politics, especially Marcial Godoy, Jill Lane, and Diana Taylor. My peer network of friends and colleagues, thank you all, especially: Arjun Appadurai, Jon Beller, Laurie-Beth Clark, Jill Casid, David Darts, Dipti Desai, Hank Drewal, Kevin Glynn, Amelia Jones, Alex Juhasz, Ira Livingston, Iona Man-Cheong, Carol Mavor, Jo Morra, Tom Mitchell, Lisa Nakamura, Lisa Parks, Carl Pope, Marq Smith and everyone at the NEH-Vectors Summer Institute "Broadening the Digital Humanities" at the University of California Research Institute in 2010.

There's no adequate formula to express what this book, and indeed my entire career and, even more, my life beyond work, owe to Kathleen Wilson. Above and beyond using the direct ideas, references, and insights that she has offered on almost every page, I have had the remarkable experience

of learning from and living with an intellectual of the first rank, as she re-configures her entire field. Latterly, I have witnessed her overcome some of the most serious challenges a person can face with courage, intelligence, and even good humor. That is an inspiration I seek to live up to every day, just as I try to become a better parent for the young woman that my daughter Hannah has become during the time it has taken me to write this book.

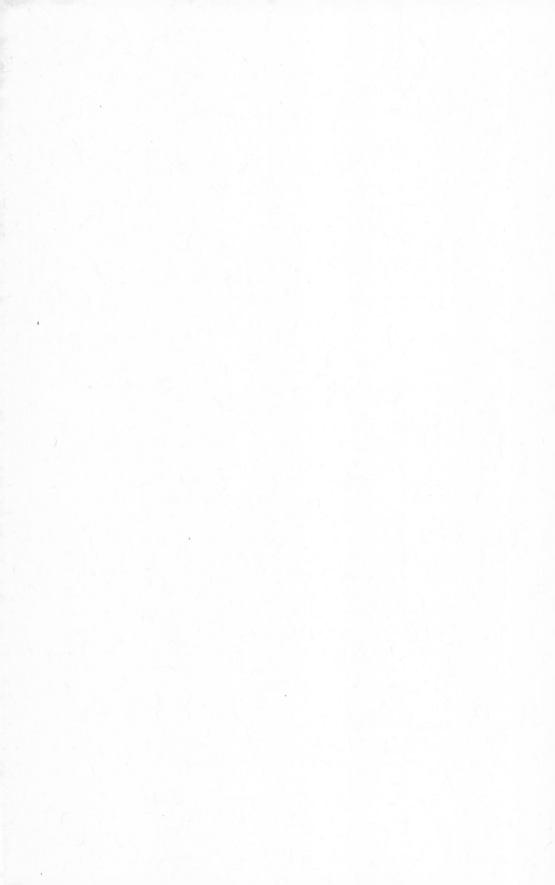

The Right to Look

Or, How to Think With and

Against Visuality

I want to claim the right to look.[1] This claim is, not for the first or the last time, for a right to the real.[2] It might seem an odd request after all that we have seen in the first decade of the twenty-first century on old media and new, from the falling of the towers, to the drowning of cities, and violence without end. The right to look is not about seeing. It begins at a personal level with the look into someone else's eyes to express friendship, solidarity, or love. That look must be mutual, each person inventing the other, or it fails. As such, it is unrepresentable. The right to look claims autonomy, not individualism or voyeurism, but the claim to a political subjectivity and collectivity: "The right to look. The invention of the other."[3] Jacques Derrida coined this phrase in describing Marie-Françoise Plissart's photo-essay depicting two women in ambiguous pursuit of each other, as lovers, and in knowing play with practices of looking (see fig. 1).[4] This invention is common, it may be the common, even communist. For there is an exchange, but no creation of a surplus. You, or your group, allow another to find you, and, in so doing, you find both the other and yourself. It means requiring the recognition of the other in order to have a place from which to claim rights and to determine what is right. It is the claim to a subjectivity that has the autonomy to arrange the relations of the visible and the sayable. The right to look confronts the police who say to us, "Move on, there's nothing to see here."[5] Only there is, and we know it and so do they. The opposite of

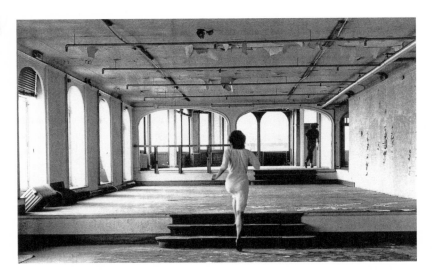

FIGURE 1. MARIE-FRANÇOISE PLISSART FROM *DROIT DE REGARDS*
(PARIS: EDITIONS DE MINUIT, 1985).

the right to look is not censorship, then, but "visuality," that authority to
tell us to move on, that exclusive claim to be able to look. *Visuality* is an old
word for an old project. It is not a trendy theory word meaning the totality
of all visual images and devices, but is in fact an early-nineteenth-century
term meaning the visualization of history.[6] This practice must be imagi-
nary, rather than perceptual, because what is being visualized is too sub-
stantial for any one person to see and is created from information, images,
and ideas. This ability to assemble a visualization manifests the authority
of the visualizer. In turn, the authorizing of authority requires permanent
renewal in order to win consent as the "normal," or everyday, because it is
always already contested. The autonomy claimed by the right to look is thus
opposed by the authority of visuality. But the right to look came first, and
we should not forget it.[7]

How can we think with and against visuality? Visuality's first domains
were the slave plantation, monitored by the surveillance of the overseer,
operating as the surrogate of the sovereign. This sovereign surveillance was
reinforced by violent punishment but sustained a modern division of labor.
Visualizing was next the hallmark of the modern general from the late
eighteenth-century onward, as the battlefield became too extensive and
complex for any one person to physically see. Working on information sup-

plied by subalterns—the new lowest-ranked officer class created for this purpose—and his own ideas and images, the general in modern warfare, as practiced and theorized by Karl von Clausewitz, was responsible for visualizing the battlefield. At this moment, in 1840, visuality was named as such in English by the historian Thomas Carlyle (1795–1881) to refer to what he called the tradition of heroic leadership, which visualizes history to sustain autocratic authority. Carlyle attempted to conjure the Hero as a mystical figure, a "living light fountain that it is good and pleasant to be near . . . a natural luminary shining by the gift of Heaven."[8] If visuality had been the supplement to authority on the plantation, authority was now that light. Light is divine. Authority is thus visibly able to set things in motion, and that is then felt to be right: it is aesthetic. Visuality supplemented the violence of authority and its separations, forming a complex that came to seem natural by virtue of its investment in "history." The autonomy claimed by the right to look is thus opposed by the authority of visuality. Visualizing is the production of visuality, meaning the making of the processes of "history" perceptible to authority. Visuality sought to present authority as self-evident, that "division of the sensible whereby domination imposes the sensible evidence of its legitimacy."[9] Despite its name, this process is not composed simply of visual perceptions in the physical sense, but is formed by a set of relations combining information, imagination, and insight into a rendition of physical and psychic space. I am not attributing agency to "visuality" but, as is now commonplace, treating it as a discursive practice that has material effects, like Foucault's panopticism, the gaze or perspective. A given modality of visuality is composed of a series of operations that can be summarized under three headings: first, visuality classifies by naming, categorizing, and defining, a process defined by Foucault as "the nomination of the visible."[10] It was founded in plantation practice, from the mapping of plantation space to the identification of cash-crop cultivation techniques and the precise division of labor required to sustain them. Second, visuality separates the groups so classified as a means of social organization. Such visuality separates and segregates those it visualizes to prevent them from cohering as political subjects, such as the workers, the people, or the (decolonized) nation. Third, it makes this separated classification seem right and hence aesthetic. As the decolonial critic Frantz Fanon had it, such repeated experience generates an "aesthetic of respect for the status quo," the aesthetics of the proper, of duty, of what is felt to be right and hence pleasing, ultimately even beautiful.[11] Classifying, separating, and aestheti-

cizing together form what I shall call a "complex of visuality." All such Platonism depends on a servile class, whether formally chattel slaves or not, whose task it is to do the work that is to be done and nothing else.[12] We may engage in whatever labor is required to do that work, visual or otherwise, but for us, there is nothing to be seen.

The right to look claims autonomy from this authority, refuses to be segregated, and spontaneously invents new forms. It is not a right for declarations of human rights, or for advocacy, but a claim of the right to the real as the key to a democratic politics. That politics is not messianic or to come, but has a persistent genealogy that is explored in this book, from the opposition to slavery of all kinds to anticolonial, anti-imperial, and antifascist politics. Claiming the right to look has come to mean moving past such spontaneous oppositional undoing toward an autonomy based on one of its first principles: "the right to existence." The constitutive assemblages of countervisuality that emerged from the confrontation with visuality sought to match and overcome its complex operations. I shall gloss these terms here using the radical genealogy of the philosopher Jacques Rancière, whose work has been central to this project, while emphasizing and insisting that they are derived from historical practice. Classification was countered by education understood as emancipation, meaning "the act of an intelligence obeying only itself, even while the will obeys another will."[13] Education has long been understood by working and subaltern classes as their paramount means of emancipation, from the efforts of the enslaved to achieve literacy, to nineteenth-century campaigns for universal education that culminated (in the United States) with the Supreme Court case *Brown* v. *Board of Education* (1954). Education was the practical means of moving on from the work allocated to you. Separation was countered by democracy, meaning not simply representative elections but the place of "the part that has no part" in power. Plato designated six categories of people with title to power: all those who remained, the great majority, are those without part, who do not count.[14] Here the right to look is strongly interfaced with the right to be seen. In combining education and democracy, those classified as good to work and nothing else reasserted their place and title. The aesthetics of power were matched by the aesthetics of the body not simply as form but as affect and need. This aesthetic is not a classificatory scheme of the beautiful but "an 'aesthetics' at the core of politics . . . as the system of *a priori* forms determining what presents itself to sense experience."[15] In this book, these forms center around sustenance and what I shall call the "politics of

eating," adapting a phrase from African and African diaspora discourse. It might now be described as sustainability. These countervisualities are not visual, you might say. I did not say they were. I claim that they are and were visualized as goals, strategies, and imagined forms of singularity and collectivity. If they do not seem "realistic," that is the measure of the success of visuality, which has made "vision" and "leadership" into synonyms. It is precisely that extended sense of the real, the realistic, and realism(s) that is at stake in the conflict between visuality and countervisuality. The "realism" of countervisuality is the means by which one tries to make sense of the unreality created by visuality's authority from the slave plantation to fascism and the war on terror that is nonetheless all too real, while at the same time proposing a real alternative. It is by no means a simple or mimetic depiction of lived experience, but one that depicts existing realities and counters them with a different realism. In short, the choice is between continuing to move on and authorizing authority or claiming that there is something to see and democraticizing democracy.

COMPLEXES OF VISUALITY

The substance of this chapter—it is more than an introduction to the rest of the book, although it is of course also that—explores how to work with the interfaces between visuality and countervisuality within and between complexes of visuality from a decolonial perspective. "Complex" here means both the production of a set of social organizations and processes that form a given complex, such as the plantation complex, and the state of an individual's psychic economy, such as the Oedipus complex. The resulting imbrication of mentality and organization produces a visualized deployment of bodies and a training of minds, organized so as to sustain both physical segregation between rulers and ruled, and mental compliance with those arrangements. The complex that thus emerges has volume and substance, forming a life-world that can be both visualized and inhabited. I consider the complexes of visuality to be an articulation of the claim to authority in what decolonial theory has called "coloniality," meaning "the transhistoric expansion of colonial domination and the perpetuation of its effects in contemporary times."[16] As Achille Mbembe has shown, such coloniality is formed by modes of "entanglement" and "displacement," producing "discontinuities, reversals, inertias and swings that overlay one another."[17] This sense that the "time is out of joint," appropriated by Derrida from Hamlet,

ias come to be seen as the expression of the contradictions of globalization.[18] Identifying these entanglements and moments of displacement are central to defining the genealogies of visuality and form the material for the chapters that follow. Such networks also remind us that no such genealogy can be comprehensive. Mbembe's emphasis on complex temporality further suggests that one modality of visuality was not simply succeeded by another, but rather that their traces linger, and can be revived at unexpected moments. The present is precisely one such moment, in which the legacies of the plantation complex are once again active in the United States, due to the Obama presidency, while imperial dreams are being worked out globally in full interface with the military-industrial complex. The very emergence of all the modalities of visuality at once suggests an emergency, as both the condition of a critique of visuality and the possibility of the right to look. The symptom of that emergency is precisely the ability to detect the crisis of visuality, such that the visibility of visuality is paradoxically the index of that crisis.

The authority of coloniality has consistently required visuality to supplement its deployment of force. Visuality sutures authority to power and renders this association "natural." For Nelson Maldonado Torres, this colonial violence formed a "death ethic of war," meaning the extensive presence of war and related social practices, such as mass incarceration and the death penalty, to which I would add slavery, understood as being derived from "the constitutive character of coloniality and the naturalization of human difference that is tied to it in the emergence and unfolding of Western modernity."[19] This decolonial genealogy means that it will not be sufficient to begin a critique of visuality in the present day, or in the recent past, but that it must engage with the formation of coloniality and slavery as modernity.[20] As Enrique Dussel has aptly put it: "Modernity is, in fact, a European phenomenon but one constituted in a dialectical relation with a non-European alterity that is its ultimate content."[21] In order to challenge the claimed inevitability of this history and its hegemonic means to frame the present, any engagement with visuality in the present or the past requires establishing its counterhistory. In fact, I suggest that one of the very constitutive forms of visuality is the knowledge that it is always already opposed and in struggle. To coin a phrase, visuality is not war by other means: it is war. This war was constituted first by the experience of plantation slavery, the foundational moment of visuality and the right to look. In antiquity, authority was literally a patriarchal modality of slavery. The modern hero's

authority restates the ancient foundations of authority as slave-owner and interpreter of messages, the "eternal" half of modern visuality, to paraphrase Baudelaire, the tradition that was to be preserved.

Authority is derived from the Latin *auctor*. In Roman law, the auctor was at one level the "founder" of a family, literally the patriarch. He was also (and always) therefore a man empowered to sell slaves, among other forms of property, which completed the complex of authority.[22] Authority can be said to be power over life, or biopower, foundationally rendered as authority over a "slave."[23] However, this genealogy displaces the question: who or what empowers the person with authority to sell human beings? According to the Roman historian Livy, the indigenous people living on the site that would become Rome were subject to the authority (*auctoritas*) of Evander, son of Hermes, who ruled "more by authority than by power (*imperium*)." That authority was derived from Evander's ability, as the son of the messenger of the gods, to interpret signs. As Rancière puts it, "The *auctor* is a specialist in messages."[24] This ability to discern meaning in both the medium and the message generates visuality's aura of authority. When it further becomes invested with power (*imperium*), that authority becomes the ability to designate who should serve and who should rule. Such certainties did not survive the violent decentering of the European worldview produced by the multiple shocks of "1492": the encounter with the Americas, the expulsion of the Jews and Islam from Spain, and the heliocentric system of Copernicus. At the beginning of the modern period, Montaigne could already discern what he called the "mystical foundation of authority," meaning that it was ultimately unclear who or what authorizes authority.[25] As Derrida suggests, "Since the origin of authority, the foundation or ground, the position of the law can't by definition rest on anything but themselves, they are themselves a violence without a ground."[26] Authority's presumed origin in legality is in fact one of force, the enforcement of law, epitomized in this context by the commodification of the person as forced labor that is slavery. This self-authorizing of authority required a supplement to make it seem self-evident, which is what I am calling visuality.

The ancient Greek historian Herodotus tells us that the Scythians of antiquity blinded their slaves. As the Scythians were horse-riding nomads, modern historians have concluded that this practice was designed to prevent the slaves from escaping.[27] It cannot but also suggest that slavery is the removal of the right to look. The blinding makes a person a slave and removes the possibility of regaining the status of a free person. While chat-

tel slavery did not physically blind the enslaved, its legal authority now policed even their imagination, knowing that their labor required looking. For example, in the British colony of Jamaica the enslaved were forbidden even to "imagine the death of any white Person."[28] By contrast, in the metropole it became a capital offence for subjects to imagine the death of a king only during the revolutionary crisis of the 1790s.[29] The difference in these laws suggest that any white person in the plantation colony was the equivalent of the sovereign in the "home" nation. Such laws became necessary when authority feared that the enslaved or feudal subject might act on such imaginings, the always possible revolutionizing of the plantation complex. This anxiety moved from plantation to metropole. In the North American context, "reckless eyeballing," a simple looking at a white person, especially a white woman or person in authority, was forbidden those classified as "colored" under Jim Crow. Such looking was held to be both violent and sexualized in and of itself, a further intensification of the policing of visuality. As late as 1951, a farmer named Matt Ingram was convicted of the assault of a white woman in North Carolina because she had not liked the way he looked at her from a distance of sixty-five feet.[30] This monitoring of the look has been retained in the U.S. prison system so that, for example, detainees in the Abu Ghraib phase of the war in Iraq (2003–4) were forcefully told, "Don't eyeball me!"[31]

In short, complexes are complex. They are divided against themselves first as configurations of visuality against countervisuality and then as material systems of administering authority interfaced with mental means of authorizing. In tracing a decolonial genealogy of visuality, I have identified three primary complexes of visuality and countervisuality in this book, from the "plantation complex" that sustained Atlantic slavery, via what was known to certain apologists for the British empire as the "imperialist complex," to President Dwight Eisenhower's "military-industrial complex," which is still very much with us. Each responded to and generated forms of countervisuality. The clash of visuality and countervisuality produced not just imagined relations but materialized visualizations as images of all kinds, as natural history, law, politics, and so on. The extended encounter between the right to look and visuality created a "world-generating optic" on modernity, such that "modernity is produced *as* the West."[32] What was at stake was the form of the real, the realistic, and realism in all senses. From the decolonial perspective used here, it is the way that modernity looks when seen from the places of visuality's application—the plantation, the

colony, the counterinsurgency—back toward the metropole. That look is not a copy, or even a reverse shot, but is equally constitutive by means of its own reality effect of the classified, spatialized, aestheticized, and militarized transnational culture that in its present-day form has come to be called "globalization." Indeed, the contradiction that has generated change within the complexes of visuality has been that while authority claims to remain unchanged in the face of modernity, eternally deriving authority from its ability to interpret messages, it has been driven to radical transformation by the resistance it has itself produced. This force has applied to visuality and countervisuality alike as what Michel Foucault called "intensity," rendering them "more economic and more effective."[33] Under the pressure of intensification, each form of visuality becomes more specific and technical, so that within each complex there is, as it were, both a standard and an intensified form. That is the paradox glimpsed by Carlyle, in which history and visualization have become mutually constitutive as the reality of modernity, while failing to account entirely for each other.[34] It is that space between intention and accomplishment that allows for the possibility of a countervisuality that is more than simply the opposition predicated by visuality as its necessary price of becoming.

In significant part, therefore, these modes of visuality are psychic events that nonetheless have material effects. In this sense, the visualized complex produced a set of psychic relations described by Sigmund Freud as "a group of interdependent ideational elements cathected with affect."[35] For Freud, the complex, above all the famous Oedipus complex, was at first the name of the process by which the internal "pleasure principle" became reconciled with the "reality principle" of the exterior world. Following the experience of shell shock in the First World War, Freud revised his opinion to see the psychic economy as a conflict between the pleasure drive and the death drive, leading to a doubled set of disruptions. For Jacques Lacan, as Slavoj Žižek has described, the subject was constituted by the inevitable failure to overcome this lack: "The place of 'reality' within the psychic economy is that of an 'excess,' of a surplus which disturbs and blocks from within the autarky of the self-contained balance of the psychic apparatus—'reality' as the external necessity which forces the psychic apparatus to renounce the exclusive rule of the 'pleasure principle' is correlative to this inner stumbling block."[36] The diagram that visualizes this process is an arrow that travels around a circle until it is blocked at the last minute. The pleasure principle cannot quite fulfill its wish because something from outside its

domain intrudes and prevents it from doing so. For Lacan that "thing" was epitomized by the Oedipus complex in which the law of the father prevented the infant from achieving its desire to possess the mother. Authority thus counters desire and produces a self-conscious subject who experiences both internal desire and external constraint as "reality." In this book, I take the existence of this doubled complex to be the product of history, as opposed to a transhistorical human condition, specifically that of the violence with which colonial authority enforced its claims. From the dream-world of the Haitian and French Revolutions and their imaginaries to the imperial investigation of the "primitive" mind and Fanon's deconstruction of colonial psychology, producing and exploring psychic complexes and complexity was central to the labor of visualization. Needless to say, visualization has in turn now become part of the labor of being analyzed.

THE PLANTATION COMPLEX: AUTHORITY, SLAVERY, MODERNITY

Visualized techniques were central to the operations of the Atlantic world formed by plantation slavery and its ordering of reality. The plantation complex as a material system lasted from the seventeenth century until the late nineteenth, and affected primarily those parts of the globe known as the Atlantic triangle: the European slave-owning nations, Central and West Africa, the Caribbean and the plantation colonies of the Americas. The plantation complex designates the system of forced labor on cash-crop plantations, in which the role of authority was described by historian Phillip Curtin: "The [slave] owner not only controlled his work force during working hours, he also had, at least de facto, some form of legal jurisdiction. His agents acted informally as policemen. They punished most minor criminals and settled most disputes without reference to higher authority."[37] Sovereign authority was thus delegated to the plantation, where it was managed in a system of visualized surveillance. While the overseer was always confronted with revolt large and small, his authority was visualized as the surrogate of the monarch's and hence Absolute. The overseer, who ran the colonial slave plantation, embodied the visualized techniques of its authority, and so I call them collectively "oversight." Oversight combined the classifications of natural history, which defined the "slave" as a species, with the spatializing of mapping that separated and defined slave space and "free" space. These separations and distinctions were enabled by the force of law that allowed the overseer to enforce the slave codes. This

regime can be said to have been established between the passing of the Barbados Slave Code, in 1661, and the promulgation of Louis XIV's *Code Noir*, in 1685. This ordering of slavery was interactive with the "order of things" famously discerned as coming into being at the same period in Europe by Foucault. A certain set of people were classified as commodifiable and a resource for forced labor. By means of new legal and social codes, those so enslaved were of course separated from the free not just in physical space, but in law and natural history. Once assembled, the plantation complex came to be seen to be right. In his justifications for slavery, the nineteenth-century Southern planter John Hammond turned such stratagems into axioms of human existence: "You will say that man cannot hold property in man. The answer is that he can and actually does all the world over, in a variety of forms, and has always done so."[38]

Under the plantation complex and in the long shadow of its memory, a moment that has yet to pass, slavery is both literal and metaphorical: it is the very real trauma of chattel slavery and an expression of a technically "free" social relation that is felt to be metaphorically equivalent to slavery. So, too, is abolition literal and metaphorical. It expresses a moment of emancipation, but also a condition in which slavery of all kinds would be impossible. As early as the mid-eighteenth century, the enslaved had devised counters to the key components of oversight. Maroons, or runaway slaves, had established settlements in many plantation colonies, sometimes signing formal treaties with colonial powers and thereby remapping the colony. The enslaved had a superior understanding of tropical botany and were able to put this knowledge to good effect in poisoning their masters, or so it was widely believed. Finally, the syncretic religions of the plantation complex had produced a new embodied aesthetic represented in the votive figures known as *garde-corps*, literally "body guard." The revolt led, in 1757, by François Makandal in Saint-Domingue, now Haiti, united these different techniques into an effective countervisuality that came close to overthrowing slavery. The plantocracy, as the ruling planter class was known, responded by intensifying slavery. By the time of the revolution, in 1791, Saint-Domingue was the single greatest producer of (colonial) wealth in the Western world. Huge numbers of people were imported as forced labor as the planters sought both to achieve autonomy for the island from the metropole and to automate the production process of the cash crops, especially sugar. This intensification in turn produced the world-historical event of the Haitian Revolution (1791–1804), the first successful act of de-

colonial liberation and the key transformation in producing modern visu-
ality. This intensification in the countervisuality of antislavery produced
the revolutionary hero as the embodied counter to the sovereign authority
represented by the overseer. The popular hero, such as Toussaint L'Ouver-
ture, incarnated democracy as the representative of the people, embody-
ing a willed emancipation that was at once education and, in his or her
symbolic form, an aesthetic of transformation. Almost immediately, the
hero was subject to its own intensification within the new imaginary of
the "people." This pressure produced a cleft within the revolution: was the
priority now to be the imagined community of the nation-state or the sus-
tainable community at local level? In the events covered by this book, this
question has been persistently resolved by force in favor of the nation-state
from Toussaint's 1801 Constitution for Haiti, to the ending of Reconstruc-
tion in the United States, in 1877, and the reconfiguration of the Algerian
revolution, in 1965. The shared subsistence economy claimed by subaltern
actors in each case, most familiar now in the Reconstruction slogan "forty
acres and a mule," was presented as naïve, even reactionary, as it still is today
in the face of the disaster of climate change. The perceived necessity to re-
state national authority opened the way for the imperial appropriation of
the revolutionary hero in the figure of Napoleon Bonaparte, the archetype
of the modern Hero for Carlyle.

The specter of Haiti haunted the long nineteenth century that ended
with decolonization. The images of Dessalines cutting the white section
out of Haiti's flag, in 1804, even as he declared it illegal for "whites" to own
property on the island were, to use Michel-Rolph Trouillot's trenchant term,
"unthinkable." The permanent alienation of "property" by the formerly en-
slaved in Haiti claiming their own right to autonomy forced the remaking
of visuality as a permanent war, visualized as a battlefield map. These two-
dimensional representations of the array of forces as they confront each
other became the visualization of history in Carlyle's imagination. Given
this separation, I will describe the forms of visuality and countervisual-
ity separately from this point forward. Visualizing was the hallmark of the
modern general from the late eighteenth century onward, as the battle-
field became too extensive and complex for any one person to physically
see. The general in modern warfare as practiced and theorized by Karl von
Clausewitz was responsible for visualizing the battlefield. He worked on in-
formation supplied by subalterns—the new lowest-ranked officer class cre-
ated for this purpose—and by his own ideas, intuitions, and images. Carlyle

and other defenders of authority appropriated the hero from the Atlantic revolutions and merged it with military visualization to create a new figure for modern autocracy. Although Carlyle liked to assert that visuality was an attribute of the hero from time immemorial, he was above all haunted by the abolition of slavery. In his monumental history of *The French Revolution* (1837), all revolution from below is "black," a blackness that pertained to the popular forces in France, described as "black sans-culottes," from the storming of the Bastille, in 1789, but especially to Saint-Domingue, "shaking, writhing, in long horrid death throes, it is Black without remedy; and remains, as African Haiti, a monition to the world."[39] This "blackness" was the very antithesis of heroism that Napoleon finally negated. For Carlyle, to be Black was always to be on the side of Anarchy and disorder, beyond the possibility of Reality and impossibly remote from heroism. It is precisely, then, with "blackness" and slavery that a counterhistory of visuality must be concerned. The function of the Hero for Carlyle and other devotees, appropriated from those revolutions, was to lead and be worshipped and thereby to shut down such uncertainties. His visuality was the intensification of the plantation complex that culminated in the production of imperial visuality.

IMPERIAL COMPLEX: MISSIONARIES, CULTURE, AND THE RULING CLASS

Carlyle's attempt to embody visualized authority in the Hero might have appeared somewhat marginal in the immediate aftermath of the emancipation of the enslaved and the envisaged self-determination of many British colonies, to which India, as a dependency, was understood as an exception. However, the multiple shocks generated by the Crimean War of 1856, and the return to a centralized model of empire following the Indian "mutiny" in 1857, and other acts of anticolonial resistance from Aotearoa New Zealand to Jamaica, reversed the position. Direct rule became the favored model of British imperial administration, emancipation and self-rule were out of favor, and Carlyle's views became mainstream. The crisis of imperial rule caused the opening of what became known as the "ruling class" in Britain to certain sectors of the educated middle-classes, who would be central to the governance of the immense empire. The "eminent Victorians" debunked by Lytton Strachey were emblematic of that class, as was Strachey himself, as part of the Bloomsbury group. As Edward Said famously pointed out, by 1914 some 85 percent of the world's surface was under the control of one

empire or another.[40] Nonetheless, the imperial complex was presented as if it were a form of mental disorder. In 1883, the historian J. R. Seeley described the British empire as having been acquired in a "fit of absence of mind."[41] The term "fit" is striking, as if the mental condition of "absence of mind" was closer to epilepsy than to forgetfulness. The phrase soon entered political language. For example, the Labour newspaper the *Daily Herald* argued, in 1923, having cited Seeley: "It was only when we found ourselves in occupation of vast expanses of territory in all parts of the world that we developed what psychoanalysts would call the 'Imperialist complex.'"[42] This modality of denial produced its counterpart in the colonized, as Fanon argued in a well-known passage of *Black Skin, White Masks*: "By calling on humanity, on the belief in dignity, on love, on charity, it would be easy to prove, or to win the admission, that the black is the equal of the white. But my purpose is quite different: What I want to do is help the black man to free himself of the arsenal of complexes that has been developed by the colonial environment."[43] The contest of visuality and countervisuality is not, then, a simple battle for the same field. One sought to maintain the "colonial environment" as it was, the other to visualize a different reality, modern but decolonized.

In this second alignment of visuality, an imperial complex had emerged, linking centralized authority to a hierarchy of civilization in which the "cultured" were necessarily to dominate the "primitive." This overarching classification was a hierarchy of mind as well as a means of production. Following Charles Darwin's proposal of the theory of evolution, in 1859, it was now "culture" that became the key to imagining the relations of colonial centers and peripheries, as visualized by the colonizers. In 1869, Matthew Arnold famously divided British modernity into tendencies toward desired culture and feared anarchy, while giving unquestioned support to the forces of law: "While they administer, we steadily and with undivided heart support them in repressing anarchy and disorder; because without order there can be no society, and without society there can be no perfection."[44] With an eye to the political violence in London in 1866, Arnold claimed "hereditary" authority from his father for his remedy, namely "flog the rank and file," even if the cause were a good one, such as the "abolition of the slave-trade." Ending slavery itself would not by 1869 take priority over maintaining authority. The classification of "culture" and "anarchy" had become a principle of separation whose authority was such that it had become right in and of itself.

Political divides at home between the forces of culture and those of anarchy were subsequently mapped onto the distinctions between different layers of civilization defined by ethnographers. So when Edward Tylor defined culture as the "condition of knowledge, religion, art, custom and the like" in primitive societies, he was clear that European civilization (as he saw it) stood above all such cultures.[45] This dramatic transformation in conceptualizing nations as a spatialized hierarchy of cultures took place almost overnight: Arnold's *Culture and Anarchy* (1869) was followed by Darwin's *Descent of Man* and Tylor's *Primitive Culture*, in 1871. Tylor presented Darwin's description of the evolution of humanity as existing in real time, with the "primitive" being separated only by space from the "civilized." Whereas Carlyle's hero was a literally mystical figure, it was now "civilization" that could visualize, whereas the "primitive" was ensconced in the "heart of darkness" produced by the willed forgetting of centuries of encounter. In this way, visuality became both three-dimensional and complexly separated in space. As Western civilization tended, in this view, toward "perfection," it was felt to be aesthetic and the separations it engendered were simply right, albeit visible only to what Tylor called "a small critical minority of mankind."[46] That minority was nonetheless in a position to administer a centralized empire as a practical matter in a way that Carlyle's mystical heroes could not have done. The "white man's burden" that Rudyard Kipling enshrined in verse was a felt, lived, and imagined relationship to the imperial network, now visualized in three dimensions. Its success was manifested in the visualization of the "primitive" as the hallmark of the modern, from Picasso's *Desmoiselles d'Avignon* (1903) to the recent monument to the French president François Mitterand's imperial ambition that is the Musée du quai Branly, a museum of the primitive in all but name.

The foot soldiers of this labor of imperial visuality were Christian missionaries, who directly represented themselves to themselves as Heroes in the style of Carlyle, bringing Light into Darkness by means of the Word. One of the distinguishing features of imperial visuality was its emphasis on culture as language, or more precisely on the interpretation of the "signs" produced by both the "primitive" and the "modern." As W. J. T. Mitchell among others has long stressed, word and image are closely imbricated, and this relation forms a field in itself, central to the understanding of modernism.[47] Rancière understands this as the "sentence-image . . . in which a certain 'sight' has vanished, where *saying* and *seeing* have entered into a communal space without distance and without connection. As a result, one

sees nothing: one does not see what is said by what one sees, or what is offered up to be seen by what one says."[48] This chaos of the "civilized" was articulated in relation to the excavation of the "primitive" as a resource for the understanding of modernity and its civilization. Just as the plantation was the foundation of discipline, so can we see the missionaries as the agents of what Foucault called the "pastorate," the model for governmentality. The Christian pastorate moved beyond territory, operating "a form of power that, taking the problem of salvation in its general set of themes, inserts into this global, general relationship an entire economy and technique of the circulation, transfer and reversal of merits."[49] The global pastorate proceeded by specific techniques for the care and production of souls. Whereas in the West, the priority was from the first the conduct of souls, imperial visuality sought first to create them from the raw materials of the "heathen." There is an entanglement that could be developed here with the genealogy of imperial visuality in the Americas, with the difference that the Carlyle-inspired missionaries never imagined the conversion of entire peoples so much as the delegated control of populations by means of targeted Christianizing. In this process, the colonized had to be made to feel and visualize his or her deficiency or sinfulness. This awareness would both lead them to Christianity and generate desires for the consumer goods of civilization, such as Western-style clothing. Only then could the newly minted "soul" be subjected to discipline, and these subjects, the mimics of the colonizers, were always a minority within the colony. The emblematic new souls were the indigenous baptized and especially the priesthood. Within the former plantation complex, the "souls of black folk" were, to borrow W. E. B. Du Bois's famous phrase, subject to a "double consciousness" across the primary mode of division and separation in the twentieth century, the color line.

In this book, I explore these entanglements via the concept of *mana*, so central to modern theories of the "primitive" from Durkheim to Lévi-Strauss, which was reported to Britain's Royal Anthropological Society, in 1881, by the missionary R. H. Codrington. Relying on two indigenous priests as "native informants," Codrington had elaborated a theory of mana as that which works by the medium of spiritual power. This majesty and force then attached itself to specific individuals, the precursors of the modern hero. In short, the primitive mind was used as a source of, and justification for, the imperial theory of domination. Almost at once, by virtue

of the prevalent uniformitarianism, mana became central to the modern theory of the global primitive. However, mana has since been shown to be a verb, not a noun, expressing an abstract state rather than a spiritual medium. Imperial visuality was based on a set of misrecognitions that nonetheless sustained and enabled domination. In an often-overlooked moment in 1968, under pressure from radical students, Jacques Lacan admitted that the Oedipus complex was a colonial imposition. The Oedipus complex, complex of all complexes, instigator of the unconscious being structured as a language, stood refashioned as a tool of colonial domination, just as Fanon and others had insisted, marking a certain "end" to the imperial complex.

The viewpoint from which imperial visuality contemplated its domains was first epitomized in the shipboard view of a colonial coastline, generating the cliché of gunboat diplomacy—to resolve a problem in the empire, send a gunboat. This view was represented in the form of the panorama and told in the form of multi-destination travel narratives. Just as the theorist of the "primitive" relied on information supplied by missionaries that was actually obtained from a handful of local informants, imperial visuality displaced itself from the "battlefield" of history itself, where Carlyle had romantically placed his heroes. The place of visualization has literally and metaphorically continued to distance itself from the subject being viewed, intensifying first to that of aerial photography and more recently to that of satellites, a practical means of domination and surveillance.[50] The calm serenity of the high imperial worldview collapsed in the First World War. Far from being abandoned, it was intensified by bringing colonial techniques to bear on the metropole and the aestheticization of war, a merger of formerly distinct operations of visuality under the pressure of intensification. In this vein, the formerly discarded concept of the mystical hero-leader was revived as a key component of fascist politics, but, as Antonio Gramsci properly saw, this leader was the product of the centralized police state, not the other way around. In this context, fascism is understood as a politics of the police that renders the nation, the party, and the state as one, subject to the leadership of the heroic individual, defined and separated by the logics of racialization. The combination of aestheticized leadership and segregation came to constitute a form of reality, one which people came to feel was "right." Fascist visuality imagined the terrain of history, held to be legible only to the fascist leader, as if seen by the aerial photography used to prepare and record the signature bombing campaigns of blitzkrieg. Fascists

from Manchester to Milan acclaimed Carlyle as a prophet and a predecessor, just as decolonial critics from Frantz Fanon on have seen fascism as the application of colonial techniques of domination to the metropole.

THE MILITARY-INDUSTRIAL COMPLEX: GLOBAL
COUNTERINSURGENCY AND POST-PANOPTIC VISUALITY

While in Western Europe the end of the Second World War marked a break in this domination, these conditions were not changed in the colonies. This continuity was exemplified by the violent French repression of a nationalist demonstration, in 1945, in the town of Sétif, Algeria, on V-E Day itself (8 May 1945), with estimated casualties ranging from the French government figure of 1,500 to Fanon's claim of 45,000, following Arab media reports of the time. However, the war of independence that followed (1954–62) was not simply a continuance of imperialism. For the French, Algeria was not a colony, but simply part of France. For the resistance movement, led by the Front de Libération Nationale (FLN), much energy was expended in trying to gain the sympathies of the United Nations, including the legendary general strike known as the "battle of Algiers." Algeria marked the failure of the imperial aesthetic to convince its subject populations that their domination was right. As part of the wave of decolonization, it was a central moment in the failure of the classification of "civilized" and "primitive" that was asserted as clinical fact by colonial psychology of the period. Despite their best efforts, the French were unable to sustain the physical and mental separation between the colonizer and the colonized. Counterinsurgency in Algeria began the practice of "disappearing" those suspected of aiding the insurgency in material or immaterial fashion, beginning the sorry genealogy that reaches from Argentina and Chile to today's "renditions" of suspected terrorists to so-called black sites by the CIA and other U.S. government agencies. Yet today French cities and villages are increasingly decorated with monuments and inscriptions to what are now called the wars in North Africa, marking the consolidation of global counterinsurgency as the hegemonic complex of Western visuality.

The emergence of the Cold War division between the United States and the Soviet Union almost immediately forced metropolitan and decolonial politics into a pattern whereby being anticolonial implied communist sympathies and supporting colonial domination was part of being pro-Western.[51] This classification became separation in almost the same

moment, at once aestheticized as "freedom." The Cold War quickly became a conflict so all-enveloping by 1961 that even President Dwight Eisenhower famously warned of the "total influence—economic, political, even spiritual" of what he called "the military-industrial complex."[52] In 1969, the novelist and former president of the Dominican Republic Juan Bosch, who had been deposed in a coup seven months after his election, in 1963, warned that "imperialism has been replaced by a superior force. Imperialism has been replaced by pentagonism."[53] Bosch saw this "pentagonism" as being separate from capitalism, a development beyond Lenin's thesis that imperialism was the last stage of capital. In common with the Situationists, Bosch envisaged a militarization and colonization of everyday life within the metropole. While his analysis is rarely remembered today, the global reach of counterinsurgency since 2001 and its ability to expand even as capital is in crisis has borne him out. The tactics of the now notorious COINTELPRO, or Counter-Intelligence Program (1956–71), of the FBI have now been globalized as the operating system of the Revolution in Military Affairs (RMA). Launched at the end of the Cold War, the RMA was at first conceived as high-technology information war, but has intensified into a counterinsurgency whose goal is nothing less than the active consent of the "host" culture to neoliberal globalization.

The entanglements and violence of counterinsurgency that began in Algeria and continued in Vietnam and Latin America have intensified into today's global counterinsurgency strategy, known to the U.S. military as GCOIN, which combines the cultural goals of imperial strategy with electronic and digital technologies of what I call post-panoptic visuality. Under this rubric, anywhere may be the site for an insurgency, so everywhere needs to be watched from multiple locations. Whereas during the Cold War, there were distinct "battle lines" producing "hot spots" of contestation, the entire planet is now taken to be the potential site for insurgency and must be visualized as such. Thus Britain, the closest ally of the United States, has also produced a steady stream of violent insurgents. Despite this literal globalization, visualizing remains a central to counterinsurgency. The Field Manual *FM 3-24 Counterinsurgency*, written at the behest of General David Petraeus, in 2006, tells its officers in the field that success depends on the efficacy of the "commander's visualization" of the Area of Operations, incorporating history, culture, and other sets of "invisible" information into the topography. This visualization required of the commander in Iraq or Afghanistan—of the flow of history as it is happening, formed by

past events with an awareness of future possibilities—would have been entirely familiar to Carlyle, even if the digital metaphors and technologies would have eluded him. GCOIN is an entanglement of nineteenth-century strategy with twenty-first century technology. The counterinsurgency commander is further recommended to read T. E. Lawrence (of "Arabia"), whose First World War heroics were the apogee of imperial visuality, and such works as *Small Wars*, by a nineteenth-century British general. Today's counterinsurgent is encouraged to see him or herself in a continuum with wars ranging from Algeria to Malaya (as was) and Latin America, and cognitively part of a history that is held to begin with the French Revolution, in 1789. In a further amalgam of past strategies of visuality, the distinction of "culture" that spatialized the imperial complex has now become the very terrain of conflict. Anthropologists are attached to combat brigades under the rubric of Human Terrain Systems so as to better interpret and understand local cultures. It has been with the counterinsurgency phase of the military-industrial complex that the "soul" of the (neo)colonized has most fully entered the frame. In this form of conflict, the counterinsurgent seeks not simply military domination, but an active and passive consent to the legitimacy of the supported regimes, meaning that regime change is only the precursor to cultural change. This desire for consent reaches across the entire population. As Carlyle would have wanted, today's global hero wants both to win and to be worshipped.

The post-panoptic visuality of global counterinsurgency produces a visualized authority whose location not only cannot be determined from the visual technologies being used but may itself be invisible. This viewpoint can toggle between image sets, zoom in and out of an image whether by digital or optical means, and compare them to databases of previous imagery.[54] It is able to use satellite imagery, infrared, and other technologies to create previously unimaginable visualizations. In everyday life, the prevalence of closed-circuit television (CCTV) surveillance marks this switch to post-panoptic visualization, with its plethora of fragmented, time-delayed, low-resolution images monitored mostly by computer, to no other effect than to make the watching visible. For while CCTV has been able to track the path of the 9/11 or 7/7 terrorists after the fact, it did nothing to prevent those attacks, let alone reform those observed, as the panopticon was intended to do. The signature military technology of GCOIN is the Unmanned Aerial Vehicle (UAV), a computer-controlled drone armed with missiles that is manipulated by operators at any location, usually in safe spaces within the

United States, rather than in proximity to the battlefield itself. The rise
the UAV has caused controversy among the theorists of GCOIN, such as
David Kilcullen, who feel that the tactic undermines the strategic goals of
winning the consent of the population. As James der Derian has eloquently
argued: "The rise of a military-industrial-media-entertainment network
(MIME-NET) has increasingly virtualized international relations, setting the
stage for virtuous wars in which history, experience, intuition and other
human traits are subordinated to scripted strategies and technological arti-
fice, in which worst-case scenarios produce the future they claim only to
anticipate."[55] Ironically, the script of using cultural understanding from his-
tory and experience to win consent has now simply been declared to have
been enacted. The 2010 campaign in Afghanistan was marked by extraordi-
nary theater in which General McChrystal announced his intention to cap-
ture Marja and Kandahar in advance, hoping to minimize civilian casualties,
but this tactic also reduced Taliban casualties, so that it is entirely unclear
who is really in charge on the ground. This suggests GCOIN is now a kind
of theater, with competing stunts being performed for those who consider
themselves always entitled to see. The U.S. military are having an intense
internal debate about which form of GCOIN is the future of military tactics.
It is clear that UAV missile attacks in Pakistan and Afghanistan have been
notably accelerated. These tactics increasingly resemble those of the Israeli
Defense Force, in which the real goal is maintaining a permanent state of
crisis, rather than achieving a phantasmatic victory. In the game context in
which war is now visualized, the point is less to win than to keep playing,
permanently moving to the next level in the ultimate massively multiplayer
environment.

In sum, the revolution in military affairs has designated the classification
between insurgent and counterinsurgent as the key to the intensified phase
of the military-industrial visuality. The separation to be enacted is that of
insurgent from the "host" population by physical means, from the barriers
separating the newly designated "Shia" and "Sunni" districts of Baghdad to
the Israeli defense barrier in the Occupied Territories and the wall between
Mexico and the United States, where border agents now use the rubrics
of counterinsurgency. With the triumph of *The Hurt Locker* (dir. Kathryn
Bigelow, 2008) in the movie awards ceremonies in 2009, counterinsurgency
has achieved an "aesthetic" form. In this view, duty is its own narrative,
giving pleasure in its fulfillment, as one bomb after another must be de-
fused. The "enemy" are largely invisible, motiveless, and entirely evil. The

ne depicts Staff Sergeant James (Jeremy Renner) striding
sunset, but to defuse yet another bomb, opening an imag-
ture of counterinsurgency. In its aestheticization of sac-
he Hurt Locker gained the recognition that had eluded the
attempted to critique the war, even though it failed to
cess at the box office. Whether this alignment of counter-
nore stable than its predecessors remains to be seen. What
seems likely is that the overarching project of designating a global will to
power as counterinsurgency will remain active for some considerable time
to come, even though, as I complete this book, it is being challenged by a
new form of revolutionary politics across North Africa and the Middle East
in early 2011.[56]

CONCEPTUALIZING COUNTERVISUALITY

Carlyle presented visuality as naturally authoritative while being aware not
only of opposition, but of foundational defeat during the Atlantic revolu-
tions. However, not all opposition to visuality can be considered counter-
visuality, a point which will help us to understand the difficulties involved.
Considering the development of globalization around the end of the twen-
tieth century, Arjun Appadurai noted the "split character" of the globalized
work of imagination: "On the one hand it is in and through the imagination
that modern citizens are disciplined and controlled—by states, markets, and
other powerful interests. But it is also the faculty through which collec-
tive patterns of dissent and new designs for collective life emerge."[57] In the
case of visuality, we need to introduce a similar distinction. As a discursive
organization of history, visuality was never able to achieve its goal of rep-
resenting totality, because "history" itself as a form of the historicopolitical
was not monolithic, but structured as conflict. In his study of Marx's theory
of capital, Dipesh Chakrabarty has described two modes of history as it
was formed under capitalism. History 1 is that history predicated by capi-
tal for itself "as a precondition" to its own existence, whereas History 2 is
that which cannot be written into the history of capital even as prefigura-
tion and so has to be excluded.[58] Chakrabarty has sought to recover that
History 2 without privileging it either as the new dominant mode of His-
tory, or as the dialectical other to History 1. Rather, he suggests, "History 2
is better thought of as a category charged with the function of constantly
interrupting the totalizing thrusts of History 1." This doubled interaction

offers a model for thinking about visuality that incorporates its embodied dimension at an individual and collective level, together with visuality as cultural and political representation.

In these terms, Visuality 1 would be that narrative that concentrates on the formation of a coherent and intelligible picture of modernity that allowed for centralized and/or autocratic leadership. It creates a picture of order that sustained the industrial division of labor as its enactment of the "division of the sensible." In this sense, photography, for example, contributed to Visuality 1 in the manner famously critiqued by Baudelaire as the tool of commerce, science, and industry.[59] This form of visuality, one proper to the docile bodies demanded by capital, developed new means of disciplining, normalizing, and ordering vision, ranging from the color-blindness tests that were introduced for industrial workers in the 1840s, to state-funded compulsory literacy and the public museum. Consequently, the modern production process that culminated in Taylor's and Ford's systems came to rely on a normative hand-eye coordination, trained in sport, managed by the distribution of corrective lenses, and controlled with sight tests.[60] In visual representation, its dominant apparatus would become the cinema, understood in the sense of Jonathan L. Beller's "cinematic mode of production," which creates value by attracting attention.[61] Its logical endpoint was what Guy Debord famously called the "spectacle," that is to say, "capital accumulated to the point where it becomes an image."[62] In this sense, then, a certain history of visuality—or at least Visuality 1—has already been written and is not unfamiliar. This book does not revisit that story for several reasons. The History that Chakrabarty describes as being the precondition for capital is not exactly the same as the History visualized by visuality (and this is, of course, no criticism of Chakrabarty—quite the contrary). Whereas it may be said that capital will do anything to preserve and extend its circulation, so that even carbon emissions are now being formulated into a market, visuality was concerned above all to safeguard the authority of leadership. So whereas Chakrabarty established a diachronic binary distinction between the two modes of History under capitalism, I have tried to define a successive set of synchronic complexes for visuality and countervisuality from slavery to imperialism and global counterinsurgency.

How should we conceptualize, theorize, and understand countervisuality in relation to this divided visuality? It is not simply Visuality 2. If Visuality 1 is the domain of authority, Visuality 2 would be that picturing of the self or collective that exceeds or precedes that subjugation to centralized

authority. Visuality 2 was not invisible to authority and has been figured as the barbaric, the uncivilized, or, in the modern period, the "primitive." In the imperial complex, an army of self-styled "hero" missionaries generated an epistemic apparatus to discipline and order it, whereas the "primitives" in the metropole were to be controlled by the new imperial Caesar and his command of imagery. The leading taxonomies of such "primitive" visuality were idolatry, fetishism, and totemism, in order of seniority.[63] This definition of Visuality 2 was enacted in the colonial and imperial domains that Conrad called the "blank spaces of the map," the blind spots of visuality. Within the metropole, an artistic version of Visuality 2 was that "irrational modernism. . . . that escapes . . . appropriative logic," such as Dada and Surrealism, often of course using the forms and ideas of indigenous art and culture from colonized domains.[64] By now, surrealism in particular has nonetheless been thoroughly appropriated, especially by advertising and music videos. For Visuality 2 is not necessarily politically radical or progressive; it is only not part of authority's "life process." There are multiple forms of Visuality 2, because that difference "lives in intimate and plural relationships to [authority], ranging from opposition to neutrality."[65] The two modes of visuality are not opposed in a binary system, but operate as a relation of difference that is always deferred. So not all forms of Visuality 2 are what I am calling countervisuality, the attempt to reconfigure visuality as a whole. For example, many forms of religion might deploy some mode of Visuality 2 without seeking to change the perceived real in which that religion is practiced.

Countervisuality proper is the claim for the right to look. It is the dissensus with visuality, meaning "a dispute over what is visible as an element of a situation, over which visible elements belong to what is common, over the capacity of subjects to designate this common and argue for it."[66] The performative claim of a right to look where none exists puts a countervisuality into play. Like visuality, it interfaces "formal" and "historical" aspects. The "right" in the right to look contests first the "right" to property in another person by insisting on the irreducible autonomy of all citizens. Autonomy implies a working through of Enlightenment claims to rights in the context of coloniality, with an emphasis on the right to subjectivity and the contestation of poverty.[67] By engaging in such a discussion, I am implicitly rejecting the dismissal of rights as a biopolitical ruse presented by Agamben.[68] There is no "bare life" entirely beyond the remit of rights. Hardt and Negri powerfully cite Spinoza to this effect: "Nobody can so

completely transfer to another all his right, and consequently his power, as to cease to be a human being, nor will there ever be a sovereign power that can do all it pleases."[69] Ariella Azoulay has expressed the legacy of revolutionary discourses of rights as precisely "struggles pos[ing] a demand that bare life be recognized as life worth living."[70] Azoulay rightly sees these demands being enacted in feminism from Olympe de Gouges's *Declaration of the Rights of Woman and the Citizen* (1791) on. As Rancière points out, de Gouges's insistence that if women have the "right" to be executed, they are foundationally equal, also shows that "bare life itself is political."[71] Precisely the same argument can be made with regard to the enslaved, who were subject to legal codes specifying punishments. In following what you might call "Carlyle-ism" (a pattern of discourse concerning the visualization of imperial autocracy) to shape this book, I was at first concerned that his emphasis on heroic masculinity would engender a similarly masculinist project. However, I came to notice that all the efforts at countervisuality I describe here centered on women and children both as individual actors and as collective entities. The actions and even names of individual women and children (especially of the enslaved) have to be reclaimed from historical archives that are not designed to preserve them and have not always done so.

THE RIGHT TO THE REAL

The claim of the right to oneself as autonomy further implies a claim of the right to the real. The Italian political organization Autonomia, which was active in the 1970s, defined autonomy as "anti-hierarchic, anti-dialectic, anti-representative. It is not only a political project, it is a struggle for existence. Individuals are never autonomous: they depend on external recognition."[72] By the same token, the right to look is never individual: my right to look depends on your recognition of me, and vice versa.[73] Formally, the right to look is the attempt to shape an autonomous realism that is not only outside authority's process but antagonistic to it. Countervisuality is the assertion of the right to look, challenging the law that sustains visuality's authority in order to justify its own sense of "right." The right to look refuses to allow authority to suture its interpretation of the sensible to power, first as law and then as the aesthetic. Writing of such refusals of legitimation, Negri points out: "It is once again Foucault who lays the foundation of this critical experience, better still of this unmasking of that (in our civili-

zation) ancient Platonism that ignores the right to the real, to the power of the event."[74] The right to look is, then, the claim to a right to the real. It becomes known by genealogical investigation that is here always repurposed as decolonial critique. It is the boundary of visuality, the place where its codes of separation encounter a "grammar of nonviolence," the refusal to segregate, as a collective form. Confronted with this double need to apprehend and counter a real that did exist but should not have, and one that should exist but was as yet becoming, countervisuality has created a variety of "realist" formats structured around such tensions. Certainly the "realism" usually considered under that name in the mid-nineteenth century is one part of it, as is the neorealism of postwar Italian visual culture, but countervisuality's realism was not necessarily mimetic. To take a famous example, Picasso's *Guernica* both expresses the reality of aerial bombing that was and is central to contemporary visuality, and protests against it with sufficient force that American officials asked for the replica of the painting at the United Nations to be covered when they were making their case for war against Iraq, in 2002.

The realism of the right to the real highlights the "struggle for existence," meaning a genealogy of the claim of the right to existence, beginning with the enslaved, via the banners claiming the "right to life" in the Paris Commune of 1871 and the "new humanism" of decolonization sought by Aimé Césaire and Frantz Fanon. Throughout the struggle to abolish chattel slavery in the Atlantic world, countervisuality endeavored to construct what I call "abolition realism," in homage to Du Bois's concept of abolition democracy, where there would be no slavery, rendering what seemed unimaginable into "reality." This realism represented the "enslaved" as being of equal status with the "free," while also showing the realities of slavery for what they were, as opposed to the benign picture of paternal leadership presented by apologists like Carlyle. This picturing therefore created and worked in realist modes of representation from painting to photography and performance in an intense moment of challenge to visualized authority. The defeat of Reconstruction in the United States together with that of the Paris Commune marked the defeat of abolition in the Atlantic world as an index of reality, as indicated by the persistence of racism.

Autonomy has also expressed the indigenous desire for self-government or regulation. In this book, I take the transformation of Aotearoa into New Zealand (1820–85) as a key site of entanglement and displacement in this process because James Anthony Froude, Carlyle's biographer and succes-

sor as the dean of British historians, saw it as the place from which a new "Oceana" could be launched, meaning a global Anglophone empire. For the Polynesian peoples living in Aotearoa, a wide-ranging series of adjustments had to be made in their imagined communities, resulting from their inter-pellation as "native" and "heathen" by the missionaries and settlers. Follow-ing prophets and war leaders like Papahurihia (?–1875), the Maori imagined themselves as an indigenous and ancient people, the Jews of the Bible, the ancient bearers of rights, rather than "primitive" savages. They deployed their own readings of the Scriptures to assert that the missionaries were in error, created rival flags to those of the British, and imagined themselves to be in "Canaan." This imagined community compelled the British Crown to sign a land-sharing agreement known as the Treaty of Waitangi (1840), which, although nullified by legal fiat within two decades, has proved de-cisive in shaping modern Aotearoa New Zealand into a bicultural state. In both metropolitan and colonial contexts, the performative act of claiming the right to be seen used the refusal to labor as one of its key strategies, from written accounts that considered the Israelites leaving Egypt as a general strike, to the campaign for May Day holiday, and the contemporary poli-tics of the refusal of work. Although the general strike was adopted by the Confederation Générale du Travail, the French trade union, in 1906, and was famously endorsed by Rosa Luxemburg in her pamphlet of the same year, the failure of the Second International to resist mobilization for what became the First World War ended the hope that it might in fact be the revolutionary form for the twentieth century. Emblematic of the transfor-mation in Europe of the period was the shift of the once-anarchist Georges Sorel, whose *Reflections on Violence* (1908) had contained the most elaborated theory of the general strike as a means of creating the "general image" of social conflict, to an anti-Semitic Royalism, which Mark Antliff has called a "proto-fascism."[75]

Writing in the 1930s with a full awareness of fascism's dominance, both W. E. B. Du Bois and Antonio Gramsci came to see the need for a new point of view that both in different ways called the "South." For Du Bois, the South was the southern part of the United States that practiced seg-regation under so-called Jim Crow laws, whereas for Gramsci it was the Italian *mezzogiorno*, a mix of feudal rural areas and unregulated modern cities like Naples. The South was, of course, intensely contested, rather than some imagined point of liberation, but for both thinkers no strategy could be successful that did not imagine itself from the South. Understood in

this sense, fascism did not end in 1945, as the names Franco, Pinochet, and many others attest. Antifascism has had, therefore, to create a neorealism that could counter fascism's sense of ordering engendered by subjugation and separation. It must do so from within the "South" and as the South opposed to the North. This doubled realism can be hard to see. In *The Battle of Algiers*, the resistance leader Ben H'midi tells Ali la Pointe that if it is hard to start and sustain resistance, the hardest moment of all comes when you have won.

We might take Bertolt Brecht's caution about working with "reality" and realisms to heart here: "Reality is not only everything which is, but everything which is becoming. It's a process. It proceeds in contradictions. If it is not perceived in its contradictory nature, it is not perceived at all."[76] This creation of reality as a perceptual effect is not the same as realism as it has usually been defined in literature and the visual arts. The realist painter Gustave Courbet, for instance, is supposed to have said that he could paint only that which he could see with his eyes, making it impossible for him to render an angel. Realism has largely been understood in this sense as meaning the most sharp-edged, lens-based representation of exterior reality possible, from photography to the 35-millimeter film and most recently high-definition video. In the terms that I have sketched here, that would be a realism of Visuality 1, the sensory training and standardization required by industrial capital. Countervisuality seeks to resituate the terms on which reality is to be understood. If, as Barthes famously formulated it, all reality is an "effect," then that effect can be subject to change. For Freud, the ego engages in a persistent reality-testing which, as Avital Ronel elucidates, "should in the best of worlds, confirm and countersign the satisfaction of our wishes but in fact put the self at risk."[77] In this sense, all realisms are an attempt to come to terms with the tendency of modernity to exceed understanding in its permanent revolutionizing of conditions of existence. As the poet Pier Paolo Pasolini later mused in his consideration of Antonio Gramsci, "Perhaps we should, in all humility and with a bold neologism, simply call reality that-which-must-be-made-sense-of."[78] Countervisuality is not, as this example suggests, simply a matter of assembled visual images, but the grounds on which such assemblages can register as meaningful renditions of a given moment. Thinking the genealogy of visuality and its countervisualities produces both a sense of what is at stake in present-day visualizing and a means to avoid being drawn into a perpetual game in which authority always has the first move. This book

is a claim for a different form of visualizing by those who would oppose autocratic authority. This visualizing would take the planetary viewpoint in giving priority to the biosphere and the survival of all forms of life over the continuance of authority. The image of the biosphere is a countervisuality to the partisans of the "long war" against terror and the permanent state of emergency. The vernacular countervisuality of the "South" has centered on democracy, sustainable production, education, and collective solutions to social problems as a different mode of visualizing cultural possibilities since the Atlantic revolutions of the 1790s. While this approach has for just as long been condemned as impractical by leaders of Left and Right, it has come to seem like the last option remaining. In the aftermath of the earthquake that struck Haiti in 2010, sustainable local agriculture was finally advanced as the best solution for the country.[79] Nonetheless, the emergence of government strategies such as "climate security" shows that this position offers no guarantees of success. Here we take the measure of the long success of visuality. It seems "natural," or at least reasonable, that visuality should visualize war and that different groups of people should be physically separated. This project hopes to call such assumptions into question and make us take a second look at some old choices.

One response to my claim for the right to look might be: so what? In other words, while these issues may be of importance, what difference does my claim make and why should you care? I take it that many of my readers will be in some way engaged with universities and academic life, so my response is shaped in that domain. In March 2003, a law professor at the University of California, Berkeley, named John Yoo, who was then working in the Justice Department as a deputy assistant attorney general, wrote a memorandum regarding the interrogation of so-called enemy combatants. Relying on his interpretation of "the President's authority to successfully prosecute war," Yoo notoriously concluded that there were in effect no limits on what could be done, claiming that "the Framers understood the Commander-in-Chief Clause [of the Constitution] to grant the President the fullest range of power recognized at the time of the ratification as belonging to the military commander."[80] From this academic interpretation of authority, stemming, like visuality, from the eighteenth-century general, resulted the scandals of Guantánamo and Abu Ghraib, the renditions of suspects to places where torture is openly practiced, and, more broadly, the hubris of presidential authority. In the summer of 2009, faced with a difficult financial situation the chancellor of the University of California,

Mark Yudof, had the regents ascribe to him hitherto unknown "emergency powers," resulting in redundancies, tuition raises, class cancellations, and "furloughs" (meaning days for which one would not be paid for work) for all staff, including, one hopes, John Yoo, who has returned to his academic job. In 1988 I happened to visit the University of California, Berkeley, and what I saw then was the inspiration that led me to an academic career in general and to one in the United States in particular. The new deployment and interpretation of authority by academics in government and in the university has changed the world we live and work in. Networks long in the making are rapidly being undone, while new ones are being made. Attention should be paid.

I conclude this opening section with a brief chapter plan. The first four chapters deal with the plantation complex and its transformation into the imperial complex. In the first chapter, I describe the ordering of slavery by means of visual technologies and surveillance under the headings of mapping, natural history, and the force of law. In the British and French Caribbean, a rapid revolution created the possibility of this regime in the years either side of 1660. In the generations that followed, the enslaved learned how to counter each aspect of oversight. In the second half of chapter 1, I describe first the attempted revolution led by François Makandal on Saint-Domingue, in 1757, and then the planters' attempt to create an independent slave-owning republic in the early years of the French Revolution. These mutually contradictory claims to autonomy opened a space for a different revolutionary imaginary, which I explore in chapter 2. Throughout I counterpoint the metaphorical slavery being challenged by revolutionaries in France with the revolution against chattel slavery in Saint-Domingue. I stage this interaction in five moments, beginning with the visualization in popular prints first of the "awakening" of the French Revolution, in 1789, and next the Declaration of the Rights of Man and the Citizen. I emphasize that the Declaration at once claimed to end "slavery" and defined racialized and gendered exclusions from the category of rights. These exclusions led to a new claim to a "right to existence" embodied in the hero as the leader of the "imagined community" of the postmonarchical nation-state. The revolt of the enslaved in Haiti successfully used the tactic of the hero to focus their resistance to the authority of oversight. Slave-owning sover-

eignty found itself confronted by a person invested with authority by those it claimed had none to give—the people, the enslaved, and women. During the revolution, a further contest emerged between the national hero as Great Man, who incarnated authority, and what I call vernacular heroism, whose primary function was to make enslavement impossible. These different claims could not and did not cohere. I end chapter 2 by looking at the violent confrontation between Toussaint L'Ouverture and the subaltern rank-and-file in Saint-Domingue over the question of land. The formerly enslaved wanted self-sufficiency, while the leadership demanded the maintenance of cash-crop agriculture to fund the emergent nation-state. At the same moment, the first person to ask for a position as an anthropologist, the Frenchman François Péron, was engaged in an encounter with the aboriginal people of Tasmania that foreshadowed the hierarchy of "culture" that was to shape imperial visuality. I counterpoint these chapters with a reading of the double vision of reality in the paintings of José Campeche, the Puerto Rican painter, perhaps the first artist to emerge from slavery that we can name.

In the early nineteenth century, radicals imagined new strategies like the Jubilee and the National Holiday to advance their claim to represent the nation. In response, visuality, named and deployed by Thomas Carlyle in 1840, appropriated the revolutionary tactic of the national hero as leader to reclaim the altered terrain of history into a renewed system of domination (chapter 3). His model was the visualization of the battlefield by the modern general, epitomized by Napoleon, in order to gain tactical advantage over a closely matched enemy. It was the visualization of a revived sovereignty that might again own slaves, as decreed by Napoleon, or, that might, as in the case of British imperialism after the so-called Indian Mutiny of 1857, reassert a centralized colonial authority. Inspired by its desire to prevent all challenges to authority, Carlyle's visuality claimed boundless dominion for its heroes and refuted all emancipations. As a result, leaders like Sojourner Truth and W. E. B. Du Bois actively contested this "heroism" with different modalities of heroism. The nineteenth century saw a protracted struggle as to whether and how a reality could be shaped that did not sustain and support slavery. In chapter 4, I look at this interpenetrated history of metropole and colony around the Atlantic world, from the abolition of Danish slavery witnessed by the future impressionist painter Camille Pissarro to the Civil War and Reconstruction in the United States and the Paris Commune of 1871. The reality and realisms of modern Paris, Benjamin's capital of the

nineteenth century, are placed in counterpoint to the reality and realisms of the abolition of slavery. I look first at the visualized policing of "emancipated" plantations, followed by the visualization of freedom during the Civil War in the United States. Then I survey the contradictions of realism and abolition in 1867 in artistic visualizations by Pissarro, Manet, and Degas. I conclude chapter 4 with the attempt to institutionalize autonomy during Reconstruction and the performance of autonomy during the Commune. The counterpoint to these chapters is a reading of Francisco Oller's masterpiece *El Velorio* (1895), or *The Wake*, which I interpret as a mourning both for the hopes of abolition, achieved in Puerto Rico in 1873, and also for the lost opportunities of realism.

By this point the "imperial complex" had become the dominant form of visuality. In chapter 5 I examine how visuality became imperial visuality as an impersonal form of power, generalized and globalized within an Anglophone network of power sustained by naval domination. Here I take Aotearoa New Zealand as the key point of entanglement, as described above, both because Froude had seen it as the key to his Oceana, the global empire of visuality, and because Maori resistance in the form of self-identifying as "Jews" was so notable a claim to autonomy. The bishopric of New Zealand was also the site of the ethnographic "discovery" of the concept of mana, held to be what one might call the aura of authority. Introduced to European anthropology in 1880, the idea took hold at once and has continued to play a role in recent debates about the state of exception. This empire was subject to a new Caesar, more imagined than actual, but distinguished by his ability to dominate the mass population by means of the image. Within imperial nations, radical movements similarly sought to challenge the authority of imperial capital by claiming a genealogy from what they called the "ancient lowly," meaning the workers of ancient Greece and Rome. Heroes like Spartacus were taken both as a validation for modern claims and as a means of creating a history for those without it. This countervisuality used this history to claim a "general picture" of the social by means of new institutions, such as museums of labor, and new actions, such as the general strike.

After the First World War, the collapse of high imperialism brought down the Austro-Hungarian, Ottoman, and Russian empires and transformed Caesarism from a theory of imperial leadership into a violent exaltation of the leader as Hero in fascism (chapter 6). As noted above, antifascism must find a means to render a neorealism capable of resisting fascist

ordering. After analyzing the turn to the "South" made by Gramsci, Du Bois, and other intellectuals, I take the fifty-year-long crisis of decolonizing Algeria (1954–) as a case study of the entanglement of the legacies of fascism, imperialism, the Cold War, and decolonization. I concentrate on the battles for Algiers in psychiatry, film, video art, and literature that have been fought almost without a break over this period. I set the legendary neorealist film *The Battle of Algiers* (dir. Gillo Pontecorvo, 1966) into the context of innovative film practice in the Algerian revolution, including a remarkable short film documentary made in 1961 and inspired by Fanon's work with children in Algerian refugee camps in Tunisia, as well as the "ciné pops" movement of popular film and the first features created in independent Algeria. Since the invasion of Iraq, Fanon's experience in Algeria has generated new visualized responses from the Finnish video artist Eije-Liese Ahtila and the African American novelist John Edgar Wideman, while the Algerian revolution haunts recent films like *Caché* (dir. Michael Hanneke, 2005). This entanglement of decolonization and independence with its many displacements is counterpointed by *Pan's Labyrinth*, a film about Spain, directed by a Mexican-American, which spoke as strongly to its own time as the fascist period under Franco it depicted.

If antifascism quickly became anticommunism in the Allied nations, especially in the United States, the resulting military-industrial complex linked the antislavery with new antiterror rhetoric to justify its formation of what Paul Edwards has called "the closed world." In this closed world, every enterprise is linked to the central struggle to separate and defend the "free" world from the terror of the communist world to prevent it becoming enslaved. As General Douglas MacArthur declared to Congress, in 1951, this threat of slavery meant that communism had to be resisted everywhere.[81] From the outset, the classification of separation was not only right, but justified any action in its name. The resulting counterinsurgency against communism spanned the globe from Algeria to Indochina and Latin America. Visualizing became a key strategy of what the U.S. military has termed the Revolution in Military Affairs (RMA) since 1989 (chapter 7). The RMA is the intensification of the Cold War. It makes information the key tool of war, visualized by the commander to gain control of the area of operations. Drawing at once on imperial era heroes like T. E. Lawrence and postmodern theorists of nomadism, the RMA found its high point of revolution in the war in Iraq. An active neovisuality has been enshrined as a key part of United States global counterinsurgency strategy, supported

by an entire discursive apparatus from the Ivy League universities, to the media, to military theorists, many of whom are connected to the Obama administration. This apparatus rejects Guantánamo Bay and other such visible means of punishment as both unnecessary and jeopardizing to the mission of winning full and permanent cooperation. Neovisuality is a doctrine for the preservation of authority by means of permanent surveillance of all realms of life, a *Gesamtkunstwerk* of necropolitics. Needless to say, it not only expects but needs resistance to its visualizing of the geopolitical as always already potential terrorism. In its current manifestation as counterinsurgency, it has developed a new radicalism, resisting challenges to its authority from within and without the military. Paradoxically, visualized information war depends increasingly on making the visible invisible, provoking a crisis of visuality itself. The simple fact that a counterhistory of visuality can be written suggests that it has lost its force as "natural" authority. A tremulous moment of opportunity awaits to set aside visuality for the right to look, to democratize democracy. Or to once again authorize authority. It's up to us.

COMPLEXES OF VISUALITY

Table 1. Complexes of Visuality 1

COMPLEX	METONYMIC FIGURE	PERIOD OF DOMINANCE
Plantation Complex	Overseer	1660–1860
Imperial Complex	Missionary	1860–1945
Military-Industrial Complex	Counterinsurgent	1945–present

Table 2. Complexes of Visuality 2

	VISUALITY	COUNTERVISUALITY
Plantation Complex (standard form)	Oversight (1660–1838)	Revolutionary realism (c. 1730–1838)
Plantation Complex ("intensified" form)	Visuality (1802–1865)	Abolition realism (1807–1871)
Imperial Complex (standard form)	Imperial visuality (1805–1914)	Indigenous counter-visuality (1801–1917)
Imperial Complex ("intensified" form)	Fascist visuality (1918–1982)	Antifascist neorealism (1917–present)
Military-Industrial Complex (standard form)	Aerial visualization (1924–present)	Decolonial neorealism (1945–present)
Military-Industrial Complex ("intensified" form)	Post-panoptic visuality (1989–present)	Planetary visualization (1967–present)

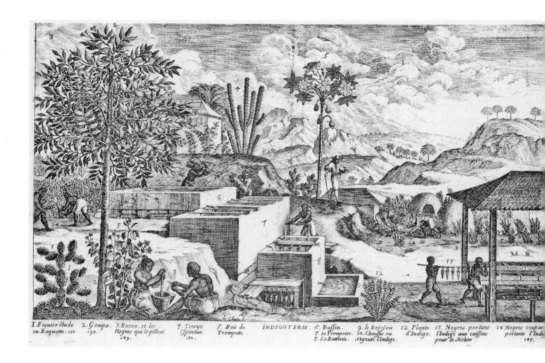

FORM OF MATERIAL VISUALITY

1. OVERSIGHT: THE SURVEILLANCE OF THE OVERSEER

> The duty of an overseer consists in superintending the planting or
> farming concerns of the estate, ordering the proper work to be done,
> and seeing that it is duly executed.
> —John Stewart, Jamaican planter, *A View of the Past and Present State
> of the Island of Jamaica* (1823)

**Note the overseer in white at the center, managing fourteen operations
by visual surveillance alone.** | FIGURE 2. JEAN-BAPTISTE DU TERTRE, "INDIGO-
TERIE," *HISTOIRE GÉNÉRALE DES ANTILLES HABITÉES PAR LES FRANÇOIS* (PARIS, 1667).

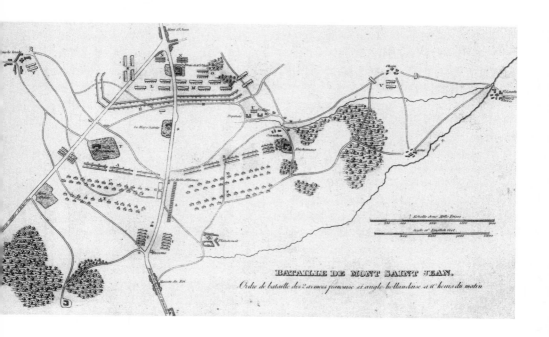

BATAILLE DE MONT SAINT JEAN.
Ordre de bataille des 2 armées française et anglo-hollandaise à 11 heures du matin

2. VISUALITY: THE BATTLE PLAN

> War [is] an act of imagination . . . imprinted like a picture,
> like a map, upon the brain.
> —Karl von Clausewitz, *On War*

Napoleon's defeat at Waterloo, seen here as an after-the-fact visualization of the "mind's eye" of the general, combined with the physical realities of the locale. A symbolic and nontransparent mapping of history. | FIGURE 3. *PLAN OF THE BATTLE OF WATERLOO.* Photo courtesy of David Rumsey Map Collection, http://www.davidrumsey.com.

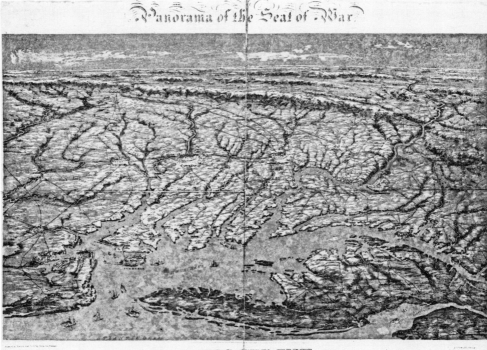

BIRDS EYE VIEW
OF VIRGINIA, MARYLAND DELAWARE AND THE DISTRICT OF COLUMBIA

3. IMPERIAL VISUALITY

Once, I remember, we came upon a man-of-war anchored off the coast. There wasn't even a shed there, and she was shelling the bush. It appears the French had one of their wars going on thereabouts. Her ensign dropped limp like a rag; the muzzles of the long six-inch guns stuck out all over the low hull; the greasy, slimy swell swung her up lazily and let her down, swaying her thin masts. In the empty immensity of earth, sky, and water, there she was, incomprehensible, firing into a continent. Pop, would go one of the six-inch guns; a small flame would dart and vanish, a little white smoke would disappear, a tiny projectile would give a feeble screech—and nothing happened. Nothing could happen. There was a touch of insanity in the proceeding.

—Joseph Conrad, *Heart of Darkness* (1899)

FIGURE 4. JOHN BACHMANN, *PANORAMA OF THE SEAT OF WAR: BIRD'S EYE VIEW OF VIRGINIA, MARYLAND, DELAWARE AND THE DISTRICT OF COLUMBIA* (1861). Photo courtesy of David Rumsey Map Collection, http://www.davidrumsey.com.

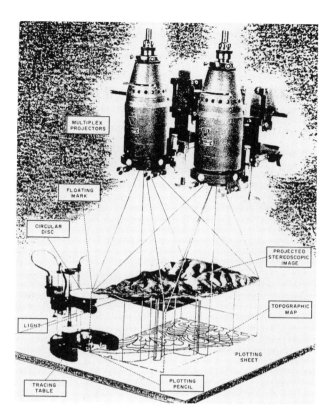

4. MILITARY-INDUSTRIAL VISUALITY

> In general, mass movements are more clearly apprehended by the camera than by the eye. A bird's eye view captures assemblies of hundreds of thousands. And even when this perspective is no less accessible to the human eye than to the camera, the image formed by the eye cannot be enlarged in the same way as a photograph. This is to say that mass movements, and above all war, are a form of human behavior especially suited to the camera.
> —Walter Benjamin, "The Work of Art in the Age of Its Technological Reproducibility"

The aerial photograph visualized the viewpoint of blitzkrieg, so that the world can be seen for bombing, but it was also a political viewpoint. | FIGURE 5. "MULTIPLEX SET" FROM FM-30-21 *AERIAL PHOTOGRAPHY: MILITARY APPLICATIONS* (WASHINGTON: WAR DEPARTMENT, 1944).

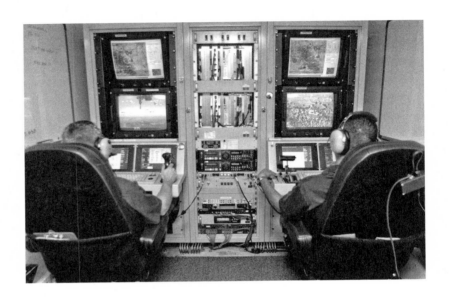

5. POST-PANOPTIC VISUALITY

> *Commander's visualization* is the mental process of developing situational understanding, determining a desired end state, and envisioning how the force will achieve that end state. It begins with mission receipt and continues throughout any operation. The commander's visualization forms the basis for conducting (planning, preparing for, executing, and assessing) an operation.
>
> —FM 3–24 *Counterinsurgency* Section 7–7

An Unmanned Aerial Vehicle provides remote surveillance of the Mexican–U.S. border, the divine viewpoint of visuality now from an unknowable location. | FIGURE 6. *UNMANNED AERIAL VEHICLE*. Photo by Master Sergeant Steve Horton, U.S. Air Force.

Table 3. Countervisuality

COUNTERVISUALITY	VISUALIZATION
Revolutionary realism (c. 1730–1838)	The Hero/the popular hero
Abolition realism (1807–1871)	A real without slavery
Imperial countervisuality (1801–1917)	The general strike
Antifascist neorealism (1917–)	The "South"
Planetary visualization (1967–)	The biosphere

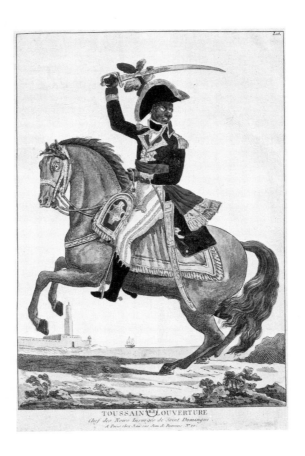

TOUSSAINT L'OUVERTURE
Chef des Noirs Insurgés de Saint Domingue
À Paris chez Jean rue Jean de Beauvais N° 10

1A. THE HERO

> An expression in the form of a question that would become famous is
> "How is thinking possible after Auschwitz?" . . . Who has ever asked
> the question: "How is thinking possible after Saint-Domingue"?
> —Louis Sala-Molins, *Dark Side of the Light*. (Sala-Molins is referring
> here to Adorno's often (mis)quoted remark that lyric poetry was
> impossible after Auschwitz)

**Toussaint L'Ouverture, hero of the Haitian Revolution (1791–1804) and
defeater of colonial slavery.** | FIGURE 7. ANONYMOUS, *TOUSSAINT L'OUVER-
TURE, LEADER OF THE INSURGENTS OF SANTO DOMINGO, DOMINGUE* (CA. 1800). Color
engraving. Photo by Bulloz, Bibliothèque Nationale, Paris, France. Photo courtesy of Réunion des
Musées Nationaux / Art Resource, New York.

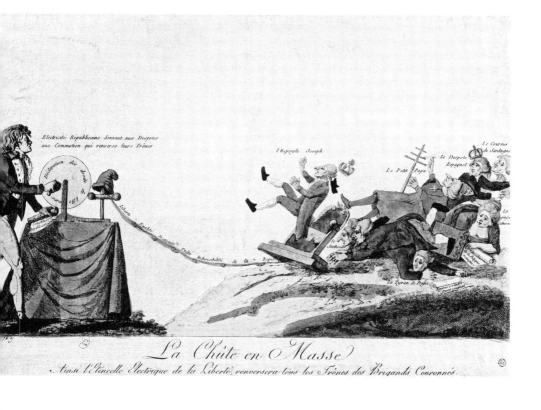

1B. THE VERNACULAR HERO

"Republican electricity gives Despots a shock that overturns their thrones." The vernacular hero visualized as a generic Sans-Culotte turns an electric generator to overthrow the crowned heads of Europe (1793).

FIGURE 8. DUPUIS, *LA CHUTE EN MASSE* (PARIS, 1793). Photo courtesy of Corbis Images.

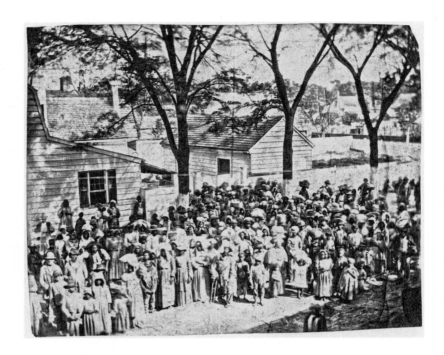

2. ABOLITION REALISM

> This was not merely the desire to stop work. It was a strike on a wide basis
> against the conditions of work. It was a general strike that involved directly
> in the end perhaps half a million people.
>
> —W. E. B. Du Bois, *Black Reconstruction in America* (1935)

The general strike against slavery in South Carolina. | FIGURE 9. TIMOTHY H.
O'SULLIVAN, *UNTITLED [SLAVES, J. J. SMITH'S PLANTATION, NEAR BEAUFORT, SOUTH
CAROLINA]* (1862). Albumen silver print, 21.4 x 27.3 cm. Courtesy of the J. Paul Getty Museum,
Los Angeles.

3A. INDIGENOUS COUNTERVISUALITY: THE INDIGENOUS GENERAL STRIKE
(see plate 1)

> There was a Crusade at the Time among the Natives, so that everything was
> at a Stand-Still; they had no opportunity of getting on with anything. That
> was occasioned by a new Religion, which has sprung up, called Papahurihia.
>
> —Joel Polack, quoted in the *Report of the Select Committee of the House of Lords
> Appointed to Inquire into the Present State of the Islands of New Zealand* (1838)

3B. INDIGENOUS COUNTERVISUALITY:
THE METROPOLITAN GENERAL STRIKE

> [The general strike is] an arrangement of images capable of evoking instinc-
> tively all of the sentiments which correspond to the various manifestations
> of the war waged by socialism against modern society. Strikes have inspired
> in the proletariat the noblest, deepest and most forceful sentiments that it
> possesses; the general strike groups them all into a general unified image. . . .
> Thus we obtain that intuition of socialism that language could not give in
> a perfectly clear way—and we obtain it as an instantly perceivable whole.
> —Georges Sorel, *Reflections on Violence* (1906)

**The general strike for a May Day holiday called by the Second Inter-
national in Milan.** | FIGURE 10. EMILIO LONGONI, *MAY 1 OR THE ORATOR OF THE
STRIKE* (1891).

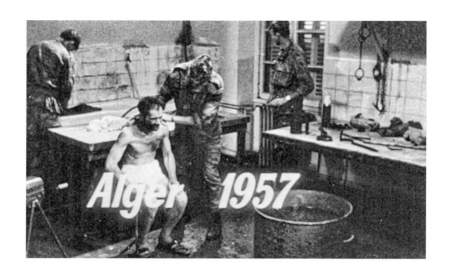

4. ANTIFASCIST NEOREALISM: THE "SOUTH"

> The South [is] a metaphor for human suffering under global capitalism.
> —Enrique Dussel, quoted in Walter Mignolo "The Geopolitics of Knowledge."

The opening scene from *The Battle of Algiers* shows the torture room that was supposed to remain unseen, countering the imperial worldview.

FIGURE 11. *THE BATTLE OF ALGIERS* (DIR. GILLO PONTECORVO, 1966).

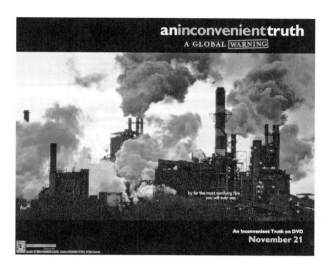

5. THE BIOSPHERE

> "It has become easier to imagine the end of the world than the
> end of capitalism."
> —Frederic Jameson

Each of the last ten years, counting back from 2010, is one of the eleven warmest years on record. Global emissions of carbon dioxide and equivalent gases reached record highs in 2010, despite the recession, at a level measured at 394 parts per million, compared to the level of 350 parts per million considered safe. | FIGURE 12. *AN INCONVENIENT TRUTH* (DIR. DAVIS GUGGENHEIM, 2006).

Oversight

The Ordering of Slavery

The deployment of visuality and visual technologies as a Western social technique for ordering was decisively shaped by the experience of plantation slavery in the Americas, forming the plantation complex of visuality.[1] If it has often been claimed that modernity was the product of slavery, there has been insufficient attention to the ways in which the modern "ways of seeing" also emerged from this nexus.[2] What one might call the received genealogy of modern visual culture begins with the major change in the mid-seventeenth century in the European division of the sensible. It created what Foucault called "the division, so evident to us, between what we see, what others have observed and handed down, and what others imagine or naïvely believe, the great tripartition into *Observation, Document*, and *Fable*."[3] In this new formation, there was a gap between things and words, a gap that could be crossed by seeing, a form of seeing that would dictate what it was possible to say. As the seeing preceded the naming, that which Foucault called the "nomination of the visible" (132) was the central practice. He emphasized that this was not a question of people suddenly learning to look harder or more closely, but a new set of priorities attached to sensory perception. Taste and smell became less important, now being understood as imprecise, hearsay was simply excluded, while touch was limited to a series of binary distinctions, such as that between rough and

smooth. This new "order of things" was itself produced by the necessities of European expansion and encounter, above all in the plantation colonies. As W. J. T. Mitchell has cogently put it, "An empire requires not just a lot of stuff but what Michel Foucault called an 'order of things,' an epistemic field that produces a sense of the kinds of objects, the logic of their speciation, their taxonomy."[4] Empire thus claims objectivity. What we need to insist on here, at the risk of seeming blunt, is that the primary "thing" being ordered was the "slave."[5] The "slave" was first classified by natural history, which created a relevant modality of "species," then separated from "free" space by mapping, while the force of law embodied in slave codes that sustained the logic of the division, enforced it against challenge, thereby making it seem "right," and hence aesthetic.

This transformation has been clearly summarized by David C. Scott: "The slave plantation might be characterized as establishing the relations and the material and epistemic apparatuses through which new subjects were constituted: new desires instilled, new aptitudes molded, new dispositions acquired."[6] Such changed relations were not uniform among the European colonizing powers but were enacted primarily in British and French colonial space by the Barbados slave code (1661) and the Code Noir (1685) respectively. In Spanish America, a violent visual transformation had begun as early as the sixteenth century, seeking to transform the "idols" of the indigenous into "images."[7] While that history is far from irrelevant here and indeed will keep insisting on being included, it has not been within my powers to include it throughout and retain coherence within the compass of a manageable book. On the sugar islands of the Caribbean, the colonizers were more concerned with slaves than with the indigenous, whose genocide was all but complete by the time that the seventeenth-century "sugar revolution" shifted emphasis within the "plantation complex" from Dutch Brazil to the French and British possessions in the Caribbean.[8] It was not by chance that these were the locations that influenced Carlyle's formation of the discourse of visuality. So the slavery under discussion in this book is not a metaphysical condition of servitude (as in Hegel, for example), but the legally regulated, visually controlled, hyperviolent condition of forced labor in Atlantic world cash-crop plantations. What results is therefore not that which Foucault has called the classical order of representation, derived from the great image of Spanish absolutism, Velazquez's *Las Meninas* (1651).[9] The ordering of slavery was a combination of violent enforcement and

visualized surveillance that sustained the new colonial order of things. I call it here "oversight," meaning the nomination of what was visible to the overseer on the plantation.

VISUALIZING THE PLANTATION

Oversight was the product of the interaction of the universalizing frames of Christianity and sovereignty in the context of the drama of "race" and rights created by seventeenth-century expansion and the beginning of the plantation system. It created a regime of taxonomy, observation, and enforcement to sustain a visualized domain of the social and the political that came to be known as "economy." It maintained a delineated space in which all life and labor were directed from its central viewpoint because the production of colonial cash crops, especially sugar, required a precise discipline, centered on surveillance, while being dependent on spectacular and excessive physical punishment. While this may appear as a contradiction between traditional spectacular punishment and the discipline that Foucault argues succeeded it in the modern period, the modernity of oversight was precisely its combination of enforcement and discipline. Indeed, as we shall see, the planters in Saint-Domingue attempted to modernize the colony within the plantation system. This effort failed because the enslaved had created a "counter-theater" to the system of surveillance and discipline from natural history to mapping and law.[10] For planter and enslaved alike, the frame of the local plantation as the sovereign space of oversight was broken by conflicting desires for autonomy from both the enslaved and the plantocracy, meaning the ruling classes of the plantation colony. The enslaved aspired to self-regulation, but so did the planters, who hoped to create a colonial republic supported by slavery. Indeed, Saint-Domingue imported more slaves and produced more goods in the years immediately preceding the revolution than ever before.[11]

In the plantation complex, the overseer was the surrogate of the sovereign, entrusted with power over many life-forms that were not his (gender intended) equal.[12] The monarch was superior to ordinary people, even aristocrats, by virtue of having been anointed in coronation, making him or her in a certain sense divine.[13] By the same token, the overseer dominated those classified as different, spatially displaced, and without legal personality or standing. The power of sovereignty was in the last instance the power to give and take life, surrogated to the overseer in the colony

as a regime that Achille Mbembe has called "commandment" (*commandement*). Commandment is a "regime of exception" in which the slave-owner or colonist takes on the attributes and rights of royal power itself.[14] Central here was what Foucault saw as the principle of all Western judicial thought since the Middle Ages: "Right is the right of royal command."[15] This command had not always reached to the New World, as one scandalized French traveler reported from Brazil, in 1651: "Everyone leads a lascivious and scandalous life—Jews, Christians, Portuguese, Dutch, English, Germans, Blacks, Brazilians, Tapoyos, Mulattos, Mamelukes and Creoles—living promiscuously, not to speak of incest and crimes against nature."[16] The ordering of slavery that began soon afterward was therefore intended to restrain planter and enslaved alike. The extravagant consumption of the planters was matched only by their excessive punishment of the enslaved. In one sense, the notorious violence of slave plantations mimicked the minutely prescribed ceremonies of execution and punishment that Foucault described as "spectacular." At the same time, as Kathleen Wilson points out, "given that penal remedy for the enslaved was transmitted through performance and custom, rather than statute, slave punishments did not enact a prior law but *were* the law performed."[17] In the regime of oversight, even the abstraction of the law was made visible and performative.

This order of colonial things was itself visualized in the practical guides for the practice of planters published in the period. Books of this kind were not just produced as a form of travel literature, or as an entertainment for those remaining in Europe, but as practical manuals for plantation and colonization. To give an example that maximizes time and distance, the British officer Philip Gridley King wrote to the botanist Sir Joseph Banks, resident in London, describing the progress in cultivation and botany being made in the new colony of Australia in 1792. He detailed his success in planting indigo, guided by Jean-Baptiste Labat's account, in 1722, of the process in the French Caribbean.[18] From this example, one can see that oversight was temporally and spatially complex, crossing presumed divides such as those between the Atlantic and Pacific worlds, Anglophone and Francophone colonization, and different models of forced labor. What one might call (with a pinch of the proverbial salt) the *Las Meninas* of oversight were the plates to the missionary Jean-Baptiste Du Tertre's history of the French Caribbean, published in 1667 (see plate 2).[19] These images have remained part of the cultural memory of the region and were incorporated into an installation entitled *The Indigo Room*, by the Haitian artist Edouard Duval

Carrié, in 2004.[20] In fact, the first plate of the volume concerning natural history illustrates the workings of indigo cultivation.[21] Eleven enslaved Africans are shown working at all the stages of this complex process, while at the precise center of the plate stands the outlined figure of a white overseer in European dress (see fig. 13). He is posed with a *lianne*, the rod used to discipline the enslaved, but posed here as if it were a cane or walking stick. The overseer's cane was as thick as a man's thumb, described by the English botanist Hans Sloane as "lance-wood switches."[22] Ironically, lance-wood was a species native to the Caribbean, used to punish its forced migrants. This incongruous scene is not a literal depiction of indigo production, although it depicts each stage of the necessary work and its resultant division of labor, but its schematic representation, which makes visible both the process and the power that sustained it. This was a drama of culture and cultivation enacted as work, strikingly codified after only twenty-five years of French colonization.[23] While the overseer is present as sign of the compulsion that ultimately underpinned the labor force, his cane is at rest. It is his eyes that are doing the work. As the only waged laborer in the scene, the overseer's job is to maintain the flow of production. Symbolized by the cane that could wield punishment, his looking is thus a form of labor that compels unwaged labor to generate profit from the land. In Du Tertre's visualization, the overseer is the central point of contradiction in the practice of forced labor. Looking at Van Dyck's portrait of Charles I (1635), the would-be absolutist monarch of England, after thinking about Du Tertre's representation of the overseer is to have a flash of recognition: Van Dyck's calm aristocratic figure standing with one hand on his hip and the other resting on his cane might have served as Du Tertre's model (see fig. 14). Indeed, the sight of a ship at anchor in the sea visible behind Charles I reminds the viewer that the source of monarchical power was England's naval empire. Portraits of seventeenth-century European monarchs often showed them carrying a cane, rod, or even a scepter, the ultimate source of this symbol of domination. In visual representation and plantation practice alike, the overseer was the surrogate of the sovereign.

Even the landscape attests to the transformation wrought by European oversight on the indigenous condition of the land, which Du Tertre called "a confused mass without agreement."[24] The mountains and indigenous wilderness visible in the background of his image give way to the regularly divided and organized space of plantation. This change was represented as

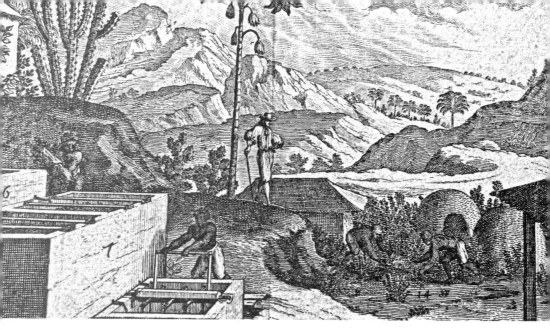

FIGURE 13. "OVERSEER," DETAIL FROM DU TERTRE'S "INDIGOTERIE," *HISTOIRE GÉNÉRALE DES ANTILLES HABITÉES PAR LES FRANÇOIS* (PARIS, 1667).

what later colonists would call the "civilizing process," but it was in fact evidence of the emergent environmental crisis caused by plantation. Sugar in particular required so much wood to heat the boilers of the sugarcane juice that islands like Barbados had become deforested as early as 1665, causing soil erosion and depletion of water sources.[25] In a striking phrase, the historian Manuel Moreno Fraginals has described the plantation itself as a "nomad entity."[26] Planted as a monoculture, sugarcane exhausted even fertile soils more rapidly than they could be replenished by manuring or other fertilization techniques of the period. With the conjunction of soil depletion and the deforestation caused by the processing of the sugar, it was estimated at the time that a mill could remain in one location for a maximum of forty years before environmental exhaustion set in. By way of tracking this destruction, it can be seen that whereas in 1707 Hans Sloane noted that in Jamaica "their Agriculture is but very small, their Soil being as yet so fruitful as to not need manuring," by 1740 Charles Leslie remarked that the necessity of manuring required double the number of workers than "while the land retain'd its natural Vigour."[27] By 1823 John Stewart reported that the accessible land was "almost denuded of timber trees," forcing the importation

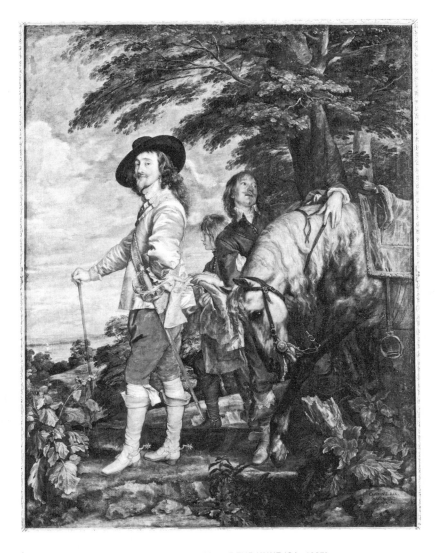

FIGURE 14. ANTHONY VAN DYCK, *CHARLES I AT THE HUNT* (CA. 1637).
Oil on canvas, 266cm x 207cm. Inv. 1236. Photo by C. Jean, Louvre, Paris, France.
Photo courtesy of Réunion des Musées Nationaux / Art Resource, New York.

of pine timber and coal to burn in the mills.[28] The practice of the plantation destroyed its own conditions of possibility and forced it to move physically and conceptually, a movement that it was ultimately unable to sustain.

For the technicians of oversight, surveillance and the management of time and labor were the key functions of the practice. The Jamaican planter John Stewart held that "the duty of an overseer consists in superintending the planting or farming concerns of the estate, ordering the proper work to be done, and seeing that it is duly executed."[29] By means of such ordering, the overseer produced slavery itself as a mode of labor and value generation. It began with the cultivation of plants, requiring the coordination of a network of labor, transport, and supplies that utterly transformed its environment. In the plantation economy, art and culture were techniques to generate increased biomass of cash crops without regard to other considerations. The imperative for the overseer was, therefore, as one Saint-Domingue planter put it, "to never leave the slave for an instant in inaction; he keeps the fabrication of sugar under surveillance, never leaving the sugar-mill for an instant."[30] For all its implied and actual violence, being an overseer was a complex task of time management and asset allocation. As befitted and defined a capitalist enterprise, the labor force was also divided because the multistage operation of sugar (or coffee, indigo, or cotton) production could not be carried out or supervised by one person, as the naturalist Patrick Browne observed in Jamaica: "The industrious slaves, frequently undressed, are obliged to watch by spells every night, and to engage with equal vigour in the toils of the day; while the planter and the overseer pass the mid-night hours in uninterrupted slumbers, anxious to secure the reward of their annual labours."[31] Note the sense that the enslaved were industrious, that is to say, disciplined, even if naked, while the overseer slept on. While modern European labor resisted time management, plantations were (at least in theory) in permanent production.[32] With the expansion in demand for sugar in the eighteenth century, it became standard plantation practice to suggest that a minimum of two hundred enslaved people was required to maintain a sugar plantation, thereby making competent overseers in great demand.[33] Oversight became a career path open to people of all literate backgrounds, which is to say, of the middling classes and up.[34]

In practice, much of the necessary surveillance was delegated to the enslaved drivers, or assistants to the overseer, who were rewarded with better food and clothing in exchange for maintaining discipline and production. The head overseer, usually but not always European, had a series of depu-

ties that the historian Michael Tadman has called "key slaves." These people were enslaved but held places of importance on the plantation, especially the driver and the domestic or "house" slaves. Specialist tasks involved in sugar production, like boiling the cane juice, distilling rum from molasses, "potting" the granulated sugar into molds, and coopering, all had head figures.[35] Rewarded in terms of material goods, authority, and prestige, the key slaves were distinguished from the rank-and-file of the three Gangs that worked the fields under the supervision of the "drivers." These field workers, in the famous formulation of C. L. R. James, "were closer to a modern proletariat than any group of workers in existence at the time," and lived in a similar state of deprivation.[36] The planters were keenly aware that the drivers were their sole means to control these field workers, as the American planter and politician James H. Hammond set out in his "Plantation Manual": "The head driver is the most important negro on the plantation. . . . He is to be treated with more respect than any other negro by both master & overseer. He is on no occasion to be treated with any indignity calculated to lose the respect of other negroes without breaking him. He is required to maintain proper discipline at all times, to see that no negro idles or does bad work in the field & to punish it with discretion on the spot."[37] The driver was thus the doubled surrogate of oversight, standing in for the overseer, who was himself the surrogated representative of the owner. However, if it became necessary to punish the driver, he was to be "broken," meaning demoted but also clearly referring to a humiliating loss of prestige. In this way, plantation slavery surrogated the psychic vulnerability of domination to the slaves themselves, allowing the owners to maintain what Tadman calls "positive, benevolent self-images," which were disseminated in their writings and led to the myth of planter "paternalism." Yet many revolts of the enslaved, such as the Hanover revolt in Jamaica, in 1776, were led by precisely these drivers, craftsmen, and domestics, "who had never before engaged in Rebellions and in whose Fidelity [the planters] had always most firmly relied."[38] Oversight could and ultimately did turn against itself, above all in Saint-Domingue.

TECHNIQUES OF OVERSIGHT

As a regime of power, oversight depended on a set of combined techniques, operated in theory by the one individual known as the "overseer," but in practice a combined labor of the plantocracy. These techniques can be sum-

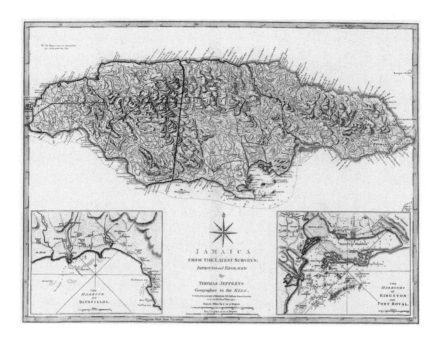

FIGURE 15. THOMAS JEFFREYS, *MAP OF JAMAICA* (1794).
Photo courtesy of David Rumsey Map Collection, http://www.davidrumsey.com.

marized as mapping, natural history, and the force of law. Mapping reified observations made at a local level that were systematically categorized and divided by natural history and made sustainable by the force of law (see fig. 15). These means of creating "natural" distinctions were challenged and contested both within the "free" planter and settler population and above all by the enslaved. In what follows, I outline the patterns of mapping, natural history, the force of law, and the counters to each of these practices. I then set out two major efforts to reconfigure the entire apparatus in Saint-Domingue, selected both because it was the greatest generator of wealth of all the plantation islands and of course because it was the site of the revolution of 1791. First, I discuss an earlier, ultimately unsuccessful, but wide-ranging revolt of the enslaved on Saint-Domingue, led by François Makandal from 1756–58. Next, I consider how the plantocracy there set out to form an independent, self-regulating colony on which the plantations were organized automatically. The tensions between these different aspirations to autonomy created a revolutionary situation in the island.

How did oversight visualize authority? As a technique of governance, visualized domination was both represented by and encapsulated in the emergent technology of mapping. As recent histories of cartography have made clear, the map was practically "nonexistent" in Europe at the start of the fifteenth century, but was "the bedrock of most professions and disciplines" two centuries later.[39] Following David Buisseret, several key factors can be identified in the formation of the map, bringing together the new modalities of realism in Northern European art, and the rediscovery of perspective, with the development of techniques for plotting land to make surveys of state and private property, and the consolidation of the nation-state apparatus.[40] Tom Conley links all these developments to the formation of "selfhood" and the production of subjectivity. Christian Jacob has further emphasized the importance of the map "not as an *object* but as a *medium* of communication," one that makes a claim about the understanding of exterior reality.[41] Like other media, the map extends the human sensorium beyond its physical capacities and integrates itself with it as "a technical prosthesis that extends and refines the field of sensorial production, or rather, a place where ocular vision and the 'mind's eye' meet."[42] This intersection is precisely that which will later be claimed as visuality.

As the plantation economy developed, oversight produced a regular mapping of plantations at the local level, rendering colonized space into a single geometric plane. This modulation of space developed the distinction between "cultivated" and "empty" space that motivated settlement into a determining principle that organized and aestheticized perception.[43] It was calibrated by the practice of land survey, which delineated the extent of a given plantation.[44] This shift to formal representation marked the enactment of oversight as a governmental practice in the Caribbean. In Barbados, for example, there had been no definition of the boundaries of plantations until, in 1670, the Council for Plantations ordered "exact mapps, platts, or charts of all and every our said plantations abroad."[45] The actual work of the overseer was now complemented by this abstract representation of land as colonial plantation within a functioning system of imperial power.

In Jamaica, a settler was given as legal title to his or her land a drawing that "represent[ed] the form of a parcel of land," to quote the "patent," as it was called, held by Francis Price for his Jamaican estate, Worthy Park.[46] This Letter Patent of 1670 contained a line drawing depicting an irregular poly-

hedron of land by virtue of its borders with adjacent holdings and natural features, drawn to scale and in accord with a compass, but not represented within a larger map. An act of the Jamaica Assembly passed in 1681 permitted "any person or persons whatsoever to survey, resurvey, and run any dividing lines, and give plats of any land," meaning by "person" a free, white settler.[47] Oversight of the fundamental division of the land was thus vested in the entire settler population. The survey would physically mark the dividing lines by cutting blazes into trees at regular intervals and noting the type of tree to be found at each turn in the boundary of the holding. Such precise understanding of local natural history was so crucial to the mapping of the plantation that a British survey taken after the end of slavery found some 675 "colonial names" for plants in use on Jamaica.[48] Next, from the field notes created during the survey, a "plat," or plan, was drawn to scale. The scale measured "chains," the sixty-six-foot-long feudal measuring device used to make such surveys, which were manipulated in practice by the enslaved under settler supervision. The plans were guides rather than precise depictions, but subsequent correlations have found them to be quite accurate.[49] Their purpose was both to create a legal account of the ownership of land and to provide a functional guide for the overseer of an estate as to where his boundaries lay. A copy of the "plat" was often to be found in the overseer's office for this purpose.[50] However, the compass on the surveys represented magnetic north, rather than true or meridional north, and as that varied over time, there were many border disputes in the Jamaica courts.

Jamaica's long history of settlement and conquest, its hills, and its complex population made geometric irregularities in its plantations inevitable. On flatter and more recently colonized islands, simpler solutions were found. The Dutch exported their medieval system of "long lots" to the Americas, in which space was divided into abstract rectangles of roughly 1,000 acres with one side bordering on a river. The Brazilian island of Itamaraca was thereby divided into forty-seven such lots, in 1648, with a road built on its longest axis. No allowance was made for the conditions on the ground or for the placement of existing structures, causing all kinds of practical problems.[51] On the Danish island of St. Croix, which was to Denmark what Barbados was to Britain—an engine of sugar production that created spectacular wealth from a relatively small space—the land was divided by what was called the Center Line, linking the two main white settlements of Christiansted and Frederiksted. This long straight line was turned into a

well-made road allowing for speed of access that was essential to the colonizers in repressing the great revolts of 1733 and 1848 (see chap. 4). New plantations on St. Croix were allocated in 4,000 acre lots, drawn as rectangles and arranged either side of the Center Line in one of the nine sections created by the West India–Guinea Company.[52] In the fertile areas of such spaces, the colonial crops were planted, often represented as a perfect rectangle of sugarcane, analogous to the "squares" formed by European soldiers of the period.[53] Within the cane fields, a further geometry attended the planting of the cane, known as "holing." The field was divided into squares and each square was planted with a number of cane "tops," or cuttings of the cane plant, taken from the flowering top of the plant, where the buds were most fertile. This orderly planting was also designed to allow better oversight of the enslaved.[54] If Cartesianism was the mathematicization of space in theory, sugar planting was its implementation in practice, creating a spatialized geometry designed to produce maximum yields and hence profits. Indeed, the sugarcane plantation gave physical form to the table as a means of data organization that is often seen to be emblematic of the period. This functional geometry was the counterpoint to the spectacular mapping that was made of the metropole. The cartographer Jacques Gamboust produced a detailed map of Paris in 1652, which he dedicated to the young Louis XIV. Among its uses, Gamboust claimed, the map was designed "in order that, in the most distant countries, those who have believed the representation of Paris to be above the truth may admire its greatness and beauty."[55] This mapping was designed to impress the reality of Paris in representation on people at a distance, whereas mapping in the plantation was addressed primarily to the local audience. Both forms of mapping relied on the visible nomination of what was depicted in those maps and ultimately on the force of law that connected the disparate aspects of sovereignty.

Space was mapped by the enslaved to enable entertainment, commerce, and outright resistance to slavery. Despite many ineffectual prohibitions, Africans in slavery found ways to congregate to dance, sing, and practice their religions. So insistent were the enslaved on these performances that a portion of the calendar was devoted to them as "carnival," the persistent tradition whereby the subaltern groups in plantation society reversed the social order for a brief period of bacchanalia. The costumes for carnival were often made with fabric and other items purchased with the proceeds

of sales made at the markets held by the enslaved on Sundays, where they exchanged produce grown in their "gardens" to supplement their meager diet and to generate produce for exchange. These market scenes were often romantically depicted by colonial artists, such as Agostino Brunias (1730–96), an Italian painter, who created a series of scenes of Caribbean life in the 1770s, and the French diplomat Grasset de Saint-Sauveur (1757–1810), who made a similar series in Martinique around 1805.[56] Brunias's works were in no sense realistic: his painting of *A French Mulatress Purchasing Fruit from a Negro Wench* (1770) shows the woman of the title conveniently disrobed so as to reveal her breast. In depicting a chain of commerce that ranged from this simple sale of a piece of garden-grown produce to the complex fashions of the linen-markets that supplied dress and costumes for the carnival, Brunias nonetheless recorded the existence of the interstitial subaltern economy of the plantation. Although "passports" were needed to attend these markets—meaning a signed permission from the overseer or owner—these were easily forged or altered for reuse.

This mobility created an understanding of the topography that facilitated outright resistance or escape. The Maroons, as those who escaped enslavement were known, were found in all slave-based economies. In larger settlements like Jamaica, or mainland colonies like Surinam, where the forest offered shelter, Maroon communities became permanent. Indeed, so persistent were their attacks on plantations in these two colonies that both the English and the Dutch came to legal agreements with the Maroons by treaty and divided the space of the colony. By creating a physical division of the colony where Maroons, or so-called runaway slaves, could live, Makandal and later the Jamaican Maroon leader Nanny transformed the theory and practice of mapping. Indeed, the interior of Saint-Domingue, away from the plantations that lined the coast, was unmapped right until the revolution and was first formally represented in an atlas as late as 1985. That is not to say it was Unknown, but that it was mapped by what in Vodou is now known as *kustom* (custom), oral and other forms of vernacular sign making. The Maroons succeeded in remapping colonial space to create a permanent zone of exclusion in which slavery was not permitted.[57] In his *Histoire des Deux Indes*, the abbé Raynal spelled out the meaning of this mapping in a passage that has often been taken to be prophetic of the Haitian Revolution: "Already two colonies of black fugitives [maroons] have established themselves safe from your assaults, through treaties and force. These

streaks of lightning announce the oncoming thunderbolts, and the blacks only need a leader."[58] Many have seen Toussaint L'Ouverture foretold here, including perhaps Toussaint himself.

NATURAL HISTORY

The possibility of using visual representation as the key to dominant discipline hinged on the new science of natural history in practical and theoretical form. In Jill Casid's groundbreaking analysis (pun intended), it was by transplantation of plant species and machinery with which to cultivate and process them that "colonial administration and plantation economically, politically, and aesthetically refashioned its Caribbean island possessions as hybrid landscapes."[59] Indeed, as she emphasizes, all the plants associated with the Caribbean islands were imported, from sugarcane to coffee, indigo, and even the coconut palm. The planters further intended that the enslaved should grow their own food, thereby inculcating in them the mentality of cultivation. Two spaces came to be described as "gardens": the "kitchen gardens" immediately surrounding the houses of the enslaved, and the "provision grounds," which were located on the margins of the plantation. However, the planters often complained that the enslaved did not always grow staple root crops for basic subsistence, and it was widely noted that they grew tobacco for their own use and for trading.[60] The "plantations" of the enslaved were often cited by defenders of slavery as examples of the generosity and benevolence of the plantation system.[61] The reality was somewhat different. On St. Croix, for example, the space formally allocated to slaves for their gardens was some thirty square feet, not much more than a patch of ground. In Jamaica, where the fertile land was entirely given over to sugar, the provision grounds were often displaced to remote regions of the hills, making them even harder to cultivate, or were omitted altogether.[62] On those Jamaica plantations where provision grounds were created, they were often described in the surveys as being part "ruinate," and, according to Barry Higman's calculations, were located at least a mile from the plantation buildings.[63]

In addition to these practicalities, the Atlantic world was also a prime location for the establishment of natural history as an abstract science centering on observation. However, although sight became its preeminent sense, it, too, was subject to restrictions. The botanist Linnaeus ruled, "We should reject . . . all accidental notes that do not exist in the Plant either for the eye or for the touch."[64] One example of such accidental detail was color,

whose variations and subtleties were held to elude precise categorization. The result was that natural history relied on what Foucault described as a "visibility freed from all other sensory burdens and restricted, moreover, to black and white."[65] In the context of slavery, in which a visible racialization came into being in precisely this period, this distinction must give us pause. It suggests that in this period "race," while being neither invented nor rendered exterminationist in the period, became visualized in terms of a binary distinction between black and white, reinforced by the new natural history. While Foucault was usually circumspect about dating his transitions from one epistemological frame to another, in this instance he offered a very precise reference, namely the publication of Jonston's *Natural History of Quadrupeds*, in 1657. Although there are of course many ways to nuance this assertion, this shift from general history to natural history is an "event," to wit "the sudden separation, in the realm of *Historia*, of two orders of knowledge henceforward considered to be different."[66] History had become the field of what would become known as visuality. It was marked by a division of the sensible that produced the new slave law codes, the creation of plantation maps, and the split within History itself around 1660.

Given that Jonston's book was published in Amsterdam, it is striking to read Charles Ford's observation that "the first Dutch 'racist' text (and perhaps the first racist text in any language) is Johan Picardt's *Korte beschryvinge* of 1660."[67] Picardt created a genealogy that traced the division of peoples back to Noah and to the story, which has since become notorious, that the "blackness" of Africans was a punishment for Ham looking at Noah's nakedness. Here illicit looking was punished by a visible distinction. Although centuries of racism have claimed that this story dates from time immemorial, Benjamin Braude has recently shown that it was in fact an early modern extrapolation of the Bible that has no basis in Genesis. The very convenience with which the story fits the new paradigm of natural history should be enough to alert suspicion. Whereas the Elizabethan writer George Best had argued that the dark color of African skin was the result of an infection, seventeenth-century writers like George Sandys insisted on the curse of Ham. From a close reading of the elusive texts, Braude concludes: "Slavery seems to have been the new element that made Sandys's arguments more persuasive than Best's."[68] In properly genealogical fashion it can be concluded that rather than modern visualized racism taking its cue from the story of Ham's punishment, the story was used to justify a shift that had already taken place. Perhaps no objects so epitomize this shift

than the *casta* paintings created in Mexico, beginning in the early eighteenth century, to represent the different forms of "miscegenation" between African, Spanish, and Indian residents of New Spain. These small paintings were arranged in the form of a table, allowing the viewer to track the progression of a particular kind of person. This tabulation might also allow for the nomination of tropical fruits, vegetables, or other objects of curiosity to natural history. Casta paintings did not entirely essentialize "race," allowing the "crossed" child of a Spaniard to "return" to Spanishness in two or three generations, but a reverse journey "out" of Africa was not permitted. Such paintings had not been seen before, and they did not survive the era of natural history, disappearing before 1810.[69]

Natural history provided significant purchase for those trying to resist oversight. The botanical knowledge and tastes of those in forced diaspora in the Caribbean changed the development of the plantation system in numerous ways. The Africans on plantations knew to eat the berries of certain trees, like the Black-heart Fiddlewood, while the fishermen among them ate the common sea crab as a mainstay of their diet.[70] They were held to be especially partial to avocado, leading to the extensive cultivation of these trees. Plantains were a staple in the diet of the enslaved, but came to be an item of choice for Europeans as well.[71] The Jamaican Jews introduced to the island a number of fruits and vegetables not usually eaten by gentiles, such as the "Brown-Jolly" (or eggplant, which was salted and boiled in place of greens, although it was otherwise not eaten by gentiles in the Americas), sesame seeds, and even tomatoes.[72] The ambivalent interaction of European natural history and African cultivation found its point of intersection in the cassava. The root of this plant was dried and ground to make a form of flour that was a staple for the enslaved, bringing an African vegetable to the Americas. Yet its juice was said to be extremely poisonous—although some disputed the claim—and planters feared that the enslaved might introduce it into their food. Consequently, among the planters was a widespread suspicion of any enslaved person seen to have a longer-than-average fingernail, because that was held to be the method by which cassava poison could be carried and delivered.[73] Soon the colonizers feared that "there [were] hardly any slaves . . . who in [their] colonies [did] not have knowledge of various plants containing poisons."[74] However, African medical knowledge was literally vital to the transplanted population. The British naturalist Hans Sloane, for instance, recalled that an enslaved African had cured a swollen limb that had been bothering him for some time.[75] The enslaved also kept

and maintained in oral form genealogical information about themselves and others. Hughes recorded that on a Barbados plantation then belonging to Thomas Tunckes, one family of the enslaved knew themselves to be descended from "the first Negroes that ever came hither from *Guiney*." They also remembered that before the land on which the plantation now sat was deforested, there had been an indigenous settlement in the woods at a place that they still called the "Indian Pond." The Africans recalled that these Indians fiercely resisted what Hughes called "Subjection by the *Whites*" and finally departed the island in canoes, rather than submit.[76] Ethnographic research has shown that these oral traditions are often substantially accurate. There is a more permanent record. When the revolutionaries of Saint-Domingue achieved independence, in 1804, they named the island Haiti, in memory of the indigenous population, a permanent memorial to the first Atlantic genocide.

FORCE OF LAW

The map and the table depicted an abstract field of visible nomination that was sustained by the force of what was taken to be law, whether human or natural. The law, although invisible, thus formed the ground for the possibility of representing space and species in distinct but exchangeable form. It followed that because "free" men (predominantly "whites") had rights over the enslaved, those so subjugated could have no rights at all. Just as all "persons" could survey land, so did all slave-owners have a wide range of discretion over the treatment of the enslaved. While the law codes of different colonial systems varied in degree, some measure of corporal punishment was permitted to all slave-owners, racializing the function of the "police" in the plantation system. For example, the Colonial Council in Saint-Domingue declared in 1770 that "neither the royal prosecutor nor the judge have the right to monitor the severity of the police that masters exercise over their slaves, even if there is mutilation of limbs."[77] Only a few years after the first natural history was published, a slave code was passed in Barbados, in 1661, as part of the reestablishment of sovereignty entailed in the restoration of the English monarchy, in 1660. This code was influential across the Anglophone Atlantic world, being formally adopted later in Jamaica, South Carolina, and Antigua. Its declared purpose was the "better ordering and governing of Negroes." In order to separate and distinguish them, the law defined Africans as "a heathenish, brutish and an uncertaine dangerous kinde of people," thereby justifying their being treated in the

same way as "men's other goods and chattels."[78] Almost as soon as natural history had been defined, it was being used as a form of legal division between legal subjects and other forms of people.

With the sugar trade growing in importance, Louis XIV published his *Code Noir*, in 1685, to regulate the French slave trade and its plantations. Its preamble established the dialectic of dominant discipline under the universalizing premise of Catholicism. Louis demands "obedience" to himself and to the "discipline" of the Catholic Church, of which he is the protector. The code was intended to overcome the physical separation of the plantations from the metropole by establishing "the extent of our power [*puissance*]." As Louis Sala-Molins points out in his exemplary commentary on the code, the term *slave* is introduced "without a line of judicial justification or theorization."[79] Indeed, its very title defined the subject of the code as "the discipline and commerce of black slaves in the French islands of America," further racializing the term *slave*.[80] In the racialized Catholic commercial discipline instituted by the code, the "nègre" is "'canonically' a man, but he is 'juridically' an item of merchandise."[81] Yet the "nègre" was no more defined than the "esclave," creating an aporia that can only be resolved by force of law: the "slave" is the person enslaved by the law, and the "black" is a person enslaved, unless otherwise freed by law. Consequently, the code was careful to define the legal outcome of marriages across the free-slave divide. In the version of the code that appeared in 1685, a free man who married his slave according to the rites of the Catholic Church thereby freed her, a regulation rescinded in 1725, when all marriages between "blanc" and "Noir" were forbidden. In order for planters to maintain control of reproduction, all marriages between the enslaved had to be approved by their owners, while enslavement descended in the matrilineal line only. The force of law, and its transparency, were above all questions of filiation, as Edouard Glissant has pointed out, avoiding the opacity of all so-called miscegenation by the tactic of oversight.[82] Here the immediate and constant intermingling, whether forced or consensual, between Africans and Europeans was deliberately overlooked in order to allow the divisions of the law to retain force. While it has been repeatedly observed that the Code Noir and all other slave codes were rarely, if ever, followed in detail, the proper purpose of such codes was above all to legitimate force in the minds of those using that force. For all its manifest hypocrisies, the slave code was a necessary component to the plantation system in order to sustain its reproduction at the biological and ideological levels.

Those on the margins of freedom, like Jews and free people of color, attempted from the very inception of plantation slavery to use the colonial legal system to assert their claims. In 1669, only nine years after the slave code was passed, Antonio Rodrigues-Rezio successfully petitioned that Jews in Barbados should be allowed to give legal testimony, taking an oath on the Old Testament, unlike the enslaved, whose testimony was banned.[83] In 1711, it was the turn of John Williams, a free African, to claim such testimonial rights. When he was denied, a further demarcation of the racialized division between "white" and "black" came into being, vacating the term "freedom" of substantive meaning.[84] That is to say, these Africans were emancipated insofar as they were not chattel, but they remained legally minors, unable to speak as an adult in court. In 1708, the Jamaican Assembly moved to preempt any such action by decreeing that "no Jew, mulatto, Negro or Indian shall have any vote at any election of members to serve in any Assembly of this Island."[85] As ever, such prohibitions imply that some people were making precisely such claims. With the passage of the Plantation Act, in 1740 (13 Geo. II), Jews who had been resident in British colonies for seven years could be naturalized, taking an oath on the Old Testament. Abraham Sanchez, who had become naturalized, took the logical next step in 1750 and demanded the right to vote. After being refused by a returning officer in the parish of St John, Kingston, he asked the assembly to overturn the decision. The parishes of St Andrew and St Catherine presented opposing petitions, and the assembly ruled against Sanchez and had the resolution printed in the *Jamaica Courant*.[86] The public sphere, as manifested in the colonial assembly and the newspaper, used its racialized consensus to suppress rights that were legitimately claimed. That is to say, first, that the "public" was defined as "white," meaning not "Jew, mulatto, Negro or Indian." Second, when one puts these traces from the archive together with the long history of slave revolt, there was a consistent counterpoint of rights claims in the Atlantic world that long preceded the Age of Revolution, so often held to be the agent of such actions.

AUTONOMY OF THE ENSLAVED

The confluence of a counter to oversight in mapping, natural history, and the force of law can be illustrated through the remarkable history of François Makandal (d. 1758), a disabled, Islamic, sexually promiscuous, African resistance leader and priest in the plantation economy. Makandal incar-

nated what was and, in the current moment appears to remain, the nightmare of white domination.[87] Enslaved in Africa at the age of twelve, he was able to read and write Arabic and had an extensive knowledge of medical and military botany. In maronnage for eighteen years, Makandal created an extended network of associates across Saint-Domingue (present-day Haiti), as well as establishing a mountain settlement in which cultivation was extensively practiced. He disseminated a form of power-figure known as a *garde-corps*, literally "body-guard," which contained various elements that could induce forces from the dead to protect the living. These power-figures were the syncretic product of Kongolese and Fon power-figures (*minkisi* and *bo*) together with colonial practices that have become known as "Vodou," a spiritual means of understanding and controlling the relation of space, time, and causality. When Saint-Domingue was isolated by the outbreak of the Seven Years War, in 1756, Makandal set his network to instigate an insurrection against the colonists. The plan, as the French came to understand it, was to poison the water in all the houses in Le Cap, the colony's capital, and then send bands of insurgents out into the countryside to liberate the enslaved. It was believed that he intended to kill all the whites in the colony. In revenge, the French planters instituted a veritable moral panic, burning dozens of people at the stake on the basis of the most tenuous connection to the Makandal network. Makandal himself was arrested by chance and later executed.

Under interrogation, Brigitte, Makandal's wife, described a magic phrase with which the power-figure was invoked: "May the good god give eyes to those who ask for eyes."[88] This form of second sight was the counter to oversight. In Kongo cosmology, the second sight was that used in the space of the dead, normally invisible to the living. It is noticeable that Makandal used the term "the good god [bon Dieu]," which was to become the dominant figure in the invisible spirit world as conceived by Haitian Vodou.[89] Makandal made this second sight available to his followers via the garde-corps. The figures were invoked to perform a service, deal with a complaint, or even to harm others, and the French judge Courtin accepted that "it is indisputable that this brings harm to anyone one wants." That is to say, the colonial powers accepted that *minkisi makandal* had power and therefore that the balance of power in the colony had changed. Makandal was known for performing a symbolic enactment of this transformation. He would stage a demonstration of his powers in which he pulled out of water a cloth that was colored olive, for the original inhabitants of the island. At the next

pass, the cloth would be white, for the present rulers, and finally it emerged black, to indicate the future passage of the island to African control.

By the end of Makandal's revolt, Saint-Domingue had two versions of visualized power in contestation with each other, European oversight and Caribbean second sight. Makandal had remapped the island as a kinship and commercial network. According to Carolyn Fick, Makandal "knew the names of every slave on each plantation who supported and participated in his movement."[90] His itinerant traders (*pacotilleurs*) traveled to the plantations from his mountain sanctuary and remapped the French colony into a place of his own making. In the third element of his contestation of oversight, Makandal directly challenged the force of colonial law by claiming a liberty that instantiated the right to look. All sources are agreed that Makandal and his followers sought liberty. From the perspective of the planters, the insurrection was caused because the enslaved had noticed that masters offered in their wills to free their slaves after their own deaths, as a mark of wealth and civility. The poisoning sought to hurry this process along, according to the official theory. The view from the enslaved was far more direct. According to a man named Médor, arrested for poisoning at the Lavaud plantation, "If slaves commit acts of poisoning, they do it in order to obtain their freedom." Under interrogation as to whether she had poisoned her master, a rebel named Assam testified that a free African named Pompée had encouraged her to do so. When she refused, he declared: "'Well! So much the worse for you since you do not want to become free.'"[91] The involvement of Pompée and many other free Africans in the insurrection shows that the freedom sought was not simply personal, because they were already free, but political. It practiced a view that another's lack of freedom denatures one's own. At the famous meeting at Bois-Caiman, in 1791, that instigated the revolution in Saint-Domingue, the Vodou priest Boukman expressed this theory of freedom to the Saint-Domingue masses: "Listen to the voice of liberty, which speaks in the heart of us all."[92] The meeting was not far from the Le Normand plantation where Makandal had been enslaved.

The French authorities went to considerable lengths to demonstrate that they had defeated Makandal, showing him to his associates after his capture and commissioning a portrait painted by a Parisian artist named N. Dupont (d. 1765), as if to create their own counter power-figure. However, the execution itself was botched, as Makandal was able to free himself from the pyre, and he tumbled to the ground to the sound of the crowd shouting,

"Makandal is saved!" In Moreau de St. Mery's account, "the terror was extreme, all doors were locked." Although Makandal was recaptured and burned, "many of the blacks believe even to the present day [1796], that he did not die in the torture."[93] The African population may have literally believed that Makandal escaped, or they may have meant that he continued to be a powerful spirit within the world of the living although present in that of the dead. Phrased in the terms that would become current during the revolutionary period, Makandal had become and continues to be a hero. His revolutionary and magical powers remain part of cultural memory in Haiti to this day, where his name is invoked in popular songs and in the present-day genealogies of the gods.[94] In Edouard Duval-Carrié's powerful painting, *La Voix des Sans-Voix* (1994), Makandal is shown as one of the revolutionary pantheon, alongside Toussaint, Dessalines, and Pétion, watching the coup against Aristide, who is represented as the latest such figure to speak for those "without voice," the spokesperson for the part that has no part, the people.[95]

COLONIAL AUTONOMY: REGENERATING OVERSIGHT

On the eve of the Atlantic revolutions, the planters in Saint-Domingue sought to restore each of the different components of oversight within a structure less dependent on individual supervision, whether free or enslaved. Having defined the borders of the colony, the planters intended to strengthen the force of law by making power local, and to transform the production of sugar into an automated, high-volume process. This strategy was itself a recognition that the supervisory regime I have called oversight had broken down. Strikingly, the plantocracy envisaged a modernization of government, cultivation, and the public sphere within the regime of slavery but independent of the monarchy. In effect, they imagined an independent Saint-Domingue. The resistance of the enslaved that became outright revolution in Saint-Domingue began as a strike over the new labor conditions generated by the new production processes that then generalized into a revolt against the entire means of production.

The key to the planter strategy was the formation of what the historians James McClellan and François Regourd have called the "colonial machine," which endeavored to automate oversight into an autonomous form, governed locally. It was produced by the interaction of colonial learned societies, botanical gardens, chambers of agriculture, hospitals, newspapers,

and "functionary experts" like botanists.[96] This newly formed apparatus set out to enhance what it saw as the outdated methods of colonial agriculture, botany, engineering, and medicine, all centered around the authority of the state but acting independently of it. Whereas natural history in the colonies had been the preserve of motivated individuals compiling texts, botanists were now directing the formation of specific botanical gardens designed to enhance colonial production of cash crops. At the same time, agriculture was being directed by new bureaucracies like the Chambre d'Agriculture established in all the French islands in 1763. The first work in tropical medicine and disease took notable initiatives, such as the vaccinations against smallpox carried out in Saint-Domingue from 1745, including the mass vaccination of the enslaved after 1774, long before they were practiced in metropolitan France.[97] All of these activities came to be discussed by the self-styled "enlightened public" of Saint-Domingue, ranging from grand planters to aspiring intellectuals among the small but well-connected membership of its learned society, the Cercle de Philadelphes (1784), later the Société Royale des Sciences et Arts.

The impetus to independence was a peace agreement with the Maroons in 1785, defining a border on the French and Spanish sides of the island. This new mapping promised to enable better control of runaways with Maroon cooperation, as had been the case in Jamaica. The new colonial apparatus could now be devoted to the creation of a disciplined, numerically regulated form of sugar production, known as the "vegetable economy."[98] Dependent on a handful of printed guides, traditional sugar production was an art not a science, a skill handed down from refiner to refiner, incarnated in an obscure and specialized language. The planter Barré de Saint-Venant arranged for a young naturalist named Jacques-François Dutrône la Couture (1749–1814) to come to Saint-Domingue from Martinique, in 1784, in order to inculcate his new methods of cultivation.[99] By the time Dutrône's book on sugar was published in 1791, on the eve of the revolution, he had worked on six plantations and had become a member of the Société Royale des Sciences et Arts.[100] Dutrône sought to transform the techniques of a tactile and verbal artisanal craft into a visualized, modern technology, all designed so that "blacks of a very ordinary intelligence can direct [the work]."[101] In short, he envisaged a Taylorism of the vegetable economy, by which the plantation could function as an unskilled, automated factory visualized and regulated by numerical data.

First, he reorganized plantation labor by means of a tabulated form that

FIGURE 16. "PLANTATION FORM," FROM JACQUES-FRANÇOIS DUTRÔNE
LA COUTURE, *PRÉCIS SUR LA CANNE* (PARIS, 1791).

allowed the overseer to tell at a glance the monthly patterns of labor, pro-
duction, and weather conditions (see fig. 16). Columns identified the health,
work detail, and status (Maroon, runaway, ill, etc.) of each enslaved per-
son, as well as specifying the quantities produced of sugarcane juice and
each of the different forms of sugar. Even the quantity of rain was to be re-
corded. Surveillance was improved, even as the individual overseer was not
required to be physically present to sustain it. This visualized and statistical
tabulation of labor accorded with the physiocratic principles of François
Quesnay, who argued for the use of graphs and tables to create an "eco-
nomic picture" that was held to be unachievable by means of discourse.
Dutrône's system was designed to further reduce the difficulties of over-
sight's surveillance by standardizing sugar production. The old inefficient
iron boilers and cement basins would be replaced with copper apparatus,

better suited to heating without overboiling and not subject to decay from the sugar. The established system relied on the expertise of the refiners, who had an arcane vocabulary of artisanal terms designed to designate stages of readiness of the heated cane-juice that would require transfer from one boiler to the next in a sequence of five, until the final stage of readiness, in which the sugar would make a string between finger and thumb when drawn out.[102] Readiness would now be simply determined by temperature. Sugar begins to form, according to Dutrône, at 83 degrees Réaumur, and the water remaining in the juice was entirely evaporated when it had reached 110 degrees.[103] The new "laboratory" could therefore work all night under the supervision of one of the enslaved drivers, rather than having to be suspended between midnight and the early morning as was traditional.[104] In short, making sugar was far less complicated than had been thought and could be achieved by a simple regulatory process. Furthermore, Dutrône claimed that the use of his strategy at the de Ladebate plantation had raised net receipts of sugar by 80 percent, a startling gain.[105]

His gains may have come from a change in the cane being cultivated. The sugarcane in use in the Caribbean was known as the "creole" cane, one of several varieties of *Saccharum officinarum*, as Linnaeus named it (see fig. 17). It grew to about six or seven feet tall and was easy to grind, although relatively little *bagasse*, or "trash" as the English called it, was produced to burn for fuel. In the late eighteenth century, planters across the Caribbean began to experiment with what they called "Otaheite" cane, using the European misnomer for Tahiti. It was both taller, reaching thirteen feet, and thicker, growing up to six inches in diameter. It was first planted in Cuba around 1780, the sources being very unclear on these matters.[106] At the same time, another even larger cane, known as the Bourbon variety, from its presumed origin on the Ile de Bourbon, began to be widely used. According to the Jamaica planter John Stewart this fifteen-feet-tall, eight-inch-wide cane came into use around 1790 and had taken over as the dominant variety by the time he was writing, in 1823. Although these names were not used in Saint-Domingue, the new canes were clearly being cultivated there. Dutrône called them "strong" canes, which he contrasted with the older "weak" canes, a reasonable distinction in that all the plants were varietals of the same species. In 1799 a naturalist observing abandoned plantations saw that some canes grew to five feet while others reached fourteen feet in height, making it clear that different varietals had been in cultivation.[107] The Bourbon cane was at first far more productive than the older varieties,

FIGURE 17. "SUGAR CANE," FROM JACQUES-FRANÇOIS DUTRÔNE
LA COUTURE, *PRÉCIS SUR LA CANNE* (PARIS, 1791).

but it also required intense labor to maintain because it exhausted the soil at a rapid rate, requiring extensive manuring.[108] Given that the Bourbon cane was three times the size of the older Creole variety, work in the cane fields trebled in quantity. As the larger varietals spread around the Caribbean, from 1780 onward, one part of the heightened resistance of the enslaved came from the greatly increased workload the new plants required.

These changes were not intended, however, to simply improve the cultivation of sugar. By transforming the colonial machine, they implied a new mechanism of power. In the influential view of Emmerich de Vattel, cultivation was not only the first responsibility of government, but it also justified colonizing North America because the land was not being used.[109] Dutrône implied a similar theory of government in describing the administration of a plantation: "The Master, being he who governs and commands, must absolutely be present at all times. The Art of governing a Plantation

is necessarily tied to the art of cultivation. The Master must therefore be a Cultivator. Since the cares of his government are very extended and multiplied, he shares them with trustworthy men, white and free like himself, charged with transmitting his orders and seeing to their execution."[110] This insistence that oversight (*commandement*) must be both present and involved in cultivation was nothing short of a call for a colonial republic.

These implied reforms were spelled out, in 1789, when the planters came to present their grievances to the Estates-General, called in France to detail all such local concerns. While much attention has been paid to the illegal election of these deputies and their rebuff by the Estates-General, the content of their program has often been overlooked. It was, however, published in Saint-Domingue, making their plans clear on the island itself.[111] The leading planters were aiming for functional independence, allowing the monarchy to retain direct authority only in military and diplomatic affairs. They demanded free trade for their products and raw materials, especially in forced African labor. With this new force of local law, the planters intended to reform what they called the "police" of the island, especially as regards the enslaved. The costs of liberating an enslaved person were to be raised, even as marriage between whites and nonwhites of all kinds was to be severely restricted. The regulations, instituted in 1785, granting more "free" time to the enslaved and a less onerous workday were to be repealed. Each district was to be allocated a new judge lieutenant of crime and police, with wide authority over economic and police matters. The complicated legal system was to be reorganized and codified. The planters envisaged what they called "the complete regeneration of the Colony in all aspects of its administration."[112] Regeneration was a privileged term among the reformers of the French Revolution, marking an understanding of a physical need to repair the body politic. The colonists emphasized that "local experience is more certain than the best theory" and set out as a result to establish permanent local assemblies, both colony-wide and provincial, to administer this regeneration.[113] As was later admitted, the move to give power to the assemblies implied that "Saint-Domingue is not the subject but the ally of France," to quote an address to the Constituent Assembly in Paris in 1790.[114] These Assemblies were, among other functions, to replace the Chambres d'Agriculture and to reinforce their mission with greater authority. Among the first tasks proposed was the production of a new topographic map of the island and the precise determination of the boundaries of holdings by a surveyor.[115] Taken together these projects amounted to a local regeneration

of oversight, with new formations of mapping and the force of law sustaining the disciplined production of sugar.

The establishment of a plantation complex of visuality in the seventeenth century had entered into crisis, challenged first by the enslaved themselves and now by the plantocracy. From the Makandal period on, the enslaved had developed effective counters to the strategies of visualized domination that had been forged in the settler plantation colonies. Far from being deterred, the plantocracy sought to intensify their regime by automating production, increasing labor, and tightening restrictions on the enslaved, even as they claimed autonomy for the island from the metropole. Both challenges to metropolitan authority came at a time of external disruption: Makandal had used the tumult of the Seven Years War to launch his revolt, while the planters adapted the rhetoric of liberty and grievances against the monarchy that were prevalent in the first years of the French Revolution (1786–90). Oversight had sought to frame its authority locally within the bounds of a given plantation that was subject to the surveillance of a particular overseer. This authority gained force as the surrogation of the omniscient gaze of the sovereign, even as it was granted an exceptional autonomy from the procedures of judgment. By the late eighteenth century, this localized practice was challenged from within and without by Maroons, abolitionists, rebel slaves, and finally even the planters themselves. Unable to sustain its form, the plantation complex entered a period of crisis, competing with a new visualized regime of "liberty," whose counterpoint would be visuality.

The Modern Imaginary

Antislavery Revolutions and

the Right to Existence

The revolutions of France (1789–99) and Haiti (1791–1804) challenged and overturned the ordering of the plantation complex, defeating both monarchy and slave-owning authority.[1] While the overthrow of monarchs was not without precedent, nowhere had plantation slavery been reversed. The formation of Haiti as an independent nation on what had been the richest plantation island of the Atlantic world marked a decisive turning point in the ways that it was possible to imagine the relations of the people and authority. The specter of African communism has haunted modern empires ever since. This revolutionary geoimaginary was and is a central and indispensable part of modernity. However, as it erupted into the plantation complex, it was also paradoxically "unthinkable," even as it happened in a series of radicalizing steps that "challenged further the ontological order of the West and the global order of colonialism."[2] The existence of this new order within the old was constituted by a tension between new "liberty" and old "slavery" in colony and metropole alike. Unlike the plantation imaginary dominated by a single authority, this visualized revolution was therefore structured around division. It was the modern form of dissensus, defined by Rancière as "putting two worlds in one and the same world," that constitutes the political. In the antislavery revolutions of the period, the imaginary of this dissensus was the question of "rights" and the right-

ing of wrongs. The decisive intervention in a dissensus over rights comes when a person who does not have a given right claims it as if they already do. It is a performative claim, validated only by the act of making it and visualized as what I have called the right to look. The active imagining of that right and its visualization produced modernity as the visualized contestation of right between authority and the people. So effectively was this claim "unthought" by Carlyle and other apologists for autocracy that it is only now fully being realized to what extent such diverse questions as sustainability and the concept of universal history should be thought in relation to the antislavery revolutions. Far from being the preserve only of specialists, footnoted as a gesture to diversity by grand theorists of the modern, it is here that the modern imaginary was formed.

The process produced what one might call a new imaginary of the imaginary itself. For the division and dissensus imagined and enacted by the Haitian Revolution was produced in the visualizing and understanding of the psychic economy in equal measure with that of political economy. The first moments of revolution were understood as an "awakening," creating a vernacular form of what Walter Benjamin would later call the "optical unconscious." From the realms of "sleep," popular forces shook off the literal and metaphorical chains of slavery. In the metropole, this awakening produced the Declaration of the Rights of Man and the Citizen (1789), designed both to recognize certain gains, especially the end of feudalism, and to prevent new concessions. It was left to the enslaved and urban radicals to revolutionize the revolution. Using the terminology of the African diaspora, I call this new distribution of order "the politics of eating," entailing both the literal production and distribution of food (both staples and cash crops), and the resulting authority. This politics challenged the "big men" of slavery and created embodied counterpoints in the revolutionary hero and the "people" who authorized him. For the Saint-Domingue rank-and-file, sustenance and sustainability were the key issues, named in France by the radical sans-culottes as the "right to existence." Against all hitherto existing concepts of history, the enslaved and their allies visualized themselves not only as acting within history, but as making History. Invested in the hero was a willed emancipation in which those absolutely without a part in the slave colony instituted their claim to be seen, a claim that generated an embodied aesthetic. Those so designated as heroes would ultimately choose to sustain the nation-state rather than those without title, creating a dissonance within the revolution that allowed figures like Napo-

leon to emerge and remaster the popular imagination. For this supreme act of self-fashioning, he would later become the prototype of the antirevolutionary, anti-emancipation Hero for Carlyle. Nonetheless, the enslaved had renamed themselves as the people, classified themselves as rights-holders, and aestheticized their transformation in the person of the Hero and the concept of History. This was not just an act of revolt, but the inauguration of antislavery as revolution.

The resulting symbolic forms were both a representation of the revolutionary process and an event within it. Their rapid circulation caused them to "condense," by which I mean that (for example) a designation of the equality of the three "Estates," or orders of French society, condensed from being the subject of an entire representation to a symbolic triangle. In the contested new imaginary, relations between the nation, the multitude and liberty were literally worked out and visualized. With the collapse of royal censorship in France and its empire, revolutionary events were visualized as prints, engravings, or even paintings, ranging from the anonymous vernacular caricature to works by pillars of the Royal Academy of Painting, with some of the most interesting images being popular themes rendered by elite artists.[3] Further, the revolutionaries visualized new social agents, such as the Third Estate (all the population who were not nobles or clergy), the sans-culottes (the vernacular term for artisans and other middling groups), and above all the formerly enslaved. By 1800, we can identify men and women descended from the enslaved engaged in visualization: Madame La Roche, a silhouettiste, in Saint-Domingue (fl. ca. 1800), and the painter José Campeche (1751–1809), in Puerto Rico. The revolutionary geoimaginary entailed new spatial imaginaries, such as the "land of liberty," the space in which rights were held to pertain. Colonial anthropology ventured into the South Pacific in the hopes of locating a topographical origin for these rights. Ironically, these ventures served as the beginnings of imperial visuality structured around a distinction between "civilization" and the "primitive." Taken as a necessarily contested whole, this imaginary was not all there was to the revolution, but it was nonetheless a revolutionary form, as Lynn Hunt and Jack Censer have recently shown: "Artistic representation of events and people was integral to the conflict over the meaning of the French Revolution."[4] If "art" means visual representation and imagination in its broadest sense, this position suggests that the visual image as a representation of visualization did revolutionary work. Rather than merely illustrate decisive events, visualized power worked as one of several episte-

mic apparatuses that were involved in producing the discursive practice of the reality and realism of the Atlantic revolutions. Whereas monarchy was eternal ("the King is dead, long live the King"), the sheer pressure of change transformed visual form, creating a legacy that defined the contradictions of modernity. To render the production of this imaginary comprehensible, I have highlighted five central moments of entanglement between the revolution against plantation slavery and that against feudal slavery that produced the new imaginary with which we are still in some senses engaged. Consequently, the fifth act is not a dénouement so much as a further intensification of revolutionary authority that would spark the beginnings of both visuality and imperial visuality.

AWAKENINGS

It is the early days of the French Revolution, in August 1789. A technically accomplished print produced anonymously shows a National Guardsman running from a burning pile of feudal insignia, showing that the abolition of feudalism, on 4 August 1789, was its cue (see fig. 18). It was an interstitial moment, after the setting aside of feudal *droits de seigneur* (rights of the lord), but before the Declaration of the Rights of Man and the Citizen had been issued by the National Assembly. The scene depicts a low-lying colonial island, with commercial ships visible sailing off the coast. Outside the picture space, printed captions separated the "Land of Slaves," at left, from the "Land of Liberty," at right, the direction in which the guardsman is running. In the land of slaves, some plantation buildings can be seen flying a flag, whereas in the land of liberty, the sun shines on free people, some of whom are people of color, dancing around a Liberty tree and having a celebratory drink. No work is being done. A Greco-Roman temple in the background reinforces the allusiveness of the Phrygian cap, better known as the liberty bonnet, on top of the tree. This awkward headgear had been the symbol of emancipated slaves in the Roman empire. It was a visual icon of freedom in the revolution in the North American British colonies, in 1776, and came to be a garment worn during the French Revolution. Liberty in general was understood here as the abolition of colonial slavery, bringing freedom first to the colonies and then to the metropole. The print created a universalized figure of slavery to refer to abuses colonial and domestic that could never be restored once rectified. The colonial setting thus recalled at once the slavery of feudalism and the beginnings of revolution in

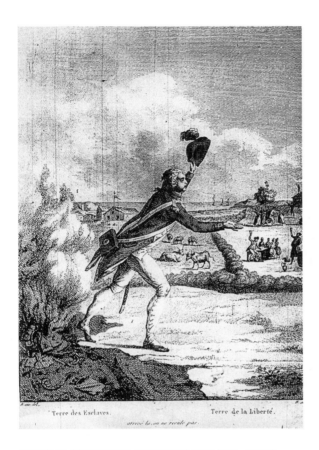

FIGURE 18. ANONYMOUS, *"TERRE DES ESCLAVES — TERRE DE LA LIBERTÉ,"* Collection de Vinck, tome 44, no. 6032, Bibliothèque Nationale de France, Paris.

the Americas that was to be completed in France. The caption reads, "Once there, you never go back," referring to the land of liberty. This is the new imaginary of revolution, visualized as a postslavery colonial space.

This print displays a vivid range of intellectual and visual reference to represent the popular metaphor of life under the ancien régime as slavery. It captures the paradoxical frame of mind described by Jean Jaurès (later cited by both C. L. R. James and Christopher L. Miller) in his understanding of the relation of slavery and the French Revolution: "The fortunes created at Bordeaux, at Nantes by the slave trade, gave to the bourgeoisie that pride which needed liberty and contributed to human emancipation."[5] This contradiction was that visualized in this print, strikingly distinct from the

formal means used either by the painters of the Royal Academy or popular woodblock prints of the period. It captures the sense of transformation as described in a contemporary newspaper: "Finally, the moment has arrived where a great revolution in ideas and things is going, so to speak, to transport us out of the mire of slavery into the countries of liberty. . . . In the new world, the brave inhabitants of Philadelphia have given an example of a people reclaiming their liberty; France will give it to the rest of the world."[6] From slavery via the Americas to freedom has been visualized as "from slavery to freedom in the Americas." This sense of permanent transformation was also a revolutionary political aesthetic, later canonized in Thomas Paine's classic *Rights of Man* (1791). Paine consistently referred to monarchic regimes as "slavery," which were vulnerable to the revelation of liberty: "The mind, in discovering truth, acts in the same manner as it acts through the eye in discovering objects; when once any object has been seen, it is impossible to put the mind back to the same condition it was in before it saw it."[7] Once seen, one never goes back. By extension, then, it is not possible to "unknow . . . knowledge, or unthink . . . thoughts." Once seen, liberty cannot be unseen. "Unfreedom," as slavery was euphemistically described in the late eighteenth century, become freedom could not revert. This imaginary of the mind as physically retaining an irreversible trace of intellectual ideas both anticipates Freud's idea of the unconscious as a writing pad and also looks back to the Enlightenment goal of perpetual peace. Both were held to be irreversible: the unconscious never forgets and universal peace cannot be disturbed. In keeping with this psychic dimension to revolutionary imaginary, the visual impact of the print relies in significant part on the disproportionate size of the guardsman relative to the background, as if he is intended to be "real," while the background is a metaphor. The background is a form of dream-work, given that it is obviously imaginary and that the symbols at work are highly condensed. These impressions must be registered and described in a form of archiving that is also the formation of a certain optical unconscious.[8]

Such visualizations seem poised between the iconography of monarchy and Freud's interpretation of dreams. Monarchy sustained a knowing distinction between the individual royal person, often frail, old, or tired, and the unchanging glory of Majesty, visualized as the Sun itself, incorporating a set of symbols, ranging from flags to coins and the paraphernalia of kingship, such as scepters and crowns. For Freud, dreams condense the complex dynamics of the psyche into symbols. In his view, condensation creates "an

intermediate common entity" out of the conflicting elements that are subject to being "overdetermined," that is to say, used repeatedly with multiple associations. This condensation is crucial for the dream-symbol to achieve the intensity to force it out of the unconscious into dream-work.[9] This condensation was achieved in revolutionary images by the intensity of social conflict being represented, images that then circulated around the Atlantic world. The combination of conflict and circulation produced the embodied form of the hero. This hero was not necessarily a named individual so much as the visualized embodiment of revolution. The National Guardsman was one such imagined hero in the moment of transformation, like Superman emerging from his phone-booth. Perhaps the best-known popular image of 1789 was of this kind, known as *The Awakening of the Third Estate* (see plate 3). In this relatively simple lithograph, a then new technology designed for mass reproduction, a figure representing the Third Estate awakes in the shadow of the Bastille, the notorious royal prison that had been stormed on 14 July. The caption, written in popular argot, reads, "What a con, time I woke up, the oppression of these chains is giving me a nightmare that's a little too strong." The popular print medium combined with the dialect made this in every sense a vernacular image. The Third Estate was a vernacular hero, while the ancien régime was now literally represented as a bad dream from which the Third Estate was struggling to wake, laden down with chains, creating the overdetermined reference to chattel slavery. As the Third Estate wakes, he finds himself surrounded by weapons, causing fear and panic in the priest and the noble standing nearby. The transformational experience of revolution was visualized as the awakening of a heroic popular figure from a nightmare incarnated as slavery into a new possibility of liberty. Of course, the other possibility is that this "awakening" was itself part of the dream and not yet achieved. The Third Estate was an "intermediate entity," whose identity was subject to intense questioning. In the best-known account of the Third Estate by the abbé Sieyès, there is no need to have a monarchy to have a nation, the very situation that the print visualizes.[10]

If monarchy was the Sun, which also made its power visible, it was in a certain sense blind, insofar as it did not see specific events. As Foucault emphasized, sovereignty was the power to withdraw life.[11] It repaired damage to the body-politic by inflicting retributive violence on the body of the condemned, but it did not see the crime as it was happening. By challenging royal authority, forever symbolized by the storming of the Bastille, the

popular forces claimed a different means to see events and to administer justice. Both were expressed as the Lantern, literally meaning the *révèrberes*, the mirror-based streetlights installed in Paris, in the 1760s, to illuminate the night. The cry "To the lantern!" was a call for summary execution from the sturdy metal lampposts. The image of the Lantern emerged as a visible symbol of popular justice, directed at the physical bodies of the First Estate, or the nobility, and at the metaphysical body of Majesty and its claim to illuminate the world. Writing in that summer of 1789, Camille Desmoulins proposed a new national holiday: "Passover will be celebrated on the 14th of July. It is the day of the liberation from servitude in Egypt. . . . [I]t is the great festival of *lanterns*."[12] The proposed festival of popular liberation was a prophetic celebration of the end of slavery in which the new Moses, showing the way to the promised land, was the people itself, symbolized by the Lantern. The Lantern was the people and it was also a living machine in the service of the revolution, always on hand to accelerate change and to eliminate obstacles. It was shown with its own viewpoint on 14 July (see fig. 19). It was depicted flying with wings to chase the enemy or as a walking machine labeled "First Avenger of Crimes." This Avenger marked the historical halfway point between the Golem and the Terminator as modalities of the automated popular hero. Vernacular images, like that of the Lantern, now became political agents in themselves. For instance, immediately after the passing of the Declaration of the Rights of Man and the Citizen, there was an effort to restrict the franchise to the wealthy, thereby refuting any claim to universality. One such proposal was that only those who paid a *marc d'argent* in taxes could be eligible to vote. As a silver mark was worth fifty-two livres, or pounds, that would have excluded almost all the population. A similar proposal from Saint-Domingue specified that only those identified in the census as owning twenty slaves would be allowed to vote.[13] This exclusionary rule failed, noted Condorcet, because "the caricatures had made it ridiculous."[14] For example, a print entitled *Balance Eligible du Marc d'Argent* shows the Lantern supervising a balance between a heavy boar, signifying the aristocracy, and the Third Estate, which it outweighs. The idea of a fat pig outweighing the people was enough to make the careful phrases about property and responsibility seem absurd.

Much of the politics of the revolution was enacted in direct action that also had profound symbolic form. The prints and lithographs that survive were part of this extended performative drama. In this case, the visibility of colonial slavery contradicted the claim that the revolution had created

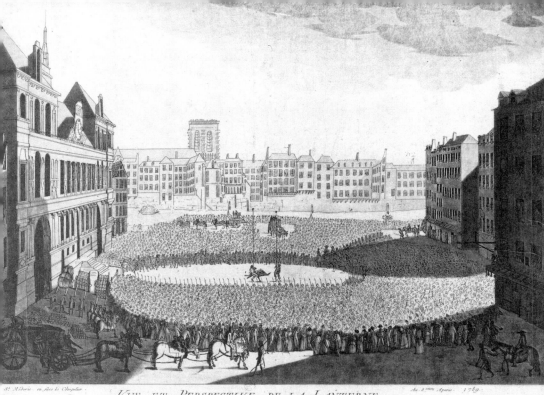

FIGURE 19. ANONYMOUS, *THE LANTERN LOOKS AT 14 JULY* (PARIS, 1789).
Photo courtesy of Bibliothèque nationale de France.

liberty for all. In August 1789, the same month as the Declaration of the Rights of Man was made, a group of the enslaved wrote to the governor of Martinique: "We know we are free."[15] Those who are "slaves" cannot say "we are free," except in dissensus. By the same token, Olympe de Gouges later claimed civil rights for women because they were liable to legal penalties. Her point was that if women are legal subjects when accused of crimes, they should be majoritarian legal subjects at all times.[16] That same hot summer of 1789, the Saint-Domingue revolutionary Vincent Ogé, a wealthy planter of color, demanded admission to the National Assembly of white colonists from the island at the Hotel Massiac. This address was in and of itself destructive of the colonial order of things, by its refusal to acknowledge the colonial color line. As he attempted to cross it, Ogé declared that the "union" of liberty and reason "produces a uniform light, ardent and pure, which, in enlightening our spirits can inflame all hearts."[17] By his

very embodiment, Ogé testified that the color line was more honored in the breach than the observance. In speaking the metaphorical language of sexual reproduction, he became "unthinkable" to the colonists, who denied him access. His assertion that revolution was so pure a light that all became color-blind challenged the light of monarchy as well as the racialization of slavery. Rebuffed, Ogé returned in secret to Saint-Domingue, where he launched an uprising, in October 1790, for those he called "the American colonists formerly known under the insulting epithet 'mixed blood.'"[18] Unable to support the enslaved, or recruit local people of color in force, he fled, only to be deported back to Saint-Domingue, where he was brutally executed. Not all awakenings had been realized. Once seen, it seems, one can still go back.

THE WALL OF RIGHTS

That possibility was produced in both practical and representational politics concerning the Declaration of the Rights of Man and the Citizen, issued by the National Assembly of France in August 1789. The Declaration (as I shall call it from now on) opened a visualized problematic as to who was and was not included in the "universal," limiting the right in rights. This performative representation necessarily set limits, just as a perspective drawing shapes and directs the field of vision. In another famous lithograph, from 1789, the figure of the Third Estate is again seen, now reaching down to lift a bundle labeled "the rights of man" from a figure representing liberty, with another argot caption: "Ha, I'll be well pleased when we have all these here papers." Here progress is represented as upward movement and the passing of legislation both from the netherworld into the light and metaphorically from the visible to the sayable. The dream of transformation took on textual form to prevent any regressions. The mythical space below ground was traditionally that of Hell or the grave, but here it has become a popular zone, the land of the people, hitherto excluded, now coming into view.[19] The land of the people may have existed previously, but it was not a political actor, or recognized as such. We need to distinguish between "the people" ruled over by a monarch and the anti-state popular forces so detested by thinkers like Hobbes, who distinguished the two senses: "The *People*, stirring up the *Citizens* against the *City*, that is to say, the *Multitude* against the *People*."[20] In contemplating the French Revolution, the British conservative Edmund Burke similarly condemned the "swinish multitude." So this image might

also be seen as the dream-world of the multitude, moving from the night-mare of the ancien régime to the imagined future of the rights of man. This unconscious was necessarily in the dark, out of sight of the Sun (King). The question was exactly what would or could be written on those papers. These are, then, literally dream images, the formation of a group psychology try-ing to imagine different futures that seem to be at hand.[21]

When the actual "papers" reached the light of day, far from proposing a universalism based on nature, the Declaration upheld a series of national claims and positions, inflected by race, gender, and class. In the final text, there was no abolition of slavery; it limited the "universal" to those al-ready "free," that is, the non-enslaved adult male citizen. This position was not simply one of omission, for slavery had been much discussed. Jacques Necker, Louis XVI's leading minister, for example, spoke against chattel slavery in 1789, noting "these men similar to us in thought and above all in the sad faculty of suffering."[22] In many of the drafts proposed over the five weeks of debate, a clause would have offered all citizens the property of their own person, thereby making slavery illegal. Such a clause was in fact inserted by the Convention, in 1793, prior to the abolition of slavery, in February 1794. In 1789, one proposal, claiming to have been written by a peasant, made this the very first article of the Declaration, and it was in-cluded in several others.[23] Another proposal, by the noble de Boislandry, declared that "France is a country of liberty, where no man can be subject to mainmort, be a serf or a slave: it is enough to live to be free."[24] Indeed, a number of slaves had successfully claimed freedom in French courts under this rubric during the ancien régime. Now the "land of liberty" was being recast as always and already "France." During the 1789 debate, the liberal aristocrat the Comte de Castellane reminded the National Assembly of this uniquely French quality of rights: "However, gentlemen, if you deign to cast your eyes around the world's surface, you will without doubt shiver as I do to see how few nations have preserved not even what I would call the totality of their rights, but some ideas, some remains of their liberty; with-out being obliged to cite the entirety of Asia, or the unfortunate Africans who have found in the islands an even harder slavery than that they ex-perienced in their own country; without, I say, leaving Europe, we can see entire peoples who believe themselves to be the property of some master."[25] Despite recent assertions that the Declaration granted rights by simple fact of birth, they were clearly limited, not universal even within Europe, with boundaries delimited by slavery and the "Oriental." In fact, many mem-

bers of the National Assembly argued against the Declaration altogether, saying that its principles were self-evident, that it should be accompanied by a list of "duties," or that it should be postponed until a constitution had been written. All these maneuvers had the more or less explicit goal of preventing a declaration and it was not until the proposal to add duties to the articles of rights had been defeated, on 11 August 1789, by the relatively close margin of 570 to 433 that it was clear that it would pass.[26] For many delegates, even France was not to be imagined as a land of liberty so much as one of duty.

The Declaration should thus be understood less as a precisely formulated set of words and more as a symbol, interpreted differently from place to place and person to person. A well-known print, from 1789, by Claude Niquet the younger placed the full text of the Declaration on a tablet supported by a vaguely biblical palm tree, itself a symbol of regeneration (see fig. 20). The tablet was placed so as to catch the light coming from the sun, which can be read as the monarchy in the tradition of the Sun King. The regenerative power of the Declaration was symbolized by a woman showing a child the text. In the light, a group of figures dance around a liberty pole, a symbol of the American Revolution (itself a Dutch Protestant emblem) and thereby also an allusion to the concept of the American "land of liberty."[27] In the dark shadows of Niquet's image, feudalism is laid low by lightning, an attribute both of Moses receiving the tablets of the Law on Mount Sinai, and of the Ark of the Covenant.[28] The monarchy had long appropriated these biblical references, most notably in Louis XIV's personal chapel at Versailles, decorated with bas-relief carvings of the Ark and the Tablets of the Law. Niquet's print was dense with such reference, appealing to the educated rather than the vernacular audience, with its final meaning being a monarchical endorsement of the Declaration as light over shadow and thereby of monarchy as the savior of France. France was free by virtue of its subjection to monarchy, which had offered rights to the people as a gift.

These complex allegories condensed into an intermediate form as the Tablets of the Law. This image, which became hegemonic for the Declaration, was created by Jean-Jacques-François Le Barbier (1738–1836), a history painter from the Royal Academy of Painting and Sculpture, with the print itself being made by Pierre Laurent (1739–1809) (see fig. 21).[29] Le Barbier adapted quickly from being a painter for the king to being one for

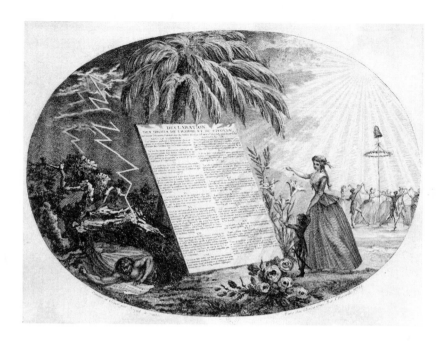

FIGURE 20. CLAUDE NIQUET THE YOUNGER, *DECLARATION OF THE RIGHTS OF MAN AND THE CITIZEN* (PARIS, 1789).

the revolution—and later back again. His print of the Declaration was first sold at the high price of four livres from the academy's own shop in Paris, in August 1789, before being distributed nationwide.[30] His image was thus formed and disseminated within the institutions of the ancien régime and literally contained radical interpretations. The picture space was almost entirely taken up with the text of the Declaration, depicted as if carved into stone in the shape of Moses' tablets. As expected from the Academy, there was neoclassical imagery, such as the fasces, together with the revolutionary liberty bonnet. The monumental size of the tablets formed a wall, marking a limit to those with rights and those without, as if Niquet's tablets had been raised to dominate the entire space of representation. Such projective and theatrical facades would have been familiar to eighteenth-century citizens from Baroque churches. The device thus incorporates classical, "Jewish," and Catholic imagery into the emblem for rights, giving it visual authority and power.

A wall is designed both to keep something out and to keep something

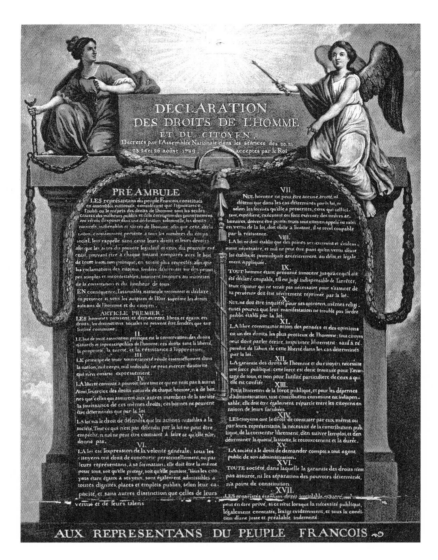

FIGURE 21. JACQUES-FRANÇOIS LE BARBIER, *DECLARATION OF THE RIGHTS OF MAN AND THE CITIZEN* (1789, PARIS).

in. The "wall" of rights was designed to serve as a reconfigured mode of separation within the continued monarchical order. The Declaration was a structure to ensure the continuation and expansion of private property without the encroachments of past feudalism or any future egalitarianism. Its exclusions were also questions of boundaries and limits, denoted by the two allegorical female figures sitting on top of the wall. On the left was France, holding the now obligatory broken chains of feudal slavery, and on the right a winged figure of Law. Light comes from the Eye of Reason in a triangle above, itself a condensed form of the three-sided balance that had become a symbol of the unity of the three estates in the National Assembly. Further, the eye had been an attribute of the allegorical figure of Reason, which she would carry on a scepter that quickly condensed to represent Reason, as it does here.[31] The image was a projection of the new terrain of a united France, held together by what the text called "liberty, prudence and the wisdom of government," rather than by the body of the King. It was also a taxonomy of the tenets of that liberty, and as a decree of the National Assembly, it had the force of law. This was an image designed to end debate and contain the radical potential of the Declaration and vernacular imagery alike into recognizable forms within the framework of colonial monarchy. Widely disseminated in France and still recognizable today, the Declaration as a wall of law named the classifications of limited rights, separated those with right from those without, and aestheticized the resulting visualization of the new form of France as an imagined community.

The separation was directed in no small measure to the French colonies and plantations, where the revolution created expectations of radical change, leading images and texts to circulate in unaccustomed and newly powerful ways. For example, on 28 May 1790, the colonial assembly at Saint-Marc on Saint-Domingue claimed that the Declaration gave the planters the right to supervise all the internal affairs of the colony, meaning above all their "right" to continue to own human property.[32] At the same time, they feared an "awakening" of the enslaved and would always claim that it had been instigated from "outside," ignoring a century of evidence to the contrary.[33] In the first days of the Saint-Domingue revolution, in August 1791, a planter claimed to have captured an enslaved rebel with "pamphlets printed in France [concerning] the Rights of Man. . . . On his chest, he had a little sack full of hair, herbs, bits of bone, which they call a fetish."[34] The description of the "fetish" fits that of the power-figures associated with earlier claims to liberty and figured the Declaration as another "primitive"

fetish. Another planter, named Félix Carteau, later went so far as to argue that books and visual images had caused the revolution, especially the engravings that the enslaved could look at "and listen to the interpretation of the subject, which was repeated from mouth to mouth."[35] At the same time, if it did not create the idea of freedom, the Declaration gave support to the enslaved and their claims. A "mulatta" woman named Dodo Laplaine was whipped and branded in Le Cap, the capital of Saint-Domingue, at the end of 1791 for reading the Declaration to the enslaved.[36] French perceptions of the centrality of the Declaration were not met by the experience of the revolution itself. When the French commissioner Sonthonax declared slavery abolished, in August 1793, the first article of his Decree of General Liberty provided for the publication and display of the Declaration "everywhere it is needed."[37] But, as it had become clear that the Declaration had not been intended to grant liberty to the enslaved, Haiti's 1804 Declaration of Independence did not refer to it.[38]

If it was widely agreed that authority was now limited by a culture of rights, it did not necessarily follow, as the Saint-Domingue planters argued, that chattel slavery had to be opposed. Rights were always about boundaries and limits, the practicalities of the universal they claimed to be. An important print produced in Paris after the festival of 14 September 1791, celebrating the passing of the constitution, visualized these limits. It depicted the allegorical figure of the Nation carving the Declaration and the Constitution, using the scepter of legislative power as a chisel (see fig. 22). The symbol of the wall used to denote the Declaration had literally condensed, enabling its boundaries to be made visible within the picture space. The "land of slaves" that bordered the "land of liberty" could now be seen. On the far right is the tomb of Mirabeau, a hero of 1789, who had recently died, evoking his claim that the Declaration should have abolished slavery: "The distinction of color destroys equality of rights."[39] On the far left, an "Asian despot" looks on in fear, a familiar caricature from sources as varied as Montesquieu's classic *Lettres Persanes* and the anti-Islam doctrines of Christianity. In an interesting conflation, the text identifies him as a "rich slave of Asia, who does not know what all of this might mean: the poor thing, in his country even the name of liberty is not known" (see fig. 22a). The majoritarian Frenchmen who gained rights in 1789 insisted that "universal" liberty was specific to their national territory, a form of *ius soli* (law of the soil) that could in no way be exported or even explained to Asians or Africans, who were similarly defined by their unfreedom. Awakening and the visualiza-

LA CONSTITUTION FRANÇAISE.

« Allégorie sur la Constitution », gravure en couleurs anonyme. Bibl. Nat. Paris.

FIGURE 22. ANONYMOUS, *LA CONSTITUTION FRANÇAISE* (1791),
from Michel Vovelle, ed., La révolution française: Images et recit, tome 2, 307.

tion of the land of the people had been met by walls and limits, symbolized by the borders of France. Attempting to contain an explosion can, however, simply magnify its effects.

THE POLITICS OF EATING

If rights had become a limit, the "work of righting wrongs" had to be re-configured.[40] The imaginary centered on a "land of liberty" from which no retreat could be made had turned out to be simply an awakening of ex-pectations. These hopes might be summarized as the desire for the end of slavery and the institution of a new ordering of "eating." In West Africa and Kongo and their diaspora, the "politics of eating" expresses a concept of social ordering:[41] "An ordered society is one in which 'eating,' both literal and metaphorical . . . is properly distributed."[42] A ruler should eat, prodi-giously, but should also ensure that all the people do, entailing some nego-tiations with the spirits who need "feeding" and *ndoki* (witches) that "eat people." Eating is, then, the distribution of the sensible and its resultant ordering to sustain itself. The subalterns of the Saint-Domingue revolu-

tion were above all concerned to create a sustainable local economy outside slavery. Although it was the producer of the greatest colonial wealth, Saint-Domingue was a place of extreme material deprivation for the enslaved population, a situation attested to by its failure to reproduce itself. While over 800,000 enslaved Africans were brought to the colony during the eighteenth century, the resident population was only just over 400,000 in 1788, a population loss caused partly by violence, but mostly by deprivation. By the same token, the revolutionary unrest from below in France was linked to the failure of the king to sustain food provision, the most fundamental function of sovereignty, necessitating vengeance. The radical sans-culottes in Paris formulated this need into a political project that they called "the right to existence."[43] Colonial produce was central to the food supply of the Parisian multitude, linking the two modalities of eating. In the revolutionary crisis, a performative iconography of eating explored power, the righting of wrongs, and the distribution of material goods to create an imaginary of modernity.

A predatory, vampiric modernity was engendered by the slave trade across the Atlantic world that persists until the present.[44] The right to existence sought to right this wrong. In a brilliant interpretation of witchcraft among the Temne people, in Sierra Leone, Rosalind Shaw shows that "witchcraft" was at once produced by the slave trade and intensified it as an economy of power. Before slavery, misfortunes were dealt with by making requests of the gods and spirits, which Europeans called "idols." The evils of slavery led Temne people to attribute their wrongs directly to the actions of an individual, a "witch," whose agency could be unmasked. Witch-finding allowed those discovered to be enslaved in turn as a punishment for their own presumed "eating" of others. This divination allowed for "an 'eating' in which the appearance and accumulation of new wealth was engendered by the disappearance of people into oblivion."[45] The witch was reputed to have four eyes, two to see in the spirit world and two for material space. The witch-finder, too, claimed special powers of seeing and interpretation. This symbolic order allowed for the righting of wrongs by attributing them to the agency of specific individuals, known as witches, magicians, conjurors, those who fooled the people — or traitors, (counter-)revolutionaries, or any of the other categories of wrong-doer referenced in the revolution. Such a person could be enslaved. One measure of the politics of eating was literal and metaphorical size. A "big man" might be on the people's side against the witches, but might also use witch-finding skills to enslave them. Witch

trials in seventeenth-century Europe and North America were, it should be remembered, followed by the creation of modern circulation embodied in people reputed to be witches and sold into slavery. In the revolution, the people responded by endorsing their own champions, those who became "heroes" or "great men" (the French *grand homme* can mean "big man" or "great man"). Slave traders were also known as "big men," in the same way as the African leaders they dealt with, because both "ate" the people.[46] Europeans in Saint-Domingue were known as "big whites" or "little whites" according to their social and financial status. In 1791, the French Revolution had constructed a pantheon to its grands hommes, beginning with the ashes of Voltaire, who had invested in the slave trade and even had a slave-ship named after him, while on other occasions he had roundly condemned the institution.[47] It was this modernity that was challenged in Saint-Domingue and Paris alike.

To take an example of that imaginary, which featured largely in both Carlyle's history of the French Revolution and Dickens's novel *A Tale of Two Cities*: early in the French Revolution, on 22 July 1789, the detested government minister Joseph Foullon, who had suggested that the hungry people eat grass, was hanged from a streetlamp in the Place de Grève, Paris, scene of the spectacular execution of the regicide Damiens forty years previously. The Lantern revenged the people against the Crown, where the monarchy had previously restored itself. The mouth of Foullon's decapitated head was then stuffed with hay and paraded through the streets, an apotropaic performance that visited the fate intended for the masses on the minister.[48] The artist Anne-Louis Girodet, later to paint Jean-Baptiste Belley, an African delegate to the National Assembly from Saint-Domingue, was on the scene, and he made some sketches "after nature," or, more exactly, of the new reality created by the revolution.[49] In this new realism, Foullon's head was sketched from the front and the rear, showing the hay in his mouth sprouting out beneath a handlebar moustache in a way that is unmistakably comic, albeit in a terrible way (see fig. 23). It was one of a sheet of sketches of decapitated heads that also showed the head of the marquis de Launay, governor of the Bastille, on a pitchfork, with a look of surprise on his face, and the mutilated head and heart of Bertier de Sauvigny, intendant of Paris, on pikes. The last was Foullon's son-in-law, executed on the same day, for the kin of a witch were also considered witches. In a ritual symbolizing the reversal of power from kinship network to popular sovereignty, Bertier was presented with Foullon's head on a pike to chants of "Baise papa" (kiss

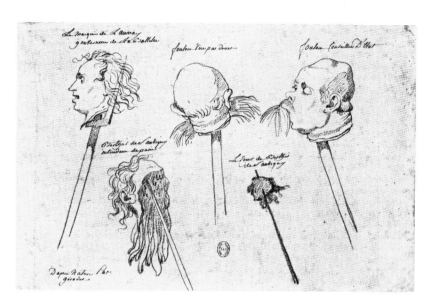

FIGURE 23. ANNE-LOUIS GIRODET, *UNTITLED [SKETCHES AFTER NATURE]* (1789).

Daddy).[50] Bertier's own symbolic "eating" was then made plain by the display of his heart as a trophy alongside his head. While artists had long been urged to draw from classical sculptures showing the effects of personal suffering, these drawings are evidence of a new revolutionary realism, trying to keep pace with changing events. It is not what one might call naturalism, or an attempt to depict exterior reality as closely as possible. In French, a still life is *nature morte*, dead nature. Revolutionary executions prompted a debate about end of life and whether the head continued to "live" briefly after decapitation. These are, then, studies after undead nature, an exploration of the interstitial, magical zone that the revolution had engendered. The revolution did not create this vampiric eating, but visited it in kind on those who had done so.

Indeed, the threat of decapitation entered into the dream-work of French citizens not as the now standard Freudian formula "decapitation = castration," but as itself, a fear of (and desire for) execution.[51] Dreaming and madness explored the new imaginary and exposed its limits. Philippe de Pinel, the famous liberator of Bicêtre, is supposed to have cast off the chains of those detained as insane, a widely celebrated "liberation" that metonymically replicated the revolution itself. Pinel compared the former regime in what he called "lunatic hospitals" to that of "despotic governments,"

where the inmate was treated as "an untameable being, to be immured in solitary durance, loaded with chains, or otherwise treated with extreme severity."[52] While this description seems designed to recall slavery, Pinel emphasized that it would be "ridiculous" to treat everyone in the same way: "A Russian peasant, or a slave of Jamaica, ought evidently to be managed by other maxims than those which would exclusively apply to the case of a well-bred irritable Frenchman."[53] It seems that "breeding," mixing race and class together, trumps insanity. Further, as Foucault has emphasized, Pinel's liberation of madness entailed a new "enslavement," to the institution of the asylum.[54] He stressed that the "notion of madness, such as it existed in the nineteenth century, took shape inside a historical consciousness."[55] For Pinel, slavery existed "outside" history, just as the French revolutionary process had depicted it. By contrast, the revolution was everywhere in his asylum, where there could be found a watchmaker who believed that he had been guillotined but then, having had his sentence reversed, had been given the wrong head back. Another believed he was to be executed, and still a third lived in perpetual fear that he might be tried.[56] None of these men could be persuaded otherwise, even in the case of the last, the tailor Poussin, for whom Pinel staged a mock trial and acquittal. Such traumas, caused by what we call history, were understood by Pinel as derangements of the imagination, whose excess was considered the prime cause of madness throughout the eighteenth century.[57] The intensification of the imagination caused by the revolution had in turn engendered an explosion of madness.

For Freud, as Foucault goes on to say, madness was considered a moral and social question, "the hidden face of society." Nonetheless, revolutionary beheading did not necessarily symbolize castration. Freud considered the experience of Maury, a French doctor and his precursor in the study of dreams, who had dreamed that he had been tried, condemned, and executed by the guillotine, right up to the point where he felt his "head being separated from his body."[58] It turned out that a piece of wood from the top of Maury's bed had fallen and struck his neck in the place where a person might be executed. Freud discussed the remarkable length of the dream from trial to execution in response to this instantaneous stimulus. He concluded that the dream was a "phantasy which had been stored up ready-made in his memory" and was accessed because of the sensation on the neck. Freud indulged himself in recreating this phantasy involving the gallantry and wit of the aristocrat on the scaffold, "bidding a lady farewell—kissing

her hand and mounting the scaffold unafraid!" Or maybe ambition was the key, a desire to "picture himself as one of the Girondists, perhaps, or as the heroic Danton!"[59] No need here to explore the sexualized ramifications of all this, the erotics of picturing oneself a hero at a century's remove from the scene of visuality's formation. It seems that the revolution retained a capacity for mental damage by overstimulus to the imagination for Maury/ Freud and the countless readers of Carlyle, Dickens, Anatole France, and the other dramatizers of the revolutionary scene in the nineteenth century. Note also that one identification is impossible or at least inadmissible within all this dream-work, mania, and phantasy: an identification with the revolution. The revolution was the "bad liberty" that led to the tyranny of popular rule, opposed to the "good liberty" that simultaneously unchained the well-bred mad, separated them from criminals and other subjects of detention, and then inserted them into the institutional structure of the asylum.[60] An entire imaginary of modernity is condensed into these formulas of limit, fantasy, exclusion, excess, desire, and the dream.

In Saint-Domingue, the very outside of the European dream-world, the revolution that began in August 1791 was a decapitation of the means of (sugar) production, led by the enslaved elite, such as the drivers, most notably Toussaint from the Bréda plantation, who took the name L'Ouverture, the opening. The surrogates of the overseers revolted against the new forms of oversight, tending toward the automation of production. The pattern of events in 1791 made it very clear that the enslaved would no longer be "eaten" by the means of wealth production. The revolutionaries destroyed sugar mills, burned cane fields, and killed such overseers and plantation owners as they could find, a noticeable change from the "traditional" revolt in which the trash-house, where the dried cane fibers used to fuel the burners were stored, was set on fire. Fields were even flooded to prevent any return to full-scale plantation cultivation.[61] In November 1791, Dutty Boukman, the first leader of the revolution and a former slave-driver, was captured. He was beheaded, and his head was publicly displayed to dispel the myth of his invincibility. The remaining leaders, such as Jean-François and Georges Biassou, now sought a settlement. They proposed an amnesty for all the revolutionaries; the banning of the whip and the *cachot*, or prison, on the plantations; freedom for four hundred of the *commandeurs*; and the abolition of all attorneys and bookkeepers.[62] In short, the labor hierarchy that planter regeneration depended on was to be abolished, even if slavery was not. For the historian C. L. R. James, these proposals were therefore

nothing short of an "abominable betrayal," one that has more recently been castigated, by Robin Blackburn, as "servile trade unionism."[63] If these judgments seem harsh, they also show that the long history of modernity is understood to be condensed into these first revolutionary exchanges. However, other than the Maroon partitions of colonies, no revolt of the enslaved had yet succeeded in making permanent gains. Indeed, the Le Chapelier law, of 1791, which outlawed trade unions in France, had long-lasting negative consequences for the nineteenth-century French labor movement. Finally, any negotiated settlement would have entailed a recognition of the enslaved as rational human beings that was a critical gain in itself. For twentieth-century writers, these gains would never have been sufficient, threatening to erase the possibility of revolution that still seemed alive in their own time.

Unaware of this future to come, the rank-and-file of the revolutionary armed forces were above all concerned to ensure their "right to existence" by winning their "three days," meaning three days during which they would not have to work on the plantation but could attend to their own cultivation. These subalterns and their leaders were formulating what would have seemed "unthinkable" until 1791: vernacular demands on sovereign power.[64] The planters rejected this interim proposal, further radicalizing the enslaved under arms, whose slogan now became "*bout à blancs*," that is, "an end to the whites."[65] The subaltern strategy countered planter regeneration by imagining a general self-sufficiency created by the allocation of small parcels of arable land to each person, reinforced by a local market economy for non-essential and recreational goods and to exchange surplus. The subalterns were in effect claiming the right to eat via ownership and extension of the "slave gardens," which already generated a good deal of revenue for the enslaved in Saint-Domingue at the Sunday food market in Le Cap. The means of exchange was by barter or by pieces of sugarcane that in an evocative fashion became a money-form for the enslaved.[66] We can get a sense of what postslavery cultivation might have looked like by comparing two surveys taken of "Negro Gardens" in Jamaica. In a survey taken in 1811, with slavery in full vigor, each person was allocated a small plot of about half an acre in a rigidly geometric pattern. By 1837, during the "apprenticeship" that led to full abolition, in 1838, the area of each plot was much larger, reaching as much as sixteen acres, and the cultivation was shared on each plot among men, women, and children of all ages (see fig. 24). Crops grown ranged from staples like yam, cassava, and plantain to cash

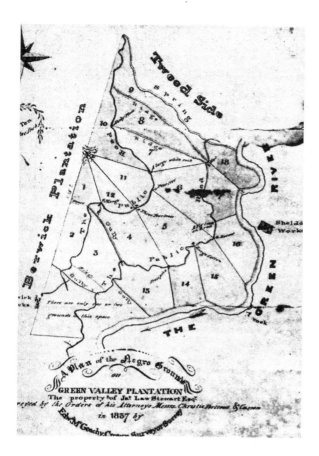

FIGURE 24. EDWARD M. GEACHY, *A PLAN OF THE
NEGRO GROUNDS, GREEN VALLEY PLANTATION* (1837),
from Barry Higman, ed., Jamaica Surveyed.

crops like sugarcane and guinea grass.[67] It seems reasonable to assume that
this difference did not reflect the attitude of the planters in these locations,
but how the formerly enslaved envisaged their future. This style of culti-
vation could certainly have supplied enough to eat and a surplus for local
exchange. Even hostile observers remarked on the diversity of the local
markets, seeing products from hats and sculpted calabashes to fish, fruit
and game.[68] The market during slavery and the "garden" after it, with their
associated economic and social structures, embodied the politics of eating
in Saint-Domingue in all senses.

The very success of the revolution in Saint-Domingue generated in
France shortages and price rises of colonial products like sugar and cof-

fee, which set off popular agitations and even riots, bringing to a head the contradictions of national and social revolution. Sugared coffee had become a staple foodstuff of the Parisian working classes, especially for breakfast, as it is today. When these commodities seemed to be both rising in price and in short supply, the popular forces were not inclined to accept these changes as a market response to the revolution of 1791, as merchants wanted to present them. Rather, seeing well-stocked storage places, they intervened directly to ensure fair prices. Even government officials described the merchants' idea that prices should be set by "the consumer's fancy," that is to say, by demand, as nothing more than a "sophism."[69] The realism of the market that is now all but unquestionable had yet to claim the definition of reality. The "wall" of property rights that sustained the revolutionary leadership seemed on the verge of collapse, creating the same fear of anarchy that the planters had experienced in Saint-Domingue. Such interventions were justified as a protection of the "indigent," the symbolic vernacular figure of poverty.[70] From this position, a society could be run to ensure the sustenance of the neediest, rather than the "equality" of value offered by the market. Into this charged environment emerged new popular discourses. A typical police report of February 1793 described an intervention at a sugar warehouse, beginning with the dramatic cry of a pregnant woman: "I must have sugar for my little one!"[71]

The commissioners for the Arsenal section described another such event in detail.

> There was a woman of fairly good appearance, unknown to me but whom we would recognize perfectly. . . . She was about five feet, one inch tall, thirty years old, with blonde hair, white skin and slightly red eyes. She wore her hair in a demibonnet to which a rose-colored ribbon was attached. She was dressed in a *déshabillé* made out of linen with a blue background and a standard design on it. She wore a mantlet of black taffetta and a gold watch on a steel chain. . . . This woman did everything in her power to add to the sedition. She had gone on the inspection [of the warehouse]. And once they returned, it was she who set the price for soap at twelve *sous* per pound and for sugar at eighteen.[72]

This passage attests to the observational power of the police, whose eye for detail makes the account read like a realist novel, accruing its "reality effect" item by item. It creates a compelling image of the seditious woman, stylishly dressed as bohemian, cutting sugar prices from sixty sous a pound

to eighteen, a rate even below the pre-speculation price of about twenty-five sous. Egalitarian price control was the metropolitan equivalent of the land-sharing politics of the Saint-Domingue subalterns, and it is appropriate that colonial produce should have sparked the dissensus. This combination of colonial goods, popular agency in the market, the politicization of women's roles as mothers and as consumers, and police observation is a dialectical image in which the egalitarian, vernacular forces of the revolution can be seen for an instant.

For the sans-culotte movement of artisans, shopkeepers and laborers, the renewed Declaration of the Rights of Man and the Citizen, in 1793, came to imply a "right to live" that surpassed the rights of property.[73] They condemned "those who, using liberty and their rights as property-owners as an excuse, think that they can squeeze the last drop of blood from the miserable and starving section of the population."[74] In the terms of the politics of eating, one might summarize this position as "No more vampires!" or the more familiar "bloodsuckers" of popular discourse. This movement reached its highpoint with the imposition of the "maximum," meaning price ceilings for basic foodstuffs in the Year Two (1793–94). Indeed, the price of bread was set by the state until 1978, a legacy of this popular struggle. The sections of the Paris Commune referred directly to the Declaration in support of price regulation, citing article 4's proposition that liberty consists in not hurting others and article 6 to the effect that one does not have the liberty to harm others. Their opponents consistently referred to the "sacred right of property" as trumping all such secondary concerns.[75] Their fears were soon realized as radical thinkers began to draw the conclusion that ownership of land itself should be limited, to as little as twenty acres in some proposals.[76] In 1804, independent Haiti would forbid all property ownership for "whites," and insistent political demands by the veteran soldiers led to an extensive division of the former colonial estates (1809–19).[77]

The right to live came to be extended to the need for universal education. Michel Le Peletier (now best remembered as a revolutionary martyr painted by Jacques-Louis David) argued that education was "the Revolution of the poor, but a gentle and peaceful revolution" to be developed via "the meeting of citizens in popular societies, theatres, civic games, military evolutions and local and national festivals."[78] Combined with sustainable economy, this performative, collective sense of education in the broadest sense was central to the imaginary of vernacular heroism. It was "visible" because it was collective, open to debate, and shaped by performance, sport, and

military training, like the disciplinary society that would coopt its forms and supplant it in the nineteenth century. As the radical pedagogue Joseph Jacotot emphasized in the early nineteenth century, any education that did not subjugate the pupil to the schoolmaster was a form of emancipation.[79] Consequently, it is not surprising to see a strong emphasis on education in independent Haiti, beginning with the presidency of Alexandre Pétion (1770–1818) in the Republic of Haiti, established in the southern half of the modern nation in 1806. Pétion not only distributed small plots of agricultural land to former soldiers, but established education for boys and girls. Combined with his assistance to Simón Bolívar, the liberator of South America, in exchange for his support for the abolition of slavery, Pétion's regime (1806–18) endeavored to enact the full meaning of emancipation implied in the politics of eating. An imaginary constructed around democracy (meaning here the place of the people as having title within the state), sustainability, and education was in place, only to be dislocated by the massive indemnity imposed by France in 1825 as "reparations" for their lost colony.

HEROES AND THEIR DISCONTENTS

Righting such wrongs came to take embodied form in the figure of the leader and the hero, who became the image of the revolution in order to sustain the authority of a nation. The hero had the avenging power of the Lantern and took on responsibility for the politics of eating. Heroes were first the condensation of the popular movements, as in figures like Jean-Paul Marat or Toussaint L'Ouverture, and later the means to contain them, epitomized by Napoleon Bonaparte, the paradigm of the Hero for Carlyle. This investment in the hero was divided into two competing imagined futures, which might be characterized as "vernacular" and "national." The central tension within the revolutionary movement over its mode of realization would echo down the long nineteenth century. As early as 1793, Georges Biassou declared the revolution in Saint-Domingue to be "a period that will be forever memorable among the great deeds of the universe."[80] Prints and engravings of Toussaint, Christophe, Dessalines, Pétion, and other Saint-Domingue leaders circulated around the Atlantic world, forming the figure of the African hero, bringing a new kind of memory into play, and giving the enslaved everywhere a new weapon. This embodied heroism was able,

like the imagined figure of the Third Estate or the Sans-Culotte, to encapsulate a social movement.

In France, in 1793, the Committee of Public Instruction, directed by Léonard Bourdon, a follower of Le Peletier, published a list of popular heroes in pamphlet and poster form. It was part of the instruction in the "Rights of Man, the Constitution and the list of heroic or virtuous acts" now required in the new state schools for children aged from six to eight.[81] Bourdon's list of heroes for the age of mechanical reproduction ran for only five editions, but was printed in runs of up to 150,000 copies in 1794. He argued for a realist style of writing in which "the writer must entirely disappear, the actor alone should be seen." These "pure" word pictures would replace the functions of the catechism, which "prepares children for slavery."[82] The stories themselves present some sanctified accounts of rank-and-file military heroism, including that of the drummer boy Joseph Barra painted by David, as well as some intriguing slices of everyday life. We hear of a gardener named Pierre Godefroi, who saved a little girl, Goyot, from drowning in a mill trace, or of a woman named Barbier, from Mery, who, seeing that there were no horses to carry her grain, said, "Eh bien, sisters, let's get sacks and carry the wheat on our backs to our brothers in Paris." All were described as the actions of the "sans-culottes of regenerated republican society."[83] Alternative histories come to light, such as that of Rose Bouillon, who demanded a discharge from the army, in which she had served and fought "as a man" for six months after her husband, Julian Henri, had been killed in action.[84] These sans-culotte politics echoed in the colonies, where the French commissioner Sonthonax justified his addition of a de jure abolition of slavery, in 1793, to its de facto accomplishment by the revolution by arguing "the blacks are the true sans-culottes of the colonies, they are the people, and only they are capable of defending the country."[85] What was at stake in such claims around the Atlantic world was the transformation of what Marat had called *le menu peuple*, the little people, into the people as such, the subject of the revolution and its realization.[86] The "little people" had become "Big Men."

This imaginary of the people emerged in visualized form as the new subject of the Declaration. In a striking print by the otherwise unknown Dupuis entitled "La Chute en Masse" (Paris, Bibliothèque Nationale [1793]), an idealized sans-culotte is seen turning the wheel of an electric generator, labeled "Declaration of the Rights of Man" (see fig. 8, p. 43). His power-

ful musculature referred to the sense that revolutionary regeneration had worked on the body of the people, transforming the figure of the Third Estate into the sans-culotte. From the pole of the Declaration-Generator, decorated with a liberty bonnet, a conducting cord leads to a sequence of European monarchs such as the pope, the Emperor Joseph, and George III, all designated by unflattering nicknames. The shock throws them to the ground as a caption says: "Republican electricity gives Despots a shock that overturns their thrones." That electricity was generated by the people using the force of rights to transmit an insuperable message, spelled out along the cord: "Liberty, equality, fraternity, unity, indivisibility of the Republic."[87] The chains of slavery had become an electrifying means of liberation. This metaphor transformed Paine's rational and irreversible "impression" on the mind into a visualized medium that has corporal and political power. This image of the electronic Declaration of Rights further condensed into a composite symbol of the electrified Tablets of the Law, in the representation by sans-culotte printmaker Louis-Jean Allais (1762–1833) of the Declaration and the 1793 constitution as flashing lightning into darkness.[88]

This transitional moment produced not just new modes of representation but new collective means of creating visual images. The royal academies, including the Academy of Painting, were abolished in 1793, leading to the creation of the Société Populaire et Républicaine des Arts.[89] In its brief span, the society created a stir mainly by those it invited to sit in judgment on the arts, including a shoemaker, Plato's symbol of the worker who should do his work and nothing else. Equally striking was the reconfiguration of the map office in the reformed military and colonial office under the command of General Etienne-Nicolas Calon. The Committee of Public Safety created a new Agency of Maps, on 8 June 1794, bringing army and navy maps into one unit that also took over a mass of maps from private, that is to say aristocratic, hands. Recognizing mapping as the "most useful science for the communication of peoples," Calon purged the office of "aristocrat" artists and replaced them with "patriots," including the marine painter Genillon, a wine-seller named Macaire, soldiers, clerks, and many sons of geographical engineers. Astronomers, engravers, professors of mathematics and drawing were brought in to educate this unlikely crew, who were to contribute to a proposed museum of geography, military topography, and hydrography in the Louvre.[90] As quickly as such radical changes were reversed after the fall of the Jacobins, they laid the ground for the transformation of military mapping under Napoleon and therefore,

ironically, for the defeat of popular heroism and its replacement by the national Hero.

The revolutionary leaders in Saint-Domingue fully understood the importance of a heroic visual iconography. Dessalines, while still a general under Toussaint, had a life-size portrait of himself surrounded by his troops painted in oils at the house he had expropriated.[91] When he took over power, in 1804, Dessalines symbolically cut the white section out of the French tricoleur to make the new nation's flag, a nation that he renamed Haiti in homage to the Indian ancestors.[92] There was a flourishing visual culture in Le Cap, before and after 1791, for the new order to draw on. In the period of slavery, paintings of all genres were frequently offered for sale in Saint-Domingue, including a purported Michelangelo. Resident artists included Noël Challes, a prize-winner at the Royal Academy of Painting in Paris, while artistic education was available for both men and women from artists such as Jubault and Madame de Vaaland respectively.[93] Marcus Rainsford, a sympathetic British witness to the revolution, noted that the theater, "always so prevalent in St. Domingo," continued "in more strength and propriety than it had done before."[94] While there were still some French actors, the pieces were played mostly by "black performers," who performed Molière, but also a new piece called *The African Hero* (1797).[95] This three-act pantomime was set in Kongo, but other than that we know nothing of it. Sibylle Fischer has suggested that it was a deliberate riposte to a pair of performances under the title *The American Hero*, staged by the French actor and future revolutionary Louis-François Ribié in Le Cap during 1787.[96] Certainly, the title of the 1797 piece was highly suggestive of the strategy of the post-1791 revolutionary leadership to create African heroes from the formerly subjugated ranks of the enslaved and people of color.

A common icon of Toussaint showed him on horseback in full uniform with raised sword against a generically tropical background (see fig. 7, p. 42). In this image, Toussaint was depicted as having mastered several codes of conduct that were typically held to be beyond Africans: control of a rearing horse, the symbolic deployment of European modes of clothing to claim high rank, the use of the cavalryman's saber, and indeed the command of disciplined soldiers. Seen from a European perspective, the horseback pose seems to be derived from David's famous equestrian portrait *Napoleon at the St. Bernard Pass* (1799), where the consul masters his rearing horse on the verge of the conquest of Italy (see fig. 25). David painted the names of Charlemagne and Hannibal in the rock under Napoleon's feet, to show his

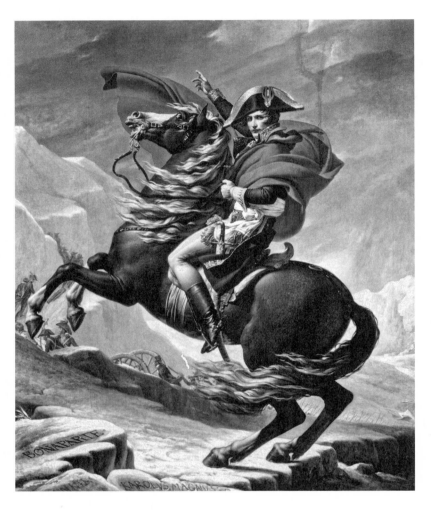

FIGURE 25. JACQUES LOUIS-DAVID, *NAPOLEON CROSSING THE ST. BERNARD PASS* (1800), CHARLOTTENBURG CASTLE, STIFTUNG PREUSSISCHE SHLÖSSER UND GÄRTEN BERLIN-BRANDENBURG, BERLIN, GERMANY. Photo courtesy of Bildarchiv Preussischer Kulturbesitz / Art Resource, New York.

mastery of History. The painting further evokes the equestrian statues of monarchs that had been destroyed in the early years of the French Revolution. If we look at the Toussaint print in this light, his horse stands over both a colonial fortress and a ship, the essential technology of the Atlantic triangle. Toussaint was visualized as having authority over colonialism and slavery, in direct contrast to the subservient imagery of white abolitionists, such as the "Am I Not a Man and a Brother?" motif showing a kneeling African man requesting emancipation. By contrast, Toussaint is seen fighting for liberation. The visual homonym created an association between the two leaders, one that Napoleon was determined to eliminate, leading to the French expedition to Saint-Domingue, in 1802, and Toussaint's death in exile.

Srinivas Aravamudan points out that these images can also be understood in terms of Vodou: "The French law (loi) is a Kréyole homophone for the personal deity (lwa), and the terms for the human as the religious vehicle for the manifestation of the deity as chwal, analogical to a horse being mounted by its rider. A more knowing interpretation of Toussaint's equestrian portrait may now come to mind."[97] Toussaint could be understood, then, as being a lwa, riding his people as the personification of the law. The image is not just generically allusive but a specific visual homonym for the divinity known as Sen Jak in Kreyòl, St James in English, Santiago in Spanish, and Saint Jacques in French, who always appears armed on horseback. Introduced into Kongo by Portuguese missionaries in 1480, the saint was an important syncretic figure in Africa before Atlantic slavery. In Vodou, Sen Jak is a key avatar of the Ogou family of warriors and fighters for justice, who is, appropriately enough, depicted in present-day images in a mystical merger with Toussaint.[98] This heroic visualization was a final rebuttal to the force of law that had structured oversight. Joan Dayan has emphasized the importance of such possession: "To conceive of the *image* of the god in oneself is to be possessed. It is a deed of the most serious conception. Thought realizes itself in the imaging of the gods."[99] This performative act of imagination was to allow oneself to be possessed by others, a voluntary subjection made by people who were claimed as possessions. The "dancer" is not dominated by the spirit, but performs it, discovering a new sense of "self" via this other in a body that the dancer had not previously been at liberty to make available for this or any other purpose. This imaging, for all its psychological and performative density, leaves no representative traces, being rather

the product of a trance. The embodied image of the gods produced in this performance was the subaltern hero.

For this second reading to be available, it is necessary to show that the image could have been made or at least seen in Saint-Domingue. Aravamudan speculates in what he calls counterfactual fashion about a potential woman reader for such images, whom he names as Toussaint's daughter-in-law. The more intriguing possibility is that a woman may have made them, or at least something like them. Rainsford, who met Toussaint, noted that around 1800 "painting, from some recent specimens, appeared to be encouraged, and cultivated as an accomplishment." By the latter phrase, Rainsford meant that it was taught to women as a "proper" activity for them to pursue, an implication borne out by his following sentence: "A young lady of colour, of the name of La Roche, presented a large company, of which the writer was one, in the course of a few minutes, with their likenesses, very accurately cut in profile."[100] He was describing the then fashionable practice of making silhouettes, sometimes using a specially designed machine, which would show the subject's face in profile, cut from black paper. Here we have perhaps the first named African diaspora woman artist, the silhouettiste La Roche. Her work reminds us of Moses Williams, the enslaved silhouetteist of Charles Wilson Peale's Philadelphia Museum.[101] As far as we know, Williams cut only one silhouette of an African American, although he was cutting over 8,000 portraits a year.[102] Clearly, La Roche was depicting the revolutionary society of Le Cap, a very different situation from that of Williams, who used the money he earned to purchase his own freedom. A sympathetic eye might even discern that the equestrian portrait of Toussaint has a formally "flat" feel, as if the French version had been adapted from a silhouette. While the association is certainly unprovable, the fact remains that the free island of Saint-Domingue, later Haiti, created a heroic iconography for its own cultural imaginary that included work by women of color.

CRISIS: DIVIDING THE REVOLUTIONARY SENSIBLE

By 1801, the revolutionary imaginary was in crisis, divided against itself and uncertain of its purpose. While this turning point is usually marked by the triumph of Napoleon Bonaparte, in 1799, I identify the divide in the revolutionary sensible by means of a colonial counterpoint between the crisis in Saint-Domingue and a French attempt to reinvent the land of liberty in

the South Pacific. The result of this counterpoint was simply discord, rather than a dissensus or even a transculturation. From the beginning of his public career, Toussaint had asserted that in order to create a modern nation-state, the revolution in Saint-Domingue needed to be forged from a balance of liberty, meaning freedom from slavery, and responsibility, meaning continued agricultural labor on cash-crop plantations for the majority.[103] His goal was to render the revolutionary imaginary into an "imagined community" of workers and leaders under the control of the army and pursuing Catholic observance. By the same token, the subalterns had consistently imagined sustainability as their key goal, from the "three days" campaign, in 1791, onward. Now Toussaint observed with concern that groups of workers were banding together to "buy a few acres of land, abandoning plantations already in use to go and settle on uncultivated land."[104] In the 1801 Constitution, he therefore required all those who were capable to work on the land unless they had another profession. All were forbidden from purchasing land in lots smaller than roughly 150 acres, excluding almost all people of color. The goal was above all to generate exports, meeting the needs of the treaties signed in 1798 with the United States, and to reinforce the place of the state and the army.[105] It has perhaps only been very recently that it has become possible to imagine that local, sustainable agriculture might have been preferable to a "modern" nation, and that discussion is still controversial today. In 1801, workers were no longer slaves, but they were tied to their plantation and under the watchful eye of the new police Touissant had created and his own *police générale*.[106] If slavery was over, it now seemed that the plantation complex was not, and it was exactly such a going back that the subaltern classes had feared.

These new rules provoked an uprising by the subalterns who had fought the revolution throughout the north of the colony in October 1801. Their leader (whether by acclamation or intent) was the formerly enslaved General Moïse, not only an associate of Toussaint's, but his nephew and adopted son. As the agricultural inspector for the north, Moïse knew the aspirations of the workers and was in favor of dividing the plantations among junior officers (literally, the subalterns) and soldiers from the ranks.[107] While rumors unfairly abounded that Toussaint was reintroducing slavery for all, as the French had done in Guadeloupe, he had legislated the right to "import" workers from Africa, who were unlikely to be volunteers. The tension within the imaginary of the revolution between subaltern vernacular heroism and the national hero had now become an open conflict. With

the support of the army, Toussaint quickly defeated Moïse and had him summarily executed. In an extraordinary proclamation, which he ordered to be read after Sunday Mass, Toussaint railed against the entire populace, describing the postslavery population as comprising "bad citizens, vagabonds, thieves. And if they are girls, then they are prostitutes."[108] The historian Laurent Dubois has called this rant, with its subsequent imposition of security passes and other surveillance techniques, a "delirium."[109] Pinel might have agreed: he saw delirium as a form of mania incited by strong and furious passions, such as those that "originate in fanaticism or chimerical delusion."[110] What was Toussaint's delusion? He believed that he could create what has been called "egaliberty" (equality and liberty in one) by means of his own personality. It was, in short, the delusion of the hero. Heroes are not good for popular movements, as we have had to learn time and again from, as C. L. R. James would have it, Toussaint to Castro: and now, perhaps, Obama. By the same token, as the diffuse and inchoate revolt of November 1801 showed, popular movements are unpredictable, hard to control, and likely to be defeated by the persistent application of intense violence.

This moment has been much discussed. It inaugurates, from the perspective of this project, the possibility of counterrevolutionary visuality, ironically incarnated in Toussaint's conqueror Napoleon. For James and after him, Aimé Césaire, it was the tragedy of revolution, a dialectical image that jumped out of history. Both writers compared Toussaint's situation to that faced by Lenin after the October Revolution of 1917, when tsarist officials and bourgeois economics had to be restored to save the nascent state, known as the New Economic Policy. Although James shaped the conflict between Toussaint and Moïse in terms of race and imperialism, rather than political economy, he acknowledged the severity of this crisis: "To shoot Moïse, the black, for the sake of the whites was more than an error, it was a crime. It was almost as if Lenin had had Trotsky shot for taking the side of the proletariat against the bourgeoisie."[111] Not to mention—as James did not—the extensive and more or less random execution of subaltern combatants on mere suspicion of having sympathies for Moïse. For James, Toussaint crossed an irrevocable line with these actions, but his proposed solution of a campaign of explanation and mobilization is unconvincing: such proposals had been made to the subalterns under arms since 1791, and they had always rejected them. David Scott has nuanced James's position by ar-

guing that Toussaint and others like him were the "conscripts of modernity," forced to involve themselves with its project.[112] In this discussion, it seems that the entire scope of one form of modernity became visible to the decolonial historians of Haiti in this moment. That genealogy was encompassed by the Haitian and French Revolutions via the October Revolution of 1917 and perhaps ended in 1989. But why not, as Diana Taylor has suggested in a different context, take the comparison from within Toussaint's terms?[113] It might be said that Toussaint could no longer ride the *lwa/loi*, the "horse" that had carried him through the revolution. If that horse was the people, it seems that they had thrown him. Present-day accounts of spirit possession emphasize the total exhaustion of the rider when the spirit departs.[114] The people no longer imagined themselves as Toussaint, who could in turn no longer imagine what it was that they needed.

In 1799, as if accepting that the Atlantic world revolution had faltered, the French had literally set sail in search of a different narrative on history, rights, and the means of representation. The Directory-sponsored Australian expedition of Nicolas Baudin (1754–1803) arrived in Van Diemen's Land (modern Tasmania) in the decisive year 1801. Organized by the newly created Society for the Observation of Man, in Paris, Baudin set out to literally explore the origin of human rights, a mission to regenerate the French Revolution by means of knowledge transplanted from the South Pacific.[115] On board was François Péron (1775–1810), a twenty-five-year-old member of the society, and the first person ever to apply for a position as an anthropologist—which he did not get (he was sent as a zoologist). This curious venture was a fusion of Atlantic world slavery, the French Revolution, and Pacific discovery. Baudin had served in the Caribbean and as a slaver in Mozambique, where he learned some of the local language that he was later to try to use in Van Diemen's Land.[116] He was a convinced supporter of the revolution because its abolition of feudal privileges in the armed forces had allowed him to be promoted to the rank of captain. Likewise, the naturalists and artists on the expedition were all children of the revolutionary era, accustomed to acting on its principles. Whereas oversight had been a general surveillance that often ignored details, Baudin's voyage was scrutinized, catalogued, and collected in the pursuit of difference.[117] Over 100,000 animal specimens were collected, including live kangaroos and other species transported back to Europe. All of this was depicted by the artists Charles-Alexandre Lesueur (1778–1846) and Nicolas-Martin Petit

(1777–1805) in minute, almost hallucinatory detail. The expedition sought to create a synthesis of philosophical imagination with practical observation, a philosophical taxonomy characterized by attention to detail.

A key question for the expedition was whether the aboriginals were in the state of nature and hence the predicate of Rousseau's "man is born free," to which the French had become the object of "but is everywhere in chains." While sailing off Maria Island, a small islet close to Van Diemen's Land, Péron saw a fire and landed with a small party. The aboriginals he met were probably Tyreddeme people of the Oyster Bay group.[118] The Tyreddeme invited them to sit down, suggesting that they interpreted the meeting as a friendly one for the exchange of goods, as was a common experience with other locals and also a few European travelers. In what was one of the first pieces of anthropological fieldwork, Péron proceeded according to the plan devised by the Society of the Observers of Man. In nine subheads, the paper, drawn up by the society's secretary, Jauffret, emphasized that "difference" and the "place in the living scale of things" was the key to observation.[119] Péron attempted to communicate in gesture, using signs that had been taught to him at the newly established Institute for the Deaf in Paris, but it was the Tyreddeme's physical inspection of the genitalia of a young sailor, causing him to get erect, that opened a field of exchange. Unsuccessful translations continued, as Péron addressed the aboriginals in pidgin Polynesian and attempted in vain to test their strength on a dynamometer.

Unlike earlier accounts of encounter in the South Pacific, Péron drew no parallels with classical antiquity or European painting. In his notebooks, he adopted the role of philosopher, using the encounter to imagine himself to himself, employing the indigenous people as a medium. Working hard to acquire the "habit of observation," Péron deployed a modern gaze that validated the self through its mediation with what he called "the zero point of civilization," projected onto the Tyreddeme. This observational gaze sought to suppress the self in favor of a picturing from the outside, while being confident of its superior state of culture. This was to become imperial visuality, coeval with the visuality of the hero and that of the right to look. His sense of the encounter was disrupted by the feeling that he was becoming the object of their gaze, restoring his sense of self: "They seek to interpret our looks. They observe us closely. Everything they see us do, they suppose to be something mysterious, and always their suspicions of us are unfavorable." Péron's observation of difference required that

his object not look back, for to do so was a threat of violence. In apparently contradictory fashion, he nonetheless argued that this Natural Man was the "faithful trustee for the fundamental rights of the human species, he preserves them intact in their basic completeness. . . . It is among these people, then, that we are able to discover those precious rights which we have lost following the upheavals among peoples and the progress of civilization."[120] Péron framed rights in a hierarchical, stadial notion of history, in which natural rights were observable but lost. Uncertainty abounded; he wondered whether "this state of nature, so celebrated today, is truly one of innocence, virtue and happiness." Perhaps, then, Tasmania was *terra nullius*, as the British colonizers would later decide, leading to a genocide of the indigenous population.

The picturing of the revolution had failed to hold. I find myself haunted by three images, which I imagine projected simultaneously, like Abel Gance's silent film *Napoléon* (1927), about Carlyle's prototype hero. At the left is Moïse, the African general, being shot by African troops: "He died as he had lived. He stood before the place of execution in the presence of the troops of the garrison, and in a firm voice gave the word to the firing squad: 'Fire, my friends, fire.'"[121] In the center is the almost farcical scene of Péron pointing his musket at an aboriginal man, who wanted to trade for his waistcoat, while shouting "*mata*," the Polynesian word for death. And on the right is Bonaparte as a young artillery officer, mowing down Parisian radicals in the street in 1795, the scene that endeared him to Carlyle. These are scenes of actual and potential violence, none of which could have been imagined in 1789. A Corsican artillery officer was as unlikely as an African general in the hierarchical world of monarchy. While Kant had lectured on anthropology since 1774, he meant by that something called "human nature," rather than Péron's empirical study of human beings. So something had radically changed. But this was not yet the perpetual peace of the land of liberty, with French slavery about to be restored, while British and U.S. slavery had decades ahead of them. The revolutionary use of violence as a social actor, epitomized in the Lantern, had been intended to be a singular or foundational event, like the burning of feudal insignia. But as Allen Feldman has shown, "Violence itself both accelerates and reflects the experience of society as an incomplete project, as something to be made."[122] Here we might understand that "society" as the very possibility of a modern imaginary. The revolutionary era and its defeats had first engendered the possibility for the transformation of the plantation complex into the mod-

ern imaginary. It was to be produced by heroes for the people, who claimed their right to existence and a politics of eating. Not for the first or last time, that moment ended in failure. The way was open both for what Carlyle would name "visuality," a perpetual conflict to prevent perpetual peace, and for the imperial visuality that would claim to end that conflict in the *Pax Britannica*. That modern visualization was and is nonetheless haunted by its unthinkable others. The next three chapters trace the dynamic unfolding of visuality from these beginnings in the Atlantic revolutions. The following chapter shows how Carlyle appropriated the revolutionary strategy of the hero for anti-emancipation goals, leading to an intense contestation over the hero. As chapter 4 describes, this contest came to a head in the entanglement of the abolition of slavery in the United States and the last Atlantic revolution that was the Paris Commune. Chapter 5 then shows how imperial visuality globalized and institutionalized the use of culture as an abstract form of biopower.

The entanglements of the revolutionary challenges to slavery and the plantation complex were visualized in the paintings produced by the remarkable Puerto Rican artist José Campeche (1751–1809), perhaps the first nameable painter to emerge from slavery in the Caribbean. Campeche was the son of an enslaved gilder, decorator, and painter, Tómas de Rivafrecha Campeche, who had purchased his own freedom (*coartación*).[1] As his father was of African descent and his mother was deemed Spanish, Campeche was described as a "mulatto" under the precise racializing tabulations of the day. He gained his training in part, presumably, from his father, in part from books and engravings, in part from African artists among the enslaved, and finally from the fortuituous presence in Puerto Rico of the exiled Spanish painter Luis Paret, in 1775–76.[2] Campeche's earliest surviving works are clearly directly indebted to Paret's rococo style, although Paret also used his time on the island to paint a striking self-portrait in the costume of a *jíbaro*, that is to say, a rural peasant, as well as some depictions of the enslaved. Almost all of Campeche's known work was commissioned by the church and colonial state, and so it had to operate within clearly defined limits. Nonetheless, he was able to visualize both the operations of oversight and the alternatives to it in a series of meticulous works that operated a colonial double vision.

Just after the outbreak of the revolution in Saint-Domingue, Campeche was commissioned to paint the portrait of the new governor of Puerto Rico

(see fig. 26). Campeche's midsize canvas conveyed the full range of oversight available to the new governor in the revolutionary moment. As the deputy of the king in the colonies, the governor carried the powers of sovereignty, marked in the painting by his combination of noble dress, sword, and the cane of office. On his desk are two forms of cartography: a plan of the city of San Juan, showing its recent expansion, and an architectural elevation of an ecclesiastical building, linking church and state as means of visualizing space. On the other side of the governor is a display of books, arranged to be seen rather than read, another instrument of power. Behind and above him, Campeche represented three alternative modes of depicting colonial space. On the right, as we see it, is a bucolic landscape featuring a proposed bridge for San Juan, represented as if spanning a romantic wilderness. Above billow the folds and cords of sovereign drapery, the theatrical and antirealist shaping of space that marks the presence of power. Perhaps the most widely commented on section of the painting is that seen to our left, through what appears to be a window but might also be another painting. Here Campeche has depicted an idealized scene of San Juan as an extensive modern city laid out on a grid, featuring commodious two-storey buildings. On the street, there are a number of activities in progress. Some women street vendors offer their wares from their broad hats. A funeral party proceeds down the street, carrying a coffin. And an overseer directs a work party of enslaved Africans and indentured servants in repairing the road. The overseer carries his cane, just as the governor does, so that the painting visualizes the chain of authority from God to king, king to governor, governor to planter, planter to overseer, and overseer over the enslaved.

Contemporaneous with the portrait of the governor was another of the bishop of Puerto Rico, *Obispo Don Francisco de la Cuerda y Garcia* (Collecion Arzobispado de San Juan de Puerto Rico, 1791–92). Whether by coincidence or design, the portrait is much larger than that of the governor, but it is not executed with the same level of skill, suggesting that much of it was executed by Campeche's studio assistants. The painting is in a sense interesting for what it does not show. Although depicted in the pomp associated with his office, Don Francisco was a Jansenist who preferred to live outside San Juan, in the Cangrejos district of Santurce, a neighborhood of freed former slaves—like Campeche's father.[3] There seems to be a hint here that Campeche was more favorable to the (briefly) antislavery church than to royal authority. Certainly, he was able to convey very different versions of the

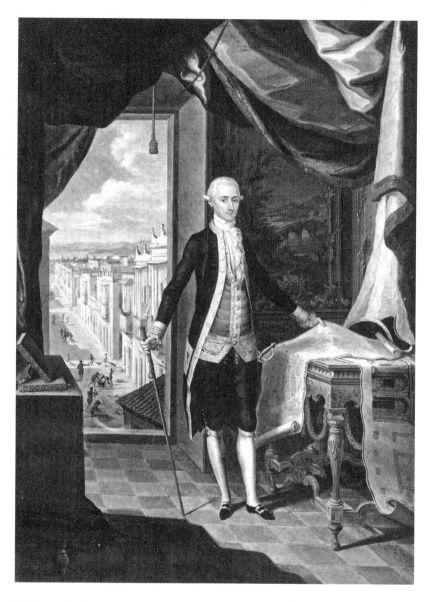

FIGURE 26. JOSÉ CAMPECHE, *DON MIGUEL ANTONIO DE USTÁRIZ*
(CA. 1792), GALLERIA NACIONAL, SAN JUAN, PUERTO RICO.

same event for different audiences. After the Spanish repelled an English attack on the island, in 1797, in which Campeche participated as a member of the militia, he created two different commemorative paintings. One was a commissioned portrait of the then governor *Don Roman de Castro* (Museo de San Juan, ca. 1800), showing him in dress uniform overlooking the defenses of Fort San Cristobal that he had constructed. The portrait is a conventional depiction of the military and colonial officer of the period, so much so that the individual is almost invisible.

The other commemorative image was made on his own initiative for the church as an *Ex-voto of the Siege of San Juan by the English* (Collecion Arzobispado de San Juan de Puerto Rico, ca. 1798), a very different image in style and intent. Painted in a naïve fashion, the *Ex-voto* depicted the city under siege from a high viewpoint, as if from the battlements of the fortress. It shows the course of the military action across several engagements, rather than in a single moment. The text underneath attributes the safety of the town not to the twenty-five-year fortification project, but to the presence of a sixteenth-century Flemish painting of the *Virgin of Bethlehem* in the Dominican convent. Citing "the general opinion, pious and Christian, of the inhabitants of this noble island," Campeche wrote in the text at the bottom of the painting that the retreat of the English was due to the "continual prayers that the faithful offered to the beloved image of the Virgin." In other words, the oversight here was divine, not human, in response to the will of the people, directed by a power-figure. Similar vernacular objects were found throughout Puerto Rico in the form of the *santos*, carved wooden figures of saints. Whereas a depiction of a saint in a church might have offerings or prayers made to it, the santos were kept in the home and were expected to intercede directly for their household. If they failed, they might find themselves turned to the wall as a punishment, out of sight of daily life.[4] These figures were Kongolese in inspiration and often represented the African magus Melchior, one of the Three Wise Men who attended the birth of Christ. In some surviving nineteenth-century versions, such as examples made by Zoilo Cajigas Sotomayor (1875–1962), the three kings represent the Caribbean diversity of "white," "brown," and "black," suggesting that they were seen as symbols of syncretism (Galleria Nacional, San Juan). Certainly Campeche's painting shows a doubled response to oversight, like Makandal's second sight, creating images that depicted the world as subject to the sovereign gaze of the colonizer for their consumption, but also depicting a popular syncretic vision of the made ob-

ject as a powerful agent for the oppressed. This second mode of visualizing is necessarily implied, in the manner of all syncretic doubled imagery in the Americas, rather than literally depicted. For that reason, Spanish imperial policy became increasingly suspicious of the indigenous and non-European worship of images, leading the Spanish Academy of History to denounce even the cult of the Virgin of Guadalupe as "fanaticism," in 1794.[5] In that context, Campeche's exaltation of the *Virgin of Bethlehem* was certainly open to a range of interpretations.

A few years later Campeche further visualized this doubled sense of looking in the Atlantic world in his extraordinary portrait *El niño Juan Pantaleón de Avilés de Luna* (Instituto de Cultura Puertorriquena, 1808) (see plate 4). Campeche's portrait showed a twenty-one-month-old child who had been born without arms and with diminutive legs. He did so giving the child a remarkable dignity, modeled on depictions of the Infant Jesus. In the painted text, Campeche named the child and his parents, Luis de Avilés and Martina de Luna Alvarado, making Juan Avilés one of the few among the subaltern masses of the plantation system for whom we have both an identifiable image and a genealogy. That right, denied to the enslaved, was visualized through the disabled body of a child, literally labeled as being from the working classes in Campeche's text.[6] Most accounts suggest that the painting was made out of scientific curiosity, with hints of a possible Puerto Rican nationalism.[7] Yet its very status as a necessarily colored painting, rather than a line drawing, as well as its substantial size, suggests that other forces were at work here. By its very presence as a named portrait of colonial subaltern disabled child, *Juan Avilés* is a powerful syncretic image. The picture was a power-figure, a local hero in an era of revolution but not in a revolutionary situation. I want to draw out one possible interpretation that would have been available to some viewers in the period. Although Puerto Rico had not been a significant sugar colony prior to 1760, its plantations were given a dramatic boost by the decline in Saint-Domingue's sugar industry, especially after 1800. By 1815, shortly after Campeche painted this piece, there were some 18,000 enslaved Africans in Puerto Rico, most of whom had come from Dahomey and Kongo.[8] Juan Avilés was painted preternaturally "white" for a working-class child in a slave colony, which in itself indicates that the painting was not intended to be mimetic. In Vodou, any disabled child is part of the Vodou spirit group known as *tohosu*, whose powers were described by the anthropologist Melville Herskovits: "The *to-husu* are held able to speak at birth, and to turn at will into men of any age,

in order to pit their strength against giants, sorcerers and kings."[9] This way of seeing leaves its questions open. What is Juan Avilés looking at, away to his right? What did he want? An end to slavery, an end to monarchy—or just the right to be, to look, and to be seen?

Soon after Campeche made this painting, Cuban authorities were appalled to discover a volume of some sixty pictures depicting religious, historical, and political subjects in the possession of a free *moreno* (African) named José Antonio Aponte. Further, his pictures had been viewed by a number of others arrested—all enslaved, would-be rebels.[10] According to his sentence of execution, in 1812, Aponte's book was part of "an attempt to overturn the old and well-established submission of the serfs."[11] There were images in the book that were held to be depictions of the revolution in Saint-Domingue, as well as representations of Africa and an image of a broken crown that Aponte said he had acquired at the time of the French Revolution. Although he admitted having made portraits of Toussaint, Dessalines, and Jean-François, Aponte claimed to have copied them from widely circulating images available in Havana's harbor, together with one of Christophe as emperor. Witnesses at his trial described the popularity of these images with the rebels, both free and enslaved. As the insurrection plans unfolded, word spread throughout the African population that "black generals" were coming from Haiti to set them free. As Sybille Fischer puts it in her discussion of Aponte's trial and his book, "The question of verisimilitude becomes a question of life and death."[12] If we connect the visual production of Saint-Domingue to Campeche's art and the circulation of these popular images, it becomes clear that there was an extensive revolutionary realism in the Caribbean. We can go further. In response to the hallucinatory hierarchies of slave-owning sovereignty, realism was revolutionary.

Visuality

Authority and War

The organizing conceit of slave-owning sovereignty, surrogated to the overseer, was its unopposed visualized dominion, represented as light itself. This principle was appropriated by counterrevolutionary visuality for its version of the hero, with the radical distinction that it was now aware of being permanently opposed. This visuality visualized authority to cohere the chaos of the modern. Visuality was permanent war against an enemy that had threatened the "reality" prized by authority in the attempts to make revolution legitimate and to abolish slavery. The terrain of this war that visuality visualizes is what we call history. Visuality extended its claims from actual battlefields to assert that it was representation in and of itself, or "ordering." This principle was embodied in, and manifested as, the Hero celebrated by Thomas Carlyle, the theorist of visuality. The Hero embodied the idea of the nation, overcoming the centrifugal forces of labor by means of Tradition. To use Carlyle's capitalizations, the Hero was Tradition, could visualize visuality, and lead with Authority. The mystical and unclassifiable hero was nonetheless separated from all others by his ability to visualize history as it happened, thereby gaining an authority that was aesthetic. By this set of maneuvers, the plantation complex was to be sustained, even though its literally and metaphorically enslaved subalterns were assumed to be in permanent revolt. In the face of this reaction, a new countervisuality

claimed representation in all senses to be the work of the people, the really heroic forces within the nation, its tradition, and of course its labor power. This countervisuality deployed its own forms of anarchic authority, such as the Jubilee and the National Holiday (early forms of what would become known as the general strike). At the same time, unwilling to abandon a successful strategy, radicals and abolitionists continued to present heroes and heroism as a means of achieving change. Given this swirling kaleidoscope of revolution, counterrevolution, abolition, restoration, innovation, and tradition, it is perhaps not hard to understand that people felt modernity was hard to see, let alone visualize.

WAR

The sense of visuality as war was concrete, not abstract. It referred both to the necessity for modern generals to visualize a battlefield that could not be seen from a single viewpoint, as theorized by the theorist of modern war Karl von Clausewitz (1780–1831), and to the revival of military painting that constructed battle scenes from the perspective of the general. In both cases, the motivating "hero" was Napoleon, Carlyle's "bronze artillery officer," whose tactics and means of representing them transformed modern warfare.[1] In Clausewitz's theory, battle was a complex event that did not resolve itself in a single moment. War now required the ability to grasp topography as "an act of imagination . . . imprinted like a picture, like a map, upon the brain."[2] The commander-in-chief had to keep a "vivid picture" of an entire province or country in mind, unlike the subordinate dealing with a far smaller area. Each of these areas was a "theater" for the performance of war that was invisible to its actors, discernible only to the leader. Clausewitz emphasized the necessity of what he called "the genius for war," like that of a painter or poet but understood as the capacity to take decisions by deploying "a power of judgment raised to a marvelous pitch of vision, which easily grasps and dismisses a thousand remote possibilities which an ordinary mind would labor to identify and wear itself out in so doing."[3] Modern war was fought between armies so closely matched in weapons and training that, other than sheer force of numbers, leadership was the primary cause of victory, or, by its absence, defeat. Clausewitz called this capacity "the sovereign eye of genius," bringing together the ability to imagine with the absolute authority of monarchy.[4] Further, this ability to decide was the distinguishing mark of the leader: "Boldness, governed by a superior intel-

lect is the mark of a hero."[5] Clausewitz's exemplar of the heroic leader was the Prussian monarch Frederick the Great, subject of a vast biography by Carlyle.

Carlyle would simply generalize (as it were) the principle by extending the battle to all aspects of modern life, a battle that could only be won by the Hero. In 1840, eight years after the posthumous publication of Clausewitz's work, Carlyle coined the terms *visualize* and *visuality* to describe this dominant view of the Hero over History.[6] Whereas Clausewitz had defined a military strategy of rendering the battlefield as a mental picture, Carlyle generalized the visualizing of History itself as being the means to order and control it. In so doing, he epitomized Michel Foucault's reversal of Clausewitz's well-known aphorism that "war is merely the continuation of politics by other means" to read, "Politics is the continuation of war by other means."[7] If the exceptional capacity for vision and imagination was first formulated as a tactic for war, it was then reverse-engineered by Carlyle as a mode of governance. In Carlyle's view, the agent of the war that is visuality was the Hero. He took this tactic from the revolutionaries of France and Haiti, his epitome of all that was wrong with modernity, and repurposed it to serve the counterrevolution. Its terrain was authority, a subject on which Carlyle had little of originality to say. He was merely one of many Enlightenment and post-Enlightenment thinkers to grapple with the dilemma of authority's continuance in a period in which even monarchs could no longer claim absolute authority. In his little essay "What Is Enlightenment?" Kant had gone to considerable lengths to emphasize that the emancipation of knowledge could not be offered to the "thoughtless multitude." Therefore he enjoined those who practiced public reason to limit it to the "private," meaning to the offices and business of the state. Here, obedience to obligation, such as paying taxes, is required to stave off the multitude, leading to Kant's maxim: "*Reason as much as you please, and on what you please, but obey!*"[8] By the same token, Alexis de Tocqueville worried, in 1835, that the principle of popular sovereignty in America was so extended that "there are no authorities except within itself," whereas in France "the people despise authority but fear it."[9] The result was a "strange confusion," as the old order seemed to be moving inexorably toward equality and democracy. Even extreme proponents of the restoration of monarchy in France accepted the transition to popular sovereignty.[10] Determined to prevent such a revolution of sovereignty in England, Carlyle turned its techniques against itself as heroic visuality.

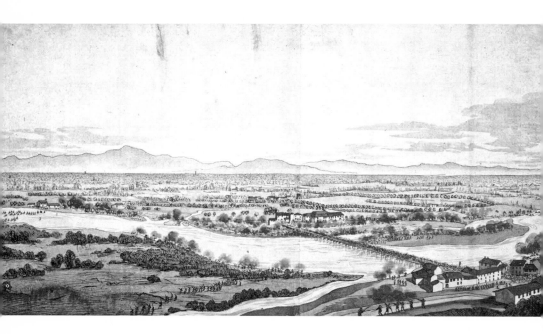

FIGURE 27. GIUSEPPE BAGETTI, *BATAILLE AU PONT DE LODI* (1796).

Napoleon would come to be the defining example of such heroic visu-
ality, a direct result not only of his well-known propaganda but also of
his bureaucratization of visuality as a tool of imperial government. The
revolution dismantled the state apparatus of mapmaking that had evolved
as a colonial resource under the ancien régime. One of Napoleon's deci-
sive changes as first consul was to reintroduce and strengthen the *ingenieurs
géographes*, geographer engineers, and to introduce a new category, the *in-
genieurs artistes*, artist engineers. These technicians were charged with cre-
ating images of battles as seen from the point of view of the commanding
general as a military resource.[11] Bonaparte had seen both the military and
political value of such images during his Italian campaign. The Italian artist
Giuseppe Bagetti (1764–1831) produced large-scale (50 x 80 cm) watercolors
of various engagements, accompanied by an outline to guide the spectator
around the ideas represented (see fig. 27).[12] This outline allowed the viewer
to experience the visuality that the general demonstrated in the field. The
Dépôt de la Guerre issued the artists with precise descriptions of the *point
de vue* (point of view) to be used, so that Bagetti's view of the famous en-
counter at Arcola was defined as being situated on the riverbank 140 meters
away. These battle views were to be painted as far as possible, in the words of

the official instructions, "to represent the terrain as the general command-
ing the troops saw it at the moment of combat; therefore it should not be
too much in isometric perspective."[13] If this form of perspective was used,
the optical angle should be marked on the canvas. Figures should be at least
four centimeters high if in the main action, or two centimeters otherwise.[14]
There is what would in the period have been understood as an "ideologi-
cal" force of belief in realism behind these instructions. Later these scenes
were combined into a *General Map of Bonaparte's Campaign in Italy*, which was
sold for the substantial price of 140 francs. These successful strategies were
institutionalized as Bonaparte rose to power. After the Battle of Marengo
(1800), Bonaparte maintained his own topographic office, and by the end
of the consulate, he had the largest map collection in the world, estimated
at some 70,000 individual sheets.[15] Perhaps the most monumental project
undertaken in this imperial cartography was the mapping of Egypt, both
ancient and modern, in the wake of Napoleon's ultimately unsuccessful
campaign, a project that was not completed until long after Waterloo. The
revival of military mapping had its corollary in the arts, where the salon ex-
hibition of 1801 saw a return to large-scale military painting, as Susan Locke
Seigfried has shown.[16] These paintings, such as the work of the baron Gros,
were interpretative versions of the mass-produced battle views generated
during the Napoleonic wars.

THE CONDITION OF ENGLAND QUESTION

Visuality marked a crossroads in the plantation complex. Throughout the
Atlantic world, the crossroads is a dangerous place. In many African reli-
gions, tricksters like the Yoruba divinity Eshu await the unwary at the
crossroads. In England, gibbets were placed there, like the infamous Tyburn
Tree, and the bodies of the condemned were buried on the spot to prevent
them from returning to seek vengeance. The spirit of this crossroads of
visuality is William Blake, a trickster if ever there was one. Blake created
a world that would have been very recognizable from Saint-Domingue,
one of complex vision that was not restricted to the sense of sight and
one of powerful spirit forces in contestation. Blake's Four Zoas were the
British *lwa*, divinities or spirits that contested the dogmatic machine-reason
of commodity capitalism (see fig. 28). He mapped space and time in the
form of a dialectic that centered on London, the capital, as the battlefield
for and against Empire.[17] In 1805, one year after the new nation of Haiti had

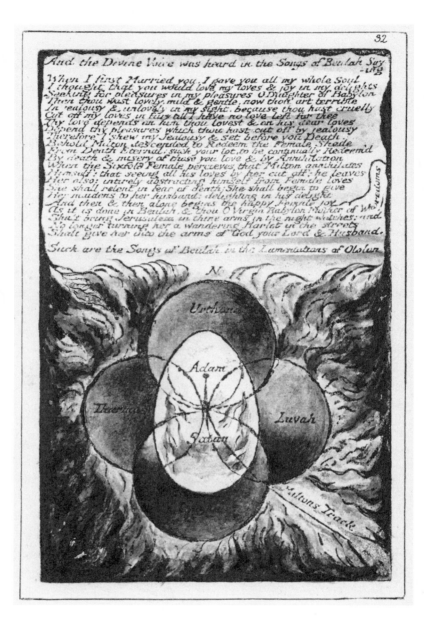

FIGURE 28. WILLIAM BLAKE, "FOUR ZOAS," FROM *MILTON*.

declared its independence, the year that Napoleon crowned himself emperor, Blake created a series of biblical illustrations for the Scottish official Thomas Butts. Blake knew what had come before, had a good sense of what could have happened next, and what, unfortunately, probably would come to pass. He took the imagery of the Rights of Man and reconfigured it for the emergent era of visuality in a drawing called *God Writing on the Tablets of the Covenant* (National Gallery of Scotland, 1805) (see plate 5). In the drawing, God stands before the tablets and begins to write the Law, whose first Hebrew character has just been inscribed by His finger, the ur-digital culture. As the Second Commandment has not yet been written, Blake can depict the form of God without being in breach of the Law. The space is a flowing series of curving flames, which both contain and are the angels and seraphim, trumpeting the definition of the Law. God here is light, devoid of color and shadow because He is illumination. For all the purple-darks of the picture, there are no shadows, as there is nothing material to cast a shadow. At last one notices the huddled figure of Moses, literally under God's feet on the top of Mount Sinai. Utterly unable to look, Moses shows that under the regime of the Law, there is and can be no right to look.

In Blake's prophecies, the figure of the Law is Urizen, described by W. J. T. Mitchell as consumed by a "rage for order, system, control and law."[18] Note that "rage," order, and Law are the very opposite of peace. That rage would consume Carlyle and his ilk. It was the self-proclaimed "Party of Order" that would initiate the massacre of the Paris Commune, in 1871, for instance, at a cost of some 25,000 lives. Blake described how Urizen writes in the "Book / Of Eternal brass / One curse, one weight, one measure / One King, one God, one Law." Blake knew that Law was as much visible in the weight of sugar produced by the plantation as in the whip, and that its insistent claim to singularity and noncontradiction marked out its dominance. For the historian E. P. Thompson, this passage suggested both the drawing from the Butts Bible and the questionings of sovereignty made by the seventeenth-century English radicals, the Diggers and the Ranters.[19] Gerrard Winstanley, the Digger leader, asked General Fairfax, the army commander, after the execution of Charles I in 1649, "whether all Lawes that are not grounded upon equity and reason, not giving a universal freedom to all, but respecting persons, ought not to be cut off with the King's head? We affirm they ought."[20] This radicality was typical of Winstanley, who insisted on following through first principles, all of which can be derived from the first sentence of his first pamphlet, written as his small group

were beginning to reclaim the common and waste land on St George's Hill, Surrey: "In the beginning of time, the great creator Reason made the earth to be a common treasury."[21] Divinity was expressed as rationality, present in each individual, who had to reconcile that potential with the corrupting effects of "covetousness," whose agency was the bodily senses. Against these forces were arrayed "vision, voice and revelation," a trinity of rationalized and internalized understanding that motivated the direct action of cultivating the land.[22] The result was that the long slavery dating from the Fall of Man was now to be overturned by a new age of righteousness.[23] Winstanley's goal of restoring the righteousness that pertained before the Fall entailed abolishing the Law that was not written until the time of Moses. Blake's image is one of the beginning of the end of that possibility, as History begins with the first character of the Law having been written. Fallen, the people are now subjected to the Law. From Paradise, the wind begins to blow. It catches the wings of the Angel of History and propels him toward the future, and unable to free his wings, he sees the first catastrophe, the writing of the Law.

Blake's dark twin in what Saree Makdisi has called "romantic imperialism"—his Spectre, to use his own term—was the mystical, dogmatic chronicler of History, Thomas Carlyle (see fig. 29). A sufficiently contradictory figure that his *Past and Present* could be used as the name of a journal founded by members of the British Communist Party History Group, in 1952, while also being Hitler's favorite author in the Berlin bunker. In Carlyle's view, the upheavals of Chartism, Luddism, and Captain Swing that shook Britain from the 1820s onward were all of a piece: a British equivalent to the French Revolution in which the working classes were expressing their discontent. Unlike Edmund Burke, Carlyle accepted that the French Revolution did have the merit of sweeping aside corruption and opening the way for the best to prevail. That in no way implied a form of democracy, for "of all the 'rights of man,' this right of the ignorant man to be guided by the wiser, to be, gently or forcibly, held in the true course by him, is the indisputablest."[24] Carlyle felt the question of England's future was one of heroic leadership, requiring a "perfect clearness" of the elites to dispel the popular adherence to what he called "an obscure image diffracted, exaggerated in the wonderfullest way."[25] The Hero, or Great Man, was able to withstand the feminized hordes of the deluded masses and was distinguished from such popular heroes as the "Dogleech" Marat. For the ordinary person, history is invisible. At the beginning of his history of the

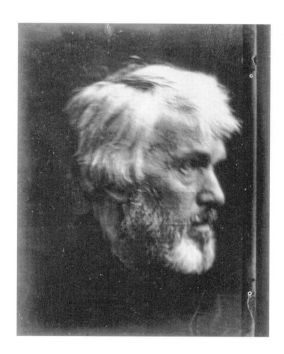

FIGURE 29. JULIA MARGARET CAMERON,
THOMAS CARLYLE (1867).

French Revolution, Carlyle provided a panorama of France at the death
of Louis XV, in 1774: "Such things can the eye of History see in this sick-
room of King Louis, which were invisible to the courtiers there."[26] The
narrator, and by extension the reader, are allowed to know better. Visuality
went one stage further, able to read "Futurity" into the present moment.
No sooner had the Bastille fallen, in Carlyle's account of the French Revo-
lution, than the popular forces were described as "Sansculottism," a name
that did not circulate in the revolutionary period for four more years, in a
very different moment. To the Eye of History, that futurity was present as
soon as the Revolution began: "the open violent Rebellion, and Victory, of
disimprisoned Anarchy against corrupt worn-out Authority."[27] The goal of
heroic visuality was to contain anarchy and restore Authority to the "sov-
ereign eye of genius." Great men are great by virtue of their ability to visu-
alize History while being in the midst of it, making them into Heroes. It
is given that they are men, or masculine, gendering all countervisuality as
feminine. In the 1840s, all political tendencies in Britain from Chartism to
patrician aristocracy negotiated their strategies in relationship to the dis-

course of Carlyle's visualized Heroism.[28] The key questions about Heroic leadership and the visuality it deployed were: how was the authority to lead conveyed? Was the nation itself Heroic? or its people? a specific set of individual leaders? or the individual Hero? In other words, the emergence of visuality was not a discourse about sight at all, but about power and its representation, now conceived in visualized terms as part of a new division of the senses.

Carlyle's arguments in *Chartism* and *On Heroes* were a counterpoint to the charter's democratic principles in general and the radical William Benbow's theory of the National Holiday in particular. The charter called for universal manhood suffrage; a secret ballot; equal electoral districts; abolition of the property qualification for members of parliament (MPs); salaries for MPs; and, latterly, for annual parliaments. Several of these claims, like the last, were directly descended from the seventeenth-century radicals. Like Thomas Hardy, the chair of the radical London Corresponding Society, Benbow was a shoemaker by trade, precisely the worker whom Socrates had declared in *The Republic* should "make shoes and occupy himself with nothing else." Commenting on this seemingly specific insistence, Jacques Rancière clarifies that "shoemaker is the generic name for the man who is not where he ought to be if the order of estates is to get on with the order of discourse."[29] This insistence on staying in place, obeying the leaders and doing what one should and nothing else was very much Carlyle's response to the radicalism of the shoemakers of his day. In his pamphlet *Grand National Holiday and Congress of the Productive Classes* (1832), the nonconformist Benbow overturned any respect for traditional hierarchies, denouncing the "preposterous right to exercise a monstrous power over almost every man," claimed by those who thought of themselves as "the *people of substance*" but were in fact no more than "the *pick-pockets*, the *plunderers*, the pitiless *Burkers*," referring in the last example to Edmund Burke's hostility to the French Revolution and the culture of rights.[30] Benbow challenged authority at the center of modern everyday life by calling into question the absolute compulsion to work for a wage. He called for the working classes to take a month away from work in pursuit of "ease, gaiety, pleasure [and] happiness," expanding Jefferson's inclusion of "happiness" as a right in the Declaration of Independence into a platform of rights to enjoyment. As this phrase suggests, Benbow's strategy was a simple and potentially effective withdrawal from the market economy of wage-labor and consumption. This refusal was intended to cause the collapse of the commercial

economy, establishing fair prices and fair labor practices as one part of an egalitarian life composed of "equal rights, equal liberties, equal enjoyments, equal toil, equal respect, equal share of production."[31] Benbow's vision of a fair economy, taking some substance from the sans-culotte strategy of price "maximums," was a politics for a commodity-dominated society, an attempt to level not land ownership but the emergent capitalist political economy.

The National Holiday was, like Blake's image, the product of a long history of Atlantic world resistance to slave-owning authority. During the English Revolution, Winstanley called on "all labourers, or such as are called poor people" to cease working for landlords and large farmers as "hirelings." He did not argue for dispossession of the rich, but instead encouraged laborers to refuse to work for them, which would lead to the inevitable collapse of large farms and estates. The historian Christopher Hill noted the repeated "call to refuse to work for landlords for wages: he advocated, that is to say, something like a general strike."[32] Like the subsequent general strike, the Digger action was opposed to the very form of wage-labor and was intended to spark a widespread movement first in England, then globally. Accordingly, a former ironmonger named John Sanders was reduced to the lower status of nailer by 1655, when he appeared on the streets of Birmingham, dressed in rags, and calling on the nailers to "hold together, by assisting and maintaining one another one fortnight or a month, and forbear working."[33] These ideas so exactly foreshadow Benbow's National Holiday that it is difficult not to suspect an oral tradition had kept it in circulation in the intervening century and a half. If so, it was literally a vernacular strategy. Benbow directly acknowledged inspiration from the Jewish tradition of the seven-year Sabbatical, or release, and the fifty-year Jubilee, at which all servants and slaves were freed and all debt rescinded. Jubilee had spread around the Atlantic world as a radical image for the abolition of slavery and was now becoming a figure for the refusal of the political economy of wage-labor that was replacing chattel labor.[34] The idea of the Jubilee gathered force in England during the early years of the nineteenth century, promoted by the Newcastle radical Thomas Spence as a combination of Jacobinism and millenarianism.[35]

The abolitionist Robert Wedderburn, son of the Jamaican plantation owner James Wedderburn and an enslaved woman in his ownership, Rosanna, saw the possibilities of applying the Jubilee to the British Caribbean colonies.[36] Wedderburn was first a sailor, then a member of the radical London Corresponding Society in the 1790s, leading to his becoming

a Wesleyan preacher, fulminating against slavery and oppression. In 1817 he began publishing a radical newssheet entitled *The Axe Laid to the Root*, which supplied details of how to enact the Jubilee in slave-owning islands: "My advice to you is, to appoint a day wherein you will all pretend to sleep one hour beyond the appointed time of your rising to labour; let the appointed day be twelve months before it takes place; let it be talked of in your marketplace, and on the roads. The universality of your sleeping and non-resistance, will strike terror to your oppressors. Go to your labour peaceably after the hour is expired; and repeat it once a year, till you obtain your liberty."[37] This tactic of nonresisting resistance was the hallmark of the general strike to come, but also of the past refusal in Saint-Domingue to accept new labor conditions on the plantations, as Wedderburn made clear: "Prepare for flight, ye planters, for the fate of St. Domingo awaits you."[38] The threat of the appropriation of property was close behind the Jubilee in these sentiments that Wedderburn claimed to be disseminating in Jamaica via his sister Frances Campbell, a Maroon. A letter attributed to her was published in *The Axe Laid to the Root*, in which she described her conversion to the Jubilee and her attempt to liberate her own enslaved workers.[39] Whether the letter was really from Jamaica or not, Wedderburn himself stands as testimony to the transnational discourse of the Jubilee that fed into the Grand National Holiday. The holiday brought together different strands of radical discourse from the Old Testament calls for emancipation to antislavery activism, revolutionary practice in England, France, and Saint-Domingue as collective action against a wage-labor economy visualized as both an extension of the plantation complex and as interactive with it.

Although Benbow had only a rudimentary plan for the implementation of the holiday, the Chartists called for one to begin on 12 August 1839, only to cancel it at the last moment.[40] The moment nonetheless arrived, in July and August 1842, when half a million workers were on strike, from Dundee to Cornwall, in a series of actions that lasted longer than the better-known general strike of 1926.[41] The principle at stake was what one Glasgow-based group had described as the workers' goal to "desist from their labour and attend wholly to their Rights, and to consider it the duty of everyone not to recommence until he is in possession of those Rights which distinguish the Freeman from the Slave, viz. that of giving consent to the laws by which he is governed."[42] Here rights, labor, freedom, and slavery were linked by means of the idea of a general cessation of work into an idea of representa-

tion. In similar fashion, Thomas Attwood declared, on presenting the first Chartist petition, in July 1839: "They would prove that the men of Birmingham *were* England."[43] That is to say, the Chartists and other radicals claimed that their political demonstrations represented a clear statement of their desires and goals, to which the body-politic must respond, because the Chartists were the nation. A political aesthetics was at work here, in which representation corresponded exactly to that which it was supposed to depict, just as the new technology of the photograph was supposed to do. In short, realism. In 1845, Friedrich Engels argued that the strikes and other strategies of the Chartists would overthrow the "sham existence" of parliament. The assertion of "real public opinion in its totality" would soon lead to the "whole nation" being represented in parliament. Once this old goal of British radicalism, dating back to the seventeenth-century Levellers, had been accomplished, Engels believed that the "last halo must fall from the head of the monarch and the aristocracy," ushering in a new Jerusalem.[44] Engels deployed an anti-illusionist theory of representation, in which the body politic would come to be composed by the body of people, rather than by the head of the hereditary rulers. In a striking moment of optimism, Engels claims that Carlyle "has sounded the social disorder more deeply than any other English bourgeois, and demands the organization of labour. I hope that Carlyle, who has found the right path, will be capable of following it."[45] For Engels, writing like a latter-day Blake, "prophecy is nowhere so easy as in England. . . . [T]he revolution must come."[46]

That it did not was due in some part to Carlyle, whose anticapitalism was no radicalism. Carlyle understood that what he called the "cash nexus" of Victorian capitalism created condensations of the social that enabled revolutionary change, as it had done in France. Produced in the same year that Benbow's holiday had been called and cancelled, his rapidly written book *Chartism* denounced all these changes. Carlyle sought a restoration of Heroic "kingship," not revolution. He claimed that "the deep dumb inarticulate" crowds of Chartist demonstrations were manifesting a desire that they could not name, symptoms of a "disease" within what he famously called "the condition of England."[47] This condition was mental, rather than physical, an examination of what he would come to call "the deranged condition of our affairs."[48] The people and the modern were, then, literally insane, just as Pinel had seen the French Revolution as accelerating madness. In this regard, Carlyle was a modern, insofar as he recognized the existence of unconscious motivations and desires. Nonetheless, he insisted that the

workers could not represent themselves because their condition had to be diagnosed by another. In the Platonic tradition, any representation was inadequate to the Ideal. As if in ironic refutation of the concept of Chartism as the "mobility," Carlyle's political solution to the problem of representation was that the working-classes should emigrate to the colonies, making empire the cure to the disease of England.[49] He recognized that the problem was caused by a laissez-faire approach in economy and government, but "the Working Classes cannot any longer go on without government; without being *actually* guided and governed."[50] The solution he arrived at was a return to a "*real* Aristocracy" formed of "the Best and the Bravest," rather than to the hereditary aristocracy that dominated British society.[51] As befitted an admirer of Frederick the Great, Carlyle envisaged an enlightened despotism, not a democracy. For having conquered the world, the second task of the "English People in World-History," as Carlyle put it, was how to share the "fruit of said conquest."

The way not to accomplish it was such "Benthamee" (that is to say, Benthamite) ideas as "elective franchise, ballot-box, representative assembly."[52] Following the publication of Foucault's *Discipline and Punish*, Jeremy Bentham's reforming Panopticon has become understood as the epitome of disciplinary surveillance in the period. However, panopticism was contested not just from the Left, but also from the imperial Right. It might be thought that the observation of work was simply a transposition of the overseer's work on the plantation to the industrial factory. The difference was not in the practice of surveillance, but in the ethics of reform espoused by Bentham. In keeping with the transition from owning labor power to regulating it in order to maximize production, panopticism sought a transformation of the subject to what Foucault called the "docile body," a person that accepted the goals of the institution and embodied them. This form of production might be considered a form of compromise between workers and employers—in exchange for suitably concentrated work, a diminished violence of the conditions of work. In the period 1801–71, such contracts, whether actual or virtual, were far from universal, even in the factories or military barracks that were supposed to be paradigms of panopticism, let alone in the colonies. Carlyle opposed any contractual arrangement between the Hero and the mass in favor of the duty of obedience, and he saw all such reform efforts as doomed to failure. Carlyle held that criminals, "the Devil's regiments of the line," were not to be dealt with domestically. A proper prison governor "will sweep them pretty rapidly into some Nor-

folk Island, into some special Convict Colony or remote domestic Moor-land, into some stone-walled Silent System."[53] Norfolk Island was a penal colony within the penal colony, an island off the coast of New South Wales, where truly draconian measures were applied to discipline recalcitrant con-victs from 1825 onward. Far from being the origin of human rights, as Péron had hoped, the islands of Australia were now the site of penal punishment. The "silent system" was the regime of compulsory silence in prison intro-duced in the nineteenth century over Bentham's vigorous objections: "This species of punishment . . . may overthrow the powers of the mind, and produce incurable melancholy."[54] What Bentham saw as an occasional pun-ishment came to be adopted as a system, endorsed by Carlyle and other conservatives. Carlyle's visuality was, then, opposed to panopticism both as a mode of visual order and as a specific system of controlling punish-ment. Hostile to Chartism, and laissez-faire economics, to social reform and emancipation, it offered a modern mode of picturing history, which con-tested panopticism and liberalism throughout the nineteenth century with both theoretical and practical consequences.

THE TRIUMPH OF THE HERO

History, understood as a form of thought, took on a new centrality in the nineteenth century, when, as Foucault has shown, "philosophy was to re-side in the gap between history and History, between events and Origin, between evolution and the first rending open of the source, between obliv-ion and the Return."[55] Where history had been the chronicle of events, His-tory was to speak of Origins, causes and impersonal forces. The nature of this terminology also indicates the distance between this form of History and the work done by present-day historians. For many reformers and con-stitutionalists after the French Revolution, representation no longer repre-sented other representations, as it had done in the past, but had to be located in History, whose characteristics were the subject of immense new efforts. Writing in 1827, the same year that Nicéphore Nièpce first succeeded in fix-ing a plate with a light-sensitive image, Augustin Thierry described his am-bition to write "a history of France that reproduces with fidelity the ideas, the sentiments and the customs of the men who have transmitted to us the name that we carry, and whose destiny has prepared our own."[56] This his-tory required the "real" production of a feeling of the national out of the divergent materials to hand, rendering History into the very science of the

Real. If oversight had marshaled the material domains of the plantation complex, visuality orchestrated its place in time.

Thierry had argued, in 1820, that all French history had been that of a divide between Gallo-Romans and Germans: "We believe ourselves to be a nation, but we are two nations within one land, two nations which are enemies because of what they remember and because their projects are irreconcilable: one once conquered the other."[57] The nobility were the descendants of the conquering Germans, whereas the majority of the Third Estate was descended from the serfs of the medieval communes. Where Carlyle was to depict the French Revolution as a generalized war of all against all, Thierry saw it as a reconciliation between these two warring "races" in which all inequalities such as that between "master and slave" were eradicated—ignoring plantation slavery as usual. Indeed, he perceived the subsequent revolutions of 1848 (which did abolish slavery) as a "catastrophe," causing him to abandon his research for years.[58] Looking back in 1866, Thierry claimed that he had begun his work in 1817 to promote his constitutional politics, without regard for his materials. But his manuscript and archival research generated a desire to understand the past for its own sake, which, when he realized it "in a piece of life or local color, I felt an involuntary emotion."[59] His history was intended to reproduce this physically felt love of country, which was indispensable to the work of producing a single "nation." Thierry warned his readers, in 1827, "It will not be enough in any sense to be capable of this mutual admiration for that which is called the Hero; one must have a larger manner of feeling and judging," which entailed a sympathy for the "mass of men."[60] If his warning was against the emergence of revolutionary Heroes, rather than the aristocratic Heroes envisioned by Carlyle, the issue remained pertinent. For Thierry, the "imagined community" of the modern nation required universal participation, making slavery impossible, even as subjection to the Hero. For Carlyle, only such subjection could ensure the avoidance of chaos.

Carlyle's work was part of a dramatic reconfiguration of historical events into the metaphysical narratives of History that involved both new technical procedures and new literary styles, derived from German Romanticism.[61] Carlyle did not follow those of his contemporaries, like Leopold von Ranke, who famously claimed to write history "to show what actually happened," albeit with a clear bias to what he called the "German race."[62] Indeed, Carlyle's dramatic sleight-of-hand in *Chartism* was to rewrite the Norman Conquest so that, rather than being a domination of French over

Saxon, the arrival of the Normans was a supplement of a French-speaking variety of Teutons to the already resident Teutonic Saxons. The difference was only that the Normans were in a "condition to govern," while the Saxons were not.[63] At once, Carlyle had refuted Thierry's theory of History and countered one of the most enabling of radical narratives, the Norman Yoke, meaning the suppression of Saxon freedom by Norman oppression. Whatever the difference between Saxons and Normans, the change must have been, as Carlyle put it, "rather tolerable" or it would not have endured. As such rhetorical maneuvers suggest, Carlyle also refused the new technical apparatus of historical research promoted by Ranke, such as the use of documentary archives, or even libraries, seeing them as the product of "Mr Dryasdust."[64]

For Carlyle, History was far more than the accumulation of facts, and historians themselves were often questionable because they presented events as "*successive*, while the things done were often *simultaneous*."[65] To capture this simultaneous quality, Carlyle wanted to convey an "Idea of the whole," which he rendered by means of what he called "a succession of vivid pictures."[66] Unlike Chartist representation, Carlyle's visuality was a counter-phantasmagoria that imagined modernity as a Platonic cinema of Ideas, cutting backward and forward across the flow of time.[67] By contrast, Ranke aspired to a "colorless" history that refused to create a false sense of unity, even if that meant becoming what he called "disconnected." His contemporaries recognized the unusual nature of Carlyle's writing. In a letter to Carlyle, written in 1837, his friend Ralph Waldo Emerson praised his new style, asserting, "I think you see in pictures."[68] Emerson's remark implied that it was possible to see otherwise than in pictures, meaning as a series of unconnected images or impressions, such as those Paine had hoped would render rights irreversible. This pictorial vision was in a sense literally History painting, that is to say, the leading genre of painting that was celebrated for its ability to sustain a narrative within a single frame and reached its highpoint as official art in the nineteenth century. In similar fashion, visuality ordered and narrated the chaotic events of modern life in intelligible, visualized form into moving pictures. At the very moment in which natural history with its reliance on visibility was becoming biology, based on what Foucault calls the "internal principle . . . of organic structure," History took what we might now call a visual turn.[69] Consequently, Carlyle was explicitly opposed to the new physiology of vision in which seeing and understanding was the same process.[70] For example, the British scien-

tist David Brewster explained, in 1832, that "the 'mind's eye' is actually the body's eye and that the retina is the common tablet on which both classes of impressions are painted, and by means of which they receive their visual existence according to the same optical laws."[71] The Hero, by contrast, was not to be limited to such external impressions, "as if no Reality any longer existed but only Phantasms of realities."[72] The Hero was marked by his effortless ability to combine sensory data and other information and intuition into a picture visible to the inner or spiritual eye, which, once opened, rendered the observer into a "Seer."[73] The homonym between see-er and Seer was part of Carlyle's intent to stress a spiritually motivated vision of History, distinct from the conflation of vision with Reason that had dominated Enlightenment discourse. The overseer was now simply the Seer: a prophet, a Hero, and a King.

This visualized history was contrasted to the "Phantasmagories, and loud-gibbering Spectral Realities" that dominated popular understanding of history as it happened, locked into an unseeing present.[74] First incarnated as an entertainment projecting ghosts and other specters by Philidor, the phantasmagoria became famous when Etienne Gaspard Robertson's version appeared in Paris, in 1797. Robertson created high camp Gothic performances in which various "shades" would be resuscitated for the audience's delight, ranging from the revolutionary Marat to Virgil and famous lost lovers, using effects ranging from magic lantern slides, to sound, and magnification. The phantasmagoria quickly turned into a metaphor for the haunted qualities of modern life. Blake had peopled his London with the Spectre, Marx saw commodity fetishism as a phantasmagoria, while Benjamin made it a feature of his Arcades Project, and even today Slavoj Žižek warns us against the "fantasy of the real." In short, there is some agreement among critics of the modern that its form is the phantasmagoria, an illusion of light and sound that displaces the real. For Carlyle, the modern was dominated by "the loud-roaring Loom of Time with all its French Revolutions, Jewish Revelations," creating a phantasmagoria that obscured Tradition and the Seer.[75] In counterpoint to this spectral vernacular reality of everyday people, with their eternal tendency to amalgamate as Revolution, Carlyle conjured a visualized form of History, dominated by Heroes.

Following his rebuttal of Chartism, Carlyle developed his ideas on visualized power in an acclaimed series of lectures entitled *On Heroes and Hero Worship*, given in 1840 and published the following year. In grand indifference to all possible objection, and as if being wholly original, Carlyle's

lectures described a tradition of Heroes running from the Norse gods, via Muhammad and Dante to Cromwell and Napoleon. Carlyle consolidated and embodied his theory of History into the Hero, who had the vision to see History as it happened, a viewpoint that was obscured for the ordinary person by the specters and phantasmagorias of emancipation.[76] The Hero that stood against the modern tide of darkness was "the living light-fountain, which it is good and pleasant to be near. The light which enlightens, which has enlightened the darkness of the world: and this not as a kindled lamp only, but rather as a natural luminary shining by the gift of Heaven; a flowing light-fountain, as I say, of native original insight, of manhood and Heroic nobleness; in whose radiance all souls feel that it is well with them" (2–3). The Hero was a projection into visuality, not visuality in and of himself. This sense of light extending in a fountain was congruous with—and perhaps appropriated from—the exactly contemporary sense articulated by John Williams, the London Missionary Society evangelist, of his South Pacific mission as a "fountain from whence the streams of salvation are to flow to the numerous islands and clusters scattered over that extensive ocean."[77] In both cases, the object of visuality's work was the "soul," in need of leadership or conversion. The visualized Hero was the true source of light and enlightenment, his insight stemming from a quasi-divine nobility to which it is pleasurable to submit, generating its sense of the aesthetic. Indeed, visuality was named as part of the Christian Heroism of Dante. For Carlyle, the Divine Comedy was a Song, in which "every compartment . . . is worked out, with intense earnestness, into truth, into clear visuality," that became a "painting" (79). Interestingly, then, from its very conception visuality was a multimedia term, connecting art, literature, and music, as Carlyle insisted that "Dante's painting was not graphic only, brief, true, and of a vividness as of fire in dark night" (80). This form of language offered strong visual metaphors, even as its meaning was opaque, perhaps unknowable. Carlyle created a visual Platonism in which the shadows on the cave wall are all mere humans can see, yet they are nothing but error.

The pleasure came from the binding of the "mystical foundation of authority" to the Hero in and as visuality. The Hero has authority because he can perceive visuality and in mystical fashion thus becomes the source of life-giving light in himself. His task is the "making of Order" (175). This order was what Carlyle called "Protestantism," a return to Reality that had to be carried out on three occasions. The first was Luther making the Protestant Reformation and overturning the false idols of Catholicism. Next came

Oliver Cromwell, who was "the one available Authority left in England" and saved it from anarchy (199). Finally came Napoleon, repeating the task with the French Revolution but performing the necessary additional function of disposing of Divine Right and "opening careers to all the talents" (205), creating a Democracy that was not Anarchy. On each occasion, authority reclaimed its force. For Carlyle, this was a three-act play in which the defeat of the French Revolution marked the final "return to reality . . . for lower than that savage *Sansculottism* men cannot go" (203). The gaze of the Hero in the modern period was to be a form of Medusa effect, petrifying the transformations of modernity into recognizable social relations. This castrating gaze was paradoxically universal, affecting all men and women, leaving only the Hero capable of visuality. No doubt the Great Man was the product of "manhood" alone, in keeping with colonial views of proper masculinity, opposed to the feminized collective of the crowd, or as Carlyle usually put it, the mob.[78] Visuality was embodied in the Hero, rather than the regenerated rights-bearing body of the French Revolution, and the Heroic masculine body was worthy of worship. Now only the Hero stands against the "cries of Democracy, Liberty and Equality, and I know not what:—the notes being all false" (12). For in the mimetic realism of representation by the people, there was no true means of founding authority, leading instead to unrepresentable chaos. Implicit in this view is a parallel between the Hero and the historian, who both stand against the chaos of modernity, for History is the history of Heroes.[79] Although Carlyle spoke of the Hero and Hero-worship as "the one fixed point in modern revolutionary history" (15), he had here doubled that point so that it represented both the Hero and his worshiper-chronicler the historian, making the Heroic viewpoint complex, even paradoxical. Visuality had its double-vision as well.

Carlyle created a counterrevolutionary sense of past time by erasing the complex time of rights in favor of a subjugating Tradition. Yet he continued to frame this conception of history in visual terms. Writing just after Louis Daguerre and William Henry Fox Talbot had announced the success of their photographic devices, Carlyle declared: "What an enormous *camera-obscura* magnifier is Tradition! . . . Enough for us to discern, far in the uttermost distance, some gleam as of a small real light shining in the centre of that enormous *camera-obscura* image; to discern that the centre of it all was not a madness and nothing, but a sanity and something" (23). Whereas the Revolution relied on a condensation of visual symbols, Tradition expanded the visual field from a single point of light, that place where law and force joined

together to found authority. In visuality, the future is always already subjected to the past, when that past is codified into Tradition. Even then outdated as a physiological model of perception, the camera obscura revealed rather than obscured those truths inherent in Time that Carlyle called Tradition.[80] This antitheoretical, antichronological History is a light penetrating the darkness of the camera in the hope of preserving sanity, meaning that perception attested to an actually existing reality and was not merely a hallucination. If, to adapt W. J. T. Mitchell's question, we ask, "What does visuality want?," Carlyle's answer is clear: "order" (175). Like Urizen, Carlyle opposed Order to anarchy as the necessary movement of human life, understanding that movement was the inevitable corollary of modernity, but insisting that it be toward order not chaos.

CHAOS, CULTURE, AND EMANCIPATION

Carlyle's work on Heroism was well received and his influence continued to grow, giving him a "long (and largely unremarked) legacy in reactionary thought."[81] Yet his views became even more pessimistic as he grew older, as he confronted the possibility that the French Revolution was not the final act of Protestantism. For there was one more descent into anarchy that might transpire, namely that the emancipation of the enslaved might lead to the dissolution of the British empire. If Carlyle's first thoughts on visuality were prompted by the memory of the French Revolution, after the decade of Chartism culminated in the revolutions of 1848, he then turned his attention to the state of the British empire after emancipation in a series of essays, published, in 1855, as *Latter-Day Pamphlets*. The eschatological tenor of his title was reflected in the tragic structure of modernity presented in the essays that set the tone for the assumption of imperialism not as exploitation but as a titanic struggle between the forces of "*Cosmos*, of God and Human Virtue" and those of "*Chaos*."[82] Carlyle denied the very possibility of reform and emancipation: "Yes, my friends, a scoundrel is a scoundrel: that remains forever a fact."[83] It was the central issue of emancipation, especially as regarded the formerly enslaved, that led Carlyle's position to gain more adherents over time. In his notorious essay in *Fraser's Magazine* (1849), reprinted as a pamphlet under the title "Occasional Discourse on the Nigger Question," Carlyle reiterated the impossibility of emancipation.[84] The essay has been widely cited for its revolting depiction of the emancipated Africans in Jamaica idling the day away "with their beauti-

ful muzzles up to the ears in pumpkins."[85] This refusal of the colonized to labor, while finding food all around, served as Carlyle's exemplary moment of the failure of what he called the "Emancipation-principle," that lowest of all sansculottisms. In short, Carlyle suggested that the emancipated had refused to sell their labor-power and instead cultivated their own "gardens." This dialectic between national economy and local subsistence had structured the Saint-Domingue revolution, and it played a central role in British debates over the abolition of slavery before and after the fact.[86] Carlyle's nasty parody would have been immediately recognizable to those familiar with these debates and served to accelerate a growing consensus that the enslaved had failed to become workers. That is to say, the plantation complex could not be reformed; it had to be reinforced. In this view, abolition had instead turned "the West Indies into a *Black Ireland*," meaning a place where work was not properly carried out.[87] Like many other commentators in the period, Carlyle insisted that emancipation had failed to create a black working class in the Caribbean and had instead produced lazy and immoral individuals. It was the other side of Chartism, a similar failure of the vernacular to rise to the challenge of leadership. From the decline of the Jamaica plantations and the experience of the Demerara rebellion of the enslaved, in 1823, Carlyle concluded: "*Except* by Mastership and Servantship, there is no conceivable deliverance from Tyranny and Slavery. Cosmos is not Chaos, simply by this one quality, That it is governed. Where wisdom, even approximately, can contrive to govern, all is right, or is ever striving to become so; where folly is 'emancipated,' and gets to govern, as it soon will, all is wrong."[88] Order required governing, governing required great men, great men visualized history as its sole actors.

The *Occasional Discourse* marked a transition in British public opinion in which, as Catherine Hall has put it, "the tide was running against abolitionist truths."[89] In 1857, the aftermath of the so-called Indian Mutiny, or First War of Indian Independence, would mark the assumption of direct colonial control in the subcontinent, suggesting that order could not be left to the market alone, as represented by the East India Company. Order required government. This anti-abolition and pro-colonial shift had important political consequences in the aftermath of the Morant Bay uprising of 1865 in Jamaica: "Months of tension between black people and white over land, labour and law erupted after an unpopular verdict from magistrates led to a demonstration and attempted arrests."[90] In the ensuing violence, eighteen officials and members of the militia were killed, leading Governor

Edward John Eyre to call out troops. More than 400 people were executed, another 600 flogged, and 1,000 homes were destroyed. In the ensuing furor, the Eyre Defence Committee was established in Britain, with Carlyle being joined by such leading cultural figures such as Charles Dickens, Alfred Lord Tennyson, and John Ruskin, the champion of Turner's work. The committee made its case so well that Eyre was never prosecuted for his actions, and Jamaican home rule was rescinded in favor of direct governance from Britain. Eyre explained, "The Negroes are most excitable and impulsive, and any seditious or rebellious action was sure to be taken up and extended." His belief that colonial authority could not "deal" with Jamaicans in the way that one might treat "the peasantry of a European country" was reinforced by the scientist Joseph Hooker, for whom it was self-evident that "we do not hold an Englishman and a Jamaican negro to be convertible terms."[91] Abolitionism had posed an enslaved man asking, "Am I not a man and a brother?" By 1865, the answer was "no." Carlyle's view of the necessity of mastery, far from being marginal, was now imperial policy. The Chartist goal of total representation was firmly set aside in favor of a nonequivalence between different British subjects.

This distinction within visuality was the move that would allow it to become a practical strategy of imperial governance, concentrating on the separation and segregation of colonizer and colonized. This additional dimension to visuality came from the addition of "culture" to the battlefield of the social imagined by Carlyle. Just as there was a certain convergence around 1660 that permitted the formation of oversight as a combination of mapping, natural history, and the force of law, so, too, did the concept of culture become deployed very quickly, around 1870. In Matthew Arnold's foundational account, culture meant "trying to perfect oneself," whereas its opposite was "anarchy," defined as "doing as one likes." Culture created light, which in turn enabled people "to like what right reason ordains and to follow her authority, then we have got a practical benefit out of culture." This chain of visualized command was all the more necessary in an "epoch of expansion," meaning industrial development, population growth, and imperial expansion. If this pattern of explanation recalls Carlyle's vision of authority and the ills of emancipation, that is not surprising, for it comes from a passage in which Arnold was modifying Carlyle so that aristocracies did not gain their privilege by birthright alone: "The very principle of authority which we are seeking as a defence against anarchy is right reason, ideas, light."[92] Such principles were central to the Carlyle of 1840,

who had become somewhat obscured by the dyspeptic later writings. The key here is to note that culture and authority have become synonyms. Culture thus came to be understood as what the ethnographer Edward Burnet Tylor called the "complex network of civilization."[93] This network was locally divided and globally staged into ranks of "development." Tylor asserted that there was "scarce a hand's breath difference between an English ploughman and a negro of Central Africa," refining Hooker's refusal to convert Jamaicans and English by a distinction of class. Among rural working classes, while there was a distinction, it was narrow, whereas the gap between British elites and Jamaicans was so broad as to be incommensurable. From this premise, Tylor drew the inference that if there was law at all, it was universal, but "actually existing among mankind in different grades" that could be assessed by virtue of the "general improvement of mankind by higher organization of the individual and of society."[94] This view of human progress as a uniform advance from barbarism to civilization, rather than the present-day "savage" marking a decline from an originary state of culture, was endorsed by Darwin in his *Descent of Man*, published in the same year, which made use of Tylor's researches.[95] All these opinions from Carlyle and the Duke of Argyll on the "Right" to Arnold's centrist position and Tylor and Darwin's "liberal" opinion form what Rancière calls a consensus, meaning not a single point of view, but a uniform range of views. In this case, it was agreed that culture was a temporal hierarchy, existing in real space and time, in which a minority were advanced ahead of the majority and thereby entitled to the authority to make choices and distinctions. This visualization of hierarchy over time gave depth and spatial dimension to culture as an actually existing means of classification and separation. In short, culture authorized empire.

COUNTER-HEROES

That imperial visuality will be considered in chapter 5, but we should not let Carlyle's sleight-of-hand deceive us. Emancipation and the imperial crisis were not supposed to happen in his scheme of ordered reality. That is to say, if the Reformation, English Revolution, and French Revolution were, against all appearances, nonetheless part of Visuality 1 and part of visuality's life-process, the self-directed emancipation of the enslaved and the colonized was not. Any such imagining was held to be insanity. Abolition and decolonization were the outside to Visuality 1's reality effect,

creating a plurality of realisms. Visuality 2 is composed of other ways of ordering reality that do not tend to support a single authority. In the genealogy of visuality, then, realism cannot be contained to a period in capital's early development. Precisely because such abolition realisms have not figured in the standard accounts of modernity, the next chapter is devoted to them. Here I want to show first that abolitionist and decolonial practice engaged with Carlyle's visuality throughout the nineteenth century by contesting heroism at the heart of the still-existing plantation complex in the Americas. At first it was not clear that promoting heroism implied rejecting abolition. In a telling moment, in September 1840, Carlyle spurned a delegation of American women to the world congress on the abolition of slavery, who had thought that the author of *On Heroes* must be a supporter of their cause.[96] He insisted it was nothing to do with him, as he disparaged emancipation as a failure. That warning was increasingly to dominate Carlyle's sense of the modern phantasmagoria, as revolution seemed to spread around Europe from the Chartists to the radical year of 1848 with its final abolition of slavery in French and Danish colonies. So central was Carlyle's visualized heroism in the period that even those adamantly opposed to his system had to pass by it. I next consider some representative examples of abolition "heroes" whose gender, sexuality or ethnicity would have excluded them from all consideration by Carlyle.

Sojourner Truth's self-presentation as a hero of abolition in the United States challenged the gendering of heroism as inevitably masculine.[97] Truth, as Nell Irvin Painter has pointed out, was the only woman who had been enslaved to take an active role in the emancipation movement (Harriet Tubman's work being of a different character).[98] Part of Truth's power as a spokesperson for emancipation was her visual presence, as Olive Gilbert, who wrote her celebrated *Narrative*, emphasized: "The impressions made by Isabella on her auditors, when moved by lofty or deep feeling, can never be transmitted to paper, (to use the words of another), till by some Daguerrian act, we are enabled to transfer the look, the gesture, the tones of voice, in connection with the quaint yet fit expressions used, and the spirit-stirring animation that, at such a time, pervades all she says."[99] Gilbert persisted in naming her subject by using her slave-owner given name of Isabella van Wagenen, rather than by the evocative name Sojourner Truth that she adopted in 1843. Nonetheless, Gilbert's sense of Truth's heroism anticipated and created a desire for cinema in her wish to transfer Truth's "look" to others. Truth herself was skilled in deploying her "look" as evidence of

her own right to look and right to be seen, by using photographs of herself to fund her activities. She manipulated a series of carefully chosen signs, making full use of the rhetoric of the pose that was already well-established by the 1850s (see fig. 30). In the best-known of these images, she is seen dressed in respectable middle-class attire, posed as if caught in the middle of knitting. Her gender-appropriate activity and dress allowed her to signify her engagement with ideas and learning, shown by her glasses and the open book. The caption that she provided for the cards showed her awareness of the ambivalences of photography: "I sell the shadow to support the substance." Photography is represented as a mere shadow, rather than the Truth that is the subject herself, the substance. Here the emancipated woman makes her image the object of financial exchange in place of the substance, her whole person, which had once been for sale. That commodification was justified by the substantive use to which their sale was to be put, namely abolishing the ownership of people. At the same time, by insisting on her own control over the financial process, Truth asserted a proper freedom that the "emancipated" did not quite fully possess.[100] As Kenneth S. Greenberg argues, "An emancipation that assumed the form of a gift from the master could only be partial," for a gift always implies an obligation.[101] It was for that reason that W. E. B. Du Bois would insist that the enslaved had freed themselves, and it is why Truth put her image into the world in this way, claiming to own not just her person but the substance of rights-bearing freedom.

Truth performed this freedom at an abolitionist meeting in Indiana in 1858, where she was directly challenged over her right to be seen. The men in the audience claimed that Truth was a man and demanded to see her breasts. That is to say, they recognized her claim to personify a Hero, but asserted that any such person must be male. Here was a direct embodiment of the slave-master's dominant gaze in the person of one Dr. Strain, a pro-slavery spectator.[102] Following a voice vote that upheld the doubters, according to the contemporary account of the Boston *Liberator*, "Sojourner told them that her breasts had suckled many a white babe, to the exclusion of her own offspring; that some of these white babies had grown to man's estate; that, although they had suckled her colored breasts, they were, in her estimation, far more manly than they (her persecutors) appeared to be; and she quietly asked them as she disrobed her bosom, if they too wished to suck!"[103] Truth rejected the slaver's gaze by claiming the right to be seen as a human. Further she classified her own body as exhibiting what Judith

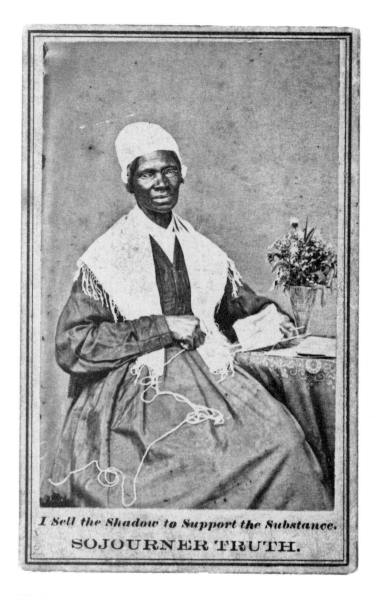

I Sell the Shadow to Support the Substance.

SOJOURNER TRUTH.

FIGURE 30. ANONYMOUS, *SOJOURNER TRUTH*.
Gladstone Collection, Prints and Photographs Division, Library of Congress.

Halberstam has called in a different context "female masculinity," upholding both terms of the identification.[104] Truth asserted that her body was certainly female, yet it was better able to engender manliness than those men around her, whom she reduced to infants by offering them her breast. This deployment of the body further contested anthropological ideas that the breasts might index racial difference, white notions of beauty, and the symbolically revealed breasts of the revolutionary figure of Liberty.[105] For Liberty nurtures the nation at her symbolic breast, whereas Truth revealed the known but hidden truth that enslaved African women actually nurtured white male infants, who would become slave-owners. She claimed that men so suckled became more "manly" men than her detractors, despite the fact that African breasts were taken as signs of degeneracy and ugliness. Here she invented the other in one of the most direct ways possible, while claiming her own right to look and to be seen.

Truth was constantly nomadic, always in pursuit of emancipation, generating a complex, even chaotic, visuality out of the stale clichés of her time. As Daphne Brooks has put it: "From the darkness of the void which she creates, surplus Truths are put into play."[106] This was Carlyle's heroism reversed, a countervisuality of the hero. For whereas his camera obscura of tradition had magnified a single point of light, Truth deployed an array of imagery to explore the tensions between the shadows and the substances of embodied labor, reproduction, and representation. Sustaining that complexity was the key, for merely gendering Carlyle's Heroism female could produce disparate effects. Gayatri Spivak has shown, for example, how the contemporaneous practice in India of *sati*, or widow immolation, was presented as a form of heroism that generated admiration for what one commentator called "the cool and unfaltering courage of Indian women." If imperialism rendered the woman what Spivak calls the "*object* of protection from her own kind," it also made them into heroes for refusing that protection.[107] Like visibility within the Panopticon, counterheroism was a trap as well as a resource, one that mobilized an entire genealogy of nineteenth-century gender.

The impact of these refigured modes of heroic visuality in the Americas can be traced via an apparently unlikely example of heroism: the figure of Jefferson Davis, president of the Confederacy. In 1865, Carlyle considered writing a pamphlet in defense of Davis as a Heroic figure, a choice he for once rejected as being too outrageous even for him.[108] Both Oscar Wilde and W. E. B. Du Bois pursued this untaken road, intending to authorize

anti-imperial and antiracist heroisms respectively, but by different means. Of course, these complex figures cannot be fully understood simply with reference to their response to Carlyle's and Emerson's theory of the Hero, but as a line of inquiry it has much to say about both of them. According to W. B. Yeats, Carlyle was the "chief inspirer of self-educated men in the 'eighties and early 'nineties,'" even including such unlikely figures as Vincent van Gogh, who thought *On Heroes* to be "a very beautiful little book."[109] Wilde, prime mover of such aspiring artists in Britain, was taken by the "stormy rhetoric" of Carlyle, whom he met in 1874 and whose writing table he later purchased for his own use. Wilde was able to quote long passages of *The French Revolution* by heart, and his own writing bears the marks of Carlyle's influence.[110]

On his tour of America, in 1882, Wilde appeared as an Elizabethan aesthete, as seen in the photographs of Napoleon Sarony, a direct challenge to the aesthetics of the hero. His pose was that of a member of "a race once the most aristocratic in Europe," namely the Irish.[111] Wilde assumed that his class would sustain his pose as a hero, deflecting any other criticism, but his perceived effeminacy created a clear sense of gender and sexual difference. However, as so often in the United States, this difference was displaced into "race" as the most effective form of classification and separation. The *Washington Post* invited its readers of 22 January 1882 to consider "How Far Is It from This to This?," which captioned two drawings: one of the legendary Wild Man of Borneo, the other of Wilde holding a sunflower. This pseudo-Darwinian fear of so-called reverse evolution was condensed into a composite visual symbol the next week by *Harper's Weekly* as a monkey admiring a sunflower.[112] Far from seeming Heroic, Wilde's aestheticism was perceived as a reverse or inverted effeminacy that was figured as racial degeneration. Accordingly, in Rochester, New York, students hired a laborer to parody Wilde as a blackface minstrel, as if to suggest that his whiteness was forfeited by his effeminacy.[113] This caricature persisted throughout his career, as in Pellegrino's caricature of him as "The Ape" (1884) and a Punch cartoon depicting the "Christy Minstrels of No Importance" (1893) at the time of *A Woman of No Importance*.[114] Wilde found that being a colonial subject did not make him a "white Englishman" when questions of difference were being put. As if reinventing himself as Carlyle, Wilde responded by making a public visit to none other than Jefferson Davis, in June 1882, where he compared the struggles of the Irish for independence within the British empire to that of the Confederacy: "We in Ireland are fighting for the prin-

ciple of autonomy against empire, for independence against centralization, for the principles for which the South fought."[115] The countervisual claim to autonomy was staged against Carlyle's Protestant reality, even if it tended to very different effect. If his being Irish could not be posed as Heroic aristocracy because of his perceived embodied difference, Wilde repositioned it as a form of Heroic resistance to tyranny that nonetheless endorsed the continuance of a decentralized British empire. He presumably did not know that Davis's plantation had been repossessed from African Americans who had been bequeathed the estate by the former Confederate president's brother. Nonetheless, Wilde was claiming the place of the slave-owner as the one from which to "see the Irish people free," an emphatic designation of the place of the master in what he would elsewhere call "Hegel's contraries."

For W. E. B. Du Bois, the legacy of Carlyle's visualized Hero had to be veiled rather than appropriated. As a student at Fisk, Du Bois was much taken with Carlyle's writing, especially *The French Revolution*, which remained a stylistic influence throughout his long career. When editor of the *Herald*, the student newspaper at Fisk, Du Bois urged his readers to adopt Carlyle's viewpoint and even to take Bismarck as their Hero.[116] During his time at Fisk (1885–88), Du Bois heard the Fisk Jubilee Singers, a group devoted to the performance of African American spirituals and other vernacular music that celebrated the concept of the Jubilee; the group used revenues from their performances to fund the university. Later Du Bois used quotations from such songs as the headings for his chapters in *The Souls of Black Folk*, where he also elegiacally discussed the history of the Fisk Jubilee Singers.[117] From the beginning of his adult life, then, Du Bois experienced and thought through the counterpoint of Carlyle's Hero and the Jubilee. Once at Harvard, in 1888, Du Bois absorbed a further espousal of Carlyle's views on the Hero from William James. In 1890, he wrote both an essay on Carlyle and a commencement speech for Harvard on "Jefferson Davis as a Representative of Civilization."[118] The reference here was to Emerson's reworking of Carlyle in his own lectures published as a book under the title *Representative Men*, in 1850. If Emerson was opposed to slavery, he did not question the primacy of the "Saxon race."[119] Working in this context, Du Bois noted that Davis's militarism and love of adventure made him "a typical Teutonic Hero." Unlike Wilde, Du Bois deployed Davis the Hero as a figure of failure, rather than of triumph, for as a "type of civilization," Davis's vision of the "Strong Man" had ultimately led to "ab-

surdity, the peculiar champion of a people fighting to be free in order that another people should not be free." This was the step that Wilde had failed to make eight years previously, and it led Du Bois to reconsider the entire system of the Hero. In casting himself as a Hero, Davis—and by extension proslavery culture as a whole—had come to adopt "the overweening sense of the I and the consequent forgetting of the Thou." In historical terms, the result had been the crushing of the Negro by the Teuton. Du Bois argued, however, that the role of the Negro was not simply to provide grist for the world-historical mill, but to challenge the Strong Man thesis with that of the "Submissive Man," exemplified by the Negro. The result would be "the submission of the strength of the Strong to the advance of all," a more perfect individualism that would assert the contribution of even "the very least of nations" to civilization. This interaction would prevent the disastrous extremes of despotism and slavery. Rather than being a simple refutation of Carlyle, Du Bois was attempting to meld his discussion of the "I" and the "Thou" from *Sartor Resartus* with the Great Men thesis of *On Heroes*. As Shamoon Zamir has pointed out, Du Bois's speech on Carlyle from the same year championed "not only the admirer of Bismarck and the author of *Hero Worship*, but also the critic of industrialization and the advocate of ethical culture."[120] Du Bois would later set aside this ultimately contradictory project in favor of a more radical contestation of heroism.

Du Bois drew from Carlyle a sense of the necessary entanglement of past and present, but he arrived at a very different conception of the intertwining of what he later called, in *Souls of Black Folk*, "the Old and the New," which made him "glad, very glad, and yet—."[121] It is in that pause marked by the dash that one can see Du Bois thinking through his own intellectual formation in grammatological form, not quite ready to reject heroism, but not content to endorse its autocratic form. His highly influential solution to the need for African American representative men was to hail the leadership of those he called "The Talented Tenth." Following Emerson's definition of the "Representative," Du Bois held that "an aristocracy of talent and character" was to perform a necessary action on behalf of their fellows: "The Negro race, like all races, is going to be saved by its exceptional men."[122] This formula was strongly derivative of Carlyle's and Emerson's Hero theory, even if the former at least might have rejected this application.[123] By rethinking the Hero within the frame of "race," Du Bois restated the tension between the individual and the collective that he had highlighted in the Jefferson Davis speech, but now as an exchange within

his own community. For Carlyle, the very concept of the Hero was always opposed to "Blackness" in its racialized and metaphorical senses, insofar as they can be distinguished. Wilde, Truth, and Du Bois tried in their different ways to revisualize the domain of the hero, as an inclusive space. In each case, the embodiment of the countervisual hero was the key figure that ultimately could not be sustained in the face of persistent racialized classification and separation that famously led Du Bois to conclude that "one ever sees his twoness—an American, a Negro; two souls, two thoughts, two unreconciled strivings."[124] Visuality dominated or converted souls, but countervisuality found itself with a doubled vision, two souls. The alternative was to take the visuality imagined by antislavery and abolition and attempt to instantiate a unified realism derived from it.

Abolition Realism

Reality, Realisms, and Revolution

Modernity did not simply end the plantation complex, as is still evident in present-day America, with its seemingly permanent state of racialized controversy, from Rodney King to Barack Obama. The intensification of the plantation complex in its policed form interpenetrated the formation of self-proclaimed modernity in both colony and metropole. The policed plantation that emerged after abolition had formally ended slavery was interactive with the reconstruction of Paris under state-of-emergency regulations. In response, the dynamics of abolition, colonization, and revolution formed a new realism that, in affiliation with W. E. B. Du Bois's concept of abolition democracy, I will call "abolition realism." Abolition realism brought together the general strike and the Jubilee in order to forge a refusal of slavery, such that abolition was observable and capable of being represented and sustained. Consequently, it was important that it be legible as "real" to others, as well as to those involved in making it. This abolition realism engaged with and shaped the realist means of visual representation that were central to the painting and photography of the period. In this chapter I map the confrontation of realisms created by this interpenetration of metropole and plantation from the revolutionary year of 1848 as seen from the plantation, via the abolition of slavery in the United States to a point of entanglement between them in 1867, whose terms were played out in the Paris Commune of 1871. In short, I place the reality and realism

of modern Paris, legendary capital of the nineteenth century, in counterpoint with the reality and realism of the abolition of literal and metaphorical slavery in the Caribbean and the Americas.

At the head of his prospectus (1935) for *The Arcades Project*, Walter Benjamin placed a quotation from *Paris, capitale de la France* (1897), the Vietnamese poet Trong Hiep Nguyen's now-obscure volume, as if to suggest that it was the source of his own, now legendary title "Paris, the Capital of the Nineteenth Century."[1] Paris was the capital of the nineteenth century not because it dominated economically or politically, but because of its colonization of the imagination, which led the Vietnamese poet to visualize it as a place where "one goes for a walk." In *The Arcades Project* itself, Benjamin returned to this theme, musing on the way that the Place du Maroc, in Belleville—site of some of the fiercest fighting during the Paris Commune—became a "monument to colonial imperialism," concluding: "What is decisive here is not the association but the interpenetration of images."[2] If the modern imaginary was formed in the crucible of the Atlantic revolutions, now modernity's image was formed in a contested process by which plantation, colony, and commercial city confronted, constructed, denied, and displaced each other within the state of emergency. In his essay of 1935, Benjamin later quoted an essay, which he (somewhat inaccurately) identified as having appeared in 1831, from the *Journal des Débats* to suggest the precariousness of capitalist domination: "Every manufacturer lives in his factory like a plantation owner among his slaves." The quote in fact comes from the journalist Saint-Marc Girardin's summary (1832) of the consequences of the silk riots in Lyons: "Let us not dissimulate; reticence and evasion will get us nowhere. The uprising at Lyons has brought to light a grave secret, the civil strife that is taking place in society between the possessing class and the class that does not possess. . . . [Y]ou will be frightened by the disproportion: every factory owner lives in his factory like a colonial planter in the middle of his slaves, one against a hundred; and the uprising at Lyons is to be compared with the insurrection at Saint-Domingue."[3] In this view, the "real" visualization of the class struggle in France understood it not as the revival of 1789, or even of 1793, but of the revolution in Saint-Domingue, at once the first anticolonial and proletarian uprising. Just as in the eighteenth century, this revolution was framed as something that had been hidden now coming to light. As Carlyle's biographer and successor James Anthony Froude often observed in relation to Haiti, what so concerned capital was not just the independence of the island but the 1804 constitution, which prohibited white ownership

of land.[4] The fear that the European "planter" would face not just revolt but a revolution in property relations was something not to be dissimulated—it was the "real conditions of existence."

To map the formation of this interpenetrated visualization of modernity, I consider the Danish Caribbean colonies, where the entanglement of metropole and plantation was instantiated between the two islands of St Thomas and St Croix during the revolutionary year of 1848, leading to the policed plantation. That interpenetration was central to the reimagining of Paris as an imperial metropole in the aftermath of 1848, when Louis Napoleon, nephew to the first Napoleon, became Napoleon III by coup d'état, in 1852. The metaphorical connection between the Danish Caribbean islands and the French capital was embodied by Camille Pissarro, who witnessed the 1848 revolution of the enslaved in St Thomas, where he grew up, and then moved to Paris, in 1856, to become one of the now legendary Impressionist group, known for their visualization of Haussmann's modern Paris. Abolition was intensified by the emancipation of the enslaved in the United States, especially as Reconstruction mobilized a social imaginary centered on democracy, education, and sustainability—the right to look. Under this intensification, the tensions in Parisian modernity came to a head in the last days of the empire and the brief interlude of the Commune.

1848: THE POLICED PLANTATION / THE SEGREGATED METROPOLIS

> All we girls must keep heads together,
> King Christian have sent to free us all,
> Governor Sholten [sic] had a vote for us,
> King Christian have sent to grant us all;
> We have signed for liberty, . . .
> Oh yes! Oh yes! Hurra! Hurra!
> All we girls must keep heads together.
> —Old Year's Night song recorded in St Croix, Danish Virgin Islands,
> 1845, two years before King Christian declared apprenticeship would
> replace slavery.[5]

In 1848, St Thomas was a bustling commercial entrepôt, where all Royal Mail steamers from the United Kingdom to the Caribbean made landfall. Its capital, Charlotte Amalia, was the second largest city in Danish hands, after Copenhagen, with a population of 32,000, making it what one might

call a colonial metropole.[6] There were nonetheless 3,500 enslaved people working plantations in 1846, and the island experienced "significant" maronnage to independent Haiti right up to abolition, in 1848.[7] Close by, to the south, was St Croix, a sugar plantation island, where, despite the gradual Danish abolition of the slave trade in 1792, some 21,000 people were enslaved in 1848.[8] In fact, Danish slavery had increased since the revolution in Haiti, as plantation owners took advantage of the market opportunity in sugar.[9] The two islands thus formed a modernized plantation complex. Despite active censorship, both islands had predominantly Anglophone newspapers, as English was the commercial lingua franca, catering to the self-described urban "intelligent middle-class," aspiring to what they called, in 1848, at the height of the ferment, "constitutional institutions and social progress," or, as we might now put it, an imagined community.[10] Members of this group included the Jewish dry-goods merchant Frederick Pissarro, Camille's father, who advertised as the agent for the estate of Dalmevda and Company.[11] Despite the geographic location, news from Europe predominated in the papers, from the famine in Ireland to the Chartist movement in England. All local aspirations to cultural development were avidly reported, from violin recitals to theatrical performances by visiting groups and art exhibitions. This last included a variety of realisms ranging from daguerreotypes displayed and taken by the New York photographer Henry Custin to a "Cosmorama," a form of magnified panorama, showing views of Paris, Havana, and Vienna. For some months in 1847, the British geologist and artist James Gay Sawkins was resident in Charlotte Amalia, offering his landscapes for sale and art lessons. Sawkins showed landscapes of Mexico that impressed locals: "The delicacy and finish of his likenesses are in a style rarely seen in the West Indies."[12] Sawkins's careful anthropological style, evidenced in his surviving work from Cuba and Australia, concentrated on observation rather than moral commentary (see plate 6).

A formal analysis suggests that his work influenced the young Pissarro, who had just returned to the island from his school in France. Soon afterward, Pissarro began his own drawings of the local African population in apparent imitation of Sawkins. These observations were sketches for a postslavery imagination, detailing the actions of those who might become either laborers or revolutionaries, such as the washerwomen, coalers, and journeying traders of the town, as well as documenting the lush landscape that could provide alternative free means of subsistence. For everyone

knew that slavery was coming to an end. There was a perceived need among the Europeans to acculturate those about to become the formerly enslaved to the disciplines of waged labor. On St Thomas, the Rev. J. P. Knox and others therefore formed a savings bank with the aim of "promoting among the industrial classes of the community a desire to economize and accumulate the surplus profits of their labor." By the summer of 1847 this bank had holdings of $114 (rijksdallers), dwarfed by the $1.2 million in the commercial Bank of St Thomas under the care of its president S. Rothschild.[13] The virtues of thrift and accumulation offered to the working classes and the soon-to-be-free were satirized by one correspondent to the newspaper, who pointed out that a saver would have to wait decades until the 3 percent interest awarded on these microsavings would amount to anything of use. Stern injunctions about the morality of work and the importance of virtuous habits followed apace. In September 1847, Governor Van Scholten returned from Denmark with news that slavery was being abolished in favor of a twelve-year apprenticeship, "the necessity of which had been amply demonstrated by the consequences of the precipitate measures which were a few years since adopted in the British West Indies Islands."[14] Carlyle's strictures about the failure to create a laboring class from the formerly enslaved had been fully understood, even as the fears instilled by "Haiti" remained active.

These gradual plans were challenged by the French revolution of February 1848, which brought abolition to Guadeloupe and Martinique in March. While the Danish monarchy faced open revolt in Schleswig-Holstein and war with Germany, St Thomas remained open to all ships for business, placing commerce over patriotism. The enslaved on St Croix lost their patience. Under the leadership of Gottlieb Bourdeaux, also known as Buddho, a general strike against slavery began on 3 July 1848.[15] It can be called a general strike because the enslaved were at first determined to use no violence other than the refusal to continue being enslaved. The only eye-witness account published at the time, while very much opposed to the strikers, emphasized that, at the outset, as they advanced on Frederiksted, one of the two towns on St Croix, "their leaders [were] strenuously recommending and ordering that there should be no bloodshed."[16] Consequently, their song ran,

All we want we freedom
We no wan' no bloodshed

Clear d'road
Le' de slave dem pass.[17]

Later that day, Governor Scholten decreed the absolute abolition of slavery without apprenticeship. Early the next morning, a detachment of troops under one Colonel de Nully encountered a "band of the now emancipated peasantry . . . and their leader armed with a musket (who was shot)." This parenthetical killing changed the strike into a revolution. Hours later, thousands of rebels approached Frederiksted, armed and with "trash" from the cane fields to set fire to the town, "in open and warlike array, sounding the Toksin [sic], by the blowing of shells and other never to be forgotten sounds."[18] The Danish contingent were rescued by a detachment of six hundred Spanish troops, dispatched from Puerto Rico by order of Governor de Reus, onboard the *Eagle*, a British Royal Mail steamer.[19] European national rivalries were set aside at a time of war in the interest of maintaining international colonial order with the means of communication becoming militarized. The Spanish troops remained in St Croix until 26 November 1848, with the country under martial law. At least seventeen leaders of the revolution were hanged in public, and other unofficial reprisals were carried out. The Danish myth of the "velvet" abolition of slavery turns out to have been a screen for a violently suppressed revolution.[20] This transnational cooperation was enacted, as the new Danish governor Peter Hansen put it in his official statement of thanks, "to ward off the horrors of a successful Negroe [sic] insurrection."[21] The goal was not to preserve slavery as it had been but to maintain a modern form of plantation colony using highly constrained wage-labor under a state of exception and thereby to avoid a revolution in the manner of Saint-Domingue, which might echo in Europe.

In short order, Hansen established a structure to sustain this colonial government. He abolished the burgher's council, a form of colonial representative assembly, and took on direct powers, a colonial state of exception. Governing by decree, of which sixteen were issued in the first six months of 1849, Hansen made field labor compulsory, except for those explicitly qualified for skilled work, just as Toussaint had done, in 1801. All the conditions of slavery relating to place of work, length of the workday, mandatory extra work at harvest, and even provisions grounds were to remain in force. Laborers were to be paid fifteen cents a day, but a deduction of five cents could be made if meals and herrings were provided—a little Danish touch there. Most notable was the displacement of authority from the overseer to

the police. The eighty-four-square-mile island was now divided into four police districts and the police were placed in charge of everything from licensing boats to certifying marriages of the fieldworkers and dismissing the driver of the field gangs.[22] All workers on the plantations and in the towns were to be enrolled at the police office, and field workers required passes to enter the towns. The state of exception was no longer localized to the plantation, as it had been under slavery, but was nationalized and enacted under the supervision of the police, rather than by overseers, who served at police pleasure. The functions of plantation oversight that foreshadowed panoptic discipline were thus directly transferred to the police, but with no pretense that moral reform was intended. Rather than relying on one individual, policing was depersonalized and bureaucratic, forestalling insurrection in the manner of Haussmann's later disciplining of Paris. Although the editors of the local press pointed out that in Denmark a constitutional monarchy with freedom of the press had been established, censorship remained in force in the colonies. The result was that over ten million pounds of sugar were exported from St Croix from January to May 1849, almost all going to Denmark.[23] Just as the revolutions of 1848 in Europe began in optimism only to end in setback for the working classes, so did the colonial revolt transpire with all conditions for the workers, other than their existential freedom, unchanged. On the commercial island of St Thomas, a similar system was announced, but most of the fieldworkers had already abandoned the plantations and headed into Charlotte Amalia, where they now worked day-to-day on the docks, the steamers, or as best they could. Capitalized, trading St Thomas, with its new urban lumpenproletariat, confronted and interfaced with the highly policed cultivation of St Croix. This counterpoint enacted the model to be described by Marx, in 1852, as having defeated the revolutions of 1848—an imperial order, backed by the military, the clergy, and the violence of marginal urban groups, stood in tension with the peasantry.[24] Whereas Marx saw the French peasantry as divided between revolutionaries and those who imagined themselves to benefit from the Second Empire, the colonial peasantry was under less illusion but greater duress. The policed plantation allowed for the maintenance of cash-crop colonialism until the riots of 1878, which, combined with the availability of sugar beet and Indian sugarcane, finally ended the regime of bonded labor. The islands were sold to the United States, in 1917, and became the U.S. Virgin Islands.

The lives of the newly emancipated African working class on the "metropolitan" St Thomas side became the central subject for Pissarro's drawing and sketching until he left the island, in 1852. Recent scholarship has re-attributed to Pissarro a large number of works formerly believed to be by the Danish artist Fritz Melbye, with whom Pissarro was to travel to Venezuela in 1852–53. If one accepts these sometimes controversial attributions, Pissarro also made drawings in Christiansted on St Croix, and in Santo Domingo, the other nation on the island of Hispaniola, which it shared with Haiti.[25] Pissarro would have been well-informed about Haiti as his mother (and aunt: his father married his brother's widow), Rachel Monsanto Pomié, was from Saint-Domingue, which the family had abandoned in haste, in 1796.[26] Rachel brought with her two formerly enslaved servants, who continued in her employ even when she later moved to France. So Pissarro cannot have been lacking in information or opinion about abolition and the revolutions of the enslaved. Furthermore, he had grown up in a district of Charlotte Amalia that was as much African as Jewish. Edward Wilmot Blyden, later a Liberian statesman and theorist of African diaspora, was born in this neighborhood, in 1832, and later recalled "for years, the next-door neighbours of my parents were Jews. I played with the Jewish boys and looked forward as eagerly as they did to the annual festivals and feasts of their church."[27] Blyden's continuing sense of African-Jewish affinity even led him to suggest that the diaspora Jews of Europe should resettle in Africa to contribute their experiences of exile and cultural accomplishment to the development of the continent.

Pissarro's Caribbean drawings and later paintings depicting life after abolition were by contrast studiously without comment, whether sympathetic or hostile, leading to divergent critical responses. Whereas one American critic has recently disparaged these works as "fundamentally colonialist," a Venezuelan curator has suggested that Pissarro's "reproductions of the Antilles society's poorest class did not intend to draw an exotic image from cultural difference."[28] Elements of both views were made available by the artist, as the poet Derek Walcott has seen.

The St. Thomas drawings have it, the taint
of complicit time, the torpor of ex-slaves

and benign planters, suffering made quaint
as a Danish harbour with its wooden waves.[29]

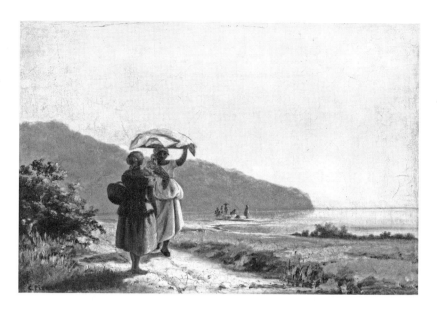

FIGURE 31. CAMILLE PISSARRO, *TWO WOMEN CHATTING BY THE SEA* (1856).
Collection of Mr. and Mrs. Paul Mellon. Photo courtesy of National Gallery of Art, Washington.

Take Pissarro's painting *Two Women Chatting by the Sea* (1856), made shortly after his arrival in Paris that same year (see fig. 31). At first it seems a quiet rural scene. Two African women dominate the foreground, pausing in conversation on their journey. In the background, other women can be seen at the water's edge. To a St Thomas resident, it would have been clear that they were just outside Charlotte Amalia, so that the painting's spectator would be looking, as it were, from the city. Here the metropole looks at the newly emancipated (lumpen)proletariat, creating a range of possible meanings in the aftermath of the slave revolution of 1848. There were over two thousand African women in Charlotte Amalia, considerably outnumbering the men. While many were domestic servants, women also served to unload and coal the steamers that plied the port. The women in the foreground of Pissarro's painting were journeying traders, who had the greatest freedom of movement in the African population before and after slavery.[30] It was widely believed that they had in fact distributed instructions for the insurrections of July 1848. Governor Von Scholten reported: "Women . . . do the same work that men do and their physical build and size render them formidable adversaries in a fight. Throughout the disturbances, they were more

aggressive, vengeful and altogether more violent than the men."[31] Pissarro's painting could be interpreted as showing the leaders of a successful slave revolt to a Parisian public that had just experienced its own 1848 revolution one of whose achievements had been the abolition of slavery. In that sense, these women were heroes of countervisuality. By the same token, Pissarro could also be taken to have represented the unimpassioned surveillance of the postrevolutionary policed plantation. It can be affirmatively said that the painting does not participate in the racialized or sexualized caricature that was so common in the period. Rather, in using Sawkins's anthropological distancing, Pissarro left it to the spectator to choose what he or she believes is represented. While few French people knew about the events in St Thomas, debates over the status and humanity of Africans relative to Europeans were well-known. Are these women simply enjoying a break from work? Or are they idling away the day and refusing to work, as the opponents of abolition maintained was endemic to all Africans? Or are they even engaged in plotting the overthrow of colonial slavery? The small painting represents the ambivalence in the metropolitan consideration of abolition and defers its own response by asking its audience to make a decision as to what they see.

It is important that the painting was made in Paris, not in the Caribbean. The presumed audience were, then, French subjects of the Second Empire (1852–70), rather than Danish colonials or emancipated slaves. The painting had resonance not just as Orientalism but as an expression of the new imperial condition. Baron Haussmann had instigated a transformation of Paris that drove long straight avenues through the formerly narrow streets of the city center, displacing working-class neighborhoods in order to aid troop movements, create lines of fire, and prevent traditional barricades. These new clear lines of sight in Paris recalled the careful clearing of space around the plantation house and the colonial militarization of everyday life. Benjamin reiterated Haussmann's own view that the Baron succeeded "by placing Paris under an emergency regime."[32] Haussmann suspended municipal government in Paris to prevent any objection to his radical project of rebuilding, and by relocating the laboring population away from the city center to the suburbs, he created what was known at the time as "segregation," albeit on the lines of class rather than ethnicity. Slavery's politics of policing and separation had now interpenetrated the metropole. Louis Napoleon, the future Napoleon III, who some believed to have been inspired by Carlyle's vision of the Hero, had occupied himself while in prison,

during 1842, with writing an *Analysis of the Sugar Question*.[33] His vision of sugar as key to the "Napoleonic idea" led him to energetically support both the cultivation of sugar beet and the "maintenance of slavery. . . . We may as well suppress the cultivation of the cane, as proclaim emancipation."[34] Deprived of slavery by the emancipation proclamation made in 1848, Louis Napoleon nonetheless availed himself of its absolute sovereignty by means of the state of exception. The first Napoleon had decreed that a city could be designated as under a state of siege "whenever circumstances require," a power that Napoleon III abrogated to himself in January 1852.[35] Indeed, the state of exception is centrally concerned with space and its management, a practice with which Haussmannization has become synonymous. In this context, the "inside" of the metropole became interpenetrated with the "outside" of the colony, so that the maintenance of order became equated with the necessity of sugar production, a commodity ventriloquized by Louis Napoleon as saying, "'I organize and moralize labour.'"[36] The order of the plantation was interfaced with the reforming goals of the disciplinary institution in the framework of imperial capital. This blurring produced the sensation of phantasmagoria identified by Marx, Carlyle, Benjamin, and Du Bois alike as epitomizing the modern. Modernity was, then, the product of the real interpenetration of colony and capital that realist means of depiction struggled to represent.

ABOLITION AND THE RIGHT TO LOOK

The modernist attempt to depict the real created by modern capital suffered from a permanent disadvantage. Whereas the "state of emergency" permitted authority to act with a clear degree of impunity and imprecision under the Roman law rubric "necessity has no law," modernist realism struggled to both represent that imprecision and to suggest some form of alternative, as Pissarro's Caribbean painting and drawing illustrates. At precisely this moment, Marx summarized the dilemma of revolutionary change as "the creation of something which does not yet exist."[37] In the terms under discussion here, that creation took two forms. It was necessary, first, to name what was being created, and then to give it visualizable and recognizable form. In short, this was a task of imagination. The enslaved in the United States engaged in this representative labor immediately at the outbreak of the Civil War. As soon as hostilities commenced, the Sea Islands of South Carolina were captured in a swift attack by Union

forces, in 1861, causing the plantation owners to flee in disarray. With the Emancipation Proclamation still two years off, the status of the enslaved Africans left behind was unresolved, in a kind of juridical no-man's-land or interregnum. It was clear enough to many African Americans that this kind of freedom was better than none, and enslaved Africans from Savannah and elsewhere made their way behind the Union lines. The nurse Susie King Taylor later described how she joined the exodus with her uncle, his family of seven, and over twenty others. In June 1862 a rumor circulated that the war might be settled and the Africans on the Union side would be sent to Liberia. King told a chaplain that she would choose this expatriation over any return to Savannah.[38] For Du Bois, writing in 1935, such expressions showed that this mass migration was not a casual activity but a general strike of the enslaved, a decisive move to end forced labor: "This was not merely the desire to stop work. It was a strike on a wide basis against the conditions of work. It was a general strike that involved directly in the end perhaps half a million people."[39] Even today one can read historical accounts claiming that the abolition of slavery had been inevitable since 1776, as the logical endpoint of the Declaration of Independence. King, Du Bois, and many others insisted to the contrary that slavery was ended by the enslaved themselves.

Timothy O'Sullivan, who later became famous for his photographs of the American West, captured the "general strike" against slavery as official photographer for the Army of the Potomac.[40] At the Old Fort Plantation, Beaufort, O'Sullivan took a group photograph of well over a hundred African Americans (see fig. 9, p. 44).[41] The group represented a mix of those on the move during the war and those to whom the war had suddenly arrived where they were already located. There were African Americans illegally volunteering for the Union army, known as "contrabands," wearing soldier's caps (most clearly visible at the extreme left of the image, third row back). The term was a legal fiction, allowing the soldiers to serve as, in effect, spoils of war, reinforcing the paradox that these soldiers fighting for freedom were not free and had "stolen" themselves. In O'Sullivan's photograph, many people are carrying small bundles of personal property, all that they could bring with them from slavery to this interstitial space. The camera was placed high up, seemingly on the roof of a former slave cabin in order to get everyone into the shot in a bright sharp light that produced some strong contrasts leaving some faces in "white-out," others too dark to see. Others moved before the exposure was complete, creating a "ghost" at the

left edge and many blurred expressions. The long exposure time prevented any overt displays of celebration, but the very event of the photograph itself suggests that all the participants were aware of the historical significance of the moment. There was no leader present, no suggestion of a hierarchy. Men, women, and children are gathered together in a collective assertion of their right to look and therefore be seen. Under slavery, the enslaved were forbidden to "eyeball" the white population as a whole, an injunction that was sustained throughout the period of segregation and is active in today's prison system. So the simple act of raising the look to a camera and engaging with it constituted a rights claim to a subjectivity that could engage with sense experience. The photograph can therefore be seen as depicting democracy, the democracy so feared by Plato and Carlyle, the absence of mastery. Under Roman law, an interregnum was a state of exception that called for the appointment of an *interrex*, the king of the in-between. In O'Sullivan's photograph we can see the *interplebs*, the in-between people. On the Sea Islands, the space between regimes became a space without regime, democracy.

This interstitial space was further visualized by the New Hampshire photographer Henry P. Moore, who accompanied the Third New Hampshire Volunteers to the Sea Islands during this interregnum period. In his photograph *Rebel General T. F. Drayton's House, Hilton Head, S.C.* (1862–63), the gates to the plantation house, which would formerly have been inaccessible to field hands, now stand wide open, held apart by a Union soldier in uniform, on the right and an African American woman, on the left, who wears the African kerchief and strong clothes typical of field hands.[42] An unlikely coalition of a New England soldier and a formerly enslaved woman opens the door to a new future, even as they seem to keep the maximum distance between them. This doubtless posed scene has attracted the interest of two other African women on the steps of the house itself, whether former "house" slaves or curious outsiders. The house seems unforgiving, with its front door shut and much of the façade obscured, as intended, by the hedges and trees at the edge of the garden. In another striking photograph, *J. F. Seabrook's Flower Garden, Edisto Island, S.C.* (April 1862), Moore appropriated the planter's hidden viewpoint from within the "big house" (see fig. 32). Taken from an upstairs window in the mansion of the departed Seabrook, Moore's picture shows a world turned inside out, but not, as the Confederates had predicted, reduced to chaos or disorder. The calm, orderly transition made visible here put the plantation economy into the background, where the slave quarters and open fields of the plantation are

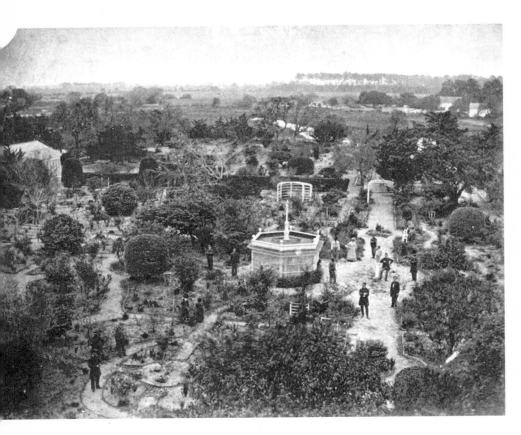

FIGURE 32. HENRY P. MOORE, *J. F. SEABROOK'S FLOWER GARDEN, EDISTO ISLAND* (1862).

clearly visible. Indeed, the photograph shows quite well how plantations were designed to be fully visible from the planter's viewpoint. In the foreground, representing the present, the elaborate artifices of the planter's garden can be seen, with its paths now peopled by a mixture of soldiers (including the commanding officer Colonel Enoch Q. Fellows, in the right foreground, with folded arms), former slaves, and contrabands. On a pedestal that might have been intended for a neoclassical statue, a young African American boy stands and salutes next to an officer also posing elaborately. This satirical gesture of obedience to the planter's house would have been impossible only weeks before, and its irony is mixed with a respect for the forces of liberation represented by the camera. There is an unintended resonance with Marx's description of slavery as the pedestal of wage labor

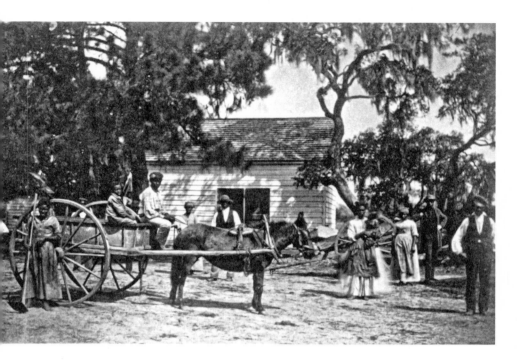

FIGURE 33. HENRY P. MOORE, *G'WINE TO DE FIELD* (1862).

and an anticipation of Barthes's famous analysis of another saluting teen-age African soldier during the liberation struggle in Algeria (see chap. 6). In these photographs, men, women, and children; former slaves, contrabands, and Union soldiers all show an awareness of the rhetorics of the photographic pose and their possibilities.

Moore also created staged photographs of enslaved life, lifeless tableaux such as *Sweet Potato Planting* and the minstrel-titled *G'wine to de Field* (both April–May 1862). This latter would become his best-known photograph despite—or because of—its hollow feel and the careful absence of any soldiers, whether white or contraband (see fig. 33). It shows a line of some ten African Americans, presumed to be former slaves because of their uniformly dark skin tone, centered around a two-wheel cart hitched to a pony and being driven by a child. It was seen as sensational because it represented a historic transition. When published in the *Philadelphia Photographer*, in 1865, the caption declared: "Such a one as we present in the issue can never more be taken. When they were taken, they were slaves; now they are free men and women."[43] In this view, abolition realism was a single, never-to-be-

repeated moment, rather than a division of the sensible. Against that snapshot version of abolition, General Sherman's Special Field Order no. 15, dated 16 January 1865, imagined what became known as Reconstruction. Under the command of General Saxton, inspector of settlements and plantations, the islands were to be the exclusive site of resettlement for displaced free people. When three or more families expressed the desire to settle, the inspector would allocate to each group the famous forty acres of tillable land. Here oversight and the policed plantation were to be reversed so that the police were now in charge of reallocating the land in small holdings to the formerly enslaved, just as they had long desired. Sherman was responding to the revolutionary change enacted since the fall of Port Royal, in 1861, and by institutionalizing and bureaucratizing a procedure for Reconstruction, he opened the possibility of a distinctly different postbellum South.

The freed responded to the invitation with alacrity, creating new political, financial, and educational networks that enacted the popular heroism of Atlantic revolutions. Just as in Saint-Domingue and France, the franchise was expanded beyond people of means; new state-organized education was created; and those formerly considered commodities were recruited into the capitalist means of circulation. I am referencing here the research findings made by Du Bois, as both valid information in themselves and evidence for the strategic use he made of them. He highlighted the reforms enacted, in 1868, by the South Carolina Constitutional Convention, whose scandal was that "twenty-three of the whites and fifty-nine of the colored [delegates] paid no taxes whatever."[44] It was, argued Du Bois, "singularly to the credit of these voters that poverty was so well represented" (391). At the state labor convention in 1869, workers demanded half the crop or a wage of seventy cents to a dollar a day, depending on the nature of the task. At the heart of the freedmen's project was education. Du Bois insisted "public education for all at public expense was, in the South, a Negro idea" (637). A school had been opened in Port Royal as soon as it fell, and others followed in Beaufort and Hilton Head as early as January 1862 (642). In South Carolina, the new State Constitution of 1868 provided for universal education from the age of six to sixteen, as well as opening schools for the disabled. By 1876, when Reconstruction came to an end, some 123,000 students were enrolled (649–50). In the economic field, the Freedmen's Bank in Charleston, South Carolina, held over $350,000 in deposits from 5,500 depositors by 1873, indicating that the laboring classes were the key to the bank (416). Taken together with the homesteads, wage-labor rates, and the

right to vote, South Carolina enacted a radical alternative to slavery, replacing chattel labor with a rights-centered democracy. These forms of abolition democracy so contradicted majoritarian concepts of representation and realism in the United States that even today they sound "unrealistic," unachievable, even hard to imagine. In part, that difficulty is the legacy of D. W. Griffith's film *Birth of a Nation* (1918), which depicted the South Carolina legislature so scurrilously but so unforgettably that its images have overdetermined the historical account.

Despite Sherman's field order, it was sharecropping that became the "standard" form of labor in the postbellum South and kept the majority of African Americans in poverty. Sharecropping was a system in which a group worked a given plot of land in exchange for a percentage of the crop, usually to the marked advantage of the planters. The crop share was not made until the end of the year, so a credit system emerged, making it difficult for the share croppers to ever lay their hands on money, let alone accumulate capital.[45] Du Bois represented this reversion as a second civil war, "a determined effort to reduce black labor as nearly as possible to a condition of unlimited exploitation and build a new class of capitalists on this foundation" (670). During Reconstruction, farm workers organized to try and improve their conditions, in which their crop shares ranged from a tenth to a third, while wages were at no more than fifty cents a day, resulting in farm strikes in 1876 (417). However, the Bureau of Freedmen insisted on the freed signing year-long labor contracts that locked them into disadvantageous situations, and after the end of Reconstruction, no other redress was available. Cotton was best suited to sharecropping, and by 1870 it was dominant across the South. So by the time Winslow Homer depicted *The Cotton Pickers* (Los Angeles County Museum of Art, 1876), there was no reasonable doubt that their labor was unfairly rewarded. Homer's painting suggests as much in the disengaged and abstracted quality that the African American women of the title bring to their work, contrasted by the art historian Katherine Manthorne with Homer's *The Veteran in a New Field* (Metropolitan Museum, New York, 1865), in which a former Massachusetts Union (white) soldier sets about reaping wheat, a crop that implies his ownership of the land. By contrast, the cotton pickers are overwhelmed by the field in which they find themselves, highlighting what Manthorne calls "the paradox of the plantation: images of harvest usually connote settlement, a stake in the earth, while the plantation bespeaks the opposite."[46] For the new plantation refused the freed the ownership of land that they had wanted in order to

create a new global class of cash-crop producers on whom industry would depend. While the cotton pickers in Homer's painting are "free," they certainly do not have autonomy or manifest a right to look.

1867: ABOLITION ENTANGLEMENT

In 1867, Reconstruction was just beginning in the United States. It was also the year of Baudelaire's death, marking the end of an era in Paris. The upheavals in the Americas came back to the "capital" of the nineteenth century, in a series of interpenetrated cultural and political shocks. In this year, Edouard Manet began his series of paintings depicting the results of French imperial adventurism in Mexico; Pissarro developed a "revolutionary" new style of painting in dialogue with the Puerto Rican antislavery painter Francisco Oller; and Marx finally published the first volume of *Capital*. These events were more than coincidence. Rather, the plantation was a significant "entanglement" within European modernity, to use Achille Mbembe's useful term.[47] If one looks around the virtual portrait gallery of the period's avant-garde created by Félix Nadar's photographs, in whose studio the first Impressionist exhibition was held, in 1874, many had a direct relationship to the interpenetration of the city and the plantation. First, there was Charles Baudelaire, seen by Walter Benjamin as the poet of modernity because it embedded itself in his body, like a photographic negative.[48] That embodiment was itself in counterpoint to that of Jeanne Duval, Baudelaire's partner, usually described as his "mistress," an odd title for the granddaughter of an enslaved woman, whom Baudelaire represented as a sex worker. Then there was Victor Schoelcher (1804–93), the leading abolitionist campaigner in France, and Alphonse Lamartine, who decreed abolition. Alexandre Dumas, père, was, whether one thinks it relevant or not, very visibly the son of his African-descended mother from Saint-Domingue (see fig. 34). When one sees the poet Charles Cros (1842–88), known as a precursor to the surrealists, it is not hard to see why many people thought he was of African descent. Others, at one degree of separation, would include Delacroix, painter of the French occupation of Algeria, in 1832, and the anarchist Proudhon. There was Manet, whose antislavery radicalism was part of his work.

By 1867 Pissarro was part of a group of younger artists struggling for acceptance, who were to become known as the Impressionists, while he continued to socialize and work with Caribbean acquaintances, like his cousin,

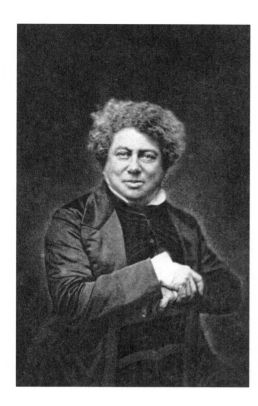

FIGURE 34. FÉLIX NADAR, *ALEXANDRE DAVY DE LA PAILLETERIE, CALLED ALEXANDRE DUMAS, PÈRE* (1855). Photograph. Photo courtesy of Adoc-photos / Art Resource, New York. Dumas (1802–1870) was a noted French writer.

the novelist Jules Cardoze, and the Puerto Rican artist Francisco Oller y Cestero.[49] The two artists had very distinct conceptions of themselves. Pissarro was, and remained throughout his life, a Danish citizen, a fact that he later used to free his son Lucien from the obligation of French military service. Although he worked with the Danish artist David Jacobsen, Pissarro never went to Denmark or otherwise expressed interest in his nationality of convenience, imagining himself "French" in all but name. Oller by contrast was strongly invested in an independent postslavery Puerto Rico. He clearly felt a strong identification with his predecessor José Campeche, as he copied Campeche's self-portrait—which unusually depicted the artist as a dark-skinned man, although one cannot be sure that Campeche's original did so—and later even lived in his house. This cross-ethnic identification with the past was both nationalist and decolonial. Although he spent extended periods of time in France and Spain, Oller predominantly lived and taught in Puerto Rico, to the mystification of his European artist friends. The counterpoint between the two artists, who met only once after 1867,

turned on the questions of slavery, abolition, and the politics of (national) representation.

Oller seems to have known Pissarro from 1859 onward, when they were taking classes in Paris, with the *juste-milieu* artist Thomas Couture and the landscapist Corot respectively. A handful of letters survive, giving us a fragmentary view of the friendly and intimate exchanges between the emerging artists. In December 1865, writing in reply to Oller's letter from Puerto Rico, Pissarro expresses relief at knowing Oller's whereabouts and jokes that he and Guillemet had assumed Oller had disappeared into "some corner of Paris in the company of some beauty."[50] Although Pissarro understood Oller's need to earn some money, he warned him away from official commissions, especially from the church, following Oller's gift of his painting of the crucifixion *Les Ténèbres* (exhibited at the Salon of 1864) to the Jesuits.[51] Strikingly, Pissarro encouraged Oller to begin a "study of a mulatresse," an apparently unlikely suggestion. However, both artists had become friends with Paul Cézanne at the Académie Suisse in 1861. According to Cézanne's dealer Ambroise Vollard, it was in 1865 that he painted his study of *The Negro Scipio*, a model at the Académie Suisse (see fig. 35).[52] This substantial portrait, once owned by Monet, has been largely ignored by art history but resonates with the abolition debates of the time. It shows Scipio seated, wearing only worker's blue trousers, leaning forward onto a white mass. The painting exaggerates the length of his back and creates a strong resemblance to the notorious photograph known as *The Scourged Back* (1863). The photograph showed a man known as Gordon, who had escaped from slavery to enlist in the Union Army, only to be recaptured and whipped on Christmas Day, 1862. As a result, his back was covered in scars, which form the subject of the photograph, reprinted in *Harper's Weekly* for 4 July 1863. The dates are significant: Christ was scourged before his crucifixion, lending the photograph its title, while the publication of the photograph on Independence Day was surely intended to remind readers of the justice of the Union cause. The textured surface of Cézanne's painting of Scipio, with a red suggestive of blood clearly visible in places seems intended to evoke Gordon's scars. Certainly his unlikely classical name—contrasted with the "Jeanne" who was a model for Manet's *Olympia*, also in 1865—suggests that he was born into American slavery, where such naming practices were common. In this context, the white mass might be read as a bale of cotton, emphasizing the American dimension of the image. Whatever Cézanne's poli-

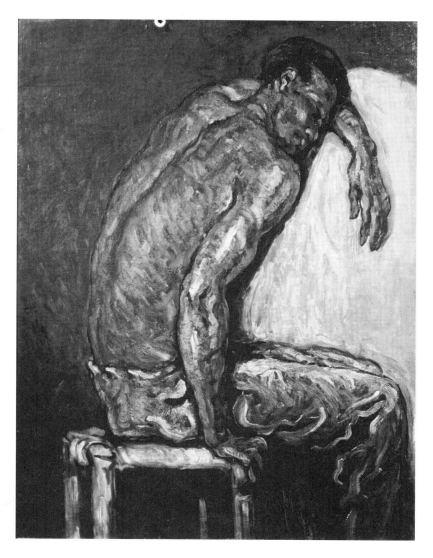

FIGURE 35. PAUL CÉZANNE, *THE NEGRO SCIPIO* (1865), MUSEU DE ARTE,
SAO PAOLO. Photo courtesy of Bridgeman-Garaudon / Art Resource, New York.

tics in his later days, *The Negro Scipio* deserves to be discussed in the context of Atlantic world abolition.

Certainly, Oller produced a painting more in keeping with abolition realism than with the Caribbean ambivalences suggested by Pissarro. Oller's *Negresse libre et mendiante* (now lost) was exhibited at the Salon of 1867, and to judge by the title, it did not depict a "mulatta," but a free African woman, forced to beg to support herself. Such scenes were taken to be an indictment of slavery, still in force in Puerto Rico. Indeed, another painter from this group, Antoine Guillemet, wrote to Oller, at Pissarro's suggestion, in September 1866, offering an unusually extended critique of an abolition realist painting. While the painting had "much character," Guillemet told Oller, "Your two figures do not agree with the background, you like Manet and will understand. The figures are very well modeled but lack appropriate *tâches*."[53] This remark suggests that the woman was accompanied by a child, perhaps lighter skinned to indicate the familiar scandals of miscegenation under slavery. The *tâche*, or patch, was the central idea of the new painting, seeking to develop form by color, rather than by line drawing. Guillemet wanted Oller to reconfigure his entire style and "treat [figures] like landscape." He criticized the portrait as having "an atrocious red background, why not work in the open air," the famous *plein air* mantra of the 1860s group. He worried further that the figure of the African woman did not stand out enough from the background. In a contradictory passage, Guillemet continues: "Your technique is good, we don't give a fuck about the rest, you know that. See by patches, technique is nothing, *pâte* and *justesse* [precision], those are the goals to pursue." Guillemet argued that "there is nothing more than the *tâche juste*," blending the exactness of *justesse* with the connotation of "justice," as if color properly seen and described would in and of itself entail justice—an abolition realism accomplished by technique as much as subject matter.

For there was a strong sense that radical aims could be now achieved by formal visual means, tending away from the content of the image toward a radicality of style. Courbet's famous claim that, as a realist, he could only paint what he saw was now being broken down into the constituent units of seeing, a riposte to those worldviews, like visuality, that claimed a unity of visual perception and understanding. The novelist and journalist Emile Zola articulated the connections between radical politics and the new aesthetics as what can be called corporal anarchy. In his review of the Salon of 1866, Zola hailed Pissarro as a fierce revolutionary, describing his paint-

ing in terms that evoked the virtue espoused by the Jacobins of 1793: "A painting austere and serious; an extreme concern with truth and accuracy, a will fierce and strong."[54] This realism was taken to be radical in and of itself, whatever the subject matter. Against the heroism of empire, Zola deployed an individualism that he called "the free manifestation of individual thoughts—what Proudhon calls anarchy."[55] Rather than accede to heroic visuality, Zola described a particularity of individual perception that could not be fused into one grand vision, except as the stale and moribund production of the academies: "It is our body that sweats the beauty of our works. Our body changes according to climate and custom, and the secretion changes accordingly."[56] This desire to individualize, to break up the heroic imperial body into its constituent parts, did not predicate a future reordering of the social. It was as pure opposition to the empire that the aesthetics of national unity could be sustained, an illusion that ended even before the conflict of the Commune.

This political aesthetic of individualized rebellion by formal means was less coherently expressed by Guillemet in the conclusion of his (unpunctuated) letter to Oller.

> Courbet has become classic. He does superb things next to Manet it is tradition and Manet next to Cézanne becomes it in turn. Try to come back. Borrow from your sister-in-law, get money there is only Paris— what the devil, do you want to do in Porto Rico [*sic*] what Pissarro did in St. Thomas, what I did in China we are painting on a volcano the '93 of painting is going to sound its funeral toll the Louvre will burn the museums the classics will disappear and as Proudhon says, only from the ashes of the old civilization can the new art come. Fever burns us; today is separated from tomorrow by a century. The gods today will not be those of tomorrow, to arms, seize in a febrile hand the knife of insurrection, let's demolish and build—and *exegi momumentum aere perennius* ["I have built a monument more lasting than bronze," Horace].[57]

Guillemet saw his present as the returned Jacobin moment of 1793, now in painting not politics, and thereby as the anarchist refoundation of society— Zola's blend of Jacobin austerity and Proudhonian individualism. Paris was capital of all revolution and all ferment, whereas the colonies, whether in Asia or the Caribbean, were not even its suburbs. All this from the tâche, from seeing color "as it is," from treating the body as a landscape and as the source of art. And the leading practitioner of this revolution was to be

Pissarro, who "makes masterpieces . . . he even had the audacity to send a realist slice of life to the Universal Exhibition."[58]

So what did all this realist revolution look like? Pissarro's painting *The Hermitage at Pontoise* (Guggenheim Museum, New York, 1867) was by far the largest painting yet attempted by the artist, suggesting that it sought to visualize the ambitious project Guillemet had described (see plate 7). It renders what at first sight seems like a minor scene on the scale of a history painting. The painting shows a little hamlet among some hills and fields with a few figures. The meeting between two women from his St Thomas painting was now reworked and reduced in the foreground. These meetings in turn foreshadow those he would paint in decades to come, extensively analyzed by T. J. Clark.[59] One woman, standing with a child, appears to be in authority, shading her face from the sun with a parasol, which makes it clear that she does not work outdoors. She is speaking to a woman who is darker-skinned, from field labor, standing with her arms deferentially held behind her back, leaning in as if to hear her instructions. Here the encounter is between women of different classes, a difference that is signified through the small "patches" of skin color. Yet Guillemet's direction should send us to the landscape, for the corollary of painting the body as a landscape might be to paint the landscape as a body, as Monet would later do. As one looks at Pissarro's landscape, it does not represent a single body, but rather a division of the sensible appears. On the left-hand side of the canvas, the smaller houses of the peasantry are jumbled together in a mass, with one open window visible, high in the attic of a house. On the right, a larger collection of buildings, which can be presumed to be that of the landlord-farmer or his local deputy, overlooks the entire hamlet through a sequence of windows. Despite the heat, a fire is going in the main house—perhaps a meal is being prepared—while the peasant houses are closed up and quiet, in the middle of the working day. The land on the right is dedicated to pastoral, whether as garden, uncultivated land, or fruit trees. On the left, the working fields are visible, albeit at a vertiginous angle. The three working people and two village children that can be seen keep to "their" side of the hamlet, marked by the unpaved path. There is a zone of transition between the two spaces, a fiercely worked "patch" of brown paint that perhaps represents a wall, but is really nothing more than paint. It is the color of the fields, of the peasants' skin. In its wet-painted-into-wet swirls and valleys, this patch of color suggests the violent affect of rural class struggle in a deferential society, a threat that was always present, if rarely articulated.

The painting itself defers its explication of difference, with the transitional zone pushed back in the picture space, just off the center that is taken by the white house. If this is "'93 in painting," it was displaced because Paris was under a state of emergency that was rendered here as the plantation evoked by Girardin, a watchful waiting for a peasant insurgency that may be imminent or may never come. One has to look hard to see this difference in the painting, a sign of Pissarro's persistent hesitation to be too direct or unambiguous. Taken with Guillemet's enthusiasm, it perhaps explains Cézanne's cryptic remark that if Pissarro "had gone on painting as he was doing in 1870 he would have been the strongest of us all."[60] It did not last long. In that same year, Guillemet wrote to Zola: "To put one violent tone against another as I did at Aix [with Cézanne] leads nowhere. It is the anarchy of painting, if I can call it that."[61] The proud claims of 1867 had been renounced even before the Paris Commune made such associations literally dangerous.

The short-lived aesthetic of corporal anarchy was the counterpoint to the disciplined body of the newly policed plantation. Nor was this counterpoint distant from the radical art of 1867, for it was in that year that Manet began his series concerning *The Execution of Maximilian* (see fig. 36).[62] As part of his project of heroic imperialism, Louis Napoleon installed Maximilian as a puppet in Mexico, only for him to be quickly defeated and executed. Manet's paintings of this moment, iconographically derived from Goya's *The Third of May, 1808*, were understood as critiques of Louis Napoleon, who even appears to be depicted as part of the firing squad in one of the paintings.[63] In these works, Maximilian appears as a hero by default, paying the price for the follies of imperial adventure. Others were less impressed. In *Capital*, published that same year, Marx noted that in Mexico, "slavery is hidden under the form of peonage. . . . Juarez abolished peonage, but the so-called Emperor Maximilian re-established it by a decree which was aptly denounced in the House of Representatives in Washington as a decree for the re-introduction of slavery into Mexico."[64] That being so, the studied neutrality of the peons looking over the wall at Maximilian's execution in the third version painted by Manet (now in Mannheim) takes on a different resonance.[65] So did Manet know? It seems unlikely that he did not. As a young man Manet had visited Brazil and seen slavery at first hand, visiting the "revolting spectacle" of a slave market.[66] He carefully studied newspaper accounts of Maximilian's death and altered details of his paintings to be more exact. In 1864 he painted two scenes from the Ameri-

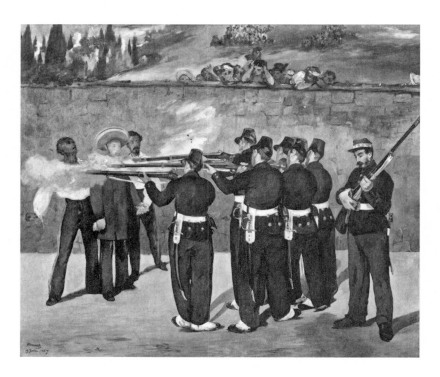

FIGURE 36. EDOUARD MANET, *THE EXECUTION OF THE EMPEROR MAXIMILIAN OF MEXICO* (19 JUNE 1867). Oil on canvas, Staedtische Kunsthalle, Mannheim, Germany. Photo courtesy of Erich Lessing / Art Resource, New York.

can Civil War naval battle that had taken place off the coast of France, the well-known *Battle of the Kearsage and Alabama*, and, to emphasize his support for the Union, a less well-known study of the *Kearsage* in harbor in Boulogne.[67] His work as a whole was understood as implicating slavery's histories. For example, a caricature version of his solo exhibition during the Universal Exhibition of 1867 featured a drawing of his scandalous painting *Olympia* (1865), in which the African servant speaks to the white prostitute in Haitian Kreyol, as if it were a form of abolition or revolution to paint the two women together.[68] Above all, there is the evidence of the paintings themselves. For why did Manet repeat this scene in three distinctly different ways if he did not feel that there was something fundamentally wrong with his earlier versions? Did not that sense of error stem from his knowledge that Maximilian was no hero, even in death, and that the real suffering lay with the laboring poor? It was not until he found a way to include them in his piece that he finally set the subject aside. All these debates were

undoubtedly well-known to Pissarro and Guillemet—and thereby Oller—because, in 1868, Guillemet was the model for the cigarette-smoking man in Manet's classic scene of modern life *The Balcony*.

Oller refused the lure of Paris's capital and remained in Puerto Rico, living in Campeche's house, painting against slavery, which he called "an institution which is an outrage to human nature."[69] Slavery disrupted in this view the very workings of the body that so exercised Zola. In six years, Oller created a corpus of antislavery work, known now only by their titles: *A Slave Flogged*; *A Slave Mother*; *The Punishment of a Slave in Love*; *A Beggar*; *Stonecutter*; *Rich Man's Lunch, Poor Man's Lunch*; and *Negresse libre et mendiante*. Together with his work as the founder and teacher of Puerto Rico's Academy of Drawing and Painting, where he had eight students, both men and women, Oller had decided to use art as abolitionist activism.[70] For in nineteenth-century Puerto Rico the enslaved population had tripled and production had increased by over one thousand percent. In 1870, the Spanish government decreed a gradual abolition of slavery by emancipating those over sixty and all newborn children. The Moret Law, as it became known after the foreign minister Don Segismundo Moret y Pendergast, rendered the freed into a form of apprenticeship, the *patronato*. At the same time, a forced labor regulation of the revolutionary era of 1849 was revived. The enslaved responded by what the British consul called "an outbreak of the slaves, or at least their refusal to work." This general strike came to a head on the Hacienda Amelia, where the leader of the strikers was publicly flogged in contravention of the Moret Law.[71] So when Oller's next submission to the Paris Salon was his *Flogged Slave* (1872–73, now lost), it was a gesture of protest. Known only through a mediocre print that plays up the sexualized aspect of the African body in pain, the painting nonetheless wanted to insist that what was real was not the "patch" but the violence of slavery. Rather than being a generalized protest, as has usually been assumed, it depicted the scene at Hacienda Amelia, showing the rebel tied to the ground as he is flogged by an overseer in the presence of other enslaved witnesses and a protesting white woman. This corporal realism did not insist on a separation of visual and physical perception in its assemblage of the real, including pain, especially pain inflicted by others in the name of profit. One might say that there is nothing more real than pain as it is being experienced, yet it resists representation.[72] Oller's painting was refused by the Salon and ignored by the press in the Salon des Refusés of 1875, where it was finally exhibited, two years after colonial slavery had finally been

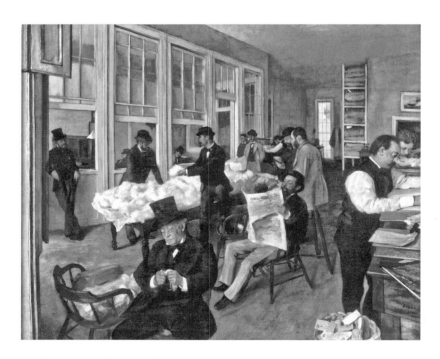

FIGURE 37. EDGAR DEGAS, *INTERIOR OF A COTTON BUYER'S OFFICE
IN NEW ORLEANS* (1873), MUSÉE DES BEAUX-ARTS, PAU, FRANCE.
Photo courtesy of Réunion des Musées Nationaux / Art Resource, New York.

abolished in Puerto Rico. In the Salon catalog the painting carried a caption
from Mirabeau: "Is to defer anything other than to tolerate a crime?"[73] That
deferral might have been the system of apprenticeship at first proposed by
the Spanish government or even the delay in exhibiting Oller's work. The
delay has consigned Oller to the status of a footnote in Pissarro's history in
most Western accounts of modernist painting.

With the emancipation of the enslaved in the United States, latter-day
histories of modernity and modernism have declared slavery to be over, and
move on in the endless pursuit of the new. In the period, matters were not
so clear. One might point to the painting by Edgar Degas entitled *A Cotton
Buyer's Office in New Orleans* (1873) as an example (see fig. 37).[74] A group of
white men in New Orleans examine cotton samples, read the newspaper
the *Daily Picayune*, study ledgers, or merely observe the proceedings. In
Benedict Anderson's well-known analysis, the newspaper was central to
the "imagined community" of nineteenth-century print culture. Here it
was being read by René Degas, the artist's brother, at a time of crisis for

the extended Degas family. The cotton business depicted was on the verge of collapse because Michael Musson, seen in the left foreground examining cotton, had invested heavily for ideological reasons in Confederate war bonds, which had now defaulted. New Orleans was one of the most contested locations during Reconstruction. African Americans organized politically from the beginnings of the war to be met with violence in the New Orleans riot of 1866, which killed thirty-four African American and three white delegates to the recalled constitutional convention.[75] Degas's uncle was a leading member of the Crescent City White League, which would defeat Republican militia and police in an open battle in New Orleans in September 1874.[76] Two years later, Degas's painting was exhibited at the second Impressionist exhibition, where it received favorable comment. The African American labor that produced the cotton, the majority population of New Orleans, or indeed the "mixed-race" relatives of the Degas family were again nowhere to be seen. The abolition counterpoint between Scipio's scarred back and the smooth white bale of cotton had been forgotten. For if the avant-garde artists now known as the Impressionists had engaged with abolition politics against the Napoleonic empire and slavery, they had already set it aside in favor of formal experimentation before the radical popular revolution of the Paris Commune.

THE PARIS COMMUNE (1871): ABOLISHING REALITY

"Travailler maintenant, jamais, jamais; je suis en grève"
[Work now? Never, never. I'm on strike]
—Arthur Rimbaud, 13 May 1871[77]

The Paris Commune was a moment of decentralized communal authority experienced in the wake of national defeat, a general strike against reality. It was the last of the Atlantic revolutions that began with the revolts of the enslaved, engendered the great revolutions in Haiti and France, and concluded with the wave of refusals that linked abolition in the United States, the 1865 Morant Bay rebellion in Jamaica, and other post-abolition risings in the Caribbean. To briefly summarize the often retold history: Napoleon's disastrous war against Prussia ended in defeat at Sedan and the proclamation of a republic on 4 September 1870. Carlyle wrote a famous letter to the *Times*, in 1870, supporting the Prussians and denouncing the French, that was held to have been influential in reducing British sympathies for

France. However, there was as yet no peace. Prussia besieged Paris through-out the winter of 1870–71, turning the metaphorical state of siege declared by Napoleon III and Haussmann into a literal conflict. The city refused to surrender, despite an almost absolute lack of supplies, until 28 January 1871. After an attempt to seize artillery pieces by the national government at Ver-sailles failed, the Commune was declared on 18 March 1871, defended by some 200,000 National Guards and the armed citizenry. For several weeks, a unique experiment in communal administration in one of Europe's largest cities played out, inspiring radicals and revolutionaries for over a century. It ended in terrible reprisals during the "bloody week" of May in which some 25,000 people were killed.

Although the Commune was brief, its example has been endlessly con-sidered by supporters and opponents alike, keen to discern what kind of political moment it had represented. While much of this discussion has centered around its relationship to the Bolshevik revolution, in the period parallels between the Commune and the American Civil War abounded on both sides of the Atlantic.[78] Victor Hugo had denounced the execution of John Brown after the Harper's Ferry raid of 1859, and the future Commune member Pierre Vesinier wrote a book placing Brown in a genealogy of revolutionary martyrs that included Vincent Ogé of Saint-Domingue.[79] In his report to the International, Marx described the Commune as "the war of the enslaved against the enslavers, the only justifiable war in history."[80] Marx repeated the metaphor of slavery throughout his text, turning the language of morality against the self-styled party of order. After the Com-mune's fall, many of those who survived, like the radical Louise Michel, were deported to the French penal colony of Nouvelle Caledonie, in the South Pacific, a return to actual slavery. And for those opposed to the Com-mune, it meant what Léon Daudet called "Paris in the hands of the blacks."[81] The lesson was not forgotten. In his play *The Days of the Commune* (1956), Bertolt Brecht directed that the set incorporate a series of banners, evoking the posters that were a key part of the ideological struggles of the event. The first poster read "The Right to Live," meaning a right to autonomy, a life lived outside the social death of literal and metaphorical slavery.[82]

The claim that the Commune represented an opposition to slavery illustrated its enactment of a different form of authority than the mysti-cal foundation of law, as visualized by visuality. In the struggle to form the Commune, new political bodies appeared, such as the Central Republican Committee of the 20 Arrondissements, formed after the declaration of the

republic. In a declaration published 9 October 1870, the Central Republican Committee redefined authority as autonomy: "Citizens: in this supreme danger to the homeland, with the principle of authority and centralization being convicted of powerlessness, we have hope only in the patriotic energy of the communes of France, becoming, by the very force of events, FREE, AUTONOMOUS and SOVEREIGN."[83] Here the law of necessity, usually cited to reinforce absolute state authority, was reconfigured and invoked as "the force of events" to institute an autonomous decentralization of all authority. When the events of 18 March 1871 required a response, it came from another new grouping, the Central Committee of the National Guard (hereinafter "the Central Committee"). Formed from men hitherto unknown in French or even Parisian public life, the Central Committee, as the Communard Prosper Lissagaray pointed out in his history, was the only body that articulated the popular demand for communal authority. The Central Committee organized elections and stepped down from power, declaring, "You have freed yourselves. Obscure a few days ago, obscure we shall return to your ranks."[84] From this place of obscurity, they had watched "the most grandiose popular spectacle that has ever struck our eyes and moved our souls. . . . Paris is opening a blank page in the book of history and is writing its powerful name therein."[85] Rather than the visuality of the hero, the Commune deployed from obscurity a dazzling popular spectacle that attempted to rewrite history not as the biography of great men, but as the actions of autonomous Paris, a collective name for the diverse populations of the city. "Paris" here updates the vernacular hero of earlier revolutions, such as the Third Estate and the sans-culottes, but did so with a strong sense of its genealogy.

In its autonomous impulse to decentralize, the Commune had strong affinities with antislavery revolutions in the Caribbean and the "general strike" against slavery in the United States. All these popular movements envisaged communities of small producers, whether on the provisions grounds of the formerly enslaved in the Caribbean, the "forty acres" of the United States, or the workshops of the Commune. It is noticeable that, just as in Saint-Domingue in 1791, the first efforts of the Commune were directed at working conditions, such as the regulation of night work, and the living conditions of the citizenry, especially as concerned rents. The experience of the Commune was, as many have remarked, one of a holiday or festival. It was the enactment of Benbow's Grand National Holiday, or general strike, at the level of the metropolis. One famous account, perhaps

by Villiers de l'Isle Adam, declared: "One enters, one leaves, one circulates, one gathers. . . . For the first time workers can be heard exchanging their appreciations on things that hitherto only philosophers had tackled. There is no trace of supervisors; no police agents obstruct the street hindering passers-by."[86] Here, then, in Rancière's sense, was a different division of the sensible, in which circulation did allow for the formation of a political subject of a kind appropriate to "the demonstrative temperament of essentially artistic people," as Jules Claretie put it.[87] The object of their practice was what Kristin Ross has called "the transformation of everyday life," an autonomy from state power.[88] When the Prussians entered Paris, the streets were decked with black flags, the fountains were dry and lights not lit. On the day after the elections for the Commune, by contrast,

> 200,000 "wretches" came to the Hôtel-de-Ville there to attend their chosen representatives, the battalion drums beating, the banners surmounted by the Phrygian cap and with red fringe around their muskets. . . . In the middle of the Hôtel-de-Ville, against the central door, a large platform was raised. Above it towered the bust of the Republic, a red scarf slung around it. Immense red streamers beat against the frontal and belfry, like tongues of fire announcing the good news to France. A hundred battalions thronged the square. . . . The banners were grouped in front of the platform, some tricolour, all with red tassels, symbolizing the advent of the people. While the square was filling, songs burst forth, the bands played the *Marseillaise* and the *Chant du depart*, trumpets sounded the charge, and the cannon of the old Commune thundered on the quay.[89]

Here the conscious echoes of the Commune of 1792–93 were performed in a context that made it clear that a new cultural politics of the "people" was being practiced and celebrated. Alain Badiou's assertion that "the Commune is what, for the first and only time, broke with the parliamentary destiny of popular and workers' political movements" properly evokes the palpable sense of rupture that the Communards experienced (if it is too singular in its forgetting of those like the Diggers and Saint-Domingue's radicals who had advocated a decentralized polity long before).[90]

That break can be characterized as a sense of being in history as an actor, rather than, as visuality would have it, as a simple follower. In the group photographs of the Communards, one sees this desire to be seen and acknowledged as part of the event in which the right to live evoked the right

to look. Often a group of National Guards, accompanied by civilians, stand in line to pose for the camera on the barricades, recalling O'Sullivan's photograph in the Sea Islands. A trumpet can be seen being played on the barricade in the rue Saint Sébastien, where one man supports his infant child so it can be seen standing.[91] On other occasions, the Commune's troops can be seen in the Hôtel-de-Ville or the courtyard of the Ecole des Beaux-Arts, where the "people" would not ordinarily have been seen. There are many notorious photographs from the Commune, ranging from the staged destruction of the Vendôme column; to the photomontages created to show the "outrages" of the Commune, such as the assassination of the archbishop of Paris, who had been held hostage against government attack; and finally to the many images of Paris in ruins after the Versaillais had attacked. But it is these group portraits, carefully arranged and posed as if for a holiday or wedding photograph, usually taken by unknown photographers, that stay with me. The carefully arranged paving-stone barricades were no match for modern artillery, especially now that Haussmann had arranged a clear line of fire, as they must have known. The conviction that history was on their side, no matter what happened in the short term, is what seems irrecuperable here, rather than the foretold and chosen deaths of those posing. I am tired of mourning. I would like to know what it would feel like to feel so engaged with history rather than death. Is there not a terrible suspicion at large in the West that did so much to prevent this history from playing out that the defiance of death has passed to those imbued with the divine rather than the historical?

Puerto Rican Counterpoint II

Mourning Abolition Realism

After the abolition of slavery in Puerto Rico, Francisco Oller worked on two dialectically related series of works (see plate 8). The first depicted plantations under postslavery conditions, paintings that seem to resist interpretation as either critiques or endorsements of agriculture.[1] In counterpoint, Oller made a series of paintings of locally grown fruits and plants, such as pineapples, plantains, and bananas, as if suggesting that these offered the possibility of a sustainable agriculture that did not need to rely on the international cash-crop market. In 1891 he painted a major canvas depicting Maestro Raphael Cordero, a formerly enslaved tobacco worker of color who had founded a school in San Juan which educated children of all classes and ethnicities. In this period of emergent nationalism, Cordero was being claimed as a prototype nationalist hero by reformists and conservatives alike, leading to Oller's painting being displayed in the conservative Ateneo club.[2] The recuperative claim to the subaltern project of education and sustainable agriculture that Oller had been exploring provoked a new direction in his work. He returned to international exhibition, in 1895, with a monumental painting, *El Velorio*, or *The Wake*, showing it first in Puerto Rico, then at two locations in Havana, Cuba, and finally it was shipped to France.

Oller traveled with the painting, which he showed to Cézanne in his studio and to Pissarro by photograph.[3] Neither artist liked Oller's new

piece, but he sent it to the Paris Salon of 1895, where it was accepted. It was also ignored there, because even Salon reviewers saw *grande machine* painting as fit for nothing other than disappearing into some institution, where it would hang unseen and unregarded.[4] As if in anticipation of being overlooked, this was a painting of disillusion, mourning, and coming to terms, both politically and artistically. Rarely even a footnote in Anglophone histories of modernism, it has been a foundational painting for Puerto Rican art, literature, and even national identity.[5] It should be required viewing for any discussion of post-abolition representation. If this was not a work of the avant-garde, measured in terms of style within a particular time period, it nonetheless reflects on how advanced painting had become detached from the counterpoint of visuality and abolition realism. Indeed, *The Wake* is in mourning for the failed project of abolition and the realism that would have depicted it. If it is, as Nietzsche or Benjamin might have said, "untimely," that constitutes the grounds for its successes and failures.

The painting is so large, at some 13 x 7 feet, and so crowded with incident, that its very subject has been obscured. It depicts a wake held to celebrate the death of a child, a formula whose oddity indicates the disjunctured nature of the painting. The syncretic ceremony, known as *baquine*, blended Kongo and Catholic beliefs that a deceased innocent child went directly to the spirit world or to Heaven, respectively, and should not be mourned, as that would hinder their journey. Oller accurately depicted the Kongo ceremonial, with an altar being made out of a table covered in a white cloth, with its libations of food and drink, and with the performance of songs to help the journey of the spirit.[6] At the same time, this was also a Catholic ceremony, known in Spain as the *florón*, commemorating the direct passage of the *angelito*, the little angel, to Heaven. Thus the child is surrounded by flowers and dressed in white. Such acceptance indicates that the infant had been baptized despite its young age, creating a visual memory connection with José Campeche's portrait of *Juan Avilès*.

No reading hitherto has suggested that this was a syncretic ceremony, because all the authority has been ceded to the text published in the catalog for the Salon of 1895.

> Astonishing criticism of a custom that still exists in Puerto Rico among country people and which has been propagated by the priests. On this day the family and friends have kept vigil all night over the dead child, extended on a table with flowers and laces. The mother . . . does not

weep for fear her tears might wet the wings of this little angel on his flight to heaven. She laughs and offers a drink to the priest, who with eager eyes gazes up at the roast pig whose entry is awaited with enthusiasm. Inside this room of indigenous structure, children play, dogs romp, lovers embrace, and the musicians get drunk. This is an orgy of brutish appetites under the guise of a gross superstition.[7]

Attributed to Oller himself, the text castigates the *baquine* as a clerically inspired orgy. Many scholars have followed this lead, all noting the "couple in full-fledged romance grabbing each other," in the left foreground.[8] But they are not (see fig. 38). As anyone who has seen the actual painting can tell, the couple are grieving. The woman has her arm across her eyes and uses her other hand to fend off the sight of the incoming sacrificial pig, while a man standing behind her holds her to offer comfort. Another man empties a bottle over their heads, oblivious to their grief. This visual oversight has the same cause in all cases. Whoever wrote the Salon entry in France—clearly it cannot have been the artist—was no doubt working from a photograph, such as that seen by Pissarro, who had no hesitation in criticizing the painting as "banal" on that basis. In a photograph the dark corner becomes obscure, so if one does not look closely, it can seem that the couple are embracing. The painting is not a simple one. It offers a series of counterpoints, visual allusions, hesitations, and dramas.

The space of the painting constructs a series of interacting groups in an off-center and apparently askew arrangement, using the pyramids and diagonals of classical composition. A pyramid links the musicians at left to the roasted pig and the celebrating priest, which also dominates the attention of one cheering man in the left background and another who reaches for a machete to carve it at the extreme right. The dead child is linked to the other children in the painting by a diagonal from the bottom left. Two children are seen having fallen down in the left corner and one standing, who can be characterized as being white, brown, and black respectively, all connected by the invisible line leading up to the dead child. He or she is illuminated by a stream of light entering through a hole in the wall, visible next to the hat of the man standing at center, enhancing the atmosphere of divinity and rendering the skin intensely white. The mourning couple are linked to two men at the extreme right-hand edge of the painting, dressed as peasants, one of whom gestures across at them. At the center of the painting stands an older African man, contemplating the dead child (see fig. 39). Finally,

FIGURE 38. "THE COUPLE,"
DETAIL FROM OLLER, *THE WAKE*.

the painting creates an empty space in the right foreground from which the implied spectator's viewpoint is constructed. Located at the intersection of the gaze of the little dog at left center and the standing woman at the right-hand side, the spectator is positioned very low, as if fallen on the floor, or from the viewpoint of a child. This open space focuses our attention on the dead child, in sympathy with the African man and the mourners, prompting us to condemn the celebrations going on all around, caused by the entrance of the pig. That commotion distracts our attention from the real source of authority in the picture—the disappearing landowner, seen out of the left-hand window, who has retained power despite the formal

FIGURE 39. "THE ELDER,"
DETAIL FROM OLLER,
THE WAKE.

FIGURE 40. "THE
OWNER," DETAIL FROM
OLLER, *THE WAKE*.

end of slavery (see fig. 40). In mourning one individual, the painting also mourns the artist's vision of a future that has failed to arrive, namely the future of abolition, as symbolized by the children. In this realist painting, Oller was trying to visualize a cross-racial society for Puerto Rico, only to collide with the unchanging realities of poverty and power in rural life.

In this context, the confrontation between the dead child and the older African man is most poignant. Whatever his personal status may have been, the elder would have been born in the period of Puerto Rican slavery and was racialized as such. The prospect of a future in which society was not divided by race, which might have been imaginable in the optimism of 1873, no longer seems available—it was as dead as the child. If we assume the other children to be the dead child's siblings, then it is also conceivable that the African elder is her grandfather or other relative. Certainly, his presence is not only accepted; he is being ignored, almost as if he is a ghost. His attention is fixed directly on the child, undistracted by the revelers and mourners alike. The intensity of this look between the living and the dead across the invisible temporal disjuncture of abolition and (apparently) across the color line is "untimely" because it should be the young mourning the old, and not vice-versa. Nor should those of the era of slavery mourn modernity, yet they have cause. It is for this reason that the painting constructs its unusual viewpoint. Either the spectator is a fallen adult, one who has failed to do what should have been done, or s/he is a child, looking at the apparent chaos of the scene and gradually deciphering its meanings. These viewpoints could be combined as that of an adult who was nonetheless legally without personality and hence a minor.

More allusively still, there were a series of references within the painting to the visual conventions of Realist style. To work across from left to right: the mourning woman on the left is derived from Courbet's peasant figures, such as *The Winnowers* (see fig. 41). The empty Roman-style chair next to the dead child recalls David's *Brutus*, as does the extended hand of the mourner at right and the semantically significant empty space at the center of the painting (see fig. 42).

Centered on the conflict between private need, and grief, and public necessity, David's work had been interpreted as revolutionary when it was first displayed, in 1789. The artful foreshortening on the chair at extreme right recalls Caravaggio's similar (if more dramatic) trick in *The Supper at Emmaus*, a painting concerning the Resurrection (see fig. 43). In the startled recognition of the disciples in Caravaggio's painting was mingled the sight

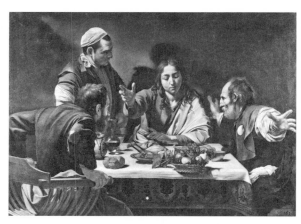

of the impossible become real and the possibility of a Catholic Church that might enable that fantasy, both of which seemed unavailable in the late nineteenth century. Finally, in an almost private reference, Oller's entire painting alludes to a drawing made by Pissarro in Venezuela at the start of his career, in 1853, that is usually known as *Dance at the Inn*, although Oller's allusion here makes it intelligible as a similar wake (see fig. 44).

Pissarro's drawing was also dominated by the figure of a grieving African man being comforted by two children. Its relatively large scale suggests that he was considering turning it into a large-scale painting, a choice he later backed away from in favor of "French" subjects like *The Hermitage*. Oller, as it were, finished the job for him in another part of the Caribbean at a very different moment. The implied reproach was not just a reflection on a single unfinished work, but a suggestion about the road not taken, for all Pissarro's avowals of radicalism. There was also a measuring of differing visualities being performed here. When Pissarro drew his sketch, slavery was about to be abolished in Venezuela, meaning that the mourning of the "father" was for a child who would not experience freedom. When Oller made his painting, Puerto Rico was about to be invaded by the United States, in 1898, inaugurating what is now over a century of occupation. While he could not have foreseen that drama, his work mourned a freedom that had failed to materialize and a right to look that had failed to perform as abolition realism. Despite the general strikes of 1848, abolition, and the Commune, visuality had succeeded in becoming imperial.

(opposite, clockwise from upper left)

FIGURE 41. GUSTAVE COURBET, *THE WINNOWERS* (1854). 131 x 167 cm. Inv. 874. Photo by G. Blot. Musée des Beaux-Arts, Nantes, France. Photo courtesy of Réunion des Musées Nationaux / Art Resource, New York.

FIGURE 42. JACQUES-LOUIS DAVID, *THE LICTORS BEARING THE BODIES OF THE DEAD SONS OF THE ROMAN CONSUL BRUTUS* (1785). Oil on canvas, 323 x 422 cm, Photo by G. Blot and C. Jean, Louvre, Paris. Photo courtesy of Réunion des Musées Nationaux / Art Resource, New York.

FIGURE 43. MICHELANGELO MERISI DA CARAVAGGIO, *SUPPER AT EMMAUS* (1601), Pinacoteca di Brera, Milan, Italy. Photo courtesy of Scala / Art Resource, New York.

FIGURE 44. CAMILLE PISSARRO, *EVENING BALL IN A POSADA DURING THE CARNIVAL IN VENEZUELA* [*SIC*] (CA. 1852-54). Sepia watercolor on paper, 36.4 x 53 cm. Banco Central de Venezuela, Caracas, Venezuela. Photo courtesy of Snark / Art Resource, New York.

Imperial Visuality and Countervisuality,
Ancient and Modern

In a sense, all visuality was and is imperial visuality, the shaping of modernity from the point of view of the imperial powers. This chapter examines the formation of imperial visuality both in the colonies and in the metropole at the interface of colonizing authority with the hierarchy of the "civilized" and the "primitive." Whereas visuality had been the prerogative of the individual Hero, imperial visuality was an abstracted and intensified means of ordering biopower. It understood history to be arranged within and across time, meaning that the "civilized" were at the leading edge of time, while their "primitive" counterparts, although alive in the same moment, were understood as living in the past. This hierarchy ordered space and set boundaries to the limits of the possible, intending to make commerce the prime activity of humans within a sphere organized by Christianity and under the authority of civilization. Imperial visuality imagined a transhistorical genealogy of authority marked by a caesura of incommensurability between the "indigenous" and the "civilized," whether that break had taken place in ancient Italy with the rise of the Romans, or was still being experienced, as in the colonial settlement of Pacific island nations. Thus it claimed an authority analogous to what it (incorrectly) took to be the aura of *mana* (power or prestige) attributed to Melanesian and Polynesian leaders. This universal authority derived from the "primitive" mind sustained the new modern Caesarism called for by Carlyle's biographer and

successor James Anthony Froude (1818–94). These abstract modalities of authority were enabled and reinforced by the local endeavors of missionaries who sought to bridge the ancient and the modern, as they saw it, by means of disciplinary religious missions. The classification of ancient and modern cultures, overlaid with that of "primitive" and "civilized," designated a separation in space and time that was aestheticized by European modernism. Despite the seemingly arbitrary nature of such formulae, the result was an effective suturing of authority to the newly centralized modalities of imperial power. In response to the crisis of authority after the First World War, there was nonetheless in some places a return to charismatic leadership in the form of fascist dictatorship.

Just as visuality itself was an antagonistic response to revolutionary tactics, so was imperial visuality an intensification of that visuality mandated by new tactics deployed by the indigenous. I map this process in Aotearoa New Zealand, both because Froude imagined New Zealand as England reborn in the empire, and because the theorizing of mana relied on fieldwork performed by missionaries and their surrogates in the extended diocese of New Zealand. The Maori repurposed Christian texts into a renewal movement that cast them as "Jews" to the missionaries Christians. This claiming of an authority at once more ancient than Christianity and more modern than received Maori belief served both to unify formerly antagonistic groups into one anticolonial force and to undermine the missionaries' credibility. This strategy forced the British Crown into a direct claim of sovereignty in the 1840 Treaty of Waitangi, which required ratification by Maori leaders, giving them legal personality and hence authority. These challenges led to a further intensification of imperial authority. Described by Froude as "Oceana," this visualization of history projected specific notions of the sacred into a generalized and abstracted "necropolitics," demarcated into two zones. One was the "normal" zone of imperial authority designated by the new science of statistics, describing patterns of life and death. The other was the space of imperial exception in which all those excluded from the normal—here the colonized and racialized body—were subject to exceptional authority, epitomized as the right of the imperial power to withhold life from the colonized. Or to kill them, in plain English. That authority was legitimized by the "discovery" of mana as the "primitive" origin of heroism, now rendered as Caesarism. Metropolitan imperial visuality was challenged from within by a countergenealogy for authority, stemming from the "ancient lowly," or the proletariat of antiquity. Epitomized by the heroic

figure of Spartacus, the ancient "strikes" against empire created an alternative genealogy to authorize the modern labor movement. Such visualizations relied less on realist visual media than abolitionism had done and turned instead to new visualized forms like the Museum of Labor, the red flag, and the May Day campaign, culminating in the idea of the general strike as an alternative means of picturing social totality. In the crisis of authority produced by the combination of radical movements and the collapse of empires after 1917, Caesarism became a new modality of dictatorial "heroism."

MISSIONARIES AND "JEWS": AUTHORITY
AND COLONIZATION IN AOTEAROA

> Papa having to do with earth
> huri with turning over
> hia
> —Kendrick Smithyman, "The World Turned Upside Down"

It was the universalizing project of evangelical Christianity that engaged in the practical construction of imperial visuality on Carlyle's model.[1] If Carlyle and Froude were visuality's theorists, its labor force was the massed ranks of global missionaries, busy in overturning idols, shipping them to museums in Western capitals, and instituting the rule of private-property rights under regimes of visualized surveillance. If missionaries were once decried as the "running dogs" of imperialism, recent studies have sought "to understand missionaries in the context of a globalizing modernity that altered Western societies as well as non-Western ones in the nineteenth and twentieth centuries; missionaries, in other words, were simultaneously *agents* of the spread of modernity vis-à-vis non-Western societies, and *products* of its emerging hegemony."[2] Nowhere was this more the case than with imperial visuality as the agent and product of globalizing, capitalist modernity. Missionaries envisaged themselves bringing light to darkness through a series of epistemically and physically violent techniques, writing what David Livingstone famously called "Christianity, commerce and civilization" over those "blank spaces of the map" that later so fascinated Joseph Conrad. Livingstone was speaking precisely: Christianity was to be introduced first, creating a desire for commerce that would in turn produce civilization.

Missionaries actively considered themselves to be heroic figures in the style of Carlyle. As Jean and John Comaroff have insightfully argued, missionaries "were the prototypical subjects of a modern 'history as biography,' producing a range of heroic texts whose linear progression gave putatively sufficient account of human motives, actions, and consequences."[3] For example, in 1837, the British missionary John Williams published a bestselling account of his travels in the South Pacific, highlighting his destruction of the "idols," or *tiki*, on the island of Rarotonga, part of the present day Cook Islands. The tiki were nonrepresentational figures, carefully wrapped to prevent their mana from escaping or harming passers-by. Williams destroyed them all, excepting one specimen that he sent back to London, now in the collections of the British Museum. The small woodcut frontispiece shows Williams seated in public, every inch the Hero, accepting the public offering of the now-disgraced power figures of the Rarotongans. With that indigenous visuality erased, his next act was to promulgate a code of laws based on property rights.[4] The missionary hero has brought light to darkness, forced a recognition of that light, and thereby effected the moment of conversion. Conversion is an internal process of the "soul," precisely that object targeted by the new disciplinary apparatus of normalizing modernity in which "the soul is the prison of the body."[5]

Here I will take Aotearoa (Land of the Long White Cloud) as an example of the formation of imperial visuality and indigenous countervisuality in the period in which it became the crown colony of New Zealand, Froude's ideal colony. It was also the site of concerted Maori resistance to colonialism, which led to the formation of an indigenous countervisuality. This countervisuality sought to contest both the genealogy of imperial visuality and its symbolic forms, and to visualize its own modality of power. British missionaries arrived in Aotearoa in 1814, but they did not succeed in making their first converts until the 1830s. For example, in 1834 one leader, according to missionaries, dismissed Christianity: "This doctrine . . . may do for Slaves and Europeans, but not for a free and noble people like the Ngapuhi," meaning the dominant confederation of peoples on the north island.[6] At this point, the indigenous remained confident of their strength in numbers and in ideas. The missionaries took such remarks seriously and prose-lytized to the enslaved and other marginal figures in Maori society. Around 1830, as the number of Pakeha (Europeans) increased, together with a high Maori mortality rate caused both by war and disease, the level of Christian observance began to rise dramatically.[7] Scholars have variously attributed

this progress to the missionaries' role as peacemakers in regional conflicts; to the perceived benefits of textual literacy that the colonizers offered once printed texts in the vernacular became available, after 1827; the material goods, such as blankets and muskets, provided by European commerce; and the devastation of indigenous populations by exogenous disease. All these tended toward the accidental and deliberate effacement of what contemporaries called the "primitive" communism of the Maori in favor of property-based relations.[8] First, the indigenous had to be made to realize the deficiency that attested to their primitivism. One leading missionary, William Yate, found the Maori deficient above all in their lack of lack, declaiming to the Church Missionary Society, in 1829, that "there is no seeking after Christ till the fetters of sin and satan [sic] gall *the Spirit*."[9] He recognized the acute sense of "dread" caused by *tapu* (Maori te reo equivalent to the Polynesian *taboo*), but claimed that its transient and human forms made it an inferior form of subjection. Yate's sense of sinfulness was perhaps all the more acute because of his purchased erotic encounters with young Maori men that were soon to lead to his dismissal. Nonetheless, in a travel narrative of his time in New Zealand, published in 1835, Yate was pleased to observe that the "real and imaginary wants" of the Maori had increased, so that "industry, regularity, and a desire to make improvements in their land, their habits, and customs, are upon the increase."[10] The Maori described this process as "going *mihanere*," a homonymic spelling of "missionary."[11] This cultivation of a sense of need where none had existed before epitomizes what John and Jean Comaroff have called the missionary "colonization of consciousness."[12]

In encountering Pakeha determined to settle, the indigenous found themselves confronted with a group that homogenized all the different *iwi* (peoples) into one "Maori" whole and had designs on their most fundamental cultural resource, the land itself. The *tohunga* (priest) Papahurihia responded by creating the prophetic discourse of Te Atua Wera, the Red God, uniting the "Maori" in counterpoint to the Pakeha (see fig. 45). In response to his understanding of the missionary teachings and texts, Papahurihia claimed that the Maori were Hurai, or Jews, giving them "ancient" founding authority in relation to the missionaries, rather than being subalterns. He celebrated the Sabbath on Saturday, according to the Old Testament (rather than the Christian Sunday), and raised a symbolic flag to testify to his actions.[13] By moving the Sabbath to Saturday, Papahurihia and his followers reclaimed the shaping of time that was an instrumental part of missionary settlement and their primary evangelical claim. For Sabbath obser-

FIGURE 45. ANONYMOUS, "TE ATUA WERA [PAPAHURIHIA?],"
FROM FREDERICK MANING, *OLD NEW ZEALAND* (LONDON: 1863).

vance was the quantitative indicator by which the missionaries marked their
progress, prompting Henry Williams to denounce the missionary-educated
rebels as "two-fold more the child of the devil than they were before."[14]
The missionaries themselves had suggested that the Maori might be one of
the lost tribes of Israel and had seen them as having "Jewish" characteristics,
such as greed and a propensity to business.[15] So the Maori knew both why
Jews were considered important in Pakeha religion and how they were the
object of systematic racialized degradation.

It is hard to avoid the suspicion that the Maori chose to identify with
Jews because they knew exactly how much it would annoy the Pakeha.
"Carlyle," wrote Froude, "detested Jews," and his description of Disraeli
(cited in Froude's novel *The Earl of Beaconsfield*) as a "superlative Hebrew
conjuror," echoes the missionary William Woon's puzzled description of
"Papaurihia [*sic*] who has fallen in with some Jews and learned juggling etc.
and on this account he is regarded as a wonderful man."[16] Unable to credit
that he might have created this movement, the British believed that Papa-
hurihia had been corrupted by a "Hebrew traveler. . . . [H]e was a sea cap-
tain, and he had some skill as a juggler and a ventriloquist."[17] It was not al-
together impossible, for there were a number of Jewish settler-traders in the
Hokianga region.[18] Certainly, many writers believed that tohunga used ven-
triloquism. What was meant by juggling is less clear. At the same period,

Darwin used "jugglery" to refer to his use of technology in South America, so Papahurihia may have had some knowledge of Western technology.[19] He was both a vernacular and a national hero, intent on the creation of an imagined community. His movement was literally based on an "against the grain" reading of Protestant doctrine translated into the vernacular, while his political goal was to forge something that might be called a Maori "nation." His appropriation of the double negative connotation of both indigeneity and Jewishness thus marks an instance of what Stephen Turner has called "native irony," meaning "the anamorphic distortion of an 'official' reality, that which is already known, expected, and elaborated in conventionalized form, through the interference of the affective consciousness of the native or local."[20] Papahurihia's movement, replete with appropriations, aporia, and performative display seems always already postmodern, a fitting subject for Kendrick Smithyman's remarkable deconstructive poem cycle *Atua Wera* (1997). Papahurihia's claim to be Jewish was repeated by later renewal movements led by figures such as Te Ua Haumene (ca. 1820–66) and Te Kooti Arikirangi Te Turuki (ca. 1814–91), which continue to have adherents today.[21] Te Ua claimed descent from the twelve sons of Jacob, while Te Kooti framed his dramatic escape from the prison of the Chatham Islands and his march into the interior, in 1868, as an exodus to the Promised Land of Moses. This nationalism was prophetic, contradictory, imaginative, and visualized.

If he claimed ancient authority as a "Jew," Papahurihia was modern in his synthesis of tradition and current circumstances. He conjured the spirits of the dead to speak and advise the people in their new circumstances, as the tohunga had always done, but now he spoke of Te Nakahi, the serpent, who was a syncretic combination of the serpent in Genesis, the fiery serpent on the rod used by Moses, and the long-standing Maori lizard spirit.[22] He raised a flag on his Jewish Sabbath, just as the British would do on the Christian Sunday. The missionaries used a variety of flags to mark their missions, often decorated with a text in Maori. The British resident John Busby had then imposed a "New Zealand" flag on a gathering of *rangatira* (leaders or chiefs), in 1835, and the renewal movements all used them.[23] While Papahurihia's flag is now unknown, later flags used by Te Ua and Te Kooti suggest that it would have had a combination of symbols, colors, and perhaps text. Te Ua had a flag with the word "Kenana" (Canaan) written on it to indicate that he considered himself Jewish. One of Te Kooti's flags used a crescent moon to indicate a new world, a cross, and the letters "WI," referring

FIGURE 46. ANON, "KORORAREKA [RUSSELL]," FROM
FREDERICK MANING, *OLD NEW ZEALAND* (LONDON: 1863).

to his Sabbath. On another one of his flags, the quadrants of the Union Jack
were colored green and brown (rather than white and blue), as were the
stars denoting the four islands of New Zealand.[24] Te Kooti seems to have
imagined a postcolonial power-sharing in which the form of the colonial
was blended with the content of the indigenous population.[25] In 1845, Papa-
hurihia became the war tohunga during Hone Heke's attack on the Pakeha
settlers, which revolved around the repeated destruction by Maori of the
flagstaff at Kororareka (present-day Russell) (see fig. 46). A flag is inherently
a militarized object, and Papahurihia and other Maori leaders understood
it as such. The flag attempted to perform the authority of sovereignty. It
indexically marked a territory as a new national possession, symbolically
designated the cultural history of the flagmakers, and iconically attested to
the presence of sovereignty. Such performances only work if received as
intended by the indigenous audience. The photographer William Lawes,
the London Missionary Society's emissary to Papua New Guinea, attended
a "proclamation of British sovereignty," as he called it, in 1888: "There was
not much display, and it was well that there was not, for flag-hoisting must
seem to the natives to be a white man's amusement. The function of the 4th
[November] was the tenth at which I had been present on New Guinea. It

is getting monotonous."[26] Perhaps the index of the desire to colonize is the amount of such ritualized boredom that can be tolerated.

Against the tedium of imperial symbol, Papahurihia deployed a complex visualized rhetoric in keeping with Maori usage of metaphor and allusion. The French missionary Louis Catherin (or Catherin Savant) offered a version of the imagery he was using around the time of the Treaty of Waitangi.

> Tanakhi [Te Nakahi, the serpent] has compared heretics to the aotea tree: this tree is placed in a straight line, another tree is placed in a curving line, starting at the foot of the straight tree. This tree is called the tree of judgement. At the end of the curved tree are the heretical Missionaries who pray: they take the road leading to Satan's fire and they go. . . . Tanakhi, the new god, appears under the bent tree and goes off to stoke up the eternal fire, then he comes up the straight tree, whose top touches heaven; the heretics also try to climb up there but when they think they have reached heaven, heaven disappears above them and they fall back into the abyss.[27]

For all the Christian language of heresy and heaven, Papahurihia's visual metaphor emerges clearly: while the missionaries falsely claim a route to salvation, it is the renewal movement that really knows how to find it. The use of indigenous plants and the question of direction-finding must have rung a chord with local listeners, who would have noticed the difference between Pakeha ignorance and their own designation of over six hundred plant species. The movement caused many Maori to abandon the loose relationship they had with Christianity and to move into a form of opposition to the colonizers. The missionaries blamed ships' captains for convincing the Maori that their "object is only to gain possession of the land: that when they are made Christians we shall make slaves of them."[28] It was not an inaccurate forecast, if slavery is understood, as the Maori would have done, as meaning reduction to a landless condition.[29] In te reo, the indigenous population often called themselves *tangata whenua*, meaning "people of the land." Conversion prompted some agonies of double-consciousness, as the missionary Yate recorded in a series of letters from Maori converts of the period. Hongi, "a married man living with Mr. Clarke," wrote that he sometimes thought: "'Ha! What are the things of God to me? I am only a New Zealander: they will do very well for white and learned people but as for us—!'" Many other letters attest to such internal conflicts, disputes between what Henry Wahanga called his "native heart" and his "new heart."[30]

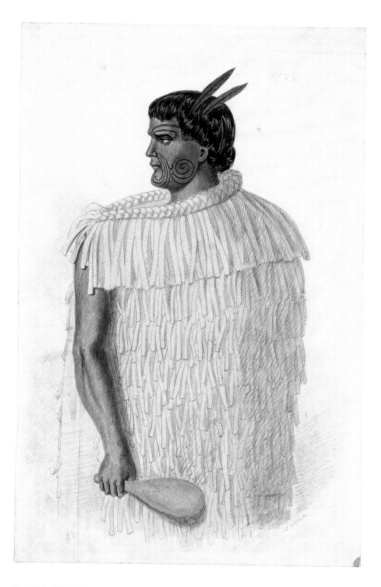

PLATE 1. ANONYMOUS, *JOHNNY HEKE* (I.E., *HONE HEKE*) (1856).
Photo courtesy of National Library of Australia.

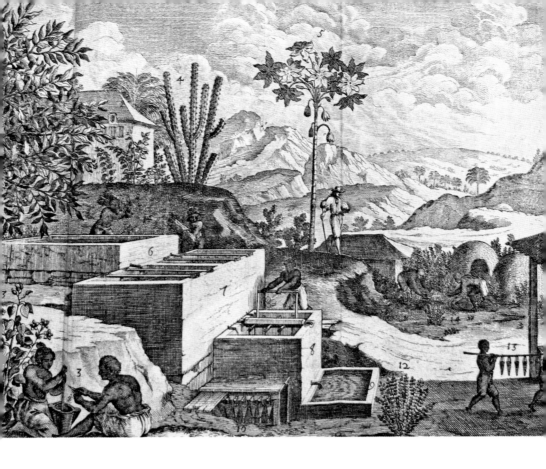

REVEIL DU TIERS ETAT.

Ma foute, il étoit tems que je me réveillase, car l'oppression de mes fers me donnoit le cochemar un peu trop fort.

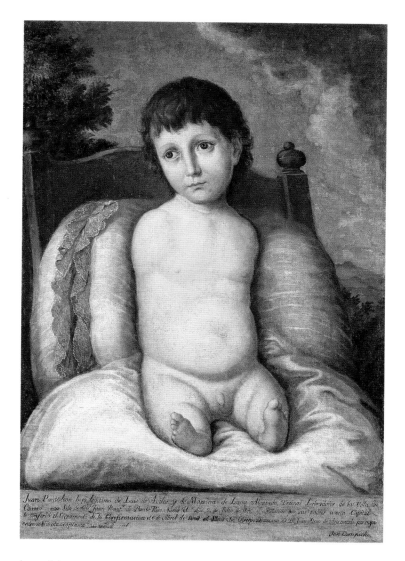

Juan Pantaleon hijo legitimo de Luis de Aviles y de Maxima de Luna Alvarado, Vecinos Labradores de la Villa de
Coamo esta Isla de San Juan Baut. de Puerto Rico. Nacio el día 3. de Julio de 1806. Recivió por sus padres a esta Capital
á conferir el Sacramento de la Confirmacion de 6 de Abril de 1808 el Illmo Sr. Obispo Diocesano D. Dr. Juan Alexo de Arizmendi por cuya
orden se hizo esta copia...

José Campeche.

(*opposite*)

PLATE 2. JEAN-BAPTISTE DU TERTRE, "INDIGOTERIE" (DETAIL), FROM *HISTOIRE GÉNÉRALE DES ANTILLES HABITÉES PAR LES FRANÇOIS* (PARIS: 1667).

PLATE 3. ANONYMOUS, *THE AWAKENING OF THE THIRD ESTATE* (1789), PARIS.
Photo courtesy of Bibliothèque nationale de France.

(*above*)

PLATE 4. JOSÉ CAMPECHE, *EL NIÑO JUAN PANTALEÓN DE AVILÉS DE LUNA* (1808), INSTITUTO DE CULTURA PUERTORRIQUENA.

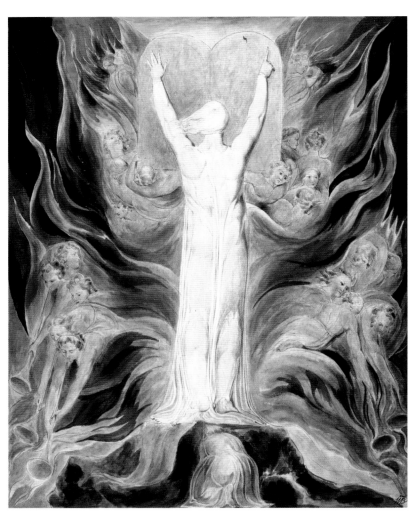

PLATE 5. WILLIAM BLAKE, *GOD WRITING ON THE TABLETS OF THE COVENANT* (1805).
Photo courtesy of the National Gallery of Scotland.

PLATE 6. JAMES SAWKINS, *ST. JAGO* [I.E., SANTIAGO DE] *CUBA* (1859).
Photo courtesy of National Library of Australia.

PLATE 7. CAMILLE PISSARRO, *THE HERMITAGE AT PONTOISE [LES CÔTEAUX*
DE L'HERMITAGE, POINTOISE] (CA. 1867). Oil on canvas, 59⅝ x 79 inches.
Solomon R. Guggenheim Museum, New York. Thannhauser Collection.
Gift of Justin K Thannhauser, 1978. 78.2514.67.

PLATE 8. FRANCISCO OLLER Y CESTERO, *EL VELORIO* [*THE WAKE*] (1895), UNIVERSITY OF PUERTO RICO, RIO PEDRAS.

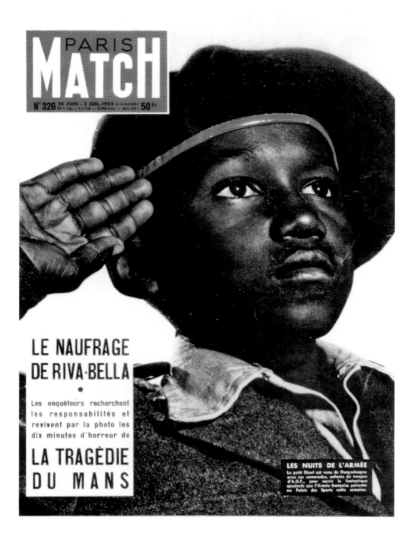

PLATE 9. COVER OF *PARIS-MATCH*.

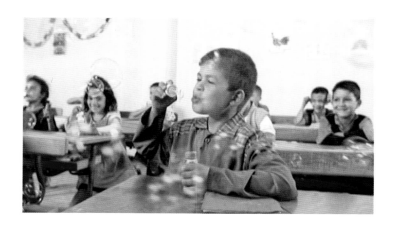

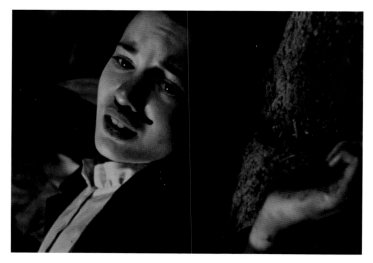

PLATE 10. BUBBLES SCENE FROM *RACHIDA* (2002).

PLATE 11. STILL OF OFELIA FROM *PAN'S LABYRINTH*
(DIR. GUILLERMO DEL TORO, 2006).

With due allowance for the writers saying what they knew Yate wanted to hear concerning their awareness of the struggle against sin, these dilemmas must have seemed very acute. While the missionaries spoke of the influence of the devil and the decline in Sabbath attendance, the (as-it-happens Jewish) sailor Joel Polack testified to the House of Lords in London of a more thoroughgoing transformation: "There was a Crusade at the Time among the Natives, so that everything was at a Stand-Still; they had no opportunity of getting on with anything. That was occasioned by a new Religion, which has sprung up, called Papahurihia."[31] Labor at a standstill suggests a colonial general strike in religious dress, much like the contemporary Chartist National Holiday.

SOVEREIGNTY OR KAWANATANGA

During the Papahurihia insurrection, Aotearoa formally became the British Crown colony of New Zealand by means of the Treaty of Waitangi, signed on 6 February 1840 by British representatives and Maori leaders. A Christian diocese was declared the following year with the appointment of an Anglican bishop.[32] Papahurihia and Waitangi were both part of the indigenous response to settler colonization. The insurrection had forced the Crown to recognize the standing of indigenous authority in order to defend its position. Polack told the House of Lords, in 1838, "It is astonishing how the Natives have gone back," meaning reverted to indigenous religion from Christianity.[33] For Papahurihia and his followers, "going back" was a challenge to the imperial future that he seems to have correctly visualized. While it is usually said that the treaty followed the New Zealand Association (later the New Zealand Company) proposal of colonization, in 1838, which had been discussed in the House of Lords, it should be added that these hearings made it clear that British authority was far from unquestioned.[34] The association presumed that "the Savages are to be dealt with as children," meaning that they were legal minors, to be protected but without rights.[35] The Church Missionary Society objected that such a designation had no basis in law, because Britain had "no claim of Sovereignty or Jurisdiction whatever." When challenged that they themselves had sought to buy land whenever possible, the missionaries pointed out that such purchase did not make a claim to sovereignty.[36] The Treaty of Waitangi was designed to end all such disputes and to give the British a basis for expansion. At the same time, by seeking out indigenous consent and thereby presum-

ing their majoritarian legal status, the treaty marked an acknowledgment of indigenous participation in sovereign claims and thereby ownership of a certain authority.

The question of sovereignty was the key issue in the Treaty of Waitangi and its subsequent history. The treaty was prepared in English and in te reo (Maori), with Maori leaders signing or marking the te reo version (see fig. 47). However, the two were significantly different. Article 1 of the treaty in English has signatories "cede to Her Majesty the Queen of England, absolutely and without reservation, all the rights and powers of sovereignty." In te reo, it reads in Ranganui Walker's English translation: "The Chiefs of the Confederation and all the Chiefs not in that Confederation cede without reservation to the Queen of England forever the Governorship of all their lands."[37] The key term *sovereignty* was rendered, in what the historian Ruth Ross has aptly called "missionary Maori," as *kawanatanga*, a neologism formed by taking the missionary word *kawana*, a transliteration of *governor*, and adding the suffix *-tanga*, meaning "things pertaining to," in order to render *governorship*.[38] At this point, Maori had no concept of "governorship," so the signatories cannot have been clear as to what they were conceding. In James Busby's earlier dealings with a smaller group of chiefs, leading to what has been called the Declaration of Independence (1835), he had used the important term *mana*. Walker concludes that had the treaty used the significant phrase *mana whenua* (power over the land), "it is highly probable that they [the chiefs] would not have signed the Treaty."[39] In Maori translations of New Testament and the Book of Common Prayer, kawanatanga tends to refer to God's authority, suggesting that the signatories might have considered that they were making a spiritual accommodation with Christianity.[40] In one legal view, the practice whereby documents should be interpreted *contra preferentem*, that is to say, against the person offering it, means that the treaty should not be interpreted as ceding sovereignty. Others agree that kawanatanga was an unclear concept, but that the right of the Crown to govern was ceded.[41] Ironically, kawanatanga has now come to be used to mean "self-determination."[42] In any event, scholars now consider that because the treaty explicitly reserves to Maori *te tino rangatiratanga*, or "the customary authority of the chiefs over their own people," signatories would have presumed that their traditional authority remained intact. The legal scholar Paul McHugh emphasizes that rangatiratanga is a concept for which there is no simple Pakeha equivalent, for "it is an integrated concept tied into the mana of the individual and the . . . community."[43] In other

KO WIKITORIA, te Kuini o Ingarani, i tana mahara atawai ki nga Rangatira me nga Hapu o Nu Tirani, i tana hiahia hoki kia tohungia ki a ratou o ratou rangatiratanga, me to ratou wenua, a kia mau tonu hoki te Rongo ki a ratou me te atu noho hoki, kua wakaaro ia he mea tika kia tukun mai tetahi Rangatira hei kai wakarite ki nga tangata maori o Nu Tirani. Kia wakaaetia e nga Rangatira maori te Kawanatanga o te Kuini, ki nga wahi katoa o te wenua nei me nga motu. Na te mea hoki he tokomaha ke nga tangata o tona iwi kua noho ki tenei wenua, a e haere mai nei.

Na, ko te Kuini e hiahia ana kia wakaritea te Kawanatanga, kia kaua ai nga kino e puta mai ki te tangata maori ki te pakeha e noho ture kore ana.

Na, kua pai te Kuini kia tukua a hau, a WIREMU HOPIHONA, he Kapitana i te Roiara Nawi, hei Kawana mo nga wahi katoa o Nu Tirani, e tukua ainnei amua atu ki te Kuini; e mea atu ana ia ki nga Rangatira o te Wakaminenga o nga Hapu o Nu Tirani, me era Rangatira atu, enei ture ka korerotia nei.

Ko te tuatahi,
Ko nga Rangatira o te Wakaminenga, me nga Rangatira katoa hoki, kihai i uru ki taua Wakaminenga, ka tuku rawa atu ki te Kuini o Ingarani ake tonu atu te Kawanatanga katoa o o ratou wenua.

Ko te tuarua,
Ko te Kuini o Ingarani ka wakarite ka wakaae ki nga Rangatira, ki nga Hapu, ki nga tangata katoa o Nu Tirani, te tino Rangatiratanga o o ratou wenua o ratou kainga me o ratou taonga katoa. Otiia ko nga Rangatira o te Wakaminenga, me nga Rangatira katoa atu, ka tuku ki te Kuini te hokonga o era wahi wenua e pai ai te tangata nona te wenua, ki te ritenga o te utu e wakaritea ai e ratou ko te kai hoko e meatia nei e te Kuini hei kai hoko mona.

Ko te tuatoru,
Hei wakaritenga mai hoki tenei mo te wakaaetanga ki te Kawanatanga o te Kuini. Ka tiakina e te Kuini o Ingarani nga tangata maori katoa o Nu Tirani. Ka tukua ki a ratou nga tikanga katoa rite tahi ki ana mea ki nga tangata o Ingarani.

(SIGNED,)

WILLIAM HOBSON, Consul & Lieutenant-Governor.

Na, ko matou, ko nga Rangatira o te Wakaminenga o nga Hapu o Nu Tirani, ka huihui nei ki Waitangi. Ko matou hoki ko nga Rangatira o Nu Tirani, ka kite nei i te ritenga o enei kupu, ka tangohia, ka wakaaetia katoatia e matou. Koia ka tohungia ai o matou ingoa o matou tohu.

Ka meatia tenei ki Waitangi, i te ono o nga ra o Pepuere, i te tau kotahi mano, ewaru rau, ewa tekau, o to tatou Ariki.

PAIHIA: Printed at the Press of the Church Missionary Society.

FIGURE 47. MAORI TEXT OF THE *TREATY OF WAITANGI* (1840).

Photo courtesy of Alexander Turnbull Library, Wellington, Aotearoa, New Zealand.

words, whether by accident or design, the English version of the Treaty of Waitangi claimed Maori mana for the Crown, an imperialism of the "soul" forged by imperial discipline. The treaty's colonization of all "rights and powers" anticipated the imperial appropriation of mana itself.

It was not long before the treaty itself was set aside altogether. The Native Land Act of 1862 nullified the presumption of what in English law was known as "aboriginal title" in order to legalize transactions between individual Maori and settlers, undermining the collective ownership of land. The land grab that followed led to the outbreak of the New Zealand Wars (formerly known as the Maori Wars), a protracted and serious conflict. Taken together with other colonial experience in the post-emancipation period, such as the so-called Indian Mutiny (1857), the establishment of internment camps for Australian aboriginals (1860), and the Jamaican Morant Bay revolt (1865), the wars led to a reconfiguration of British self-representation in relation to indigenous and subject peoples. During the period of emancipation, the state took a relatively expansive view of societies with whom it ought to negotiate and settle by treaty any British settlement or colony. However, in the case *Wi Parata v. The Bishop of Wellington* (1877), Chief Justice Prendergast devalued the treaty to what one might call *lex nullius* [a nothing law]: "So far indeed as that instrument purported to cede the sovereignty . . . it must be regarded as a simple nullity. No body politic existed capable of making cession of sovereignty, nor could the thing itself exist."[44] In this view, the Maori could not be considered "civilized" enough to enter into legal relations with the Crown. It followed that Maori relations were the business of the Crown in which the courts could not and did not interfere for the following century. Prendergast was reverting to the legal fictions under which British imperial rule in Ireland had been established and adding a new severity to them. Edward Coke had notoriously declared, in 1608, that non-Christian peoples were "in law *perpetui inimici*, perpetual enemies (for the law pressures not that they will be converted, that being *remota potentia*, a remote possibility) for between them, as with the devil, whose subjects they be, and the Christian, there is perpetual hostility, and can be no peace."[45] By renewing this formula, Prendergast gave legal sanction to Carlyle's fears that colonies were new forms of a "black Ireland." In short, "conversion" was impossible and the permanent war of visuality had to be supplemented with a permanent religious divide, understood as that between the primitive or heathen, and the civilized or Christian.

Coke's opinion had been declared "extrajudicial" by Lord Mansfield, the same judge who declared slavery to be illegal on British soil. Now Prendergast was reviving the doctrine of a permanent state of exception for indigenous peoples, without even the possibility of redemption by religious conversion. For the Maori renewal movements had convinced British authorities in New Zealand that no such conversion could be trusted and that the Maori were always of the devil's party. In place of negotiated sovereignty, the colonial assembly created what one modern legal scholar has called a "highly coercive system of confiscation, regrant and military settlement . . . similar to the policies of the English Government in 17th century Ireland," a resemblance also noted by critics in the period.[46] The treaty, already ignored de facto, was now de jure a nullity. By the time Froude visited New Zealand in 1885, he did not even mention the treaty to disparage it. Maori rights to British citizenship, defined in article 3, were also set aside by *Wi Parata*, placing Maori in a permanent state of exception, subject to British Crown authority but with no legal standing to challenge that authority. Whereas missionaries had set out to colonize indigenous consciousness, imperial authority designated the native as a legal child, incapable either of being converted or of owning property. Under this new hierarchy of the soul, it was now possible to imagine a different form of empire.

OCEANA

I shall take the transformation of James Anthony Froude, Carlyle's biographer and successor, from self-styled radical to Caesarist imperialist as a guide to this emergence of imperial visuality, which is not to say that he caused it. However, while we would now be hesitant to ascribe responsibility for a major change in discursive practice to one historian, many who were both opposed to and supportive of imperialism in the twentieth century did just that.[47] Just as with Carlyle, I understand Froude as a symptomatic interpreter of the discourse of power, certainly with personal influence, but significant mostly as an indicator of the patterns of circulation that those supportive of imperialism could perceive. Expelled from Oxford for his seemingly atheist novel, *The Nemesis of Faith*, in 1849, Froude quickly abandoned his youthful radical views of the 1840s, under the influence of Carlyle's *On Heroes*: "The natural, Carlyle said, was the supernatural; the supernatural, the natural; . . . he showed how the great course of the world had been directed by gifted men who could see this truth

and dared to speak to it, and to act upon it; who had perceived the Divine presence and Divine reality . . . the rule of gods being for a time or times made visibly recognizable."[48] Froude sought this connection in the history of the British empire and built his reputation on a monumental history of Tudor England, published between 1856 and 1870. Over twelve volumes, he narrated England's rise as a naval power, especially in the Americas, culminating with its defeat of the Spanish Armada. This new power was in equal measure attributed to the virtues of Protestantism, to which Henry VIII had committed the country in 1538, and to the sterling character of the English yeomanry. Although much criticized by other professional historians, Froude's History of England was immensely popular and helped reconfigure the popular history of Britain on the Tudor-Stuart period (such that there still seems to be a new film about Elizabeth every year, usually featuring Cate Blanchett in the title role).

Visuality was now to be understood as History linked to the Divine by the agency of the British empire. Froude's own history was in that sense an Old Testament foretelling the British seaborne empire of his own day, for which he and Carlyle were the prophets. Indeed, after he had finished the History of England, he began to advocate in journalistic essays published in Fraser's under his own editorship for a wider federation of the colonies who "are part of ourselves" (meaning Canada, Australia, South Africa, and New Zealand) with Britain.[49] When a Conservative government was returned to power in 1874, Froude carried out a diplomatic mission to South Africa, giving him the opportunity to push his case for federation within government. In two subsequent travel accounts of expeditions to the South Pacific (1886) and the Caribbean (1888), he mapped a global imperial policy for a wider audience, updating Carlyle for the high imperial era. In his first such book, Oceana, Froude looked at the ways in which Carlyle's heroism had entered its twilight but had generated its successor in the global Anglophone empire. Froude claimed to recall how he had imagined emigrating to New Zealand in the "revolutionary time which preceded the convulsions of 1848," seeing his future as working on the land, rather than the scholarly life of a gentleman—he had in fact been offered a teaching position in Hobart Town, in Van Diemen's Land, present-day Tasmania, then and now part of Australia.[50] This displacement can be attributed to his sense that New Zealand was a regeneration of England as it should be and had been in the past: "England over again, set free from the limitations of space."[51] Space here was the key to a hierarchy of culture maintained without recourse to chat-

tel slavery. The Medusa effect of visuality, its attempt to petrify all attempts to modernize, was deployed here to move a nation in space and time for a second effort at heroism.

On his travels Froude met some men who had taken the path of Antipodean regeneration, which led him to conclude that the "colonies in proportion to their population, have more eminent men than we have," meaning the Hero as evoked by Carlyle.[52] By contrast, he would soon write with his usual distasteful racism that there had been no heroes in the Caribbean, "unless philonegro enthusiasm can make one out of Toussaint."[53] Ironically, Froude's hostile account of the post-emancipation Caribbean would create a tradition of vernacular heroes that has had global impact. The Trinidadian schoolmaster John Jacob Thomas (1840–89) was so incensed by Froude's work that he wrote and published in London a detailed refutation, wittily entitled *Froudacity*. Born just after the end of slavery to a working-class family, Thomas was a product of the denominational and ward school system in Trinidad, as he proudly declared, in 1884, in a dispute with a Catholic priest: "I, who am born of the people, and who belong to them, have better opportunities of knowing their feelings and their needs than any outsider."[54] Thomas was so much a vernacular hero that he compiled an influential study of Creole, *The Creole Grammar*, which both validated the language and gave fascinating insights into its use. For example, he documents how in allegorical stories "cockroach" (*ravette*) was a term used to refer to the enslaved, while the "chicken" (*poule*) was the slave-owner.[55] His critique of Froude similarly detailed how the British claim to "fair play" was in fact undermined by such tactics as the use of Barbadian "rowdies" as policemen in Trinidad.[56] Thomas inspired his fellow Trinidadians, such as the world-renowned C. L. R. James, who re-read him in 1968 and concluded: "From Toussaint Louverture to Fidel Castro, our people who have written pages on the book of history, whoever and whatever they have been are West Indian, a particular social product."[57] James's remark, and personal example, show that vernacular and national heroes had combined in the Caribbean as a counter to the persistent claim that European values and examples were still the driving force in the region after emancipation.[58]

Returning to Froude's fantasy of England renewed in the South Pacific, we find him visiting Sir George Grey, governor of New Zealand in 1845–53 and again in 1861–68, who was now playing the part of an imperial *éminence grise*. As Froude sat in Grey's study on the island of Kawau, surrounded by medieval illuminated manuscripts, texts published under Cromwell's

British Commonwealth, and other obscurities, the two dreamed of a global Anglophone empire, bringing the United States back into federation with Britain, Australia, and New Zealand.[59] Yet Martin and Grey were men in retirement, aware that their day was past and Froude hinted that, for all his devotion to Carlyle, the era of the Hero was similarly in its twilight years. Froude's enthusiasm for the Anglo-Saxon life in Australia and New Zealand was matched by his purported regret at the condition of the post-emancipation Caribbean, which he saw as threatening to descend into "anarchy" on the model of Ireland in terms of the British empire and that of Haiti in terms of the Caribbean.[60] By contrast, Froude claimed to find an already existing state of revived Englishness in the southern hemisphere. These experiences in the colonies made him an advocate for a centrally controlled empire that would build on the model of his new historical hero, Julius Caesar, rather than on that of even a limited democracy.[61] He was careful to say that the motive force of empire was the necessity of finding space to restore the working population to rural activity and healthy living in order to sustain "the native vigour of our temperament."[62] Whereas Carlyle had seen empire as the place to dispose of excess and diseased portions of England, Froude gave expansion a vitalist tinge, while also claiming the status of indigeneity for the English. In taking his title from James Harrington's seventeenth-century work of constitutional theory, he made it clear that he was proposing a regeneration of the empire on the naval model. That is to say, he wanted to see the colonies and the metropole recognized as "one majestic organism which may defy the storms of fate" (15). In this way, Froude used the modern form of biopower to reframe the traditional concept (as he saw it) of empire. Writing in the midst of the perceived imperial crisis that followed the death of Gordon at Khartoum, Froude found the "fault not in individual ministers but in the parliamentary system" (151), and while making careful use of syntax to preserve what is now called deniability, he hoped for the coming of a "new Caesar" (152). He attributed to Carlyle the idea that since the Reform Act of 1832, England had been under a "spell" that had rendered it a "nation of slaves," meaning that emancipation for the actually enslaved had rendered the former masters into slaves. Now the "ocean empire" that Carlyle had dreamed of was at hand (153), in which "the nation was administered as a ship of war" (183). Rather than divide the empire into relatively autonomous nations with separate navies, Oceana would again become one under a single command, operating to the codes of military discipline. Command would not be bestowed in some im-

precise way on Carlyle's mystical Hero, but the ship of state would instead be subject to its captain, the new Caesar.

MANA AND BIOPOWER

The new imperial Caesar was empowered by an authority understood to be the modern counterpart to the "primitive" theory of mana. The British missionary Robert Henry Codrington (1830–1922) began the Western theorization of mana in Melanesia as part of a transformed missionary practice of the Anglican diocese of New Zealand, established after the signing of the Treaty of Waitangi under the leadership of George Augustus Selwyn, an old Etonian and Cambridge don. Inspired by Newman's Oxford Movement, like the young Froude, Selwyn envisaged a re-creation of the principles of the early church, in its first three centuries, by aristocratic English missionaries in the islands of the South Pacific.[63] This imagined imperial community made use of Christian rather than capitalist notions of simultaneity. Prefigured or prophetic events were in this view simultaneous with that which they prophesied or with any future fulfillment of them, one of the capacities of Carlyle's visualizer.[64] Selwyn's dream was enabled in 1861, when the Colonial Office agreed to allow Anglican dioceses to extend beyond the borders of British sovereignty, thereby directly expanding the British imperial sphere of influence. At this moment, missionaries literally became the foot soldiers of imperialism. As a result, a new Bishopric of Melanesia was created, under the direction of another Etonian, J. C. Patteson (1827–71), who created a missionary station named St Barnabas on the former penal colony of Norfolk Island. In another curious coincidence, the island had recently become home to the descendants of the *Bounty* mutineers against Captain Bligh, who had been moved from their refuge on Pitcairn Island. Patteson established a classic disciplinary institution on the island, with life being regulated by the ringing of bells in accord with a strict timetable. The station was intended to train Melanesians in Christianity, who would then serve as missionaries to their home islands—even conversion was a hierarchical process. In accord with Selwyn's heroic concept of the missionary, there were no distinctions at the station, with all participating in some form of manual labor. Late-nineteenth-century photographs of St Barnabas (too poor in quality to reproduce) show a re-creation of an Oxbridge college dining hall, with Gothic-style vaulting and gloomy oil paintings hung too high to be seen in detail. In accord with the

public-school ethos, physical exercise was conducted outside in all weathers year round. Codrington arrived on the station in 1863, where he was to stay for twenty years. Although remote, the islands were not excluded from global labor processes. The Queensland parliament passed the Polynesian Labourers Act in 1868, allowing plantation labor "recruiters" to visit the islands; in 1871 such "recruiters" took over fifty men and killed eighteen more from the island of Nggela alone. In September of that year, Bishop Patteson was killed on the island of Nukapu, most likely due to resentments over what Codrington accurately called "the slave trade which is desolating these islands."[65] The British sent a gunboat and shelled the tiny island in retaliation, completing the story's metonymic character as an illustration of high imperialism.

Codrington derived his understanding of Melanesian language and culture from the missionary recruits that came to St Barnabas. However, he indicated that the majority of his sources came from the small island of Mota Lava, in the Banks Islands, and the even smaller islet of Ra, fifteen kilometers to the north of Mota.[66] What these islands had in common was an established Christian mission under local auspices. Sarawia, known to the missionaries as George, the first ordained indigenous Christian priest, created a successful mission on Mota in 1869, complete with a church, garden, and "boarding-school." Codrington visited in 1870, commenting, with annoyance, "They assured me that they were quite enlightened and had done away with all bad customs and were just like us."[67] In fact he found his efforts at conversion satirized by a local man who, after a stint of labor in Queensland, wore Western dress and smoked a pipe. In his extensive photographic work, Codrington was careful to exclude all such contaminating evidence of modernity. Unsurprisingly, he concluded that "everything in this work depends on getting a native who can work on his people."[68] However, a hurricane that struck in 1873, resulting in food shortages and epidemics, was blamed on the new religion and the new recruits fell away, reverting by 1875 to a state that one British officer found "very dirty compared with those of Samoa or Fiji even."[69] That left only the small station on Ra, under the command of Henry Tagalad, where things continued to proceed "quietly and orderly," as a mission statement asserted in 1876, always to the sound of bells. The place of intersection between the West and its primitive ancestry had become almost vanishingly small.

Codrington's theories need to be understood as the product of a certain form of imperial Englishness, rather than as modern anthropological

fieldwork, just as the revisionist historiography of anthropology of the past twenty-five years would lead us to expect.[70] To be fair, in his first article (although much less so in the subsequent book to which most have referred), Codrington was aware of the difficulties of establishing communications about indigenous beliefs: "The young people among the islands know very little indeed of what the elders believe, and have very little sight of their superstitious observances. The elders are naturally disinclined to communicate freely concerning subjects round which, among Christian converts, there hangs a certain shame; while those who are still heathen will speak with reserve of what retains a sacred character."[71] At the same time, his theoretical understanding of religion was well suited to anthropological uses. He believed that no religion was without value and that there was in all people "the common foundation . . . which lies in human nature itself, ready for the superstructure of the Gospel."[72]

His findings on mana were presented first to the Royal Anthropological Society, in 1881, and then published in his book *The Melanesians* (1891), where he defined mana as "what works to effect everything which is beyond the ordinary power of men, outside the common processes of nature; it is present in the atmosphere of life, attaches itself to persons and things, and is manifested by results which can only be ascribed to its operation."[73] Mana was, then, the motivating power of life, that which gave it direction. Properly harnessed, it would be a vital medium for modern biopower, in the sense that a medium sustains a biological culture grown in it. When Codrington presented his theory in London, his audience immediately extended his inference, in keeping with Tylor's contention that what is law is law everywhere, drawing comparisons between mana and African, Australian, Babylonian, and Egyptian beliefs. It was, said one, "the ancient type of fetishism."[74] In the imperial worldview, there was now an ethnographic hierarchy of time in which people, living and dead, were allotted places on the ladder of civilization. If that ladder allocated places to all, it did not mean that all were capable of climbing it, but rather that History was now the means of distributing and organizing the sensible. The zones of exclusion and inclusion crossed and divided geographical and political borders, so that the metropolitan working class, or the inhabitants of the "South" within Europe, such as the Italian mezzogiorno or the whole of Greece, were considered closer to the actually existing "primitives" of the South Pacific than to the imperial elite because of their regressive adherence to the collective form of life. What was being enacted in the high imperial

period, and is being revisited in certain quarters today, was a visualization of History that projected specific notions of the sacred into a generalized, hierarchical, and abstracted "biopower." Mana was identified as majesty and force because the missionaries brought with them a strong sense of History as being shaped by precisely such supernatural powers.

Two modes of social, cultural, and governmental classification rendered these abstractions concrete. The first was the concept of the "norm" and the resulting predication of social laws from what has been called the "rise of statistical thinking."[75] Understood as a form of observation, statistics were first applied to the production of actuarial predictions for insurance companies. Adolphe Quetelet, a Belgian scientist, applied this probability theory to what he called "social mechanics" in order to generate his concept of *l'homme moyen*, or the average man. As Lennard J. Davis has shown, Quetelet's exaltation of the average, well suited to Louis-Philippe's monarchical strategy of the *juste milieu*, was revised by the eugenicist Francis Galton to what was known as a normal distribution in ranked order. This tabulation could then valorize desired characteristics, such as height or intelligence, rather than tending to the average.[76] The rankings were divided into quartiles, allowing for a clear distinction to be made between those above and below average. It was not for nothing that one account of statistics declared that "humanity is regarded as a sort of volume of German memoirs, of the kind described by Carlyle, and all it wants is an index."[77] Galton believed that his statistical method provided that index and sought to demonstrate that genius was hereditary and limited to a very small number of people, numbering some 250 in every million. He studied various categories of distinction, from judges to rowers and (oddly) hereditary peers, and concluded, in the style of Carlyle, that no one "who is acquainted with the biographies of the heroes of history, can doubt the existence of grand-human animals, of natures pre-eminently noble, of individuals born to be kings of men."[78] Heroes were now a standard deviation. In 1900, W. E. B. Du Bois named the second institution of division predicated on the hierarchy of civilization as "the color line." As Marilyn Lake and Henry Reynolds have recently emphasized, the color line was global, reaching from America to Asia, Africa, and the South Pacific as an institutional divide between the lighter and the darker skinned. In an article entitled "The Souls of White Folk" (1910), Du Bois emphasized that material advantage lay behind this division: "Whiteness is the ownership of the earth forever and ever, Amen."[79] It need hardly be added that these two modes of division

tended to overlap each other, so that Galton argued for eugenic improvement of the racial stock both by excluding so-called undesirables and by sustaining the color line to prevent social and sexual interaction between "races."

In the early twentieth century, leading up to the outbreak of the First World War, this hierarchy was organized into a discursive structure, linking missionary activity and anthropology to classical scholarship in a sharing of the imperial sensible. By the time of the first World Missionary Conference, held at Edinburgh in 1910, there was majority support for the concept that "animistic religions" had some "points of contact" with Christianity and were not, then, wholly false.[80] Here Codrington and his fellow aristocratic missionaries had developed Carlyle's vision of heroism as a gradually accumulating form of Truth, which was known in some respects to the Norse legends and to Islam. Now this accumulation was seen to be taking place in the same moment of time in different places at separated levels of History, demarcated as the primitive and the civilized. Codrington's concept of mana (as opposed to the Melanesian's own understanding of it) was vital as a form of connection between these zones of culture, and as such it played a central role in the modern theorizing of the primitive from Marcel Mauss to Emile Durkheim, Sigmund Freud, and Claude Lévi-Strauss. In a chain of intellectual reinforcement, these ideas found their way into interpretations of Roman imperial power and from there into theories of the state of exception. Giorgio Agamben has recently seen this sense of mana as being essential to the "undefinability" of the force of law and authority: "It is as if the suspension of law freed a force or a mystical element, a sort of legal *mana* (the expression is used by Wagenvoort to describe the Roman *auctoritas*)."[81] In Agamben's view, then, the modern use of mana has reinforced and transmitted the ancient slaveholding concept of authority as power over slaves complemented by the interpretation of messages.

While that analogy was certainly made, what should be taken into account here are the very unusual circumstances of Codrington's research and the resulting error in his conclusions. Far from being a universal trope of the "primitive" mind, the idea of mana was an imperial genealogy of High Church Anglicanism derived from what the missionaries believed to be the originary primitiveness of the Melanesians. This idea was one so shaped by the imperial state of exception that it is hardly surprising that it seems congruous with it. Agamben's historico-philosophical version of biopower misses the critical genealogical lesson and takes effect for cause. It is im-

portant to emphasize that it has now been established by the anthropologist Roger Keesing that *mana* is a "stative verb not a noun." Consequently, "things that are mana are efficacious, potent, successful, true, fulfilled, realized: they 'work.' Mana-ness is a state of efficacy, success, truth, potency, blessing, luck, realization—an abstract state or quality, not an invisible spiritual substance or medium."[82] That being the case, there is no sense in which a state of exception could be enabled by mana, given that the state of exception is a crisis of governance. Precisely because "terminology is the properly poetic moment of thought," these issues matter greatly.[83] For we are now being asked to accept that "sacredness is a line of flight still present in contemporary politics," a view that would have been congenial to the missionaries and imperial administrators under discussion here. That is not to say that there is no place for religion in understanding politics today, of course, but that there is not a persistent and consistent transhistorical discourse of power that can be named as that religion. When former President George W. Bush claimed wide-ranging authority after 9/11, it was under article 2 of the Constitution.

This sense of mana as a transhistorical source of authority nonetheless played a key role in modern thought, precisely as engendered by its difference from the primitive. In Emile Durkheim's theory of religion, published in 1912, mana was majesty, force, and the Hero rendered into a religious principle: "The idea of majesty is essentially religious." His example was taken from the select number of "souls" or *tindalo* that were worshipped in Melanesia: "Not every *tindalo* is the object of these ritual practices. That honor goes only to those that emanate from men who, during their lifetimes, were credited by public opinion with the very special virtue that the Melanesians call *mana*."[84] He then cited Codrington's definition of mana in full to complete his definition of what one might call the primitive Hero, constructed in and as biopower. Durkheim developed his concept of mana by arguing that totemism represents in imaginary forms taken from plants and animals all the nonphysical forces that the "diffuse and anonymous force" of mana comprehends. He rhetorically asked, "Does a man win out over his competitors in the hunt or in war? It is because he has more *orenda*," an Iroquois term that Durkheim proposed as yet another synonym for *mana*.[85] Developing Marcel Mauss's theory that all magic is mana, Durkheim argued that such social harnessing of force was also seen in modern historical events, such as the Crusades or the French Revolution, thereby crossing the divide between primitive and modern.[86] The idea of the Hero

that had taken the missionaries into the South Pacific and shaped their sense of evangelism as a projection of light into the space of early history had come full circle to its beginnings in Carlyle's choleric study of revolutionary France.

Scholars and administrators of what Foucault called governmentality consequently became interested at this point in what Robert R. Marett (1866–1943) considered to be the observable "phenomena of transition" between the primitive and the modern. In this view, "the types of human culture are, in fact, reducible to two." One would be the subject of anthropology, which Marett created as a degree field at the University of Oxford, in 1908, and the other that of the humanities, with the latter finding its "source in the literatures of Greece and Rome." Thus, anthropology could help classicists interpret the ancient foundations of Greece and Rome in the period prior to surviving textual sources in Latin. Trained as a classicist, Marett wrote extensively on mana and the Australian aboriginals, despite making only one brief visit to Australia, in 1914. For, like Tylor, he presumed that "the ethnographer in his library may sometimes presume to decide, not only whether a particular explorer is a shrewd and honest observer, but also whether what he reports is conformable to the general rules of civilization."[87] In order to determine those rules, Marett organized a lecture series on "Anthropology and the Classics" at Oxford in 1908, including scholars like Warde Fowler (1847–1921), whose theories of *homo sacer* have recently become the subject of renewed attention.[88] Fowler's own investigations into "primitive Italy" were predicated on a direct analogy between Polynesian and Melanesian practice as described by Marett. He cited with approval Marett's thesis that *sacer* was originally a form of taboo, although Marett had no experience of the South Pacific whatsoever.[89] Led by H. J. Rose, British classical scholarship continued to draw a close connection with Codrington's view of mana until after the Second World War, by which time it had become an element in texts aiming at the general book-reading public.[90] This change at Oxford was not a simple antiquarian diversion, but a shift in the mode of imperial discourse from what one might call "separate spheres," the radical distinction between the "savage" and the "civilized," to a continuum that extended from the primitive to the modern across an invisible but decisive break at the point when the "indigenous" Italians began to become "Romans" under Greek influence. Imperial visuality "froze" the implicit possibility of an ongoing progression in human society in this anthropological model into a permanent separation.

The anthropologist Claude Lévi-Strauss was among the first to criticize such parallels between the Polynesians and the ancient Romans, in 1950. Lévi-Strauss asserted that the "mystification" of the concept of mana had obscured its general condition as an expression of the "relationship of non-equivalence . . . between signifier and signified." For Lévi-Strauss, *mana* functioned like the general term *truc* in French, that is to say, as a notion that a person "'has something,'" as in the expression that "a woman has got 'oomph.'"[91] His investment was in presenting mana as a "universal and permanent form of thought" that, far from being divided by History, was in effect outside history altogether. While this antiracist form was certainly preferable, the sexist choice of example was unfortunate and perhaps revealing. It is by no means unsayable what "oomph" might mean, except that it might breach the conventions of polite (sexist) society. Lévi-Strauss dismissed the religious concept of mana as the sacred, but replaced it with the transcendental signified to which any signifier must be in a relation of "'inadequation.'"[92] The brilliance of this strategy is undermined when it is realized that mana is not a "thing" (*truc*), but a verb — it cannot therefore be a "floating signifier" or have "zero symbolic value," because it is a term concerning action. Even Lévi-Strauss's intervention did not put the theory to rest within classical history. Ironically, when Georges Dumézil did finally challenge the idea that mana was the key to understanding early Roman religion, he did so by means of substituting another mythology, that of the perfect continuity of "the Indo Europeans who became the Romans, who preserved without a break, without a slump, the conception which had already formed before their migrations and which is indicated everywhere and has been since the dawn of history," that is to say, the idea of God.[93] The concept of the "Indo-European" has gone out of favor in recent years, but such transhistorical generalizations have a life of their own. So even though the debate over the supposedly "conservative" nature of ancient Roman religion is now literally academic, albeit with the leading scholars now seeing the historical process as far more complicated, its deployment by Agamben and others within discourses surrounding the current "state of exception" continues to make the issue contemporary.[94] By using mana in the traditional fashion to indicate a quality of the ancient "West" deduced from modern "primitives," Agamben postulates a history of the "state of exception" that of necessity has its own exception — all those nations and legal systems that are not posited on Roman law and its presumed universality. Further, this "Western modernity," however little he finds to praise

in it, must be considered in a state of advancement over its "primitive" origins. The discourse of the state of exception has thus ironically proved to be a reinforcement to the idea of Western exceptionalism.

PROLETARIAN COUNTERVISUALITY

By contrast, nineteenth-century working-class and radical intellectuals created a decolonial genealogy of the classical period that could inform and authorize resistance to modern imperialism as a continuance of ancient class struggle. These activist scholars used modern scholarship to present an alternative understanding of classical history that characterized the Romans as slave-owning aristocrats, actively resisted by proletarian leadership. Just as the Maori had deliberately predicated themselves as Jews to the British Christians, so did European radicals identify as the descendants of Roman slaves in ongoing resistance to classicizing aristocrats. In this view, the *proles* of ancient Rome had engendered the proletarian of industrial Europe, a Tradition from below to set against Carlyle's Tradition of Heroes. Its primary strategy was the "general strike," looking back to Chartism and the Commune and anticipating a twentieth-century revolution that was yet to come. It was placed in a genealogy beginning with Moses and the Israelites leaving Egypt, continuing with the slave revolts of Antiquity epitomized by Spartacus, and revived in the modern period as the definitive means of proletarian emancipation. As the counterpoint to the hierarchy of imperial visuality, the general strike was a tactic for visualizing the contemporary by creating a general image of the social. Often inspired by Edward Gibbon's *Decline and Fall of the Roman Empire*, such accounts represented Christianity as a negative and destructive force, rather than as the epitome of the civilized. Reviewing these efforts, the historian Raphael Samuel has suggested that the articulation of "the class struggle in Antiquity . . . may be said to have been the principal site on which the claims of historical materialism were advanced."[95] This alternative genealogy would produce the May Day holiday, Georges Sorel's 1906 theory of the general strike, the Spartacists of 1918 in Germany, and the radical Plebs League in early-twentieth-century Britain. The "general strike" is here understood not simply as a work stoppage but as the right to look: to see and be seen *by each other* within a historical moment and to know how things stood.

An early example of the linkage of ancient and modern class struggle was the collection of essays by the Chartist leader James O'Brien, known as

Bronterre O'Brien, published in 1885, some twenty years after his death, in 1864, entitled *The Rise, Progress and Phases of Human Slavery*. O'Brien offered a concise and compelling world history, arguing "what are called the 'Working Classes' are the slave populations of civilized countries." Furthermore, the genealogy of these new slaves led directly back to the slaves of the ancient world, for ancient Roman proletarians were "the descendants of manumitted slaves" who had no property but their children (*proles*). These emancipated slaves, whose sign, the so-called Phrygian bonnet, became the emblem of revolution and equality in the modern period, formed the ranks of hired labor in the ancient world, as well as its beggars, thieves, and prostitutes. In O'Brien's view, the modern period saw the "development and progress of Proletarianism, which was consequent upon the breaking up of the old system of slavery, and has ever since gained more and more strength in every age, till, in our own times, it has made Proletarians of three-fourths of the people of every civilized country."[96] Ancient and modern slavery had combined to produce the proletarian, a new name for an old figure in Western history.

Most influential of all such publications was C. Osbourne Ward's (1834–1902) two-volume history, *The Ancient Lowly* (1888), originally printed and circulated privately, and then reissued, in 1907, by a "co-operative publishing house owned by sixteen hundred socialist clubs and individual socialists."[97] Ward had been a member of the Working Men's Party in 1870s New York that later became the People's Party, in 1874.[98] He went on to work as a translator for the United States Bureau of Labor, from 1885 until his death.[99] His substantial history of the class conflict in antiquity was presented as work in tune with the latest scholarship, inspired by the legendary German classicist Theodor Mommsen. It was based on his reading and translation of the inscriptions he had gathered, blended with his eclectic reading from modern anthropology and garnering of information from encyclopedias and dictionaries. His philological concerns and explorations of the origins of certain ancient rituals and practices seem curiously familiar in the wake of the classicizing impulse in recent critical theory. At the same time, Ward offered his book as academic sociology and popular "news," information to motivate his readers in the present day, highlighting the simple existence of figures like Eunus, Achaeus, and Cleon, whose army of rebel slaves in Sicily was composed of 200,000 men at its height, in 140 B.C.E. According to Ward, under the self-created monarchy of Eunus, the formerly enslaved dominated the region from 143 to 133 B.C.E., defeating Roman armies in

numerous encounters.[100] He gave a lengthy account of the triumphs of the revolutionary gladiator-slave Spartacus, composed from ancient and modern authorities, motivated by strong support for the rebels, in contrast to the standard hostility.

Nonetheless, even in the case of Spartacus, Ward emphasized that all the "general strikes" of antiquity met with the same ultimate fate of violent defeat and mass executions as a "suggestive hint to modern anarchists."[101] It was also a "new" account in its presentation of the ancient past such that the ancient *collegii* were described as "trade unions" rather than "guilds" or any such neutral term, and the gaps in the historical record pertaining to the general strikes of ancient times were attributed to the censorship of the "slave-owning aristocracy." One assertion that particularly incensed those few professional scholars who noticed Ward's work was that the red flag adopted by socialists in the nineteenth century was the *vexillum* of ancient origin, generating "the ineffaceable love in the strictly proletarian class, for the beautiful and incomputably aged red banner."[102] In support of this assertion, Ward cited Tylor's *Primitive Culture* on the power of habit, just as the Caesarists used mana as evidence of their case. In short, like C. L. R. James after him, Ward used the language and concepts of the class struggle of his own time to offer a historical genealogy of conflict from within the very heart of the legacy claimed by the ruling classes of his own day. This history from below in all senses recognized that its task was to create an alternative mode of historical identification for the (would-be) revolutionary, entailing the creation of a countervisuality. The British anarcho-syndicalist J. H. Harley even claimed the same origin for this politics, in 1912: "The nineteenth century presented itself to the great writer, Thomas Carlyle, who was the first to catch its syndicalist spirit, as primarily a century of revolution."[103] Revolutionaries must then express themselves in the terms set by Carlyle, as the manifesto of the Plebs League, formed from British miners and railwaymen, declared, in 1909: "Inability to recognize the class cleavage was responsible for the downfall of the Roman Empire. Let the Plebs of the 20th century not be so deluded. The clear seeing of the field of battle will alone save us from the follies and tragedies of compromise."[104]

For over twenty years prior to this declaration, artists and activists in the European labor movement had tried to realize this "clear seeing." The countervisuality that the radical political groups of the period were attempting to create came to use different tools than the traditional work of art as its means of experimenting with both form and content. Anarchist

newspapers, magazines, and journals extensively discussed and debated art from the late 1880s onward. Yet writers often expressed a perplexity as to the meaning of art or aesthetics in the context of modern social crisis and were more forceful in denouncing the prevailing art establishment. The syndicalist activist and writer Fernand Pelloutier (1867–1901) created a journal entitled *L'Art Social*, in 1891, to "add to the communism of bread, the communism of artistic pleasures," refering to Joseph Tortellier's practice of distributing free bread in working-class districts.[105] Pelloutier and others were by now convinced both that the Rights of Man were permanently in default under the system of industrial capital, and that the urban insurrections of 1789–1871 stood no chance of success against modern armies. In 1898, when Pelloutier visited an anti-Dreyfusard meeting in a working-class area of Paris, he was disturbed to hear chants of "Long live the King! Down with the Jews!" This experience prompted him to imagine the creation of a museum of labor to counter such prejudices. His idea followed the establishment of courses and libraries for those in search of work at the *bourses de travail*, and the "museums of the evening" that the art critic Gustave Geoffroy had proposed to inspire industrial design. The proposed Museum of Labor would have had as many sections as there were local unions to display the history of their products, as well as "the comparative situation of the capitalist and the worker," which Pelloutier believed would be far more effective than yet more oratory.[106] Unlike other museums, the Museum of Labor was to visualize the present by making the class struggle known through the silent eloquence of its displays, "because in the general insanity that characterizes this century, words themselves lose their meaning."[107] Using the comparative method, Caesarism's mana was to be countered with a visual display of the power of labor.

Like the Panopticon, the Museum of Labor was not actually built, but it was performatively created by means of the struggle to establish an international holiday of labor on the first of May, now known as May Day, widely understood across the radical movement as the first step toward a society-changing general strike. For Rosa Luxemburg, May Day was a "festival [that] may naturally be raised to a position of honor as the first great demonstration under the aegis of mass struggle."[108] In its nineteenth-century form, the May Day "holiday," or mass refusal to work, was called in support of the eight-hour working day. The eight-hour day had first been claimed by white trade unionists in the colony of Victoria (now federated within Australia) as early as 1856.[109] Radicals in Chicago demonstrated for

the shorter day on May Day 1886, leading to police violence and the retaliation several days later that is known as the Haymarket Affair. The American example led the first meeting of the Second International Working Men's Association of 1889 to call for a global observance of May Day in 1890. On that day, Engels wrote the fourth preface to the *Communist Manifesto* and observed: "The spectacle we are now witnessing will make the capitalists and landowners of all lands realize that today the proletarians of all lands are, in very truth, united. If only Marx were with me to see it with his own eyes!"[110] The May Day demonstration, like the general strike, was intended to make the strength of the proletariat visible to itself and to visualize the class struggle.

In Milan, where the working week was some sixty-three hours, organized labor called a general strike in support of May Day.[111] Fully aware of what was at stake, the Italian army attacked the demonstrators. The Italian artist Emilio Longoni painted the scene, including the army's assault, first exhibited at the first Brera Triennale, in 1891, under the title *May 1*, now known by its later title *The Orator of the Strike*.[112] The painting is dominated by a mason in his work clothes addressing the crowd while hanging loosely from a height of scaffolding. Longoni placed a red lantern at the corner of the scaffold, evoking the French revolutionary imagery of the Lantern (the street lighting from which those declared to be enemies of the revolution were hanged). While the Lantern harked back to 1789, Longoni painted it red, the color of modern socialism. The Lantern reframes the space away from the edge of the canvas, offering only a blurry view of the main body of the crowd and the intrusion of the army. Although he was experimenting with the divisionist brushstroke, that is to say the "dot" technique associated with Seurat and Signac, *May 1* is more notable for its unusual pictorial space. The orator's body angles out over the crowd, supported only by his right hand, which grips the scaffolding, and by his feet, which are precariously balanced on the top of a fence. His left fist thrusts toward the spectator, and two other clenched fists rise from the crowd toward him, although only the front row of men are distinguishable as individuals. The painterly innovations that Longoni used paradoxically mitigated against a "clear seeing" of the strike as a collective action. Further, Longoni's retitling of the painting called attention to the orator as the subject rather than to the collective practice of the strike. By naming the speaker as an orator, Longoni referenced the classical tradition of oratory as practiced in the Roman Senate and the French Revolution. If *May 1* is a remarkable evocation of the

continuity between 1789 and 1891, it did not in itself manage to create a counter to imperial visuality. That was the function of the great demonstrations themselves, as none other than Lenin observed in an early pamphlet, written from prison in 1896, calling May Day "a general holiday of Labor. Leaving the stifling factories they march with unfurled banners, to the strains of music, along the main streets of the cities, demonstrating to the bosses their continuously growing power."[113] For activists like Rosa Luxemburg, May Day was an internationalist, anti-imperial, and antiwar tactic that showed that international laborers would never go to war against each other, an illusion shattered in 1914.

In this moment of coming into visibility, proletarian countervisuality adopted the strategy of the general strike as the means of creating a "general image" of the state of the class struggle. Since the Chartist National Holiday, the general strike had emerged as a composite of revolution and messianic hope for the future in the face of modern armed forces. In his address to the 1899 Congress of the Socialist Party, Aristide Briand, a future government minister, argued that the general strike could change the 1789 Declaration of the Rights of Man and the Citizen from words to realities, while avoiding violence.[114] This assertion of the revival of rights by means of the strike was a consistent feature of radical propaganda. Consequently, the general strike was often described as utopian, a characterization revolutionaries at different moments refused and embraced. Even in the syndicalist newspaper La Grève Générale (The General Strike), it was argued, in 1894, that the general strike was only a "dream" because the impoverished workers would not have enough food to survive the weeks or months that the strike would take to prevail.[115] Such was the outcome of a miners' strike depicted by Emile Zola in his novel of the same name. At the same time, a popular anarchist song hailed the strike: "Voila, voila, voila mon rêve!" [There, there, there it is my dream!], a tradition that foreshadowed the 1968 slogan "Take your dreams for reality."[116]

Following the successful agitation for May Day, the general strike seemed to have become a viable strategy for French workers to attain specific goals. In 1906, the Conféderation Générale de Travail, the leading French trade union, adopted the general strike as its political strategy. Rosa Luxemburg understood the Russian Revolution of 1905 as the enactment of the general strike that showed "a typical picture of the logical development and at the same time of the future of the revolutionary movement on the whole."[117] The mass strike could be used to "visualize" the proletariat and the class

movement as a key tactic of "demonstration," whether or not it achieved an overall change in social relations.[118] The strikes she cited were often local, spontaneous actions, sometimes following the "state of exception" that is caused by a holiday for a monarch's funeral or coronation. These strikes were "general" not because everyone took part, but because their aim was a general transformation and renunciation of domination. The effect was to transform the "theoretical and latent" class consciousness imbued by the activities of political parties into a "practical and active" strategy on what she called "the political battle field."[119] Here she mixed the metaphors of the "dreamwork" of the general strike visualizing latent understandings with the long-standing sense of history itself as a visualized conflict.

It was left to a retired civil servant and political theorist named Georges Sorel to draw all these strands of activism and theory together in a series of essays written from 1905–7, published in book form as *Reflections on Violence*, in 1908. Sorel endorsed the general strike as pure revolt, to be enacted on the Greek model of selfless individual warfare, rather than that of the disciplined but bloodthirsty modern army. The Homeric hero, or the foot soldier in France's revolutionary wars, fought as an individual on whom all depended, in contrast to the modern war directed by generals as theorized by Clausewitz. Against the lone Hero who could visualize the battlefields of modern life, it was the collective visualization of the workers that enabled them to understand modern life as war. Proponents of the general strike came to see it as a transposition of war into the social terrain, a counter to visuality visualizing the social as a battlefield. Edouard Berth quoted Proudhon's definition of war as applying to the general strike: "A mixture of genius, bravery, poetry, passion, supreme justice and tragic heroism—their majesty astonishes us."[120] For Sorel, the general strike was the expression of "individualistic force in the rebellious masses"; it followed that "we are led to regard art as an *anticipation* of the highest form of production," an idea that has been fulfilled in today's virtuoso and creative workforce.[121] Thus the general strike formed by a series of individual choices akin to that of the artist would create a complete picture of history as it then was. Sorel saw this picture as incarnating the popular "will to act" inherent in the various declarations of the Rights of Man, and thus as depicting a popular history of centuries standing.[122] While radicals felt that the texts of the Rights of Man were now ignored, this visualization was the means to restore their efficacy. The general strike, notes Sorel, is the most effective tool available to radicals because it "encompasses all of socialism; that is to say

. . . [it is] an arrangement of images capable of evoking instinctively all of the sentiments which correspond to the various manifestations of the war waged by socialism against modern society. Strikes have inspired in the proletariat the noblest, deepest and most forceful sentiments that it possesses; the general strike groups them all into a general unified image. . . . Thus we obtain that intuition of socialism that language could not give in a perfectly clear way—and we obtain it as an instantly perceivable whole."[123] Following Bergson's notion of the "intuition of reality," Sorel argued that it was through the general image produced by the strike that the movement comes to a collective self-awareness that it otherwise lacks, albeit only for that moment.[124] For Sorel (quoting Bergson), "the moments where we capture ourselves for ourselves are rare and that is why we are rarely free."[125] In short, the general strike creates countervisuality, a brief possibility of seeing things as they actually are, who is with you and who against, just as Carlyle had claimed the Hero could do. If visuality was the visualization made by a general, countervisuality emerged in the modern period as the collective picture produced by the right to look claimed in the general strike.

It was nonetheless just a few years after Sorel had theorized the visualization of the general strike that he joined Mussolini in search of a new Caesarism. Like many others, Sorel had been influenced by Gustave Le Bon's tract *The Psychology of Crowds* (1895), which reconceptualized visuality for the era of mass society and mass organization.[126] Le Bon's work was extensively critiqued by Freud and was hailed in 1954 as "perhaps the most influential book ever written in social psychology."[127] It certainly grasped the balance of visuality and countervisuality that this chapter has attempted to describe. Le Bon identified the then present as a key turning point in history, brought about by the entry of the popular classes into politics. Here he was thinking not just of universal suffrage, but also of syndicalism and trade-union activism, which would culminate in the politics of May Day and then the general strike. Like Carlyle, Le Bon feared that such efforts "in spite of all economic laws tend to regulate the conditions of labor and wages . . . and amount to nothing less than a determination to destroy utterly society as it now exists, with a view to making it hark back to that primitive communism which was the normal condition of all human groups before the dawn of civilization."[128] He thus equated the social egalitarianism of the Second International and syndicalist groups with the "primitive communism" held to be endemic in undeveloped societies such as those of the South Pacific. Against the new "divine right of crowds" could be found only the modern

equivalent of the "world's masters," who fully understood the psychology and character of crowds. These new heroes would offer up images to the crowd because "[a] crowd thinks in images, and the image itself immediately calls up a series of other images, having no logical connection with the first."[129] This irrational mode of thought led to the crowd having respect only for "force" as manifested by a certain kind of hero: "The type of hero dear to crowds will always have the semblance of a Caesar."[130] For Le Bon, the crowd thinks in images, like the "savage," the child, or women. Its desire for a return to primitive communism can only be countered by a leader with sufficient power, or mana, to sway its unconscious desires, namely a Caesar. Le Bon seemed to at once imagine and desire the Caesarism of Italian fascism in particular and the charismatic dictatorship so pervasive in the twentieth century in general. In Froude's view, the uniting force behind this single organic entity was the common "stock," the formation of a "race" of forty-five million "Anglo-Saxons" dispersed across the globe. Le Bon shared this emphasis on the "fundamental notion of race which dominates all the feelings and all the thoughts of men."[131] Visuality was now the imagining of this global racialization within a hierarchical concept of civilization. With the collapse of the imperial age following the First World War, the hierarchy of races was to become racialized war under fascism.

THE HERO AS *DUCE*

Fascism created a visuality closer to Carlyle than to Froude, an aesthetic glorification of the leader.[132] No moment more clearly enshrined the leader as a Hero with capacities exceeding those of all others. The beholders of the fascist leader had two functions: first, to form a ground against which the leader's brilliance could be seen; and, second, to serve as the raw material for the leader to work with, as if he were an artist, but also to hate, motivating fascism's violence. Beginning with this distance between the leader and the mass, fascism aestheticized separation and the separation of bodies in physical space. Fascism is the highpoint of what Susan Buck-Morss has called the "theme of the autonomous, autotelic subject as sense-dead, and for this reason a manly creator, a self-starter, sublimely self-contained."[133] Many in the period saw this idea as originating with Carlyle's encomium to the Hero. Carlyle had been cited with approval by Edouard Drumont, the French theorist of antisemitism, in his defining text of modern reaction, *La France Juive* (1886), a reference later expanded by Maurice Barrès, the

anti-Dreyfusard writer and politician.[134] Such connections led to Carlyle being seen as a prophet of fascism in general and of Mussolini in particular. With fascism in the ascendant in Italy, a professor named Guido Fornelli published a short biography of Carlyle in 1921, comparing his work to that of Marx: "Carlyle had a more objective vision of the social problem, he understood the complexity and instability of its aspects, and perhaps we shall see in the very near future that he did not speak in vain."[135] Once the fascist regime had been established, in 1922, another professor, named Licciardelli, published a similar comparative study of Carlyle and Mussolini, proclaiming the former as "the prophet of a new social order, which, at the distance of a century, it has been given to Benito Mussolini to put on a solid footing, inaugurating the realization of the work conceived by the great English idealist."[136] Such views were also common in the Anglophone world. A British literature professor named Herbert Grierson published a lecture entitled *Carlyle and Hitler*, whose title tells all one needs to know of it. An American academic got into the act by publishing a newspaper article of similar import under the title "Carlyle Rules the Reich," which wanted to show Anglophone readers that the "strange philosophy of Hitler" was in fact very similar to the "solutions proposed by Carlyle to the problems of our industrial civilization."[137] These ideas did not go unnoticed in Germany itself, where Carlyle was hailed a forerunner of "Fuhrer-thinking" by academics in the newly purged German university system.[138]

The fascist leader was nonetheless by no means identical to the Hero. Fascist leadership required that its self-containment be acknowledged by the masses. Consequently, the masses were needed as the object of the fascist artist-leader's work, causing him to both need and detest them, as Mussolini attested, in 1932: "When I feel the masses in my hands, since they believe in me, or when I mingle with them, and they almost crush me, then I feel like one with the masses. However there is at the same time a little aversion. . . . Doesn't the sculptor sometimes break the marble out of rage, because it does not precisely mold into his hands according to his vision? . . . Everything depends on that, to dominate the masses as an artist."[139]

What the fascist wanted was to be seen but in an entirely passive modality. Whereas Bentham had wanted his jailer to see without being seen, the fascist leader wanted to be seen without anyone looking, if we take looking to be an active critical engagement with sense perception. At the Nuremburg rallies, designed by the architect Albert Speer to create a cathedral of light, the mass needed to be in attendance to create the proper en-

vironment for the Führer to be seen. This was in no sense an exercise of the right to look by the mass, but rather its utter negation. The light pillars created by Speer seemed to give material form to the concept of the Hero as what Carlyle had called a "light fountain," while the vassals of the Hero formed material shadows to put him into relief. In making that darkness part of its bureaucratic policy, fascist terror tried to normalize genocide. In terms of fascist visuality, if the presence of the mass created the shadow necessary to make the leader visible, the victims of genocide were the invisibility against which fascist visuality visualized itself. The work of genocide was to take those who it was believed should be invisible and render them hypervisible as a means to make them properly, finally, invisible. Such measures as the Nuremberg Laws of 1934, with the infamous requirement of the yellow (and other) stars, the street violence that culminated in the Kristallnacht of 1938, and the segregation of Jews rendered these racialized Others into hypervisible form. The work of genocide was to make the Other permanently invisible. As is now well-known, the Nazis made every effort to keep their crimes secret and invisible. Among those who remained, regardless of whether or not they "knew," this invisibility of the Jews and other Others was, as intended, intensely visible, following their previous hypervisibility. It was "unspeakable" in both senses, unnameable and revolting, yet present. It was this rendering of racialization by means of spacing, the massive bureaucracy of coordinated dispersal, dissemination, and secret regathering, that epitomized the work of fascist visuality to create a ground against which the Leader might be beheld.

Antifascist Neorealisms

North-South and the

Permanent Battle for Algiers

Confronted with the disasters of the twentieth century (and now those of the twenty-first), antifascism has had two tasks. First, to depict the reality of fascist violence as violence, and not as an artwork. Next it must offer a different possibility of real existence to confront the fascist claim that only the leader could resolve the problems of modern society. It meant claiming a place from which there is a right to look, not just behold the leader. For both W. E. B. Du Bois and Antonio Gramsci, writing in the 1930s, that place was what they called the "South," understood as the complex and difficult place from which resistance had to begin and also as the emergent future. The mistake of the antifascist Left, in this view, was to ignore the "South" as an atavistic relic of servile relations, failing to realize that such relations were as much part of modernity as heavy industry. Fascism itself can be situated as a South-North flow of colonial politics, sometimes literally, as in the case of Franco's use of Moroccan armies in Spain, more often metaphorically in the installation of a police state, above all in Germany. Antifascism did not fully succeed in creating a form of realism from the "South" until after the Second World War—which was by no means the end of fascism, as Frantz Fanon made clear in his writing on Algeria. Indeed, in thinking through how fascist visuality came to be the intensified modality of the imperial complex, I kept coming up against the place of Algeria and the battle for Algiers during and after the revolutionary war (1954–62). The

Algerian War was a crucial turning point for European and Third World intellectuals alike, a scission point that has reemerged in the present crisis of neo-imperialism and the revolutions of 2011. Independent Algeria was further the site of a second disastrous civil war, in the 1990s, between the army as the defender of the revolution of 1962 and what has been called "global Islam," which is ongoing. Both the country and the city were and are, then, key locations on the border between North and South, as a place of oscillation between the deterritorialized global city and the reterritorialized postcolony. "Algeria" is thus a metonym for the difficulties of creating a neorealism that can resist fascism from the point of view of the "South."

As an extensive literature has shown, fascist visuality was designed to maintain conflict. Like the colonialism of which it was an intensified form, fascism is a "necropolitics," a politics that determines who may allocate, divide, and distribute death.[1] Within colonial-fascist necropolitics, there was always the possibility of genocide that represented the intensification of the imperial complex. In 1936, Walter Benjamin made his now famous analysis that these strategies were "the aestheticizing of politics, as practiced by fascism. Communism replies by politicizing art."[2] While the first part of this proposition is widely understood as the cult of fascist leadership, its response as the politicizing of art is still debated and indeed current. Although Benjamin's essay sought to formulate "revolutionary demands in the politics of art," he did not return to his earlier endorsement of the general strike in his "Critique of Violence" (1921). Acknowledging Sorel and the German revolution of 1919, led by Luxemburg's Spartacists, Benjamin had countered the state of exception with an exception on the side of the multitude in the form of the (then) "right to strike [which] constitutes in the view of labor, which is opposed to that of the state, the right to use force in attaining certain ends."[3] By 1936, such rights had disappeared due to the triumphs of fascism over organized labor, requiring a new modality of countervisuality. To take a decolonial perspective, antifascism first refused the idea of the heroic leader, by describing him as a form of police function, then named the "South" as a place to look, refusing the subjection of fascism. From that viewpoint, it became possible to define a new realism that both described fascism as it was and predicated a different possible means of imagining the real. Just as Benjamin had come to his proposition regarding fascism from a reading of the impact of film, so I will consider how anticolonial cinema in Algeria explored the possibilities of realism from the literally guerilla documentary to the Italian neorealist-style *The Battle of Algiers*

(dir. Gillo Pontecorvo, 1966) and Algerian post-independence feature films. While this book was in production, the region was swept by revolutions, whose outcome is at the time of writing unclear, but whose lines of force were set down by the process described here.

Both Du Bois and Gramsci proposed new realisms as a counter to fascism. Du Bois's *Black Reconstruction* and Gramsci's prison writings undertook a detailed and archival description of their historical moment. Du Bois's reconfiguration of Reconstruction ran against a revisionist Confederate history that had portrayed the enslaved as loyal to their owners and Reconstruction as at best a disaster and at worst a crime.[4] Du Bois was therefore concerned to convey as many of the words of the historical actors as he could and then contrast them with the then "scholarly" accounts that still make shocking reading today.[5] Gramsci was equally concerned to restore what he called the "history of the subaltern classes" that the "modern dictatorship" tried so hard to eliminate from what he called the culture of the period. It was nonetheless present in the phenomena that he called "folklore," ranging from popular culture to newspapers, gossip, and myth. From these strata, at once present and invisible, the subaltern classes could act with an unpredictable "spontaneity" that cut against the grain of fascism's rage for order. For Gramsci, this "spirit of cleavage—that is the progressive acquisition of the consciousness of one's historical identity"—was the means by which antifascism could be actively engaged.[6] Fascist Caesarism by contrast held that the subaltern had no historical identity that could be distinguished from the leader.

In 1918, soon after the Bolshevik Revolution, Gramsci had seen historiography forming a dialectical pattern between Carlyle's conservative evocation of the hero and the bourgeois sense of history as the measure of progress, which he connected to Herbert Spencer. He contrasted the "mystical synthesis" in Carlyle and the "inanimate abstraction" of Spencer with Marx's sense of how "an idea becomes real."[7] Within a few years, fascism had shown that the question of heroic leadership could not be so easily set aside. Gramsci stressed that there was no "essence" of fascism. Rather it should be understood as "a particular system of relations of force" that has "succeeded in creating a mass organization of the petty bourgeoisie."[8] Given the Romanizing aspect of Italian fascism, he called this organization

"Caesarism," which "can be said to express a situation in which the forces in conflict balance each other in a catastrophic manner."[9] In moments of social crisis there was a possibility of mutual destruction that Caesarism held in check rather than resolving. While Caesarism had traditionally been the domain of "a great 'heroic' personality," such as Napoleon, it had become a bureaucratic system, expressed as much by Ramsey MacDonald's coalition governments in Britain as by dictatorship. Crucially, Gramsci understood that "modern Caesarism is more a police than a military system."[10] Fascism is when the boundary created by the police between what they can see and what we can see extends to the totality of the social. It was not Caesar (the Führer, the Duce) that created the police, but the police that created and sustained Caesar. Similarly, W. E. B. Du Bois set aside theories of the Talented Tenth in favor of his defense of "the Negro race" as a whole in the work of Reconstruction. He showed that the falsified history of the past produced "the current [1935] theory of democracy . . . that dictatorship is a stopgap pending the work of universal education, equitable income and strong character. But always the temptation is to use the stopgap for narrower ends because intelligence, thrift and goodness seem so impossibly distant for most men. We rule by junta; we turn Fascist because we do not believe in men."[11] In the limited racialized democracy of America in the 1930s, "fascism" was the potential outcome of a series of stopgap policing measures that became permanent as a means of controlling space.

Gramsci felt it was essential to establish and fix this new reality from a new perspective, which he named that of the "subaltern classes," a new application of military terminology to everyday life.[12] Subalterns were the junior officers introduced into European armies in the nineteenth century as a means of communicating the leadership's commands to the rank-and-file. One might say that they were the embodiment of visuality, enacting the general's superior visualization of the battlefield. In Gramsci's view, the First World War had shown that armies now depended on these links, which he compared to the interface between the mind (the generals) and the body (the soldiers), making the subaltern a medium of transmission for what Descartes had called the mind-body hybrid.[13] In the general social context, visuality was that medium. If Gramsci retained the military name, he reversed its intent so that the subaltern became an alternative way to mediate the "war" of the social itself. Gramsci understood the subaltern classes as all those excluded from power, centered on industrial workers, but including peasants, women, and other marginalized groups. He consid-

ered that the Risorgimento (1814–61), which created the Italian state had, by contrast, retreated to a pre-Napoleonic consideration of the people as dispensable units of foot soldiers, rather than as "thinking men" who could play an active part in the contest.[14] The "class struggle" had to be understood in advanced societies as having changed from a "war of maneuver," that is to say a pitched battle in the sense of Clausewitz, to a "war of position," a more cautious, long-term engagement measured in cultural form. The war of maneuver that inspired Carlyle's concept of visuality was the war of movement waged by Prussian generals since the late eighteenth century, which led both to the destruction of Louis Napoleon in the Franco-Prussian war of 1870 and to the Nazi-era concept of blitzkrieg. Gramsci was recognizing, as many radicals had already done, that modern mechanized warfare in the imperial bureaucratic states could not be defeated by traditional methods of insurrection. By contrast, the war of position required a catharsis, as in classical tragedy. For Gramsci this entailed "a struggle for a new culture, that is, for a new moral life that cannot but be intimately connected to a new intuition of life, until it becomes a new way of feeling and seeing reality."[15] Du Bois expanded this countervisuality into "a clear vision of a world without inordinate individual wealth, of capital without profit, and income based on work alone, [which] is the path out not only for America but for all men. Across this path stands the South with flaming swords."[16] Here he reiterated the long-standing effort to imagine a biopolitics designed for sustainability, rather than for maximizing the exploitation of labor.

To deploy the medium of the subaltern against the police bureaucracy of Caesarism, a place of articulation or transmission had to be defined. For both Du Bois and Gramsci that complexly overdetermined space was the South, within and without the imperial nation-state. The South is not a geographic location, but what Enrique Dussel has called a "metaphor for human suffering under global capitalism."[17] The concept of the South emerged from the postslavery Atlantic world as a means of thinking through the legacies of plantation slavery and of imagining an alternative future. In Pétion's Republic of Haiti, his education adviser, named Colombel, had reported on the success of examinations at the new Lycée Pétion in soaring terms: "Haitians, you are the hope of two-thirds of the known world."[18] A group of intellectuals who graduated from the Lycée founded the journal *Le Républicain* (later *L'Union*), in 1837, to examine the specificity of Haiti.[19] For one of these writers, the historian and politician Beauvais Lespinasse (1811–63), Haitian leadership could be accomplished by empha-

sizing the African past common to all and imagining a future as part of the global South. Relying on a social theory of evolution, Lespinasse mused,

> Africa and South America, these great lands which have almost exactly the same shape, and which regard each other as twin sisters, . . . await their destiny. These two Southern continents, the Caribbean and the innumerable islands of the Pacific will continue the work of the civilization of the North . . . The time of the races of the South is not yet come; but it is firmly to be believed that they will send to the current civilized world intellectual works along with their merchandise and the immense current of hot air, which each year softens the climate of Europe.[20]

Such ideas were most likely known to Du Bois. Since the occupation of Haiti by U.S. forces, in 1915, the affairs of the island had become a critical point of engagement for African American politics. Du Bois met the former Haitian education minister and writer Dantès Bellegarde at a Pan-African Conference in 1925 and later published his work in the review *Phylon*. Du Bois himself summarized for *Phylon* a speech given by Bellegarde on the development of "autonomous" Haitian literature, including references to Lespinasse.[21]

Both Du Bois and Gramsci developed such nineteenth-century aspirations, that the South might be the agent of global liberation, by examining how it was at the same time the key location for reaction. While there were very significant differences between the North-South pattern of domination in Italy and the United States, it may be more productive to think about the similarities. If the United States was, of course, not ruled by a fascist party, its South had a clear pattern of racialization and separation, which became known as segregation. As Du Bois convincingly argued, this violent mode of domination constrained democracy both locally and globally. Although there was no single autocratic leader in the American South, the ideologists of segregation spoke fondly and at length of its principles of anti-industrial aristocracy, which they derived from British conservatives like Carlyle.[22] At the end of *Black Reconstruction in America* (1935), Du Bois outlined the discursive formation of the post-Reconstruction South around the intersecting axes of whiteness, the penitentiary, and sharecropping. These disciplinary institutions so effectively divided and separated the working classes of the South that the distinction came to appear "natural." Gramsci summarized the Northern Italian view of the South in very similar terms: "Southerners are biologically inferior beings, either semi-barbarians

or out and out barbarians by natural destiny; if the South is underdeveloped it is not the fault of the capitalist system, or any other historical cause, but of the nature that has made Southerners lazy, incapable, criminal and barbaric."[23] Looking back on the Fascist takeover of Italy, which had seemed inconceivable even when Mussolini's party first dominated parliament, Gramsci came to see this divide between the North and South as the key to the emancipation of the nation as a whole because the South had become an internal colony: "The Northern bourgeoisie has subjugated the South of Italy and the Islands, and reduced them to exploitable colonies."[24] The "South" was then reduced to a condition in which the only resistance it could imagine was a "great 'undoing' (revolt)."[25] Nonetheless, it was precisely the spontaneity of this spirit of resistance that offered the possibility of a transformation of political culture into a form that could not sustain the racialized segregations of Caesarism.

In calling these approaches "neorealist," I am evoking the Italian postwar cinema and photography of that name without wanting to suggest a simple resumption of that tactic. While Neorealism was antifascist, the director Pier Paolo Pasolini recalled, "I also criticized it for remaining subjective and lyricizing, which was another feature of the cultural epoch before the Resistance. So, neo-realism is a product of the Resistance as regards content and message but stylistically it is still tied to pre-Resistance culture."[26] If Italian neorealism was a product of the resistance to fascism, such stylistic failures suggest that the project should not be still defined by it. Even the "content" of that neorealism is no longer controversial, in that the European dictatorships, and indeed the Jim Crow South, are now, quite rightly, among the most reviled political regimes. Indeed, the place of such regimes in cultural work today is more often to express a sense of progress and the impossibility of recurrence. Against that comforting consensus, antifascist neorealism understands the contradictory nature of a conflicted reality held in place by the operations of the police. It wants to make the continuing realities of segregation—the combination of spatial and racial politics— visible and to overcome that segregation by imagining a new reality.

BATTLING FOR ALGIERS

I decided against posing such questions to the fascism of the 1930s, which is both so extensively documented and so reviled that it has almost ceased to have substantial contemporary meaning, as evidenced by the accusation

that the U.S. healthcare proposals of 2009–10 were fascist or Nazi. Instead, I want to use the still controversial continuing struggle in and about the decolonization of Algeria as a test case. From Delacroix's *Women of Algiers* to Frantz Fanon and Assia Djebar, Algiers was and is a key node in the network that has attempted to decolonize the real, to challenge segregation, and to imagine new realities. It is not exactly the same as the historical Alger, or Al-Djazaïr, but its visualization on the border between North and South, recalling Giorgio Agamben's definition of the fascist state of emergency as a "zone of indifference, where inside and outside do not exclude each other but rather blur with each other."[27] The Algerian decolonization movement led by the Front de Libération Nationale (FLN) and the revolutionary war of 1954–62, in particular the contest for control of the capital city, Algiers, in 1957, radicalized a generation of European intellectuals and was noted for the participation of the Caribbean theorist Frantz Fanon.[28] It was Fanon, having escaped from Vichy-controlled Martinique to enlist in the Free French Army, who later posed the question in his decolonial classic *The Wretched of the Earth*: "What is fascism but colonialism at the heart of traditionally colonialist countries?"[29] This rewriting prefigures the recent turn to understanding coloniality as the very being of power. By considering Algeria as a locale of antifascist neorealism, I continue the decolonial genealogy that has motivated my entire project. The Algerian War became a test case for the war in Iraq that began in 2003 and the subsequent U.S. strategy of global counterinsurgency, so it is still worth concentrating on the battles for Algiers in psychiatry, film, video, and literature that have raged since the end of the Second World War to the present. Finally, many of the unresolved issues in the decolonization of North Africa dramatically returned to global attention when autocratic regimes in Tunisia and then Egypt were overthrown by popular revolutions in 2011. At stake throughout has been the imaginary of decolonization and the postcolonial imperial power. Was decolonization a victory or a gift? Were the rebels terrorists or nationalists? As for France, in the case of decolonizing Algeria, was it the moral victor of the Second World War, the inventor of human rights, or just another tired European power trying to maintain its dominion?

Algeria had been colonized by France, in 1832, and following the particular pattern of French colonization, it was not considered separate or distinct, but as a "department" of France. At one level the revolutionary war concerned a simple incompatibility between the French view that Algeria was in all senses part of France and the indigenous claim for independence.

Then and now it was clear that there was no solution to this counterpoint: one side would have to dominate. However, the country was entirely dominated by the French settler population, backed up by the military. By 1950, 1 out of 9 Muslim Algerians were out of work, 25 percent of the land was owned by 2 percent of the (white) population, and only enough food was being produced for 2–3 million people, despite a Muslim population of 9 million.[30] The battle for Algiers refers to the events of 1957, in which the FLN, which had begun the active guerilla war of liberation, in 1954, called for a general strike in Algiers. The FLN included the French definition of human rights as an "equality of rights and duties, without distinction of race or of religion," in their charter (1954) and pursued them alongside the armed struggle. They hoped for United Nations intervention on their behalf and claimed that their action was justified by the right to strike under the French constitution. Led by the infamous General Jacques Massu, French paratroopers repressed the strike and the FLN by the widespread use of torture to extract information. Nonetheless, the battle of Algiers came to seem a turning point in the liberation struggle, which was finally successful in 1962. Looking back on the events at a distance of forty years, the communist activist and journalist Henri Alleg, who was "disappeared" and tortured by French troops, reconfigured what had happened: "In reality, there never was a battle; only a gigantic police operation carried out with an exceptional savagery and in violation of all the laws."[31] Just as Gramsci understood the fascist Caesar to be the product of the police state, so, too, was the imperial president sustained and produced by colonial policing under martial law. One felt the forceful echoes of this history in the 2011 Tunisian and Egyptian revolutions, when the armies of both countries stood by as the revolutionary populace contested the authority of the police. In this sense, the popular takeover of the Egyptian secret police building and its archives in March 2011 marked the "undoing" of former President Hosni Mubarak's autocratic police state.

The consistent and persistent return of the battle for Algiers in art, films, television, literature, and critical writing in the period and subsequently as a figure for war, nationalism, the migrant, torture, colonialism, and its legacies suggests that what was in the period known as the "Algerian question" remains unanswered. Where is this Algiers? In Africa, Europe, or the Maghreb? And we shall ask: where is where? Whose Algiers are we describing? How is Algiers separated in time and space, now and then, and why does this battle continue? At the time of writing, the revolutionary wave that

began with demonstrations in Algeria against the rise in the price of food in January 2011 has produced an end to the nineteen-year-old state of emergency, but has not transformed the regime. It is precisely such questions that the cultural work on Algiers has raised from France to Finland, Italy, the United States, and, of course, Algeria itself. At stake is the possibility of a movement toward the right to look, the counter to visuality, against the police and their assertion that there is nothing to see here. Less clear has been the question of what would come afterward. In Gillo Pontecorvo's film *The Battle of Algiers* (1966), the resistance leader Ben H'midi says to Ali La Pointe that the hardest moment for a revolution comes after its victory. If colonization means, as Albert Memmi put it, that the colonized is "outside history, outside the city," what does it look like when that viewpoint is restored?[32] How can a right to look, framed in the language of Western colonial jurisprudence, be sustained as the place of the decolonized inside history and inside the city, whether that city is Algiers, Paris, Cairo, New York, or the *civis* of civilization itself? As the case of Algeria itself suggests, such questions have yet to generate sustainable answers, here or there. For the Algerian insistence on a nationalist solution that would, in Fanon's famous phrase, create a "new man" set aside questions of Islam as belonging to the past. If that "new man" was the image of decolonization, the investment in a new imagined community, the independent post-colonial republic, was such that it was felt to be capable of solving the questions of a postcolonial imaginary.[33] The antifascist investment in the "spontaneity" of the people was a double-edged weapon. On the one hand, it was capable of evading and overcoming even the most dedicated repression as the French discovered to their cost. At the same time, spontaneity was not invested in building institutions, allowing the FLN's Army of the Frontiers to preside over what the writer Ferhat Abbas has famously called "confiscated independence" almost as soon as the French had departed, in 1962.[34] Still worse, as the world knows, the Islamic Salvation Front won the elections of 1991, which were invalidated by the ruling FLN and the army, unleashing a civil war that cost an estimated 160,000 lives, including some 7,000 "disappeared" by the government. The practice of "disappearing" antigovernment activists—meaning having them killed and disposed of in secret—was begun by the French during the revolution and later exported by them to Latin America, most notably in Argentina and Chile.[35] Such practices, far from forming a decolonized visuality, epitomize the secrecy of the police in separating what can be seen from what must be declared invisible.

Fanon had accurately defined this condition in colonial Algeria. As a counter to what he saw as colonial fascism, he imagined the decolonization of colonial visuality as a process that "transforms the spectator crushed to a nonessential state into a privileged actor, captured in a virtually grandiose fashion by the spotlight of History."[36] The reply to the view of history as the plaything of the Hero was to transform the spectator from the passive onlooker demanded by fascism into an active participant in visualizing. The changes required were physical and mental. Fanon understood the colonial as "a world divided in two. The dividing line, the border, is represented by the barracks and the police stations."[37] These were, of course, the institutions that created Caesarism, and the border was the line where there was nothing to see. Above and beyond the physical separation of "native" sectors from "European," these divides had come to produce "aesthetic forms of respect for the status quo."[38] This aesthetic engendered a sense of what is proper, normal, and to be experienced without question. In reading this passage, Achille Mbembe has stressed that the emphasis on the police and the army means that behind this division of space lies a "spirit of violence."[39] The segregation of colonial space was thus experienced as violence by the "native," but also as the proper way of living that was visibly right by the "European." This legacy of separation has survived formal decolonization and the end of legal segregation in the United States, for, as Mbembe shows, segregation created a "large reservoir of cultural imaginaries. These imaginaries gave meaning to the enactment of differential rights to differing categories of people for different purposes within the same space; in brief, the exercise of sovereignty. Space was therefore the raw material of sovereignty and the violence it carried with it."[40] It is this aestheticized segregation that antifascist neorealism has set out to describe, define and deconstruct.

Fanon emphasized in *The Wretched of the Earth* that this aesthetics was a "language of pure violence," generating a sense that the "native" sector was "superfluous" with the result that "the gaze that the colonized subject casts at the colonist's sector is a look of lust, a look of envy" (5). Sexualized desire was displaced onto a desire for space, because that space represented possession in every sense of the term. Separation by violence produced a mirroring desire for violence: "To blow the colonial world to smithereens is henceforth a clear image within the grasp and imagination of every colonial subject" (6). While most discussion has centered on the question of violence, I want to stay with Fanon's concept of the imagination, for this was an imaginary destruction. He was intentionally using the language of

Lacan's gaze here, as he had already done in *Black Skin, White Masks* (1951), a text that he presented as a "mirror with a progressive infrastructure, in which the Negro could retrieve himself on the road to disalienation."[41] Just as Sartre insisted that the antisemite made the Jew and Beauvoir claimed that "one is not born, but rather becomes, a woman," Fanon did not understand identity as being shaped only by private or family dynamics. Rather, all three socially engaged critics shared Beauvoir's assumption that "only the intervention of someone else can establish the individual as an *Other*."[42] Fanon has often been faulted on his use of psychoanalysis here, with critics urging him to have read other essays by Lacan or pay more emphasis to the theory of castration.[43] Yet under the impact of the revolutions of 1968, none other than Lacan himself allowed that for the colonized "the unconscious . . . had been sold to them, along with the laws of colonization, this exotic regressive form of the master's discourse, in the face of the capitalism called imperialism."[44] That is to say, there was a colonial Oedipus complex and related phenomena, such as the gaze, but they had been instilled by colonial domination.[45] In a surprising reversal, little noticed among all the mathematical symbols of his often disrupted seminar at Vincennes, Lacan had come to endorse the cultural construction arguments of Fanon and Beauvoir, whose goal was to understand the constitution of inequality, rather than that of an eternally unchanging unconscious.[46]

The projected imago of the mirror stage theorized by Lacan was simply not available to the colonized subject, according to Fanon, given that the ideal body in colonial culture was of necessity "white" and that subaltern peoples were by definition not white. Indeed, in many fictional and autobiographical accounts, subaltern people of "mixed" background are repeatedly represented as staring into mirrors, trying to discern if that mixture is visible. In the racialized context, this looking meant discerning whether or not African, Indian, or Jewish ancestry was "visible," according to the stereotypes of the time. This mirror anxiety was not limited to subaltern groups. Given the widespread miscegenation of the Atlantic world, few "white" people were exempt. The mirror was in this sense a scene of colonial dispersal, rather than identification. Further, Fanon insisted that slavery and colonialism disrupted, and perhaps made impossible, Oedipal belonging, understood as a technique of colonization. For, as Deleuze and Guattari later put it: "To the degree that there is oedipalization, it is due to colonization."[47] That is to say, the divided self, or constitution by lack, is not a transcendental human condition, but a historically generated division of

the sensible. What Fanon and others have looked for was a means of transition away from that division to another possible mode of engagement with the self and with others. The goal is not some impossible constitution of a whole, but the possibility of equality. Fanon's concept of looking was therefore transitional, rather than foundational, a means of working through violence that could not but acknowledge that the desire for equality between subaltern classes was the desire for the same, a desire that the regime of Oedipus reduced to deviance. As Greg Thomas has emphasized, this desire would lead Fanon away from the frame of the national to his support for pan-African revolt, as if, even during the course of the nationalist revolution, he had come to realize its limitations.[48] As events have shown, the violence that was supposed to be instrumental in disposing of colonial rule has become institutionalized through the place of the army in governing independent Algeria. Here arises the interfaced question of what one might call, following Ngũgĩ wa Thiong'o, decolonizing the imagination.[49] While Ngũgĩ's concentration on using indigenous language remains a controversial issue in Algeria, split between French, Arabic, Berber, and other indigenous languages, the politics of the image have received less attention, but were no less significant.

COLONIAL MYTHOLOGIES, GUERILLA DOCUMENTARIES

One of the first steps in the French declaration of a state of emergency in Algeria, in April 1955, was the assertion of powers to "take all measures to ensure control of the press and of publications of all kinds, as well as radio transmissions, showings of films and theatrical performances."[50] This law was revived during the riots and demonstrations in the French *banlieux* (suburbs) in 2005, indicating that there is still a battle for a certain Algiers in Europe. This active censorship introduced an element of ambiguity into French cultural work of the period. For instance, the critic Roland Barthes began his now classic essay "Myth Today," published in 1957, with an attempt to disrupt the "naturalness," as he called it, of media imagery. Waiting in a barbershop, he happens on a copy of *Paris-Match*, published in June 1955, just after the law was passed (see plate 9). "On the cover, a young Negro in a French uniform is saluting, with his eyes uplifted, probably fixed on a fold of the tricolor. All this is in the *meaning* of the picture. But, whether naïvely or not, I see very well what it signifies to me: that France is a great Empire that all her sons, without any color discrimination, faithfully serve

under her flag, and that there is no better answer to the detractors of an alleged colonialism than the zeal shown by this Negro in serving his so-called oppressors."[51] It took a certain daring for Barthes to use this emblem of the French empire to present his theory of signification, that is to say, the combination of the effect of what is seen, what it literally depicts, and what it implies. *Paris-Match*, a relatively new magazine (founded in 1949), relied on scandalous and eye-catching photographs to attract its audience. In this case, the saluting young soldier appears to be very young indeed, younger than military recruitment age, as the caption "the night of the army" suggests. Further, if he was a soldier, he was probably one of the notorious Zouaves, African troops who were used to carry out much of the most violent work in Algeria and other French colonies.

Ignoring these connotations, Barthes developed his analysis to show that what he called "myth" froze the historical meaning of the message and rendered it neutral as what he called "depoliticized speech." He suggested that myth was naturally at home on the Right, whose great cause Algeria had become, and that an anticolonial interpretation would end the mythic status of the image. As complex as that signification was, there was also an anticolonial signification at work in his use of the image. In a footnote, he proposed, "Today it is the colonized peoples who assume to the full the ethical and political condition described by Marx as being that of the proletariat."[52] If the French Communist Party (PCF), and other leftist groups would not necessarily have agreed, the Right would have found the proposal close to treasonous. Further, the picture had an unmentionable resonance. When the FLN killed sub-Saharan African soldiers, they would sometimes fix them upright in a pose of saluting.[53] The FLN knew that the French government were using these African troops symbolically (or as Barthes would put it, mythologically) and countered with their own symbolism. While Barthes's anti-imperial semiotics has been cited in countless academic texts, the counterperformance of the same "message" by the FLN has been forgotten. A recurrent theme in Western discourse against political violence waged by nongovernmental agencies is that violence is senseless, meaningless, and pointless. To the contrary, as Allen Feldman has pointed out in the different context of Northern Ireland, "violent acts on the body constituted a material vehicle for constructing memory and embedding the self in social and institutional memory."[54] The place of violence in decolonizing visuality is a place of difficulty, certainly, but not a discourse devoid of meaning.

Colonial mythologies of the type discussed by Barthes were actively disseminated by cinema. In Algeria, twenty-four feature films were produced from 1911–1954, whose functions were later defined by Hala Salmane: "1. To distort the image of colonized people in order to justify to Western public opinion the policy of colonization; the natives therefore had to be portrayed as sub-human. 2. To convince the 'natives' that their colonial 'mother' protected them from their own savagery."[55] As Fanon had described in *Black Skin, White Masks*, such cinematic fictions as *Tarzan*, cartoons set in "Africa," and well-meaning documentaries on poverty or disease also contributed to this colonial cinema, whose aim was keep those in the colonies and in the colonizing nations invested in the aesthetics of separation. Salmane argued for restoring African identity from the distortions of colonial imagery. As a first step in this direction, the FLN established a film unit, in 1957, led at first by René Vautier, a French documentary filmmaker and former Resistance fighter, and the Algerian Chérif Zenati.[56] Vautier's first films in French colonial Africa had led to his prosecution and sentencing under still current Vichy laws, but he remained dedicated to the issue of ending and documenting colonialism. Working undercover as a filmmaker during the Algerian War, using the pseudonym "Farid," Vautier trained a group of Algerian filmmakers, including Chérif Zennati and Abd el Hamid Mokdad.[57] Nine of these filmmakers died in the conflict. His own 16 mm short documentaries were widely shown in the Arab world and in the Eastern bloc, beginning with *Algérie en flames* (1957), which showed footage taken during actual combat, making it among the first decolonial combat documentaries. Fanon met Vautier at this time, but opposed even allowing him to work in North Africa because he was French and a communist to boot.[58] Indeed, the filmmaker was later imprisoned by the Algerian resistance on suspicion of being a spy. He nonetheless continued to work with them after his release, participating in creating an unfilmed screenplay of *The Wretched of the Earth*.[59]

These projects generated the innovative short film *J'ai huit ans* (I Am Eight Years Old), officially attributed to the Maurice Audin Committee, including the filmmakers Olga Poliakoff and Yann Le Mason, commemorating a young French mathematician who had been tortured to death by the French occupation forces. The film was attributed as being "prepared by Frantz Fanon and R. Vautier," despite their earlier disagreement.[60] It was the product of a new therapeutic strategy of visualization that Fanon was experimenting with in his clinical work with Algerian refugees in Tunis.

Perhaps the best known of these patients was the writer Boukhatem Farès, who became an artist and created a series of works, called "Screams in the Night," in the Tunis hospital.[61] Farès later recalled that Fanon had told him to "visualize" what was troubling him and gave him a book on Van Gogh to help advance his artistic ideas. By 1961, when the film was made, there were 175,000 Algerian refugees in Tunisia and another 120,000 in Morocco, many of them very young. At the children's house in Tunis, Fanon asked the refugees to work through their experiences, in writing, speech, or drawing. Paper and crayons were distributed to the child refugees, who created an extensive archive of the war in the rural areas. Later published and translated into Italian by Giovanni Pirelli, a sympathetic wealthy Italian, the children's accounts range from those of aerial bombardments to those of ground warfare and torture (see figs. 48a–e).[62] For example, a line drawing by Mili Mohammed shows a French soldier whipping a man who is shackled by the arms. Ahmed Achiri produced a detailed drawing showing soldiers attacking a village, torturing men with fire and rounding up women and children. While not all the works are attributed, at least two drawings were by girls, identified as Fatima and Milouda Bouchiti, showing veiled women with children. Anonymous cutouts depict a man being shot and another man being whipped. A drawing shows the corpse of a man being carried through a village by cavalry horses. So if the torture and violence of the war were in some sense a "secret" in France, although one preserved more by denial than by actual secrecy, it was well-known to the young people of Algeria. Perhaps unsurprisingly, they were all politically radicalized as a result. One sixteen year old stated that France wanted Algeria for its oil, while an eleven year old dated the outbreak of the revolution to the massacre in Sétif in 1945 — six years before he was born. Another eleven year old, an orphan, said that his ambition was to return to an independent Algeria.[63] Collectively, these documents form the archive against which the famous case study in *The Wretched of the Earth*, describing the killing of a French child by two Algerians, should be judged, as we shall see.

In the period, it seems that Fanon or others realized the dramatic potential of these accounts, leading to both the book publication and the film. According to the titles of one version, René Vautier was responsible for collecting the images for the film. *J'ai huit ans* was made when the FLN's war of liberation was eight years old, thus memorializing the war itself, as well as the children seen in the film. It began with a minute-long sequence of filmed head-and-shoulder portraits of apparently eight-year-old children

FIGURE 48A–E.
STILLS FROM *J'AI
HUIT ANS* (1961, DIR.
RENÉ VAUTIER, 1961).

looking straight into the camera to the percussive sound of gunfire.[64] The cut to black-and-white paintings of violent scenes comes as a surprise, even a shock, enhanced by the speeded-up gunfire. A narrative in voiceover by children speaking Algerian French in seemingly deliberate monotones describes attacks on the villages by French troops and the subsequent rescue of some of the children by FLN forces, illustrated with a series of the drawings, often seen in close-up. Tanks and machine guns are accurately depicted. One French soldier appears with a tail. One drawing is signed by "Hadim," another by "Madjid." As the film progresses, a variety of voices and stories are heard, which all contribute to the theme of conflict and loss. A child says that a plane "looked at me," and then it proceeded to fire, while she hid under a large stone. Music is added. FLN guerillas lead them to the border, cut the fence, and they find refuge—one child even finds his parents. Suitably happy images follow to the sound of a chant for an independent Algeria. These visualizations of the hidden realities of the war became a form of accusation, in the classic format of Zola's "J'accuse."

Short as it is, the film contains a range of potential looks to counter colonial visuality that were not allowed expression in the colonial context. From the opening shot of the children facing the camera, the central focus is the look of the child, usually ignored in such contexts. Now we are so inured to repeated displays of impoverished children in underdeveloped countries that these images have attained a new invisibility. In the period, they were both striking and a riposte to the idea that this was a war for civilization. The children's story also made visible the French soldiers, who would rather not have been seen at all, and the torture chambers, whose existence were officially denied until a former general admitted to them, in 2002. In the period, those taken in for interrogation were known as the "disappeared," attesting to the importance of invisibility for, and as a means of, torture. These looks became visible by means of the children's drawings, which were both a means for the children to work through their own traumatic experience and, by the very fact of their authorship, an unimpeachable source for the violence being carried out by the French. Finally, and counterintuitively, the war itself uses the film, as it were, to claim an age and the right to be seen. By emphasizing the duration of the conflict, the film reminded metropolitan viewers, who might have been trying to forget, that the war persisted; to the Algerians and their allies, it showed that the full might of colonial power had not succeeded in repressing the

resistance. Realizing that this apparently humanitarian content was also a history of the war, French police seized the film at least seventeen times over many years. The French government replied by arranging some 7,500 showings of its own propaganda films in venues such as rotary clubs and other such institutions in the six months following the United Nations debate on Algeria during September 1957 alone.[65] *J'ai huit ans* was banned in France until 1973, whereupon it won a prize for best short film of the year.

This little-remarked collaboration between Fanon and Vautier marked a critical intersection between radical psychiatry and activist cinema. Fanon had created a practice in which staff worked with patients to address their conflicts, eating and socializing with them, rather than maintaining the classic clinical distance. Drawing on the teachings of Fanon's professor, the Spanish antifascist François Tosquelles, this now familiar strategy was then new, certainly in the colonial context, where colonial psychology had claimed that all Algerians were in an infantile state.[66] As late as 1952, the Algerian School of Medicine declared in its handbook for physicians: "These primitive people cannot and should not benefit from the advances of European civilization."[67] The spatialized and separated hierarchy of culture created in the late nineteenth century continued to inform such purportedly clinical judgments. Such pronouncements make it easier to understand the involvement of certain psychiatrists in torturing Algerians. Indeed, during the revolution, Antoine Porot, founder of the Algerian school, and one of his followers attributed the uprising to a pathological form of "xenophobia" among Algerians "against subjects belonging to an occupying race."[68] Hence revolutionary action was a form of madness, as Pinel had suggested in immediate aftermath of the French Revolution of 1789. Fanon's innovative ethnopsychiatry refused such stereotypes and worked to create culturally appropriate treatments, including creating a café, a mosque, and a newspaper for patients. Fanon endeavored to treat his patients on a day-clinic basis, meaning that they returned home at night and some even stayed in work. This approach required those in treatment to deal with their symptoms in everyday life as well as in the clinic.

In a lecture series he gave at the University of Tunis in 1959 and 1960, Fanon developed a theoretical framework for his decolonial psychiatry. He recharacterized the insane person as "a 'stranger' to society." Anticipating Foucault, Fanon saw that the internment of this "anarchistic element" in society was a disciplinary measure that rendered the psychiatrist into "the auxiliary of the police, the protector of society."[69] The segregation between

the European and the native that had led Fanon to revolutionary politics was both replicated and produced in and by colonial psychiatry. Rather than segregate the patient, Fanon sought to achieve his or her "resocialization," following his emphasis on the dehumanizing effects of colonialism.[70] Yet, Fanon asked, into what group was the patient to be resocialized, and "what are the criteria of normality?" His answer was to create a "society in the hospital itself: this is *sociotherapy*."[71] Fanon went on to discuss neurological and psychoanalytic approaches, including Lacan's mirror stage, before turning to the psychological effects of time discipline and surveillance. He considered the psychic impact of the time clock on factory workers, of closed-circuit television on shop assistants in large American establishments, and of auditory monitoring on telephone operators.[72] He completed the circuit by casting the presumed "laziness" of the colonized as a form of resistance to the idea that they could not be unemployed because their function was to work as and when required. The colonial system thus visualized its colonized subjects as the perfect Platonic workers, whose function was to do what was required of them and nothing else. In this context, Fanon's engagement with children as social actors and as the index of the Algerian revolution marked his commitment to the cultivation of a "new man," unconstrained by discipline or colonization. Read optimistically, had he lived longer, Fanon might have moved away from his emphasis on masculinity to imagine new modes of postrevolutionary gender identity, as part of this analysis of the racialized disciplinary society, a connection made by many radical black feminists in the United States from Angela Davis to Toni Cade Bambara and bell hooks.[73]

In this connection, it is noticeable that a number of early post-independence Algerian films, such as *Une si jeune paix* (dir. Jacques Charby, 1964) — explicitly inspired by Fanon's work — and the multi-authored *L'enfer à dix ans* (dir. Ghaouti Bendeddouche et al., 1968), featured the children of the revolution as subjects, nonprofessional actors, and screenwriters. Film was a vital medium in Algeria, where 86 percent of men and 95 percent of women were estimated to be illiterate at the time of independence. Some 330 cinemas for 35 mm films were left behind by the colonial forces that now showed both the new films produced by the independent government and Hollywood productions. Vautier took a different approach, working with Ahmed Rachedi to create the Centre Audio-visuel (CAV), in 1962. The center developed what were called "ciné-pops" (popular cinema), building on the cinema club tradition that Fanon had participated in while working

at Blida.[74] The "ciné-pops," recalled Vautier in a later interview, were designed to "initiate the people to progressive cinema with the goal of supporting them in their march towards socialism, by semantically illustrating the aspects of discourse proper to this form of socio-economic organization. Thus we always insisted on the militant and political aspects of film rather than its human value."[75] This agitprop form, recalling early Soviet cinema, organized 1,200 screenings in 220 locations in their first six months, using two projection vans taken from the old Psychological Service of the French Army. These films included Chinese works like *The Red Detachment of Women* (dir. Xie Jin, 1961), shown to a large women-only crowd just outside the Casbah; Eisenstein's *Battleship Potemkin*, screened for dockers in Alger, who identified directly with the famous staircase scene because of a similar structure in their own city; and locally made shorts, including *J'ai huit ans*. The postwar Algerian films were silent montages accompanied by a live verbal commentary that became the basis for *Peuple en marche* (dir. René Vautier, 1963), a documentary about the new Algeria shown at the first FLN post-independence conference in Algiers.[76] Despite gaining some 60,000 members, the ciné-pops movement collapsed as the government moved away from revolutionary politics, and the center was closed, in 1964. The missed encounter to develop radical cinema and psychiatry as part of decolonial governance continues to haunt attempts to visualize a postdisciplinary society.

By contrast, the FLN cadre and former businessman Yacef Saadi created Casbah Films, in 1962, and later collaborated with Pontecorvo in filming *The Battle of Algiers*.[77] As Pontecorvo had himself been the leader of the youth section of the Italian resistance, in which the screenwriter Franco Solinas had also been involved, the film was a collaboration between anticolonial and antifascist resistance fighters. The Algerians financed 45 percent of the costs of the film, and Saadi helped Pontecorvo identify the exact locations in the Casbah where the events on which those depicted were based had taken place. For example, the house where the FLN resistance leader Amar Ali, known as Ali La Pointe, died was entirely rebuilt so that it could be blown up for the film. In keeping with this desire for authenticity, all the actors bar one, who played the paratrooper Colonel Mathieu, were amateurs, recruited in Algiers. Saadi played himself, under the name Djafar, while Ali La Pointe was played by a street hustler named Brahim Hadjadj, who went on to act in many Algerian films. Saadi was concerned to produce "an objective, equilibrated film that is not a trial of a people or of a

nation, but a heartful accusation against colonialism, violence, and war."[78] In fact, Pontecorvo rejected his original treatment as being too much like propaganda and instead worked with Solinas to generate a neorealist film under a regime that he called the "dictatorship of truth." Pontecorvo shot the film on low-cost stock to enhance the grainy newsreel feel, while exposing for very strong black-and-white contrasts in the Italian neorealist style.

As a result, *The Battle of Algiers* allows for different points of interpretation. It is clearly anticolonial, but also antiwar, while arguing for the inevitability of armed conflict given the intransigence of French colonial policy. The film depicts the story of the struggle for control of Algiers in 1957. It begins just after torture has broken an FLN operative, who has revealed the hiding place of the FLN leader Ali La Pointe. From these opening moments in a French torture chamber, the viewer is plunged into the conflict. By its nature, torture is a practice that wants to be offstage, literally ob-scene. To be confronted with the tortured body, even in the current era of official avowal of so-called harsh techniques, is a visual shock. In using this shock in the opening, rather than as a central moment, as in more recent films like *Rendition* (dir. Gavin Hood, 2007), Pontecorvo visualized the normalization of torture. Henri Alleg, a French communist newspaper editor in Algiers, who was tortured by paratroopers, described this as the "school of perversion" for the young French conscripts and volunteers.[79] The actor used to play the torture victim in *The Battle of Algiers* was serving a sentence for theft in the notorious Barberousse prison, from where he was released to play the part, no doubt accounting for his confused air. By the same token, the dramatic scene that follows the titles, depicting the radicalization of Ali La Pointe in the same prison, showed the execution of an FLN activist, a key intensification of the conflict in 1956. The actor was a man who, like Saadi himself, had been sentenced to death by the French, but was not in fact executed. Pontecorvo further implicates the implied viewpoint of the spectator with the FLN. When Colonel Mathieu (Jean Martin), the fictional representation of General Marel-Marice Bigeard, sets out his information strategy to his colleagues, he shows them films taken at French checkpoints to point out that although surveillance was in effect, Algerian activists were succeeding in evading the checkpoints.[80] At that moment, a woman that we already know to have to planted a bomb passes by, creating what Soviet director Sergei Eisenstein called a montage effect in which the viewer creates knowledge that is not directly presented by the film.

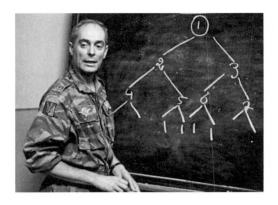

FIGURE 49. INFORMATION PYRAMID FROM
BATTLE OF ALGIERS (1966)

Mathieu presents to his staff a means of overcoming their inability to
see by transforming people into information. He demonstrates what Saadi
called the "pyramid" scheme, in which each person in the organization
knows only two others. In order for the French to reach the top-level
commanders, information must be obtained that allows them to particu-
larize the pyramid with names (see fig. 49). This "method" is Mathieu's eu-
phemism for torture, under the excuse that there was a twenty-four-hour
period to act before the organization modified its structure. This rhetoric
is what is now known as the "ticking bomb" justification for torture. Un-
like present-day politicians, Mathieu does not shy away from the realities
of the question at stake. If, he demands, you want Algeria to remain part
of France, then this is the way to do it—and he reminds the journalists
that even *L'Humanité*, the French communist newspaper, adhered to the
notion of *Algérie française*. For Republican rhetoric insisted that the country
was "one and undividable," unlike a federal nation like the United States,
where one state or another always seems to be contemplating secession. In
interviews, Saadi argued that Mathieu had to be played by a professional
actor in order for this explanation of the pyramid system to be convincing.
Indeed, some have argued that it was precisely this professionalization of
bureaucracy that limited the radicality of the FLN to that of a nationalist
revolt, rather than a socialist or self-directed revolution. The French tactic
rendered the body of the tortured into data, disguising the erotics of vio-
lence that generated it, as part of an information flow that would have been
understood as "cybernetic" in the period. As N. Katherine Hayles has sum-

marized it, Norbert Weiner decontextualized information "as a function of probabilities representing a choice of one message from a range of possible messages."[81] Thus the paratroopers find the leader of the organization (FLN) by means of tracking "messages" around their information system. This rendering of information into binary code was the reality that colonial authority now sought to find in its subject peoples, abstracting their individual identities but ensuring the free flow of information. Its obscene counterpart was that such information was for the most part obtained by the flow of electricity, the predominant method of torture used in Algeria.

Perhaps unsurprisingly, there was a gulf between the European and the Algerian experience of realism in this and other filmed representations of the war. In later interviews, Jean Martin, the French actor who played Mathieu, described the powerful affect of working with Algerians who had experienced the revolution. Martin had come to prominence playing Lucky, one of the tramps in the Paris premiere of Samuel Beckett's *Waiting for Godot* (1953). Ironically, he had been blacklisted for supporting the FLN by signing the famous Petition of the 121 against the war, and *The Battle of Algiers* itself would be banned in France until 1971. For Martin, the drama of the film came from the sight of "people reliving events," such that they were caught up in real emotions as they passed a "French" checkpoint in the film because they had so often done so in reality. For Saadi, however, making the film was a "game" compared to the reality. Pontecorvo seemed to understand that the lack of real threat diminished the experience for his nonprofessional cast, and so he shot repeated takes of even very short sequences, rendering the actors tired and frustrated. This real experience of irritation with the filming process ended up creating a "real" effect of fear, exhaustion, or anger when seen in the finished production. For many years, the film carried an opening disclaimer noting that no documentary or newsreel footage had been used, even though it wanted to generate precisely that sensibility. This decolonial dialectic of neorealism can be found across the range of cinema dealing with the Algerian War. For instance, Jean-Luc Godard's *Le Petit Soldat* (1960) dealt with the violence of the war under the rubric "Photography is truth, cinema is truth twenty-four times a second!"[82] But for the Algerian novelist Rachid Boudjedra, writing the first history of Algerian cinema, in 1971, Godard's film was nothing more than a "film of neo-fascist tendency" because of its sequences showing the FLN engaging in torture while quoting revolutionary texts.[83]

The women characters in *The Battle of Algiers* have an important role in

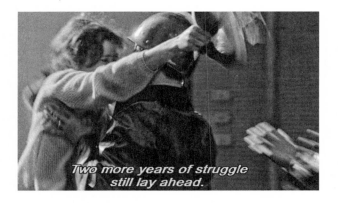

FIGURE 50. DANCING WOMAN FROM *BATTLE OF ALGIERS* (1966)

terms of the action, but have relatively little to say. In the dramatic scene in which women who are about to plant bombs in the French quarter are disguised as "modern," French-oriented women by means of hairstyle, clothing, and make-up, the original dialogue was replaced by up-tempo drumming, much to the initial shock of the scriptwriter, Franco Solinas.[84] According to an interview with Pontecorvo, Solinas later agreed that his dialogue had been weak, and he approved of the final version. Pontecorvo further emphasized that even while he was making the film, the situation of Algerian women was noticeably worsening, leading him to emphasize their place in the liberation struggle. The final scene of the film, in which independence is achieved, is marked by the ululation of women in celebration, a sound that might seem alien to many Westerners, in the way that the Islamic call to prayer has recently been stereotyped in some quarters. It was taken as the key to Ennio Morricone's powerful soundtrack for the film, or what Pontecorvo calls "music-images." The final shot of the film is a close-up of a dancing woman, in traditional dress but not veiled, which Pontecorvo intended as a symbol of the revolution, in the fashion of Eisenstein (see fig. 50). Unfortunately, the process of segregating genders has continued, rendering what the Algerian writer Assia Djebar has called the "severed sound" of Algerian women when "the heavy silence returns that puts an end to the momentary restoration of sound."[85] This silencing was an accompaniment to what she calls the "forbidden gaze" of women, hidden behind the walls of the home and the reimposed veil. Sight and sound were and are inextricably linked in decolonizing visuality, just as they had been in forming the concept.

Soon after the achievement of independence, a silence fell over the subject of Algeria in Europe. Kristin Ross has emphasized, for example, how such erasures have distorted the understanding of "May '68," which she shows needs to be understood as beginning with the "mobilization against the Algerian war."[86] For despite a seemingly endless series of books, essays, and films, the real subject of the Algerian revolution was permanently displaced, namely the fundamental wrong of colonization. Indeed, many former French settlers in Algeria have recently sought to create memorials and museums to the "culture" of French Algeria, which they seek to separate from "politics," meaning decolonization. The politics that mattered were of course those of imperialism. It has returned in the past decade as a correlative of the neo-imperialism with which we are all familiar, calling for a renewed neorealism. *The Battle of Algiers* was notoriously screened at the Pentagon, in 2003, advertised as a chance to see "how to win the war on terrorism and lose the battle of ideas." While it is unclear what lessons were in fact learned, the screening shows that neovisuality has come to trace its own genealogy of counterinsurgency to Algeria. The interrogation and torture methods used by the French in Algeria were disseminated by the notorious School of the Americas to Latin American dictatorships in the 1970s and 1980s, and have been revived for use, since 2001, by the United States. In recent years, the "Algerian" has come to be the figure of the non-Western immigrant to Europe, at first needed and now reviled, which has led to a resurgence of fascist parties across Europe, matched by anti-immigrant and anti-refugee sentiment in Australia, Britain, and the United States. So do the necessities of an antifascist neorealism reimpose themselves in the light of both the electoral success of the far Right in Europe, from France (2002) to Italy (2007) and Austria (2008), and the appropriation of powers by the Bush-Cheney administration (2000–2008) in the United States under the cover of counterinsurgency. These questions continue to converge within the frame of global cinema, from France to Spain, Finland, the United States, Mexico, and Algeria itself, indicating the centrality of "Algeria" and its location as the border of North and South to the neovisuality of the present. A recent group of films have returned to Fanon, the psychology of civil war and fascism, and the viewpoint of the child.

Perhaps the best-known of these films in the West has been *Caché* (2005), made by the Austrian director Michael Haneke, which deals with the con-

troversial legacy of the Algerian War in France. The film centers on Georges Laurent (Daniel Auteuil) and his wife, Anne (Juliette Binoche), two self-described Parisian "Bobos" (Bourgeois-Bohemians), working in television and publishing. Their comfortable lives with their son, Pierrot (Lester Makedonsky), are interrupted by the arrival of a series of anonymous video-tapes showing their apartment under surveillance, accompanied by violent drawings of a child vomiting blood or a chicken being slaughtered. As the mysterious tapes continue, it gradually emerges that the drawings represent scenes from Georges's rural childhood, when his parents employed as workers two Algerians, who lived at the farm along with their son, Majid. The two workers disappeared after attending the now infamous demonstrations in Paris on 17 October 1961. Called by the FLN to show the support of Algerians in France for independence, the demonstration was met with the most extreme police repression led by the former Vichy police chief Maurice Papon. Hundreds were killed and deposited in the river Seine, a moment that seems to be recurringly forgotten and remembered in France. Majid comes to live with Georges's family, causing the six-year-old Georges to stage some clumsy attempts to have Majid sent away, which culminate in success after he tricks Majid into slaughtering a rooster. These scenes are depicted in the drawings that accompany the videos, which have now moved on to show Georges's family home. Enraged, Georges tracks down Majid (Maurice Bénichou), who denies all involvement with the tapes as does his son, Hashem (Walid Afkir). Nonetheless the tapes continue to arrive, and Majid, who has continued to deny being their author, commits suicide by cutting his throat in Georges's presence, an incident again videotaped and distributed.

For all its excellent intentions, *Caché* exemplifies what Walter Mignolo has called the "Eurocentric critique of Eurocentrism."[87] Indeed, much of the discussion of the film has centered on the ever-elusive "universal" values it supposedly embodies. What matters for *Caché* is the impact of Algeria on French lives and minds. Majid and Hashem are undeveloped as characters to the point of being ciphers for immigrant victimhood and angry second-generation Frenchness respectively. Majid's suicide is unintelligible except as a device to shock watching (Western) viewers. All the videos in the film, from the opening shot of Georges's and Anne's apartment to the closing sequence of Pierrot's school, use the same angle of vision. The camera is placed at a medium distance from the events being watched, slightly to the right of center. Within the film, this place is identi-

fied as that from which the child Georges watched Majid being taken away to the orphanage. It is the viewpoint, then, of (colonial) guilt, betrayal, and later repression. One needs to qualify this "knowledge," because it comes, like all our visual understanding of the childhood drama between Georges and Majid, from Georges's dreams. While allowing for the obvious fact that these dream sequences are constructed, that construction was enacted by filmmakers very much aware of the mechanisms of condensation and displacement that shape dream imagery. Michael Haneke suggested that the entire film was designed to explore the "collective unconscious" of the West and that it had changed Godard's formula from *Le Petit Soldat* into "film is a lie, twenty-four frames a second."[88] That is to say, what *Caché* tries to do is undermine the cinematic consensus in which what is seen is true, without any recourse to what Georges, in cutting an edition of his show about Rimbaud, disparagingly calls "theory." There may be a "hidden" reference here to Rimbaud's lapidary phrase *Je est un autre*: for Georges there is no other, the I is all there is. Some have seen the drawings in the film as reminiscent of *J'ai huit ans* but here the purpose and meaning of the drawings are obscure, and they are also the agent of violence, rather than simply its record.[89]

Fanon had taken a strongly critical approach to this framing of Algeria. For example, in 1957, Georges Mattéi published in *Les Temps Modernes* an essay arguing that the drafting of French youth into Algerian service was teaching them to be reflexively racist and violent: "What is going in Algeria today is a large-scale attempt to dehumanize French youth." Fanon retorted: "It is worth thinking about this attitude. Such exclusion of Algerians, such ignorance about the men being tortured or of the families being massacred constitutes an entirely new phenomenon. It is related to the egocentric, sociocentric form of thought that has become characteristic of the French."[90] Even more characteristically, *Caché* centers on the exploration of the male ego. Conveniently, neither Hashem's mother nor Georges's father appear in the film, allowing the drama to circle around male egos in conflict, culminating in the dream/surveillance of the meeting of the two sons. Anne features as a plot device to exemplify Georges's inability to trust and to set up Pierrot's oedipal rebellion when he suspects her of having an affair. *Caché* invites the viewer to judge whether Majid or Hashem made the tapes, whether Georges was objectively guilty of betraying Majid, whether Anne was having an affair, and whether the sons were in league with each other. Like Freud and, all sophistication to the contrary notwithstanding, like Fanon, *Caché* cannot ask what the women in its drama might have done

or wanted in their own right. Although it visualizes a France damaged by the police actions of 1961, it cannot engage with a right to look, but offers instead a different form of (ego) policing.[91]

I want to develop these themes by counterpointing two recent treatments of one of the most difficult sections in Fanon's *The Wretched of the Earth*, in which he transcribed an interview with two teenage Algerian boys who had killed their French friend. The action was revenge for a preemptive massacre of Algerians by French militia at Rivet, in 1956, in which two of one of the Algerian boy's relatives had died.[92] All three boys had gone out to play as usual, but the two young Algerians killed their friend with a knife. Neither expressed remorse, "because they want to kill us" and because, although Algerians were being killed on a daily basis, no French were in prison. Fanon offers no commentary on the transcripts, in which he tried to emphasize that their friend had done nothing wrong, with which they agreed, and that he did not deserve to die, which they denied. In short, the boys acted on a theory of collective responsibility for which youth was no protection, just as children were involved in French attacks like those seen in *J'ai huit ans*. As Fanon suggested, "It is the war, this colonial war that very often takes on the aspect of a genuine genocide, this war which radically disrupts and shatters the world, which is in fact the triggering situation."[93] While the specific violence is acknowledged to be unjustified, the general political context made it seem that this was the only action the boys could take, because, as they said, they could not overpower an adult and they were too young to join the resistance. In response to the disaster of the post-1991 Algerian civil war, UNICEF has sponsored children's "activities such as drawing alongside group play, theatre and sport."[94] While worthy enough, such diversions cannot by their nature offer the children what Fanon's patients were claiming in a displaced and perhaps even psychotic fashion: the right to be seen as political subjects. Instead, their actions only attracted the gaze of the police and their auxiliaries, the psychiatrists, a dehumanized form of their desire to be recognized.

In 2007, the Finnish video artist Eije Liisa Ahtila created a six-screen installation entitled *Where Is Where?*, which dramatized Fanon's text as a fifty-three-minute film. Four screens showed the dramatization, while two others, placed out of the room, showed newsreel footage of a French massacre like that at Rivet. It was therefore impossible to see the entire "film," or perhaps *Where Is Where?* can be seen as a challenge to the concept of "film" in the digital-video era. In her account of this project, Ahtila de-

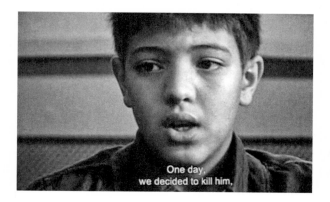

FIGURE 51. "ONE DAY WE DECIDED TO KILL HIM,"
FROM EIJE-LIISA AHTILA, *WHERE IS WHERE?* (2007),
MARION GOODMAN GALLERY, NEW YORK.

scribed how she began by writing a script that incorporated Fanon's words into a poetic drama, revolving around what she calls "words, death, space and time."[95] Language implies death that negates space and time, restored by the specificity of words to time and place. In the four-screen main space of the piece, a Finnish woman, known as the Poet, has a series of meetings with Death, dressed in the conventional black cowl and holding a scythe. She then finds Algeria literally coming through the walls of her comfortable Helsinki apartment as an allegorical space of death. The rather kitsch magic realism of these scenes and those of a mythic "Algeria" shadowed by death contrast with the cinematic realism of the later scenes from Fanon's case study (see fig. 51). In a sense, the Helsinki scenes prepare the viewer for what is to come, which dominates the experience. The overlap of space and time culminates with the manifestation of the two Algerian boys in the Poet's deserted swimming pool, sitting in a small rowing boat. Looking lost and alone, the boys have become Algerian migrants, representative of the migrants, refugees, and asylum seekers whose presence is challenging the homogeneity of white Europe. The space was darkened for the screenings, but you were in no sense immobile like the spectator in a theater. As you turned from screen to screen to see the action, you became a vigilant soldier, aware that what there is to see exceeds your capacity to monitor it. The implied viewer is by implication, therefore, European or in the place of the European. Consequently, the visitor experiences no sense of a right to look, let alone the traditional dominance of the cinematic spectator. If

there is such a place, it can only be that of the artist. Yet given its length, *Where Is Where?* is more than just a video installation, being intentionally closer to the immersive experience of classic cinema. If narrative cinema replicated the experience of dreaming, Ahtila's piece was closer to that of the nightmare or hallucination.

This imagined clash of realisms can be interestingly counterpointed with the recent novel *Fanon* (2008) by the African American novelist John Edgar Wideman, which used the same scene involving the two Algerian boys as a central moment. It was inspired by a chance meeting between Wideman's mother and Fanon, while she was a nurse in a hospital in Bethesda, Maryland, where he was being treated for his ultimately fatal leukemia. Wideman's novel is a complicated piece of writing, deliberately hard to follow, featuring both a character called John Edgar Wideman and his brother, who has been imprisoned for murder, as the writer's own sibling has been. Further, like the actual Wideman, the fictional Wideman has lost his nephew, the son of his imprisoned brother, to murder at the age of fifteen. Another layer in the novel contains a character Thomas, who is writing a book about Fanon in a book written by Wideman. These complicated changes of authorial voice place the engagement with Fanon behind a "mask," explicitly in imitation of *Black Skin, White Masks*,[96] as if he cannot be directly approached precisely because the hegemonic narrative codes of realism forbid such "unlikely" encounters. However, the characters in *Fanon* are African Americans making use of character masks, whether "white" or otherwise. Indeed, Wideman has a country house in France, emphasizing the country's dominant place in the modern imagination, but also a practice that reads "white," even if a residence in Paris might be read as "black," given the long-term African diaspora presence in the city. As Wideman's musing continues, "it becomes clear that Fanon is not about stepping back, standing apart, analyzing and instructing others but about identifying with others."[97]

In a striking change of voice, Thomas then shifts his proposed novel into a would-be screenplay for a film to be set in the African American neighborhoods of Pittsburgh, which he pitches at great length to none other than Jean-Luc Godard in a distinctively "black" voice. In the novel Godard is imagined to retort: "Images are slaves, prisoners. Images kidnapped, copyrighted, archived, cloned. Property" (80). Nonetheless, Wideman proposes a re-creation of the same scene from *The Wretched of the Earth* as that visualized by Ahtila: the killing of the French child. Only in this case it is to be set in counterpoint with Homewood, Pittsburgh, an underprivileged Afri-

can American neighborhood. The imagined film opens with a bird's-eye view of the corner of Frankstown and Homewood, placed above a "crawl" of Fanon's text, which quickly dissolves into a re-creation of the scene (113–14). Dissolve back to Homewood, where a teenager, the same age as his murdered nephew, Omar, stares at Mason's bar, watched in turn by Wideman's elderly mother from her assisted-living apartment as a "sign" on the "grid" of streets below. The teenager waits and watches for a parent who seems unlikely to emerge, placed in the streets not because of a revolution, but because a social order has collapsed. The only person left to care for this child—and teenagers, reviled as they are, are children—is a disabled senior citizen, who can offer only her benevolence. The disjunctured chain of looking performed here neither protects nor prevents. In this context, Wideman wonders, "Where do you go if someone thinks of you as dead" (116), rhyming with Ahtila's questions "When you die where are you? And where is where?" There is a section break, indicated by an asterisk, and it emerges that the teenager has been shot and killed (120). A long reminiscence from Wideman's mother about the decline of the area culminates in her account of the murder, which she had heard but not seen, and her witnessing of the police and family approaching the scene. Death negates the difference between Helsinki and Pittsburgh, but the colonial difference of "Algeria" restores time and place. Both the video piece and the novel present the Algerian experience as a direct intervention into their very different present experiences, one in the comfort of Helsinki and the other in the impoverished suburbs of post-industrial Pittsburgh. Where Ahtila finds the history of Algeria floating in her pool in uniformly white Helsinki, Wideman sees a parallel between colonial Algeria and what is happening today in segregated Homewood with its 96 percent African American population. Both see that there is an "Algeria" that marks the border between European space and that of the immigrant; and white U.S. space from African American space. Ahtila claims that death takes away time, leaving only space. What is left behind is the ghost or the specter. For Jacques Derrida, himself Algerian, the ghost is that which sees us but which we do not see: "It is still evening, it is always nightfall along the 'ramparts,' on the battlements of an old Europe at war. With the other and with itself."[98] The ramparts are those of Elsinore, in Denmark, a place now associated with its reductive cartooning of Muhammad as an assertion of the rights of old Europe. Algeria is one name for that space that the old Cold War alliance cannot escape on either side of the Atlantic, a space that returns.

FIGURE 52. RACHIDA (DJOUADI IBTISSEM),
IN *RACHIDA* (2002)

In Algeria itself, civil war returned as an uncanny double of the FLN's war against the French, as represented in Yamina Bachir's film *Rachida* (2002). Bachir studied at the National Algerian Film School, first established by Vautier. *Rachida* was Bachir's first film, made in the face of what she calls the "dismemberment of the film industry" in Algeria, after the elections of 1991. It evokes the collapse of Algerian civil society by means of the story of a young woman teacher named Rachida (Djouadi Ibtissem) (see fig. 52). Bachir developed her idea from an incident in which antigovernment militants tried to compel a teacher to carry a bomb into her own school. When she refused, she was shot, as is Rachida in the film. The film then imagines what might have happened next, as Rachida goes into hiding in the countryside, having survived being shot, for fear that her assailants would return to kill her. At first understandably depressed, Rachida returns to teaching and is attending a wedding when the local version of the terrorists (the term used in the film) attack and devastate the community. Bachir created what she calls "a 'perfect' victim" as the center of her protest, and the film suffers somewhat from this idealization. At the same time, the film was made against the background of censorship; thus, for example, when a young woman is raped in the village and soldiers come to investigate, her distress at the fact that her attackers also wore military uniforms is the only hint the film can offer to suggest the army, as well as the "terrorists," is committing outrages. The film gains in texture when seen against its predecessor, *The Battle of Algiers*. Early in *Rachida*, the television news declares that "terrorists attacked a man in the Casbah," evoking the French propaganda

of the 1950s, just as a bomb-making scene recalls the similar FLN activity in *The Battle of Algiers*. However, in *Rachida* a woman has to be coerced into carrying a bomb, whereas in *The Battle of Algiers* there were many volunteers. In another scene, Rachida watches a television news report of the murder of several monks, an incident recently made into a popular French film, *Des hommes et des dieux* [Of gods and men] (2010, dir. Xavier Beauvois). By contrast, *Hors la loi* [Outside the law] (2010, dir. Rachid Bouchareb) caused widespread controversy for its story of three brothers who witnessed the Sétif massacre in 1945 and were drawn into the revolutionary struggle in different ways. As an indication of French revisionism on the Algerian war, in part caused by the palpable difficulties of the postcolonial state, there was even questioning as to whether Sétif had really been a massacre.

While there is a postcolonial state of denial in France concerning Algeria, Bachir was trying to evoke what is repeatedly called in her film a mutual "culture of hate" operating between all sides in the country itself. Rachida needs to hide not from a colonial army but from her own neighbors, creating such great anxiety that she thinks she is going mad. A local woman doctor in the village diagnoses "post-traumatic psychosis," but adds that the "whole country suffers from it." Rachida later dreams that she will be assassinated by terrorists in the village in a very realistic scene that emerges as a dream only in its aftermath. The level of persistent psychic damage in Algeria depicted in *Rachida* reinforces the importance and necessity of the return of Fanon's case studies in *The Wretched of the Earth* in Wideman's and Ahtila's projects. Indeed, the inaugural conference of the Société Franco-Algérien de Psychiatrie, in 2003, heard case studies that Robert Keller, who attended, described as "near replications" of Fanon's from fifty years earlier.[99] Fanon's clinic in Blida is now within a center of the Groupe Islamique Armée, and the facilities are described as ruins, with the wards reduced to a "warehouse of bodies." During the revolutions of 2011, it was noticeable that people in Tunisia and Egypt repeatedly referred to losing their sense of fear. Once that fear had been set aside, it became possible to imagine a very different future. One of the most damaging legacies of the civil war in Algeria has been that people still seem unable or unwilling to set aside that fear. To be fair, if one considers the impact of under three thousand casualties on 9/11 in the United States, and then bear in mind how much smaller Algeria is, it is perhaps not surprising that after so much death, people are not yet ready for another experiment.

The village life evoked by Bachir has more texture than the simple peas-

ant scenario sketched by Ahtila. The one public telephone in the village, for instance, is constantly used by Khaled, a young man who is in love with Hadjar, whose father, Hassen, will not sanction the match because Khaled is too poor. Hadjar's arranged marriage ends the film, a counterpoint to the love match seen in *The Battle of Algiers*. In Pontecorvo's film, the FLN official apologizes for the simple ceremony, but evokes the possibility of a transformed future that *Rachida* suggests is still yet to come. The violent scenes are shot with a hand-held camera, giving the "realistic" jerky feel pioneered by Pontecorvo, but there are also long interludes in the separate spaces of the women, from the courtyard to the baths. Here the lyricism of Ahtila's Algeria is matched by reveries such as one evoked by the scent of figs. But Bachir brings us back to earth when in a subsequent scene a local man harasses Rachida, gesturing with a carrot and saying he can smell the scent of a woman. There are only two moments in the film that step outside the realism sustained by terror. As Rachida is teaching in the village, she sees a bubble floating near her head. She turns and all the children in her class are blowing bubbles at her (see plate 10). This moment is recalled at the very end of the film when, in what Bachir calls a Brechtian moment, Rachida dresses in her clothes from Algiers, sets her hair loose, and heads through the devastated village toward the school in order to teach. Several children emerge from nowhere, and they sit down in a class held in a vandalized room. Strikingly (for a Western viewer), Rachida begins the class by telling the students to take out their slates, a tool that evokes a remote past for those in wealthier locations. Although she writes "today's lesson" on the board in Arabic, she does not specify a topic. Since the Atlantic revolutions of the eighteenth century, the education of the working and subaltern classes has been central to the consolidation of the right to look. Although it proposes no solution, the ending to *Rachida* imagines another reality, in which today's lesson is always open to question, always about to be begun, and not yet foreclosed.

While that would be a satisfying place to conclude, it would overlook many more complex realities. Algerian schools have been the subject of intense national controversy, first stressing Islam and Arabic, and then returning to a curriculum that includes French and science. However, journalistic estimates in 2008 suggested that, although there is 70 percent literacy (cited without definition), only 20 percent of eligible children attended high school, with the majority dropping out for economic, political, or religious reasons. After forty years of independence that figure seems very low.

During the revolutionary period, Fanon suggested that the FLN was not paying sufficient attention to the peasantry or what he called the "lumpen-proletariat," meaning the dispossessed urban population, "the pimps, the hooligans, the unemployed and all the petty criminals [who], when approached, give the liberation struggle all they have got."[100] Some of the characters in *The Battle of Algiers*, for example, certainly fit this description. Like Gramsci, Fanon saw that the revolution depended on the "spontaneity" of this group, but that the leading party was not thinking about how to use that energy once independence was achieved. To put it briefly, the FLN stressed elements of the "North" within Algeria, such as the small urban proletariat, and did not develop a theory or practice to integrate the "South," the peasants and the dispossessed. Fanon's own belief in the "new man" that would be created by the revolution owed more to the regeneration theory of the French Revolution than to modern politics and failed to think through the practicalities of transformation, hoping instead that nationalism (or later pan-Africanism) would simply deliver them. Algeria's first difficult and then disastrous post-independence history can be seen as a working out of this failure, the internal contradiction between the FLN leadership and those in whose name the revolution was carried out.

By the same token, in 2002, the year that *Rachida* was released, French electoral politics came to a dead end when the first round of the presidential election saw the avowed racist Jean-Marie Le Pen, who had been a torturer during the Algerian War, win through to the second round, defeating the socialist Lionel Jospin. The choice was now between the "right extreme" and the "extreme right," as the queer novelist Virginie Despentes put it.[101] Diagnosing a "French psychosis" that one could put alongside the Algerian "post traumatic psychosis" discussed above, Mehdi Belhaj Kacem went further still. He called the situation "fascist democracy," because no criticism of the democractic system itself was permitted. Suggesting that any proper commitment to democracy would have led to a refusal to participate in the second round, ending the Fifth Republic just as the Fourth Republic had collapsed over Algeria, Kacem concluded that, in present circumstances, the "extreme right is the real."[102] In his view, the riots of December 2005 were perpetrated by disaffected minority youth in the French suburbs (*banlieux*), who had come to understand that their lives were being carried out in what he calls the "place of the ban" (a pun on *ban*, meaning "ban," and *lieu*, meaning "place").[103] Consistent with this analysis, Nicolas Sarkozy, who came to prominence by describing the rioters as "*racaille*" [a mob], was elected

president of France, in 2007. Soon afterward, he was declaring in Dakar that Africa had "not yet fully entered history."[104] This parody of Hegel has at least had the benefit of opening and extending academic debate of decolonization and postcolonial theory to wider discussion. More accurately, it might be said that a history that can account for Africa within modernity has yet to become accepted in the West. One key element of the crisis that is currently afflicting visuality is, then, this refusal to acknowledge the persistence of imperial visuality in both its "normal" and intensified (fascist) form. Time, that which visuality visualizes as History, is out of joint. The effort to restore visuality has become global, leaving the nation behind as one element among many in the pattern of global counterinsurgency.

POSTSCRIPT: 18 MARCH 2011

At the time of writing, the autocratic regimes in Egypt and Tunisia have fallen. There is open war against the people by the autocrats in Libya and Bahrain, while Yemen seems set to be the next "hot spot" of the extraordinary events of 2011. As I am working, the United Nations Security Council has passed a resolution authorizing intervention in Libya. Safe to say, then, that this is not over.[105] By the time you read this, you will know what will have happened, whether the dramatic events of January and February have been forgotten as globalized capital restores business as usual, or new forms of governance and activism have continued to emerge. Nonetheless, whatever the outcome, and however "success" is defined and by whom, it is clear that the entanglements of half a century of decolonization, globalization, neo-colonialism, and counterinsurgency described in this chapter have produced a striking challenge to the autocracies of the region. Often "invisible" to Western audiences, in the sense that they rarely feature in news and media reporting, the oil-producing and -protecting autocrats have nonetheless been indispensable to neoliberal geopolitics. These regimes operated a classic form of imperial visuality. Their classification was simple: for or against the regime, whether divided by family ties, religion, ethnicity, or political allegiance. Separation was effected by the traditional means identified by Fanon, the barracks and the police station. In Tunisia, there was one police officer for every forty citizens at the time of Ben Ali's fall. The Egyptian Army has over 450,000 men. Nonetheless, their regimes fell. The "aesthetics of respect for the status quo" described by Fanon disappeared as young populations—it is often said that 70 percent of the region

are under 30—networking via globalized media and interfacing with destitute rural and urban underclasses, decided that nothing was worse than the continuance of the regime.

Across the region the slogan has been, "the people demand the fall of the regime." There is no classification within the people, only one between the people and the regime. The performance of "the people" has constituted a new political subject that refuses to see or hear the regime, except when it resigns or falls. The mobilization of the army against the police in Tunisia, the popular resistance in Egypt against the police, and the contest in Bahrain for Pearl Square, culminated in the war of the state against the people in Libya in order to sustain the authority of the autocrat. Even in Libya, no one believes in the status quo. It is no longer right; it no longer commands assent. The status quo can be enforced but it will be a long time before it is once again invisibly "normal." The security states watched the subject populace and guarded the autocrat. Now the revolution is watching. That is to say, the revolution is watching us and we are watching the revolution. It is also to say that there has been a certain revolution in watching, although the casual use of "revolution" in such contexts is less convincing now. Nonetheless, despite all injunctions to the contrary, to watch is a form of action. The 2011 revolutions are reconfiguring the places of the political and the everyday. It is a watching that demands to see and be seen. It has formed a new distribution of the sensible to allow for the emergence of a new political subject, a *mobility* whose characteristics are constantly updating. There has been a radical reconfiguration of the attributes often associated with the private to the public—peace, security, a sense of belonging, and the absence of fear.

The location of this new sharing of the sensible has been the "square," epitomized above all by Cairo's Tahrir Square. The square was transformed from one of the banal "public" spaces of the thirty- year state of emergency into a site of emergence, whose form became that of the revolution. The "square" is not, in fact, square. It consists of a polyhedron, shaped something like a hatchet, with a central circle and a large gathering space. The entrance used by the revolutionaries was via a checkpoint on the Kasr al-Nil bridge, won in combat with the police on 29 January 2011.The January 25 movement called the square "Free Egypt," sending up chants of "these are the Egyptian people." Food, medical care, and civility were all provided. The poor, destitute, middle ranks of business, academics, lawyers, and filmmakers were all able to recognize each other. The guards, who

greeted each new member of this emergent Cairo commune, as if following the Commune of 1871, wore improvised helmets made from kitchen bowls labeled "the government of the revolution." Tahrir Square became an alternative city within the city, a rival source of affiliation to the nation-state. People lived there and treated it as a place of belonging. In popular discourse, the interim government is held to account with the slogan "We know the way to Tahrir Square," a line of force that was sufficient to drive out the Mubarak holdover prime minister Ahmed Shafiq on 3 March 2011. In the "square," real and virtual, people are enacting wakeful watching: an active form, wide-awake, concentrating and alert with intent. No longer subject to the police, the people move around, circulate, and are very aware that there is something to see here. People read newspapers, talk, rest, but above all they are present: alive, in the present, attesting to their presence, refusing to depart. It is simply the sense that something has snapped into focus for the first time in ages. This watching is live and alive—it is of the present but an expanded present in which certain moments are again alive, not as specters or echoes, but as actors in the new network. We shall always know the way to Tahrir Square, even if we have not quite got there yet.

The most successful attempt to frame antifascist neorealism in the present moment has come from Guillermo del Toro, a Mexican film director working on a Spanish subject.[1] The remarkable *El Laberinto del Fauno*, or *Pan's Labyrinth* (2006), unexpectedly found a means to counter the hegemonic violence of our own time by mixing a specific moment of antifascist resistance with archetypes from fairytales and digital special effects created for horror fantasy films. The film is not a template for antifascism, but an instance of it that crosses national boundaries both in its production and its narrative. *Pan's Labyrinth* begins by setting the film as a retelling, a reinscription of history. Set in 1944, the film recovers an often forgotten resistance to Franco that continued until 1948. While France was still occupied, the resistance might have been taking comfort from the invasion of Italy and the D-Day landings, hoping for an extension of the war to Spain. Our first sight is of the dying child Ofelia (Ivana Baquero) at the heart of the labyrinth (see plate 11). At once the time reverses, the blood flows back into her, and the camera enters her eye, the one eye capable of seeing the two realities of the film, that of the fascist state and that of the netherworld, which are immediately in tension (see fig. 53). That tension is visualized as blindness by means of a whiteout. In the cinematic context, this focus on the eye cannot but recall Luis Buñuel's famous scene, in *Un Chien andalou* (1929), depicting a woman's eye being cut with a razor. The eye is not visuality, we are

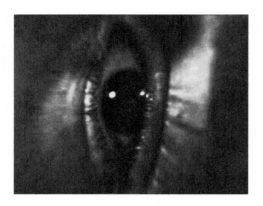

FIGURE 53. STILL OF OFELIA'S EYE,
FROM *PAN'S LABYRINTH* (2006)

reminded, either in the age of mechanical reproduction or in our present digital cinema. We cut (in the editorial sense) from that blindness into the ruined city of Belchite, a densely overdetermined site of memory. It was the site of a key battle in the Spanish Civil War, in 1937, when the Republican Army launched a counterattack on the eastern front, seeking both to retake Zaragoza and to distract Franco in the north. As well as regular troops, members of the Abraham Lincoln Brigade were involved in the conflict, including some African American soldiers reported on by Langston Hughes for a Baltimore newspaper. The town was taken and then lost, repeatedly bombed, and left in ruins by Franco as a memorial to Republican brutality. It remains in that state today.

The ruins have become a film set on a number of occasions, such as for Terry Gilliam's *Adventures of Baron Munchausen* (1987). In 1989, the Spanish artist Francesc Torres incorporated Belchite into his controversial installation *Belchite/South Bronx*, which merged the damaged built environment and social fabric from these two locations, but at fifty years distance. While the South Bronx has to a certain degree recovered, Torres has recently documented the forensic excavation of the mass graves of the victims of Spanish fascism, which are only now being documented, with great controversy. Indeed, Franco's self-declared "Crusade" to conquer Spain, with its evocation of the Reconquest and the Inquisition, sounds less archaeological now than it might have done in 1989, when the ancient régimes of Europe were falling all around. Given that the narrative departs from here, it is clear that the film is an exploration of what one might call the historical present.

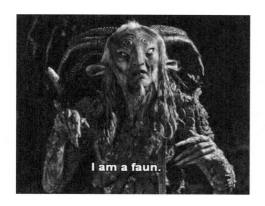

I am a faun.

FIGURE 54. STILL OF THE FAUN,
FROM *PAN'S LABYRINTH* (2006)

Ofelia finds and explores a counterreal to the world of violent domina-
tion in which she lives. Her name is of course intensely suggestive, as the
madwoman of Hamlet's desire, but the madness here is political, not per-
sonal. Ofelia is accompanying her widowed mother (Ariadna Gil) to the
mountains where her new stepfather (Sergi López), a captain in Franco's
army, is fighting the Republicans. She likes to read fairytales, and, guided
by an insect that will turn out to be magical, she finds an ancient statue that
visually evokes a similar figure in the Spanish film classic *Spirit of the Beehive*
(dir. Victor Erice, 1973). In that film, Ana (Ana Torent), a seven-year-old
girl, creates her own fantasy world in the post–civil war Spain of 1940, after
being intrigued by watching *Frankenstein*. Films, del Toro seems to suggest,
are our present-day mythology, which is not to say that they are without
meaning or politics. Ofelia discovers the existence of a netherworld, ac-
cessed by the labyrinth of the title. It was here that she was born as a prin-
cess named Moana, but she later ran away, like a latter-day Persephone, to
experience the world of the living. Ofelia meets a faun (Doug Jones), who
reveals this story to her and sets her a series of tasks that she must accom-
plish in order to return (see fig. 54). The faun is the Pan of the title, the
Greek god of shepherds, but also the originator of "panic," the fear of open
space, that has morphed into the "moral panics" that so characterize modern
authoritarian regimes. The character was created using animatronics, inter-
facing a "real" actor with costume and computer effects. The present-day
viewer is taken to be able to "read" the meeting of this composite with a
"human" character without difficulty. There are, then, at least three com-

peting layers of reference within *Pan's Labyrinth*: the specific historical references, a set of parallel associations with mythology and archetypes, and, finally, carefully placed allusions to cinematic classics. This density of reference, whether fully understood or not, is part of the film's compelling feel, making it impossible not to watch.

For example, within the diegesis of the film, the netherworld is clearly not "real" in the material sense, nor is it the same space as the above-ground experience of fascism: but it is not pure fantasy. Events in the netherworld correlate to those experienced in the fascist world and interface with them to material and embodied effect. The faun gives Ofelia a mandrake to place under the bed of her mother, who is having a complicated pregnancy, and it breaks her fever, leading to her recovery, much to the surprise of the doctor. However the Captain discovers Ofelia's intervention, and he blames Ofelia's reading for her belief in magic, just as certain Enlightenment thinkers worried that reading novels would corrupt women's morals. The mandrake dies in the wood fire, where the Captain throws it. Although it is undecidable whether this would have been visible to people other than Ofelia in the fascist world of the film, we the audience see it and are moved by it. Further, the mandrake's demise quickly entails the death of Ofelia's mother in childbirth. This archetypal narrative sets up subsequent confrontations between the Captain and, first, Mercedes (Maribel Verdú), the undercover resistance liaison who works as a servant in the barracks, and, then, Ofelia. Even after she has been detected, Mercedes taunts the Captain that she was able to smuggle goods and information under his nose because, as a woman, she was "invisible" to him, a consequence of fascism's segregation by gender. He repeats this mistake by dismissing the guard as he prepares to torture her, which allows her to attack him with her concealed knife. Hollywood's standard imaginary cannot think past depicting a "good" violence to counter the "bad" violence of the irrational other. But del Toro shows the quiet refusal of the doctor to participate in fascist torture, to the bafflement of the Captain, who repeatedly asks why he did not obey. The doctor replies, "Obeying—for people like you that's all there is." Authority here does not authorize and does not carry legitimacy. In 1944, countless thousands went to their deaths at the hands of fascists with a quiet determination to remain in control in a world gone mad. The Captain shoots the doctor, as his logic dictates, but the moral economy of the netherworld has intruded into the fascist space and is set to disrupt the order of violence. By this time, we are

prepared to accept this fantasy of justice because we have already seen the materiality of the netherworld in operation.

Perhaps the most incisive moment of *Pan's Labyrinth* is the end that is also its beginning: the death of Ofelia. A modern Antigone, she sacrifices herself to the overweening Law represented by the Captain (who would be equivalent to Creon in Sophocles's tragedy), but in this case she saves her brother's life rather than burying him. As a child and as a woman under fascism, she is twice over a minor, but here she achieves the ability to choose before the law and to represent. Her passing marks the culmination of both antifascist narratives. In the world of fascist domination, the forces in the border outpost have suffered a defeat, but Franco will remain in power, as the audience knows, for over thirty years. The victory is twice bitter-sweet, for it has cost the life of Ofelia without leading to the hoped-for better future. Further, if Ofelia has regained her place in the netherworld, it comes at the cost both of her human life and of her resistance to patriarchy.[2] For the netherworld is the domain of her father, the king, and her resistance to her stepfather ends up reinscribing her in patriarchal relations, whether willingly or not. For some, this conclusion is a disappointment, even a relapse. Another view might see it as a corollary of antifascist realism. Gramsci argued that one of the reasons that the subaltern classes could not be fully absorbed into the dominant hegemony, and thus retained the potential for revolution, was their folklore. Folklore maintained an "unstable and fluctuating" element in the nation-state that provided the potential for a spontaneous uprising, the "great 'undoing.'"[3] It could offer something significant to the organic intellectual, who was charged with overcoming the "segregation" between North and South: "It is necessary to represent concretely to his fantasy those human beings as beings who live and work daily, to represent their sorrows, the sadness of a life they are forced to live."[4] A tragic realism, then, but within the frame of fantasy—that sounds like *Pan's Labyrinth*. The frame of folklore nonetheless tended, as Gramsci also acknowledged, to the mythology of patriarchy. Think here of Freud's peculiar fantasy, in *Totem and Taboo*, of the murder of the "primal father" that inaugurates the social itself, understood as the ur-example of magical thinking. Freud held that the so-called primitive belief in magic recurred in so-called modern children especially insofar as the totem animal represents the father. You could read *Pan's Labyrinth* that way if you wanted. I prefer to think that the primal father fantasy, the construction of the child as primitive, even the subjuga-

tion by the male gaze are all really existing moments that are in themselves subject to the division of the sensible that sustains the possibility of visuality as a system of power.

Pan's Labyrinth is, then, a key example of the tension between the right to look and the law of the gaze, which it is prone to become. That is to say, the subaltern revolt tends to become reified as what Gramsci called the modern Prince, or the centralized, hierarchical political party, a form of the police technique that is Caesarism. If we rely on folklore, popular culture, call it what you will, to do the undoing of visuality, the regime of the Hero, then the final undoing, that which folklore retreats from as its condition of possibility, is that of undoing itself. The fear of undoing has been the greatest motivator of visuality, beginning with the great undoing of Saint-Domingue into Haiti by the revolt of the enslaved, which persuaded Britain to abolish slavery rather than risk a viral undoing of the mystical foundations of sovereignty. The specter of emancipation in Jamaica and Chartism in Britain prompted Carlyle to reassert the power of mysticism as visuality over that of unbinding. Without proposing a last, the first undoing, as radical movements have known and then disavowed for generations, must be the frame of the national that so effectively lends itself to the domination of the police. In short, the mystical regime of visuality can be undone by magic, as long as the next thing magic does is undo itself.

Global Counterinsurgency

and the Crisis of Visuality

The first, the supreme, most far-reaching act of judgment that the statesman and the commander have to make is to establish the kind of war on which they are embarking, neither mistaking it for, nor trying to turn it into, something that is alien to its true nature.
—Karl von Clausewitz, *On War* (1832), quoted by Col. Daniel S. Roper, "Global Counterinsurgency"

Politics is the continuation of war by other means.
—Michel Foucault, *"Society Must Be Defended"*

The coils of a serpent are even more complex than the burrows of a molehill.
—Gilles Deleuze, "Postscript on the Societies of Control"

Visuality was a technique for waging war appropriated as a means to justify authority as the imagining of history. The end of the Cold War, in 1989 might have been expected to create a postvisuality era. Instead, the global Revolution in Military Affairs (RMA) has extended and transformed visuality, using digital technology to pursue nineteenth-century tactical goals. The "small wars" of imperial revolt, contrasted to the large wars against the national armies of other colonial powers, have been digitally upgraded into a global insurgency that requires a matching global counterinsur-

gency. It should be said that from the decolonial perspective, the Cold War was always already a counterinsurgency, from Algeria to Indochina, Latin America, and now the Middle East. Classifying a conflict, as Clausewitz emphasized, was the first task of the leader and therefore the first step of visuality. As an index of the interaction of the first iteration of visuality theory and its current intensification as global counterinsurgency, Clausewitz's passage was cited by Colonel Daniel S. Roper, director of the U.S. Army and Marine Corps Counterinsurgency Center, himself commenting on then British Prime Minister Tony Blair's assertion, in 2007, that the definition of a global war against insurgency was the first task in winning that war. By defining counterinsurgency as an existential struggle, the stage is set to ensure that "they" must die so that "we" may live. This "asymmetric warfare" is visualized as the Darwinian "struggle for life," or, in Roper's words, as a way "to preserve and promote the way of life of free and open societies based on the rule of law, defeat terrorist extremism and create a global environment inhospitable to extremists."[1] Foucault's assertion that politics is war by other means is now policy. It has entailed the adoption of population control as military tactics. Counterinsurgency manages populations, not individuals, being "a population-centered approach, instead of one focused primarily, if not exclusively, on the insurgents."[2] Achille Mbembe has argued that such controls in the context of war should be considered "necropolitics," a question of who shall live and who shall die, entailing "*the generalized instrumentalization of human existence and the material destruction of human bodies and populations*."[3] Mbembe derives the genealogy of "sovereign right to kill" from slavery and colonial imperialism, where it could act with impunity and without rules. Expressed in today's military format, this becomes the mantra of counterinsurgency: "clear, hold and build," meaning remove insurgents from a locality using lethal force, sustain that expulsion by physical means such as separation walls, and then build neoliberal governance in the resulting space of circulation. Counterinsurgency classifies and separates by force to produce an imperial governance that is self-justifying because it is held to be "right" a priori and hence aesthetic. This governance is what I shall call "necropolitical regimes of separation."

The goal of such governance is not to produce disciplined, docile bodies, so much as to manage what Deleuze called the "society of control." In the parlance of counterinsurgency, this terrain is known as "culture," sometimes even defined and described using poststructuralist and cultural-studies theorists—including Deleuze. This post-panoptic imaginary operates a control

that seeks to separate the "host population" from the "insurgent," as if quarantining the former from infection by the latter. This necropolitics is invisible to the insurgent, with no expectation of reforming or disciplining that person, hence the sense that it is post-panoptic. For Bentham's Panopticon was designed above all to reform and improve the inmate, pupil, or factory worker, while post-panoptic visuality centers on population control. Despite an apparent but carefully stage-managed success in Iraq, which seems to be coming unstuck after the failed elections of 2010, global counterinsurgency has struggled to deliver basic services and public safety in its key areas of operations from Afghanistan to Pakistan and Yemen. These quantitative shortcomings are perhaps the corollary of the qualitative failure to define the practice of counterinsurgency beyond the classification and separation of the insurgent. Precisely because this is the era of globalization, characterized by transnational migration and electronic media, the digitized "border" between insurgent and host population consistently fails to hold. In the resulting crisis, the very pattern that counterinsurgency is trying to sustain is unclear: a centralized nation, a client state, or a global market? Although the U.S. military continue to use a moralized rhetoric of nation-building, their practical administration of counterinsurgency has significantly shifted to the management of disaster by means of targeted killing of insurgents using Unmanned Aerial Vehicles (UAV), Special Forces, and private contractors. Ironically, perhaps, the Bush-era pursuit of governmentality in regions like Afghanistan has yielded to Obama's necropolitics, in which killing enemy leaders is the priority, epitomized by the killing of Osama bin Laden.

The long-standing project of defining the social from the perspective of militarized visuality has been deliberately made incoherent. Today's technologically mediated means of material visualization do not generate information about the presence of the human visualizer, if indeed there even is one. If we look at the drawings made by Bagetti for Napoleon, and other such battlefield visualizations of the Clausewitz era, the viewpoint of the commanding general was critical to the technical production of the map. By contrast, a satellite image, or one taken from a UAV, tells us nothing at all about those who wanted the visualization made. In a somewhat uncanny fashion, the Medusa effect, which I ascribed to Carlyle's concept of visuality, has now found a technological analogy. By the Medusa effect, I intended to convey visuality's politics of making the separation between autocrat and ruled so permanent that it was, as it were, set in stone. A new military device known as the "Gorgon Stare" has been devised to generate

twelve separate visual feeds from one UAV platform, covering four square kilometers of territory. Each feed can be viewed separately and concurrently. While the feeds are low-grade, they can be used to direct the full-motion video feed to specific targets.[4] With perhaps surprising satire, the device is named after the mythical Gorgon, whose castrating stare turned people to stone. It is intended in part, then, to intimidate and to make it seem that whatever insurgents might do is visible and will be seen. Dehumanized weapons are certainly fear-inducing, for, in Thomas Pynchon's famous phrase, "a screaming comes across the sky."[5] Journalistic reports indicate a similar anger in present-day Pakistan, where airborne drone attacks have increased such that as many as eighteen were launched in a few days after the failed Times Square bombing of May 2010. However, it was precisely such attacks that some consider to have motivated the attempt to target New York in the first place, forming a familiar asymmetric feedback loop: increased remote attacks of increased sophistication provoke increased attacks against U.S. civilians using improvised and nonmilitary materials, like fireworks. Any such attack generates further reprisals on both sides. Further, the chaos produced by post-panoptic visuality is its condition of existence. Whereas Carlyle offered the Hero and his visualization as the only defense against chaos, the counterinsurgent requires chaos, or at least its possibility, as the means of authorization in all senses. Its gambit is simply that civilian governance lacks both the authority and the imagination to resolve any of the crises that generate the need for counterinsurgency. Increasingly, the result has been to create the seemingly contradictory practice of counterinsurgent governance, the necropolitical regimes of separation.

It is at the borders of the United States and European Union that these asymmetric flows and counterflows are worked out domestically. Other modes of separation and distinction, such as the color line, are mobilized by this intensification because they are already there. For example, the U.S.-Mexico border is a racialized distinction, just like that between "Europe" and "Africa" on Spain's southern coasts and islands. Domestic segregation is complexly interactive with the global counterinsurgency. It also visualizes its tasks as "to clear" and "to hold," which is to say to classify residents (as insurgent/illegal or "legitimate" resident) and separate them by physical means. In the United States, the domestic use of counterinsurgency became apparent in the response to Hurricane Katrina. In a (now deleted) article that appeared in the *Army Times* on 2 September 2005, Brig. Gen.

FIGURE 55. STILL FROM *WHEN THE LEVEES BROKE:*
A REQUIEM IN FOUR ACTS (DIR. SPIKE LEE, 2006)

Gary Jones, commander of the Louisiana National Guard's Joint Task Force, declared, "This place is going to look like Little Somalia. . . . We're going to go out and take this city back. This will be a combat operation to get this city under control." The journalist understood this to mean that the National Guard would be combating "an insurgency in the city."[6] In Spike Lee's powerful documentary of the events, *When the Levees Broke: A Requiem in Four Acts* (2006), several sequences demonstrate the practical consequence of this division of the sensible. We see then governor of Louisiana Kathleen Blanco histrionically announcing the deployment of the National Guard into the city with the remark that they have just returned from Iraq and will shoot to kill. We see a reporter for the BBC, usually the most decorous of journalists, quivering with rage as law enforcement near the Superdome surrounded one man accused of looting while dozens of others struggled through the by then polluted waters unassisted. We see Lt. Gen. Russel Honoré arriving in New Orleans on Friday, 2 September 2005, telling the soldiers, "Put those damn weapons down"—and their palpable reluctance to do so (see fig. 55). We realize that for the past four days U.S. troops have routinely been training their weapons on their own citizens. Ironically, the historian Douglas Brinkley, featured in Lee's film, reports that the terrorism security apparatus slowed the Department of Homeland Security's response because of all the background checks.[7] This adaptation of domestic politics to the regime of counterinsurgency has since gone viral. Opponents of gay marriage in the United States refer to such couples as "domestic terrorists." High-school principals describe their work in inner-city schools

as "classic counterinsurgency." Border patrols in Nogales, Arizona, follow the counterinsurgency mantra "clear, hold, build" as the guiding light for their enforcement of immigration law. In April 2010, a strikingly unconstitutional state law was passed in Arizona, requiring police to pursue those who appeared to be illegal immigrants and criminalizing any immigrant at large without documentation. While the law may well be invalidated, it was widely agreed that it was passed for "domestic" political reasons within the state. The intent is to intensify the racialized divide between the citizen and the undocumented migrant worker, creating a nomadic border that can be instantiated whenever a "citizen" looks at a person suspected of being a migrant. Indeed, the UAV is now widely used in cross-border surveillance, flying first on the border and more recently in Mexico itself.[8] British police have advanced plans for the extensive use of drones as domestic surveillance tools.[9] Test flights in Liverpool produced a first arrest in February, 2010, only for the drones to be grounded by the Civil Aviation Authority for lacking the requisite license.[10]

These imbrications of classic population-management discourses, from sexuality to education and immigration, with low-intensity asymmetric urban warfare both produces, and is a product of, the crisis in visuality. In 1990, Deleuze emphasized that Foucault had only been able to perceive the constraints of the disciplinary society because they were coming undone as the society of control took over. The coils of the serpent Leviathan, the state and its population management, had so extensively succeeded in driving Marx's "old mole" of class struggle underground that population could now be managed, rather than disciplined. The corollary here is that visuality itself has today become "visible" at a point of intensification in which it can no longer fully contain that which it seeks to visualize. That is to say, chaos is now not the alternative to visuality but its condition of necessity. The so-called visual turn in the humanities since 1989 is, then, a symptomatic response to first the neovisuality of the RMA, which followed the end of the Cold War, and now the intensified crisis of that visuality. Take the axiomatic phrase "Move on, there's nothing to see here," which I have borrowed from Rancière. Under conditions of (counter)insurgency, everyone knows that not to be the case. In Iraq and Afghanistan, insurgents and suicide bombers have often dressed in military and police uniforms to further confuse relations of visuality. Circulation itself becomes dangerous when roadside explosive devices and marketplace suicide bombings are the tactics of choice. The Chinese artist Cai Guo-Qiang visualized this contra-

diction in his spectacular sculpture *Nothing to See Here* (2006). It consists of a sixteen-foot-long fiberglass crocodile, impaled with bamboo spears and hundreds of "sharp objects" confiscated by Chinese transport police, such as forks, chopsticks, and scissors. The confiscations allow the passenger to keep circulating, but perhaps we are all missing the five-hundred-pound crocodile in the room. With his trademark subtlety, Cai makes us question whether the crocodile is the enemy insurgent or perhaps the body-politic of our own society, so enmired in "security" as to have lost a sense of purpose. As the economic crisis has shown, circulation is not always possible and is certainly not always an answer as to what to do next. If that circulation is by car, as in the French *circulation*, meaning "traffic," then it adds to the disaster of climate change as well. Caught between the car crash, the car bomb, and the fossil fuel–generated climate crisis, it seems impossible to know which way to turn.

MILITARY REVOLUTIONS

One index of the present crisis is the difficulty of periodization. The claim that the entire planet is a potential space for insurgency and thus requires a waiting counterinsurgent force indicates the attempt to update and intensify the Cold War. In this view, if globalization has again become the "global civil war" that was the Cold War in networked form, or has created a new state of "permanent war," then war is global politics.[11] At the beginning of the Cold War, President Harry Truman denounced the "terror" of the Soviet Union, creating a vocabulary that came readily to hand post-9/11. The military-industrial complex was designed to resist regression into its own colonial past of slavery and to maintain the present condition of "freedom." U.S. National Security Council doctrine held that it was "the implacable purpose of the slave state to eliminate the challenge of freedom," meaning that Soviet communism was slavery that must be resisted by the free.[12] This conflict was thus to be engaged wherever and whenever it manifested itself under the rhetoric of paying any price and bearing any burden in order for things to remain exactly the same. Under the threat of nuclear war, as Donald Pease put it, "Hiroshima had turned the entire U.S. symbolic system into the afterimage of a collectively anticipated spectacle of disaster."[13] Given that there had never been a nuclear war (as opposed to the single detonation of Hiroshima or later tests), this spectacle was paradoxically imaginary despite its status as afterimage: a war that will have

been. The endlessly discussed war was always in the future anterior—this will have been the nuclear war. For Derrida, the status of nuclear war as "fabulously textual" generated the very status of "the old words culture, civilization . . . [and] 'Reality.'"[14] This "Reality" was understood as binary, structural, and violent. The future that will (never) have happened was specular but textual, generating among its multiple side effects the 1980s era of "reading images."

The counterinsurgency theory launched at the end of the Cold War as the RMA, however, has always already happened and is always to be visualized as part of culture. Its academic creature was visual culture. Military theorists presented the emergence of "information warfare" as the twelfth in a series of military revolutions that began with Napoleon, following the genealogy of visuality. This is myth-making of the first order, but its use of actual historical experience within a framework long dedicated to making "history" tell the story of the West allows it to have the aura of reality. The term *revolution* was not used idly. For the military have been devoted readers of revolutionary and guerilla theory ranging from the French and Indian Wars of colonial North America to Mao and the Zapatistas. Indeed, the RMA is widely considered to have been developed first in the Soviet Union, where it was also known as the "scientific-technical revolution." The RMA was designed to give the military the advantages of speed and surprise usually held by guerilla and revolutionary groups. Consequently, the new mode of war was said to involve "dispersed ground forces," with the result that "conventional ground operations come to resemble high intensity guerilla warfare."[15] Of course, the more effective guerilla warfare is, the less visible its activities are to the opposing forces. The goal of this mode of invisible war was to establish a permanent dominance in command, control, communications, intelligence (C3I), and information that would in turn ensure military hegemony. U.S. military planners envisaged a range of new weaponry, such as "precision guided munitions, combat vehicles that require no fuel or ammunition, directed energy weapons launched from platforms not yet invented, infrasonic weapons, and computer viruses used as weapons."[16] In 1999, when the Defense Department budget was a relatively modest $263 billion, analysts questioned whether expenditures of over $50 billion on these new weapons, exceeding in themselves the entire military budget of Russia at that time, were necessary or affordable. The counterargument was that C3I dominance would actually reduce costs elsewhere in land forces and other projects. Such worries seem quaint in an era of de-

fense budgets of some $680 billion, excluding the costs of the wars in Iraq and Afghanistan, estimated as an "additional" $149 billion for 2010.[17]

In this incarnation, the RMA implied both new forms of weaponry and significant use of information technology to control and destabilize the opponent.[18] This intensification in military-industrial visuality amounted to a revolution. It shifted focus from the counterpoint of spectacular (nuclear) warfare and its documentation and classification by aerial photography to that of information and disinformation. The assemblage of information was the primary tactic of colonial counterinsurgency now applied to a global digitized warfare that had yet to be encountered but was assumed to be imminent. The Information War strategy developed into the complementary tactics of "cyberwar" and "netwar." In the view of John Arquilla and David Ronfeldt, the most prominent theorists of Information War, cyberwar involved "information-based military operations designed to disrupt an adversary," whereas netwar is "low intensity conflict at the societal end of the spectrum" of war, whose polar opposite was battlefield conflict.[19] The network form of war, including but not limited to the Internet, produced an opponent without leaders or with multiple leaders, making it hard to combat by traditional means: "Netwar is about Hamas more than the PLO, Mexico's Zapatistas more than Cuba's Fidelistas . . . and Chicago's Gangsta Disciples more than the Al Capone Gang."[20] If this sounds more like a cultural-studies paper (remember this was 1996) than a military think-tank, so it should.

Indeed, the RMA's height of ambition was to turn the military strategy into a cultural project. In a essay published, in 1997, in the *Marine Corps Gazette*, one general argued: "It is no longer enough for Marines to 'reflect' the society they defend. They must lead it, not politically but culturally. For it is the culture we are defending."[21] Cultural war, with visuality playing a central role, takes "culture" to be the means, location, and object of warfare. In his classic novel *1984*, George Orwell coined the slogan "War Is Peace," anticipating the peace-keeping missions, surgical strikes, defense walls, and coalitions of the willing that demarcated much of the last decade of the twentieth century. It was striking to observe the Israeli Defense Force making extensive use of poststructuralist thinkers like Deleuze and Guattari, the situationist Guy Debord, or the deconstructionist architect Bernard Tschumi in thinking about how to fight urban counterinsurgency warfare in the period following the al-Aqsa intifada of 2000.[22] If the conclusion was to begin "walking through walls" as a bizarre form of nomad-

ism, meaning literally piercing holes in building walls to gain the element of surprise, the rhetoric of the Operational Theory Research Institute is nonetheless disconcertingly familiar to any reader of critical theory.

The Bush-Rumsfeld doctrine (2001–6) intensified these modes of counterinsurgency into full-blown preemptive warfare as part of their declared "Global War on Terror." While returning to the rhetorics of the Cold War, the so-called war on terror relied on the counterinsurgency and information war tactics of the RMA, creating a new hybrid. What W. J. T. Mitchell has called "image wars" were a central part of this doctrine, which imagined decisively defeating its enemies in battle and in ideology. The new techniques could not only visualize the battlefield, but also engage in it, demoralizing the opponent by demonstrations of mastery, like the "surgical" strike with computer-guided weapons that visualize their own targets. This moment was the high point of the RMA, quite literally its reign of terror. Like Robespierre, Bush assumed that no opposition could be tolerated and that all measures were permitted in defense of the republic. As secretary of defense, Donald Rumsfeld implemented a strategy in the invasion of Iraq in 2003, marked by a high-tech, high-speed, lethal force capable of accomplishing significant goals with a relatively small number of personnel. It was supposed to be the apex of the RMA, integrating extensive use of "smart" weapons, dispersed ground forces, and intensive use of information war. This "Rumsfeldism" added an additional component to the war with the use of the image as a tactical weapon. As I have analyzed at length in *Watching Babylon*, the first three years of the Iraq war (2003–5) saw images used as weapons, designed to suppress dissent at home as well as resistance on the ground. These uses of the image-weapon were the culmination of a generation of Anglo-American information strategy, beginning with the Falklands/Malvinas War, in 1982, where both images and information were subject to extremely close state control. In Iraq, the strategy of embedding journalists with troops often led to them identifying with the men and women they were working with, as well as enabling control of what might be seen. One instance of the information-war policy was the creation of the Iraqi Media Network by the Coalition Provisional Authority, in 2003. An initial $15 million no-bid contract was awarded before the invasion took place, to the contractor Science Applications International Corporation (SAIC) to generate television, radio, and a six-day-a-week newspaper. Against all the odds, the renamed Iraqi Public Service Broadcaster did get on the air and opened its programming with a verse from the Koran. That

gesture was at once cancelled by Washington, which compelled the net-
work to broadcast instead an hour-long daily show called *Towards Freedom*,
produced by the British government. Unsurprisingly, six months after the
war a State Department poll showed 63 percent of Iraqis watched al-Jazeera
or al-Arabiya, but only 12 percent watched the government station. The re-
sponse was to award a new $95 million no-bid contract to the Harris Cor-
poration, a manufacturer of communications equipment with no television
production experience.[23]

SADDAM EFFECTS

As a metonym of the stages of image war in Iraq, I want to consider here
a variety of images of Saddam Hussein. The war began with the famous
shock-and-awe bombings, seen live on television. It is less often recalled
that the hope had been to kill Saddam Hussein with the first attack, based
on information received from Iraqi sources. It is possible that, had this at-
tack achieved its goal, the war might have unfolded differently. As it was,
repeated claims of Saddam's death were soon refuted or forgotten, so a
substitute had to be found. In April 2003 newspapers and television-news
programs around the world led with the story of Iraqis in Baghdad de-
molishing a statue of Saddam. Such demolition of the images of kings has
a long and resonant history, most recently with the destruction of social-
ist monuments in the former Soviet bloc post-1989. Americans might re-
call the overturning of a statue of King George III in New York during
the American Revolution. This mock execution seemed to encapsulate the
symbolic power of the American victory and locate it in a series of popu-
lar revolts. And so it was intended by the unnamed marine corps colonel
and his psychological-operations team who were commended by the army
a year later for their "quick thinking." Even at the time, the event seemed a
little too neat and the "crowd" seemed small for so symbolic an event. By
the time it became clear that the statue demolition had been an operation
of information war, the insurgency was starting to take the shine off the
supposed triumph.

Aware that events were not moving quickly enough, military intelli-
gence came under immense pressure to discover Saddam's whereabouts in
late 2003. This necessity was one of the motivating factors that led to the
intensification of interrogations in Iraqi prisons, known as "Gitmo-izing,"
that is to say, making them like Guantánamo Bay. That need to generate

"actionable" intelligence was directly responsible for the scandals that are now summarized by the name "Abu Ghraib" and that have been widely analyzed. In other words, pressure for a flow of information led Americans in Iraq, like the French in Algeria, to resort to torture in order to accelerate results. In this context, the capture of Saddam was presented as a successful effort of information war, involving the use of layered social-network analysis by Major Brian J. Reed.[24] For all the social-science nomenclature, the tactic was largely the same as that used by the French in Algeria: reach the head of the network from its outlying points of contact, in this case, one of Saddam's drivers. Again, the initial impact was strong, leading one CNN anchor to ask, "What is there left to talk about in Iraq?" As this comment illustrates, the capture of Saddam was meant, like the declaration "Mission Accomplished" and the demolition of the Saddam statue, to end what Mark Danner usefully called "the war of the imagination."[25] The war had been imagined in Rumsfeldism as a Hollywood film, with a necessarily dramatic and heroic ending.[26] It now seemed that the scenario had changed from a John Wayne drama with a suitably uplifting denouement into a self-referential independent picture in which every apparent ending turned out to be the beginning of another episode. The capture of Saddam was another moment when the "democratic tsunami" predicted by the supporters of the war could finally be unleashed without fear of the return of dictatorship. It was also assumed that anticoalition resistance would soon collapse without its leader. As we know, these predicted movements never took place. The insurgency in fact accelerated dramatically after Saddam's capture, and the long-awaited enthusiasm for America never materialized. The endlessly repeated video clip of Saddam being examined by a doctor presented the United States as a benign power, concerned for the health of even its worst enemy. It may also have been a search for poison or concealed information. More precisely, it represented modern biopower, the use of power to sustain life even and especially when the state is on the point of withdrawing that life.

On 30 December 2006 that moment was reached, when the chronicle of Saddam's foretold death came to its inevitable conclusion on the gallows (see fig. 56). What surprised and shocked the world was that it was not just told but seen. While the cell-phone video that was "accidentally" released was not officially authorized (meaning known to the occupation), there was also an official version, which lacked the soundtrack. So, unlike the "disciplined" execution presumed to be normative in the West, it was always

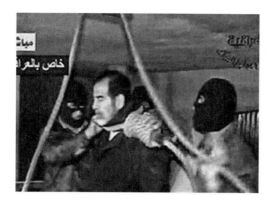

FIGURE 56. STILL FROM THE VIDEO OF THE
EXECUTION OF SADDAM HUSSEIN

intended that the moment of Saddam's death be seen, just as the bodies of his sons had been shown to the world media. It no doubt seemed important that, in the swirling, rumor-driven climate of the occupation, some form of proof be made available. It was telling that the video was first broadcast by the pro-occupation Fox News cable channel, known for their distribution of officially sanctioned "leaks." The video was always unlikely to be able to serve as proof, given that the Internet was already awash with theories that the person being held was one of Saddam's doubles, that he had not been arrested in March but six months earlier, as evidenced by some unripe dates in one of the photographs of his so-called rat hole, and so on. Yet there was an older impulse at work here: the desire of those appropriating sovereignty to show that it does not adhere to the living body of the deposed sovereign. From the execution of Charles I, in 1649, via that of Louis XVI, in 1793, and the counterspectacle of the assassination of too many slave owners and plantation managers to name, the new power wants to claim that authority has passed from the dead sovereign and now adheres not to the heir but to the executors. The double-meaning of *executor*, in which the modern sense of legal performer has replaced the older sense of executioner, suggests a legal sleight of hand following the executioner's coup de grâce, in which the last will and testament of the executed is rewritten by the will to power. In this tremulous moment, the social contract that sustains authority is made dangerously visible, and, as Foucault liked to remind us, public executions are always therefore double-edged moments, full of potential for riot and revolution. Sedated by the minimal contact between the U.S. state

and those it condemns to death by automatic injection, the occupation did not think to police its own policemen, assuming they would adhere to their rules.

In fact, the cell-phone video of the execution was a palpable horror, a digitized rendition of the realities of the quasi-judicial process. Abuse was hurled at Saddam by his guards, including a chant of "Moqtada! Moqtada!" (referring to the Shi'ite cleric Moqtada al-Sadr). One person tried to calm matters by reminding those in attendance that this was an execution, a legally ordained withdrawal of the right to live. Ironically, this furor seemed to break the deposed dictator out of a state of shock, provoking him to a sardonic rebuke and to carry out his final prayers. As if sensing that the spectacle was not progressing as intended, the executioner opened the trapdoor of the gallows before the prayer was complete. Nothing can mitigate what it means to have seen and heard an execution. It does not, of course, condone or exonerate Saddam's excesses, which were first criticized by the global Left while he was still the favored creature of Anglo-American machinations against Iran. Whatever this execution was, it failed in its primary goals to emulate the Nuremberg trials and to both legitimize the new regime and cast a pall over Baathism.

FROM WAR AS CINEMA TO DIGITAL WAR

The dissemination of the video was the culmination of the cinematic era of the RMA, a documentation of war by its participants that was supposed to have been seen only by those participants and those they trusted. In the era of networked communications, it was no longer possible to contain these images within the circle marked out by the police, beyond which we are instructed to "move on, there's nothing to see here." In fact, we might say that if what a picture wants is above all to be seen, what the digitized image wants is to be circulated, whether by copying, linking, or forwarding. Much of the military video and photography from the Iraq war has reflected this uncertain status. Raw TIFF files circulate with no means of contextualizing them, while unedited video footage of routine military events is interrupted on shocking occasion by the eruption of violence. Explanations, context, and consequences are rarely available, whether in U.S. or purported insurgent video.[27] In one notorious instance, digital images of the war in Iraq were bartered for access to an amateur pornography site, the appallingly accurately named nowthatsfuckedup.com. Chris Wilson,

the site's owner, recognized that soldiers could not use their credit cards while serving, because their companies flagged their locations as questionable. He therefore offered an exchange, whereby posted photographs of the war, whether standard poses or those in the notorious "Gory" folder, would allow the user access to the pornographic sections of the site. By the time the site was closed down, in 2004, by Florida sheriffs on grounds of obscenity relating to the pornography, there were some 1,700 photographs on the site, including two hundred "gory" images.[28] It cannot have been important to the soldiers to see this particular collection of pornography, given the plethora of such material online. Rather it seems that they wanted to show their actions to a wider audience, mirroring the shock-and-awe philosophy of their commanders and claiming a similar level of entitlement both to see and display and to be seen and displayed.

In similar fashion, digitized images accumulate on sites such as Flickr and YouTube, hoping to "go viral," a metaphor derived from infectious disease that is very appropriate to this biopolitical moment. Even the military have tried to get involved, creating a Multi-National Force Iraq YouTube channel, which unsurprisingly attracted few viewers.[29] To render the digital image into a cultural virus, it must go into a frenzy of circulation, being copied, linked, and forwarded as fast as possible. But for every Obama Girl, whose homemade video of a song called "I've Got a Crush on Obama" had millions of viewings in 2008, there are thousands of YouTube clips that languish without circulation and it is not yet predictable how and why certain scenes go viral. Visuality has always been violent and expropriative, so there is a certain homology at work in the dominance of violent scenes in the most notorious moments of twenty-first-century visual culture (9/11, Shock and Awe, Abu Ghraib, the Danish cartoons, Hurricane Katrina: this list is also a barebones syllabus). However, it is important to restate that the violence is inherent not to the content, but to visuality. While there may be a distinction between a photograph of an American soldier giving a thumbs-up gesture while standing next to an Iraqi child, and the same soldier repeating her gesture next to an Iraqi corpse, both scenes represent violence. Nowhere was this made clearer than in Errol Morris's documentary on Abu Ghraib, *Standard Operating Procedure* (2008). In the film, the now notorious former Specialist Lynddie England claimed that although she had been photographed holding a prisoner on a leash, that leash had simply been handed to her, that she had not herself dragged the prisoner out of the cell. Similarly Specialist Sabrina Harman, seen posing next to a corpse packed

in ice, giving a broad smile and a thumbs up, asserted that this was simply her automatic response to being photographed. While this may seem like defensive rhetoric, at the end of the film the army's own investigative officer Brent Pack declared that the repeated photographs showing prisoners at Abu Ghraib in so-called stress positions, with or without wearing women's underwear or hoods on their heads, were not torture but the eponymous standard operating procedure.

Violence is the standard operating procedure of visuality. While setting out to distinguish between when it is acceptable and when excessive in visual images is not my intent here, in the hands of lawyers and NGO workers such distinctions can mitigate actual harm to people, and of course I applaud such work. In the case of visuality, its violence has paradoxically, as the counterinsurgents like to put it, turned on the materialized visualization itself. This perhaps final intensification of the violence of visuality attempts to render the visible invisible, even within the zone of those authorized to see—or at least so uncertain that it cannot be decided what has been seen. There is nothing to see here, because it has been rendered undecidable, or even in a sense nonexistent. The Rumsfeld stage of the RMA attempted to achieve this undecidability by generating so many images and visualizations that no single instance could be decisive. The sovereignty of the visualizer shifted ground so that authority was now derived from the ability to ignore the constant swirl of imagery and persist with a "vision" above and beyond mere data. The justification for the invasion of Iraq centering on the "weapons of mass destruction" purportedly held by Saddam Hussein has therefore survived the apparently clear demonstration, by 2003, that there were none. Following an article by Ron Suskind that appeared, in 2004, in the *New York Times Magazine*, this attitude became celebrated as a contempt for the so-called reality-based community articulated by a "senior adviser" to Bush.[30] Less remembered in that citation was the commitment to continue "creating other new realities," a policy that has become enshrined as the counterinsurgency doctrine of necropolitical governmentality.

COUNTERINSURGENCY

The fall of Rumsfeld, in 2006, did not mean the end of the RMA, any more than the fall of the Jacobins, in 1794, ended the French Revolution. In this new moment, the past excesses of the Global War on Terror are ritually dis-

paraged, much as the French Executive Directory of 1795 decried the Terror of 1793, but claimed to be continuing the revolution.[31] Reframed as the "long war," counterinsurgency, COIN in the military acronym, has in no way diminished its ambitions. Its leading theorist, John Nagl, has argued that as well as the Department of Defense, the State Department, the Departments of the Treasury, and the Department of Agriculture need to be thinking in terms of counterinsurgency.[32] The project was repackaged as "countering global insurgency" (GCOIN), a project whose range and ambition is every bit as grandiose as before.[33] The premise is that if insurgency is global, then counterinsurgency must be as well, taking the entire planet as its "area of operations." The new doctrine (a term of art in the military) was encapsulated in the publication of Field Manual *FM 3-24 Counterinsurgency* issued by the U.S. Army and Marine Corps, in December 2006, its first statement on counterinsurgency since Vietnam.[34] Written in great haste at the instigation of General David Petraeus, in a single year from its first conception, in December 2005, this Field Manual aims at nothing less than making counterinsurgency the primary responsibility of the military, a mission that is described as both cultural and political. The project renders the biopolitical governance of populations into a military mission, now known as population-centric counterinsurgency. It contains a timeline for its predetermined success and continued application in the extended future, measured as far as fifty years ahead. Here, counterinsurgency is explicitly a cultural and political war, fought as much in the United States as it is in Iraq or elsewhere. As an indication of its significance, the new Field Manual was downloaded from the Internet over two million times by 2007, making it something of a digital global best-seller. In an extraordinary step, it was then republished by the University of Chicago Press in a $25 hardcover edition, complete with an introduction by the Harvard professor Sarah Sewall, former deputy assistant secretary of defense for peacekeeping in the Clinton administration and director of the Carr Center for Human Rights at Harvard, now an adviser on national security for Barack Obama.[35]

In Sewall's manifesto, she calls counterinsurgency "paradigm shattering" because it argues for the assumption of greater risk in order to succeed, requiring "civilian leadership and support" for the long war. Indicating a certain continuity with Rumsfeld, she claims counterinsurgency to be superior to what she calls the "Weinberger-Powell doctrine of overwhelming and decisive offensive force."[36] The term *doctrine* is being used specifically here: it is the military term for the principles governing fundamental choices

about how and when to fight war. Colin Powell's theory was not limited, however, to overwhelming force. In 1991, he was among those advising then President George H. W. Bush not to occupy Baghdad on the so-called Pottery Barn principle—that is to say, you break it, you own it. The radical RMA strategy espoused by the Bush-Rumsfeld doctrine overturned such caution with results that engendered the new need for counterinsurgency tactics. Like all revolutionary strategies, the RMA has taken the emergency presented by the disaster of the Iraq war as an opportunity. The publication of the new counterinsurgency strategy, designed both for strategic planning and for daily use in the field, was a tactical transformation of RMA and its strategic continuation. General Petraeus has thus served as the Napoleon of the RMA, a hero figure whose utterances were beyond question until the mission seemed to stumble in Afghanistan, which may serve as his Waterloo.

COMMAND VISUALIZATION AND VISUALIZED INFORMATION WAR

COIN has become a digitally mediated version of imperialist techniques to produce legitimacy. It insists that the "commander's visualization" is the key to success in the conflict against insurgents, but there is "paradoxically" less visual content (traditionally defined) to such visualization. It centers on the cultural and historical elements of a particular place, imagined and accessed as a network within a digital framework. Such paradoxical visualization seeks to generate legitimacy by means of population control, blending imperial strategy with the governmentality of developed societies. The doctrine is defined as a return to the cultural politics of war and to the concept of war as culture.[37] A digitally enabled military, using surveillance and information as its primary tools, seeks to dominate culture using a networked leadership, in patterns set by imperial regimes, that is invisible to those led. Unlike the Panopticon or plantation, the place of surveillance is not just invisible, but unknown, what one might call its undisclosed location. This is post-panoptic visuality for a new era, a neovisuality enabled by global digital technology that nonetheless understands itself to be part of a centuries-old tradition. In the first pages of the Field Manual insurgency is defined as existing on a continuum from the French Revolution of 1789, with insurgency as one "extreme" and a "coup d'état" as the other. Not by chance, figures from Napoleon on can now be presented as counterinsurgents, a version of history that would have been congenial

to Carlyle. Counterinsurgency, imagining itself quashing all modern revolts from the French Revolution to the military coup, thus figures itself as legitimacy. It seeks both to produce an acquiescent national culture and to eliminate insurgency, understood as any challenge to power. It does so not simply by means of repression, but by the progressive application of techniques of consent under the imperative "culture must be defended." The Field Manual offers an instrumental definition of power as "the key to manipulating the interests of groups within a society" (3-55). But power alone is not enough: "Victory is achieved when the populace consents to the government's legitimacy and stops actively and passively supporting the insurgency" (1-14). Dominance must be accompanied by a consensual hegemony that generates the legitimacy of counterinsurgency in thought and deed. This ideological idealism is still offered as a political justification for the war, even as the tactics have become directed at a necropolitical management of hostile populations.

While COIN wants to be framed as a heroic narrative—a story of overcoming resistance—it can best be analyzed as a set of related techniques. Resting on visualization as a military tactic enabled by digital technologies, COIN seeks to render a culture in its own image that will actively want to be subject to biopolitical imperial governance. Visualization is the key leadership tactic that holds together the disparate components of counterinsurgency into what one might call "visualized information war." Indeed, according to the counterinsurgency manual, it is policy that "the commander's visualization forms the basis for conducting . . . an operation" (A-20). In the section of the manual intended to be read by officers in the field, this visualization is defined as the necessity of knowing the map by heart and being able to place oneself in the map at any time. Nowhere is the legacy of the history of visuality described in this book clearer than in these instructions. Media and other imagery are components of the visualization, rather than its substance. For instance, "media activities" can be the primary activity of an insurgency, according to the army, while "imagery intelligence" in the form of still and moving images are vital to counterinsurgency (3-97). Visualization by contrast requires commanders to know "the people, topography, economy, history, and culture of their area of operations" (7-7). The counterinsurgent thus transforms his tactical disadvantage into strategic mastery by rendering unfamiliar territory into a simulacrum of the videogame's "fully rendered actionable space."[38] Counterinsurgency cultivates optical invisibility in support of a digitized surveillance and com-

mand structure. Its favored tactics include "disappearances," renditions, the "invisible" prison camp, no-fly lists, no-fly zones, electronic surveillance, and non-accountable interrogators, known as Other Government Agency personnel. When counterinsurgency deploys itself as a visualized field, it does so by means of representation in which the place of observation is invisible or obscured, for the state of exception is a non-place, like the mystical perception of Carlyle's Hero. Comprised of digitized images, satellite photographs, night-vision goggles, and map-based intervention, post-panoptical space creates a 3-D rendition of the insurgency that corresponds to the counterinsurgent's experience of space in a grid accessible only to the "commander," the modern-day Hero. Taken together, these abilities are summarized as the "commander's visualization," using Carlyle's own term, but this visualization is now comprised of data and imagery invisible to the unaided human eye.

In this chaotic zone of neovisuality, counterinsurgency can allow the forbidden to emerge into visibility, whether by choice or accident. So there was a deliberate "revealing" of the coercive tactics used at the otherwise invisible Guantánamo Bay camp in order to strike fear into actual and potential insurgents as to what awaited them if captured. On the other hand, the photographs from Abu Ghraib emerged in a way that was clearly accidental, even if the army had taken no precautions to prevent it. The "revelations" prevented neither the generalization of torture nor the expansion of the counterinsurgency, although they have led to limitations on cameras among enlisted personnel. A good example of the paradoxes resulting from this blurring can be seen in the new place of mapping. Whereas mapping was for centuries associated with colonial power as a technology of visuality, recent neocolonial occupations, such as that in the Occupied Territories of Israel/Palestine or in Iraq have made mapping an oppositional practice.[39] This indifference to what is known or unknown has become one of the strengths of the counterinsurgency's aspiration to a totalizing vision. No countervisualization can damage its claim to totality. The Field Manual embraces a fully sovereign visuality: "Soldiers and Marines must feel the commander's presence throughout the A[rea of] O[perations], especially at decisive points. The operation's purpose and commander's intent must be clearly understood throughout the force" (7-18). Visualized information war is imagined as a perfect signal-to-noise ratio, with messages conveyed perfectly from leader to field and back in real time. Command visualization is the field version of the nineties-era RMA term "full spectrum

dominance," the neovisuality of our times, based on dominating "offense, defense, stability, [and] support."[40] Counterinsurgency is thus legitimate because it alone can visualize the divergent cultural forces at work in a given area and devise a strategy to coordinate them.

When soldiers refer to action as being like a videogame, as they frequently do, it is not a metaphor. By turning the diverse aspects of foreign life into a single narrative, the counterinsurgent feels as in control of the situation as a player in a first-person-shooter videogame. The commander thereby feels him- or herself to be in the map, just as the game player is emotively "in" the game. This experience is sufficiently real that videogames are now being used as behavioral therapy for psychologically damaged soldiers. Numerous first-person accounts by rank-and-file U.S. troops testify to their confusion as to where they were and what direction they were going during combat missions, perhaps contributing to the high levels of suicide, depression, and post-traumatic stress disorder experienced by veterans. The popular videogame Full Spectrum Warrior, played using a virtual-reality helmet, has become an effective therapeutic tool for soldiers suffering from such post-traumatic stress. In this instance, a modified version of the game places the soldier back in a situation similar to that in which s/he was traumatized as a behavioral tool to normalize response. While the game is quite well rendered, you would not ordinarily mistake it for reality. However, a soldier engaged in visualized information war can and apparently does take this rendition as equivalent to the interface experienced in the insurgent environment. Re-performing the war can restore mental equilibrium in the "shell-shocked" patient by dint of repetition. The medium-resolution 3-D digital videogame experience is indistinguishable from the "reality" of counterinsurgency.

The counterinsurgent understanding of culture is, however, a reversion to imperial governance under a model of cultural hierarchy: "Cultural knowledge [is] . . . essential to waging a successful counterinsurgency. American ideas of what is 'normal' or 'rational' are not universal" (1–80). This cultural hierarchy is derived directly from nineteenth-century imperial practice. Consequently, readers of the Field Manual are advised to consult such apparently unlikely works as *Small Wars: A Tactical Handbook for Imperial Soldiers* (1890), by Charles E. Callwell, produced at the height of British imperialism. The U.S. Army does not ask its soldiers to accept difference, but rather to understand that Iraqis cannot perform like Americans. Such references reframe counterinsurgency as the technical management

of neo-imperial dominions, even as the notion that Iraq or Afghanistan are "small wars" undermines public assertions that they are the moral equivalent of the Second World War. Instead, it accurately locates these wars as a technique of imperial governance, rather than as an existential struggle. The counterinsurgency manual often draws parallels with the imperial hero T. E. Lawrence's experience in "Arabia," citing his maxim "Better the Arabs do it tolerably than that you do it perfectly" (1-155) as one of the "paradigm shattering" paradoxes that conclude the opening chapter of the *Field Manual*. Against this lesson from the past, Lawrence himself had advised that his "Twenty-Seven Articles" on working with Arab armies were intended only for those engaged with the Bedu[ouin], and he was, after all, promoting an anti-imperial Arab revolt. He also advised borrowing a slave as a manservant. On the other hand, for all his racialized characterizing of the "dogmatic" Arab mind, Lawrence insisted that the would-be ally of the Arabs must "speak their dialect of Arabic."[41] By contrast, the U.S. Army began, in 2007, offering soldiers a pamphlet with some two hundred Arabic words and phrases, spelled out phonetically. Culture as the ground for counterinsurgency is understood in this contradictory fashion as a totalizing system, governing all forms of action and ideas, in an oscillation between Victorian anthropology and the first-person-shooter videogame. The anthropologist Edward Tylor argued in *Primitive Culture* that "Culture or Civilization, taken in its widest ethnographic sense, is that complex whole which includes knowledge, belief, art, morals, law, custom, and any other capabilities and habits acquired by man."[42] The counterinsurgency strategy similarly understands culture as a "web of meaning" or as an "'operational code' that is valid for an entire group of people," acquired by all members of a particular society or group by means of "enculturation" (3-37). According to the manual, culture therefore conditions how and why people perform actions, distinguish right from wrong, and assign priorities, as if it were a set of rules (3-38).

NECROPOLITICAL REGIMES OF SEPARATION

Counterinsurgency directly concerns itself with governance and the maintenance of life. The still current *Small Wars Manual* (1940) argues that "small wars are operations undertaken wherein military force is combined with diplomatic pressure in the affairs of another state whose government is unstable, inadequate, or unsatisfactory for the preservation of life and of such

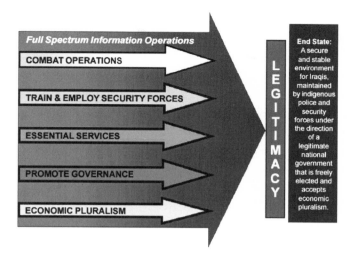

FIGURE 57. MAJOR-GENERAL PETER CHIARELLI,
"FULL SPECTRUM INFORMATION OPERATIONS."

interests as are determined by the foreign policy of our Nation."[43] Here
military intervention is again understood as militarized necropolitics: the
preservation of life, determined by foreign-policy interests. By extension,
lethal force may be used in the preservation of certain lives on the basis
of judgments made by the counterinsurgent. Command visualization thus
generates legitimacy not just by military operations, but by a militarized
governmentality, as summarized in the diagram (see fig. 57).

Devised by then Major General Peter Chiarelli, in 2005, to illustrate his
concept of "Winning the Peace," this visualization imagines security as one
of a cluster of required "information operations" that combine to produce
"legitimacy."[44] The object of control has moved from being History in gen-
eral to the population, in this case the Iraqi population, whose security is
now to be ensured by means of a series of coordinated techniques, from the
implementation of neoliberal economics to the reestablishment of essential
services and the retraining of security forces within the counterinsurgency
paradigm. The outcome is imagined to be "legitimacy," or what I have been
calling "authority," that moment when the government is simply obeyed
because it is recognized as having legitimate authority. Having achieved
legitimacy, the theory goes, the war will have rendered a culture in its own
image with elections and a free-market economy. It is important to note
the audacity of this strategy, for "legitimation" is precisely the weak point

of constitutional theories of the state in general and the state of exception in particular. In a move typical of the radical Right, that potential weakness is turned into a point of strength, as counterinsurgency assumes legitimacy as both its justification and its mission. Perhaps the greatest success of such operations has been on what is still called "the home front," that is to say, domestic U.S. political opinion and mass media culture. Its success in these domains is unquestioned: who in public life is against counterinsurgency, even if they oppose the wars in Iraq and Afghanistan or interventions elsewhere? Ironically, there is significant dissent only within the military, where many remain unconvinced by the new doctrine.

Tactically, COIN now considers its terrain to be what it calls the "host nation population," a militarized form of biopolitics.[45] While the governance and services categories now included in this Full Spectrum Operation were formerly understood by Foucault as part of civilian governmentality in Western nations, the introduction of military and police components within the context of a counterinsurgency visualized information war clearly represents a new formation. More exactly, this means of controlling the population is a "necropolitics," meaning the management of the withholding of life. These benefits are offered to the occupied "host population" as a whole, not to insurgents. It was notable that, in early 2010, it was announced that all Afghans were to be issued identity cards with biometric date and that the military were maintaining a "kill or capture" list of those they considered insurgents. Biometrics are here directly at the service of necropolitics.[46] Accordingly, the three stages of counterinsurgency are described as "first aid," "in-patient care—recovery," and the final achievement of "outpatient care—movement to self-sufficiency."[47] Counterinsurgency now actively imagines itself as a medical practice: "With good intelligence, counterinsurgents are like surgeons cutting out cancerous tissue while keeping other vital organs intact" (1-126). It is not a perfect metaphor: most cancer patients would require chemotherapy or radiation treatment to prevent recurrence, which impacts the entire system, precisely the kind of crisis counterinsurgency wants to avoid. The use of *cancer* indicates here not a specific medical parallel, but an unmistakable threat to life, requiring radical intervention. As cancer is a rapidly multiplying life-form, its (metaphorical) eradication is a necropolitics: this parasitic life must be withheld so that the "host" can live.

Counterinsurgency's means of accomplishing such necropolitical transformations were developed from the imperial hierarchies of sovereign and

subject peoples. Although the manual disavows biological constructs of race, it consistently emphasizes cultural difference, with a strong view that "Western democracy" is the superior form of culture. The long-established model for such tactics is that used by Israel in its governance of the Occupied Territories. Indeed, the de facto strategy of the "surge" was to segregate Shia from Sunni by means of walls similar to that constructed on the West Bank.[48] These barriers reified the mass internal and external displacement of Iraqi citizens, estimated at some four million of the twenty million Iraqi population. Just as in the colonial segregation of Algeria, the resulting relative decline in violence has led Western audiences to accept this violent divide of a formerly integrated population as "normal." Writing in the context of Israel/Palestine, Hilla Dayan argues that "regimes of separation . . . develop unprecedented mechanisms of containment, with forcible separation and isolation of masses trapped in their overextended political space."[49] Visualized information war produces necropolitical regimes of separation. These regimes are global, just as the terrain of counterinsurgency is global, evidenced by the extensive construction of exclusion barriers on the U.S.-Mexico border, between "Spain" and Morocco around the still-colonized cities of Ceuta and Melilla, and elsewhere, not to mention a long list of states operating internal regimes of separation. Such regimes are nomadic, requiring the immigrant—and sometimes the citizen—to have their identification cards available at all times, on threat of deportation.

The establishment of these regimes is a key goal of the counterinsurgency, both at "home" and in the global occupied territories. The geographer Trevor Paglen has documented and tracked the extensive network of "invisible" or "black" state operations in the United States, demonstrating that at least $32 billion is budgeted for such activities per year, "more than the combined budgets of the Food and Drug Administration, the National Science Foundation and the National Aeronautics and Space Administration."[50] The rendition of the war as counterinsurgency centers on the need for what is known as "actionable intelligence." Anglo-American governments have transformed this need into an unparalleled surveillance of their own populations, largely in secret in the United States, but quite openly in the United Kingdom. When the full extent of email and phone surveillance became known in the United States, in 2008, a cowed Democratic Congress soon offered full immunity to telecom companies and officials. On the other hand, in the United Kingdom, it was a Labour government that presided over the erasure of rights. The United Kingdom has now be-

come the surveillance capital of the planet, with a staggering five million closed-circuit television (CCTV) cameras estimated to be in operation in 2006, one for every twelve citizens and 20 percent of the global total.[51] By 2010, each Londoner was thought to be photographed 300 times a day by CCTV. Not for nothing, it seems, was George Orwell's vision of Big Brother set in Britain. Police procedural television dramas in the United Kingdom now routinely center around the use of CCTV footage, rendering the emergency into the new normal. So far have things deteriorated that the refusal of Parliament, in 2008, to extend a 28-day detention period (in which a person that authorities declare to be suspected of terrorist activities can be held without legal rights of any kind) to 42 days was presented as a victory for civil liberties. It increasingly seems that a key goal of global counterinsurgency is to render legitimate this massively extended domestic surveillance society that would formerly have been seen as illegal.

The necropolitical regime of separation has no hestitation in using torture and other forms of violent interrogation, derived from Cold War counterinsurgency methods. French torture methods in Algeria were transmitted to American instructors at the School of the Americas and then on to various Latin American regimes. For instance, the methods used at the ESMA concentration camp, in Buenos Aires, during the Argentine dictatorship (1973–82) have an unpleasantly familiar ring: hooding, sensory deprivation, shackling, and electricity, all designed to "dehumanize" the victim in order to obtain information. In congressional hearings and other forums, Bush administration officials repeatedly described torture as the application of "techniques." For all the doublespeak at work here, counterinsurgency relies on the gradated use of force as a technique of legitimation. It is legitimate to use torturing force on the recalcitrant body of the person designated as an insurgent because the counterinsurgency is legitimation and the insurgency must acknowledge it to be so. In this sense, Iraq, Afghanistan and other ventures of counterinsurgency, such as Iran, Palestine, or Pakistan, are technical experiments in the production of necropolitical regimes of separation.

PARADOXES OF VISUALIZED WAR

The goal of these techniques is the sustained need for the regime of separation, meaning that the ultimate paradox of counterinsurgency is that the measure of its success is its permanent continuation. The more these para-

doxes proliferate, however, the greater the uncertainty and hence the continued need for counterinsurgency. This is a long-standing argument of counterinsurgents. In 1977, the Israeli Foreign Minister Moshe Dayan declared that the issue of the Palestinian territories should be reframed: "The question was not, 'What is the solution?' but 'How do we live without a solution?'"[52] As Eyal Weizman has shown, the use of unmanned drone aircraft has been essential to this strategy in Israel/Palestine. It is therefore not surprising that in the era of paradoxical global counterinsurgency Unmanned Aerial Vehicles (UAV), such as the Predator and the Reaper, are becoming the weapon of choice in Afghanistan, Pakistan, and Yemen. While the UAV certainly visualizes the area of operations, it generates a paradox within the totalizing mission of Global Counterinsurgency (GCOIN) by being an agent of violence alone. The UAV is launched by specialists in the area, but is then managed in flight by operatives situated in Nevada or California. Far from being fully conversant with the cultural "map" of the area of operations, these soldiers are on a different continent. Further, each individual controls several drones at once, coordinating them via screens using a joystick familiar to videogame players. Inevitably, this style of warfare has led to repeated civilian deaths alongside those of the "targets" identified by the UAVs, bringing protests not just from local populations, but also from the theorists of counterinsurgency like David Kilcullen: "These attacks are now being carried out without a concerted information campaign directed at the Pakistani public or a real effort to understand the tribal dynamics of the local population, efforts that might make such attacks more effective."[53] In short, they are not proper counterinsurgency. In April 2010, it was leaked that UAVs launched at least fifty attacks in Pakistan during 2009, resulting in some five hundred casualties. By February 2011, it was reported that, while 581 insurgents were claimed killed by UAVs in Pakistan in 2010, only two were top-ranked targets.[54] The UAV is emerging as the signature technology of the new paradoxical visuality of global counterinsurgency, even being touted as environmentally friendly, relative to ground operations. On the one hand, the UAV epitomizes what Derek Gregory has called the "visual economy" of the "American military imaginary."[55] At the same time, it is clearly a departure from conceiving counterinsurgency as "armed social work."[56] Further, the current results in Afghanistan and Pakistan are unclear even by counterinsurgency standards. In asymmetric warfare, how does one even measure success?

Military discussion, both official and unofficial, has centered this ques-

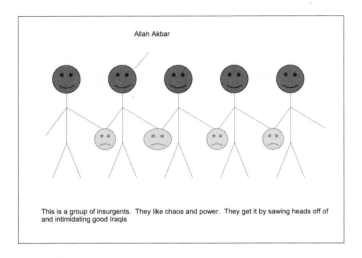

FIGURE 58. CAPT. TRAVIS PATRIQUIN, "GROUP OF INSURGENTS."

tion on the way in which digital visualization has in some sense become the mission itself. Today's junior officers spend much of their time compiling PowerPoint presentations that digitally render their visualizations. The advance on past modes of visualization was noted in the pro-counterinsurgency blog *Small Wars Journal*: "The graphics used in PowerPoint replace the massive campaign maps and problematic acetate overlays which were used by armies for decades, allowing these documents to be easily produced and mass-distributed with the click of a mouse."[57] On the other hand, in 2009, an essay in the *Armed Forces Journal* noted the "dumb down" effect of the bullet-point process of PowerPoint, which often elides the key question as to who is actually going to carry out the tasks in a list.[58] As has been widely discussed in digital circles, PowerPoint is a marketing tool, designed to sell products. An article in *Small Wars Journal* pointed to a PowerPoint made by the late Captain Travis Patriquin, in 2006, during the campaign in Anbar Province, Iraq. It was circulated widely during the military surge, including by national media outlets like ABC News, as an example of visual material that was highly effective on the ground. Although he was an Arabic speaker, Patriquin's "population centered approach" was more than a little reductive (see fig. 58). Insurgency here is reduced to an Islamic slasher movie, in which the only extant motive is to cause chaos and gain power for oneself. It so happened that the extreme violence of groups like the so-called Al-

Qaeda in Mesopotamia did lead many Sunni leaders in Anbar to cease their support, making for a tactical alliance with the U.S. Army. Using a standard phrase of Muslim piety like "Allahu akhbar" as the insurgent catch-phrase, however, shows that Patriquin had no strong understanding of the Iraqi situation.

The reverse problem was manifested in a plan shown to General Stanley McChrystal in the summer of 2009, aiming to show the flows of insurgency and counterinsurgency in Afghanistan, where he was the U.S. commander. Some months later the slide was released to the *New York Times* journalist Elisabeth Bumiller, previously best-known for her fawning coverage of George W. Bush (see fig. 59).[59] The analysis presented here does not lack for sophistication. It would, however, be hard to tell what one was supposed to do after examining it. The visualization shows only that there is no solution available. The intent behind the leak is precisely that: to show that Afghanistan remains in chaos and will need military presence for the foreseeable future. It was a continuation of the strategy whereby McChrystal leaked his request for 40,000 additional troops in Afghanistan in advance, giving Obama the choice between declaring his own general insubordinate or alienating his own supporters by sending more troops. This new leak was the first shot in the campaign over Obama's announced withdrawal date of July 2011. Using this image, McChrystal might claim either that conditions justify a longer mission or that he cannot be held responsible for any perceived failure of the mission. McChrystal soon learned to his cost that media war needs to be waged intelligently, when his insubordinate comments to a *Rolling Stone* journalist led to his dismissal in June 2010. His successor, none other than Gen. David Petraeus continues to assert that victory in Afghanistan is at hand but requires ongoing support.

Indeed, counterinsurgency has for some time deployed an apparently "paradoxical" coordinated political and military strategy to sustain chaos as a means of requiring military intervention. Those supporting the long-term occupation of Iraq claimed that future chaos would be the consequence of withdrawal and current chaos was the necessity of remaining. Whereas Carlyle persistently raised the specter of chaos as the alternative to heroic leadership, creating chaos is now a matter of technique and strategy. In December 2006, an Iraqi woman who blogged as "Riverbend" described the technique: "You surround it from all sides and push and pull. Slowly, but surely, it begins coming apart. . . . This last year has nearly everyone

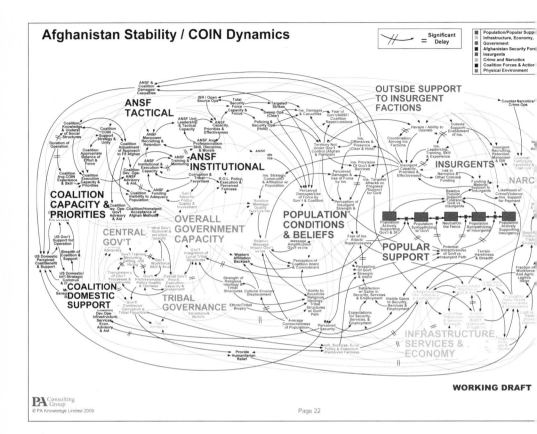

FIGURE 59. ANONYMOUS, "POWERPOINT SLIDE
OF SITUATION IN AFGHANISTAN 2009."

convinced that that was the plan right from the start. There were too many blunders for them to actually have been, simply, blunders."[60] If this seems excessive, consider the facts documented by Oxfam in July 2007: in a population of some 27.5 million, 8 million people were in need of emergency aid, composed of 4 million at risk of famine, 2 million internally displaced people, and 2 million refugees outside Iraq. Forty-three percent of Iraqis lived in "absolute poverty," while 70 percent had inadequate access to water, and 80 percent lacked access to sanitation.[61] While violence had decreased by 2009, these indicators have remained strikingly bad. In February 2009, the Brookings Institute compilation of Iraq-related statistics showed that 2.8 million Iraqis were internally displaced and another 2.3 million were living abroad. Fifty-five percent of Iraqis still lack access to drinkable water, and only 50 percent have what is described as "adequate" housing.[62] Afghanistan in 2010 remains a disaster area at all levels, from the narcoeconomy to corruption and poverty. The brief resurgence of education for women has ended. According to the CIA, Afghanistan has the second-highest rate of infant mortality worldwide and ranks 219 out of 224 for life expectancy. Forty percent of the population were unemployed in 2009, and per-capita income was only $800.[63] Figures of this kind indicate clearly that what is being enacted is a necropolitics, rather than a biopolitics. If the priority was to sustain the population, rather than to allocate and withhold death, such conditions would rightly be considered intolerable. In the "game environment" created by counterinsurgency, the trick is to get to the next level, rather than to complete every action at the current stage of play. For the goal of counterinsurgency is not to create stability, but to naturalize "the disequilibrium of forces manifested in war," not as politics, but as "culture," the web of meaning in a given place and time.[64] Counterinsurgency is trying to produce the Middle East and Central Asia as cultures of weak or failing states requiring permanent counterinsurgency. Indeed, the new mantra of the GCOIN strategists is the need to engage with the "global jihad," deriving from a newly "global Islam . . . a structureless, leaderless archipelago of communities whose energy is aroused by a nervous system based on communications technology."[65] Contrary to some assertions, such protagonists of GCOIN assert a distinction with paranoia, such as that of the Cold War, and argue the definition of the "enemy" is no longer black-and-white, but "shaded."[66]

If counterinsurgency uses neovisuality as a strategy, can we construct a countervisuality to counterinsurgency? Like all visuality, neovisuality is already a countervisuality. For it requires an opposing insurgency as a means of legitimation and will seek it out if none is forthcoming, under the slogan "Bring 'em on!" Further, its means of visualization are increasingly antivisual, making any countervisualization likely to be ineffective. Above all, if the designation of counterinsurgency as a necropolitics is right, then it cannot be opposed in its own terms. In the case of biopolitics, by contrast, there have been a range of tactical responses, including a recent edited volume entitled *Tactical Biopolitics*. Contributors working at the intersection of science, art, and questions of "life" have created public biolabs, amateur science, tactical media projects, and theoretical critiques.[67] Imagine a book or conference called "Tactical Necropolitics." In fact, of course, we don't have to, because violent terrorism, especially suicide bombing, is precisely such a necropolitics. As George Bataille put it long ago, "Sacrifice in reality reveals nothing."[68] Consequently, those opposed to the counterinsurgent formation of necropolitical regimes of separation can in no way identify with any "insurgency" that uses a micro-necropolitics of separation. Nonetheless, this is a moment of paradoxical emergency for authoritarian visuality, which requires a new "mobility" to refuse to move on. While critics of visuality are not going to affect military policy as such, the continuing critique of their claims to visualize remains salutary. Why would the Obama administration have so strenuously resisted releasing the remaining Abu Ghraib photographs if they did not fear the reaction?

It is now time, however, to stop playing the second move to whatever deployment of militarized information war comes next. The tools of democratization, education, and sustainability are to hand and have not exhausted themselves. While democracy is part of the mission of counterinsurgency in theory, the practice reveals otherwise. Rather than concern ourselves with such geopolitics as day-to-day politics, it will be more effective to consider combining democratization issues with education and sustainability in the institutions of education, where most of my readers are, I presume, engaged. As Rancière has long argued, how can the nineteenth-century hierarchies of most higher education continue to be justified in the same space as calls for radical change? What are the goals of education for a post-growth sustainable economy? Can universities democra-

tize themselves or should there be an emphasis on alternative modalities? All of these rethinkings will have to be accomplished, for those outside China and India, in the context of disinvestment, unemployment, and the casualization of labor. In short, it seems to me that the present conjuncture, as we used to say, bears more than a passing resemblance to that in which the cultural-studies project was first formed. Once again it becomes of the first importance to reclaim, rediscover, and retheorize the practices and spaces of "everyday life," but now in the context of permanent war. As the example of post–Katrina New Orleans shows, there is nothing banal or quotidian about this "new everyday."[69] At the same time, the case of New Orleans shows that simple visibility or media coverage does not ensure any change in political practice. Where once consumer and subcultural practices seemed to offer new modes of resistance, the task now is more paradoxical. In a period in which we are all suspects, provisionally guilty until proved otherwise, the need is to assert the continuance of an everyday that does not require militarization to carry on. The everyday form created in Tahrir Square, Cairo, has been the best example to date of the possibilities of a praxis of the everyday that is not found but made. Nonetheless, the spectacular, spectral, and speculative traces of visuality continue to walk the earth. It is the interim, a moment that could generate momentum for a new common, the mobility, or revert to an interregnum for a new form of autocracy. Several outcomes seem possible from this swirling crisis: a new authoritarianism, a perpetual crisis, or, just possibly, a time in which my claim to the right to look is met by your willingness to be seen. And I reciprocate.

INTRODUCTION. THE RIGHT TO LOOK

1 A claim that is continued on my blog at http://nicholasmirzoeff.com/RTL.

2 Any such claim stands on the shoulders of the critical thinking about vision and visuality, which (in recent times) runs from Laura Mulvey to W. J. T. Mitchell, Anne Friedberg, Martin Jay, and other theorists of the look and the visual. The phrase "right to look" was previously used by Clare Whatling in a somewhat different context. See Whatling, *Screen Dreams*, 160.

3 Derrida, *Right of Inspection*; Derrida, *Droit de regards*, xxxvi. I have modified the translation used by Wills, "rights of inspection," because it attempts to bridge the gap between right and law, which I feel should be kept open.

4 For an insightful discussion of this text and its implications, see Villarejo, *Lesbian Rule*, 55–82. On looking itself, see Sturken and Cartwright, *Practices of Looking*.

5 Rancière, "Ten Theses on Politics." Originally published as "Dix theses sur la politique," in *Aux Bords de Politique* (Paris: La Fabrique, 1998), 217.

6 For an analysis of visuality's use in visual culture, see my essay "On Visuality." The term was widely referenced to Hal Foster's *Vision and Visuality*, which did not refer to the earlier history of the term.

7 Compare Derrida's insistence that writing preceded speech (*Of Grammatology*, 14).

8 Carlyle, *On Heroes, Hero Worship and the Heroic in History*, 3–4.

9 Rancière, *Aux bords de la politique*, 17.

10 Foucault, *The Order of Things*, 132.

11 Fanon, *The Wretched of the Earth*, 3.

12 Rancière, *The Philosopher and His Poor*.

13 Rancière, *The Ignorant Schoolmaster*, 13. I would like to thank Kristin Ross for her brilliantly insightful introductions to Rancière's work, in print and in person.

14 Rancière, *Hatred of Democracy*.

15 Rancière, *Politics and Aesthetics*, 13.

16 Moraña, Dussel, and Jáuregui, "Colonialism and Its Replicants," 2.

17 Mbembe, *On the Postcolony*, 14.

18 Derrida, *Specters of Marx*, 3.

19 Maldonado Torres, *Against War*, xii.

20 See Smith, Enwezor, and Condee, *Antinomies of Art and Culture*.

21 Enrique Dussel, quoted in Mignolo, "Delinking," 453.

22 Wagenvoort, *Roman Dynamism*, 17–23.

23 This approach differs from the distinction between "bare life" and "social life" proposed by Giorgio Agamben in *Homo Sacer*: here, "bare life" is the "simple fact of living" (1), whose "politicization . . . constitutes the decisive event of modernity" (4). This production of a biopolitical body is seen as key to sovereign power, especially under the regime of the society of the spectacle that produces a convergence between modern democracies and totalitarian societies (10). The absence of slavery from Agamben's analysis creates an odd and insurmountable lacuna, as indicated by Ewa Plonowksa Ziarek in "Bare Life on Strike," 94–98.

24 Rancière, *Aux bords de la politique*, 31.

25 See the monumental essay by Jacques Derrida, "Force of Law," 937–43.

26 Derrida, "Force of Law," 943.

27 Timothy Taylor, "Believing the Ancients," 37–38.

28 Kathleen Wilson, "The Performance of Freedom," 52.

29 Barrell, *Imagining the King's Death*.

30 Berry, "'Reckless Eyeballing.'"

31 Greenberg and Dratel, *The Torture Papers*, 1214.

32 On the world-generating optic, see Appadurai, "Grassroots Globalization and the Research Imagination," 9. On "worlding," see Spivak, *A Critique of Postcolonial Reason*, 114–15, 228. On modernity's production as the West, see Timothy Mitchell, "The Stage of Modernity," 15.

33 Foucault, *Discipline and Punish*, 207, quoted in Nealon, *Foucault beyond Foucault*, 32 (see 32–53 for more detail on this concept).

34 Raymond Williams argued that Victorian writers like Carlyle asked the right questions but supplied the wrong answers (*Culture and Society*, 75–77).

35 Freud, *Five Lectures on Psychoanalysis* (1910), in *The Standard Edition of the Works of Sigmund Freud*, 11:31.

36 Žižek, *Enjoy Your Symptom!*, 57.

37 Curtin, *The Rise and Fall of the Plantation Complex*, 12.

38 John H. Hammond, quoted in Eudell, *Political Languages of Emancipation in the British Caribbean and the U.S. South*, 30.

39 Carlyle, *The French Revolution*, 2:222.

40 Said, *Orientalism*, 41.

41 Seeley, *The Expansion of England*, 14.

42 *Daily Herald*, 13 August 1923, quoted by Dutt, "The British Empire," available at the Marxists Internet Archive, http://www.marxists.org/.

43 Fanon, *Black Skin, White Masks*, 30.

44 Arnold, *Culture and Anarchy*, 135.

45 Tylor, *Primitive Culture*, 5.

46 Ibid., 12.

47 W. J. T. Mitchell, *What Do Pictures Want?*, 84–85.

48 Rancière, *The Future of the Image*, 47.

49 Foucault, *Security, Territory, Population*, 183.

50 See Parks, *Cultures in Orbit*.

51 Le Sueur, *Uncivil War*, 5–8.

52 Dwight D. Eisenhower, "Farewell Address" (1961), reprinted in Pursell, *The Military-Industrial Complex*, 206.

53 Bosch, "Pentagonism" (1969), reprinted in Pursell, *The Military-Industrial Complex*, 298.

54 I owe the vocabulary of "toggle and zoom" to Tara McPherson's response to the Animating Archives conference held at Brown University, 4–5 December 2009, and I thank her for allowing me to use it.

55 Derian, *Virtuous War*, 218.

56 See my blog, at http://nicholasmirzoeff.com/RTL, for more on the 2011 revolutions and visuality.

57 Appadurai, "Grassroots Globalization and the Research Imagination," 6.

58 Chakrabarty, *Provincializing Europe*, 63–64.

59 Baudelaire, "Salon de 1859," 222–24.

60 Terry Smith, *Making the Modern*.

61 Beller, *The Cinematic Mode of Production*.

62 Debord, *The Society of the Spectacle*, 35.

63 W. J. T. Mitchell, *What Do Pictures Want?*, 156–65.

64 Jones, *Irrational Modernism*, 24.

65 Chakrabarty, *Provincializing Europe*, 66, adapted.

66 Rancière, "Introducing Disagreement," 6.

67 Casarino and Negri, *In Praise of the Common*, 86–88.

68 Agamben, *Homo Sacer*, 126–35. Agamben asserts that "life" becomes a political term with the formation, in "1789," of a discourse of the Rights of Man, setting aside the entire question of slavery that is central here.

69 Hardt and Negri, *Commonwealth*, 75.

70 Azoulay, *The Civil Contract of Photography*, 64; see also Docherty, *Aesthetic Democracy*.

71 Rancière, *Hatred of Democracy*, 60.

72 Lotringer and Marazzi, "The Return of Politics," 8.

73 See Oliver, "The Look of Love."

74 Negri, *Time for Revolution*, 142.

75 Antliff, "The Jew as Anti-Artist," 51.

76 Quoted in Haug, "Philosophizing with Marx, Gramsci and Brecht," 153.

77 Ronel, *The Test Drive*, 69.

78 Viano, "The Left according to the Ashes of Gramsci," 59.

79 Stoll, "Toward a Second Haitian Revolution."

80 Yoo, "Memorandum for William J. Haynes II, General Counsel for the Department of Defense," 2, 4–5.

81 Paul Edwards, *The Closed World*, 11.

ONE. OVERSIGHT

1 For pioneering work on the visual culture of slavery, see Kriz, *Slavery, Sugar and the Culture of Refinement*, and Kriz and Quilley, *An Economy of Colour*.

2 See Eric Williams, *Capitalism and Slavery*; Gilroy, *The Black Atlantic*; and James, *The Black Jacobins*.

3 Foucault, *The Order of Things*, 129. Subsequent page references appear in the text.

4 W. J. T. Mitchell, *What Do Pictures Want?*, 155.

5 See Paton, *No Bond but the Law*, 9–12 for a concise summary of the various historical revisions of Foucault's account from the viewpoint of slavery and the plantation system. Ann Laura Stoler has also suggested the use of a "colonial 'order of things'" in her *Race and the Education of Desire*.

6 Scott, *Conscripts of Modernity*, 127.

7 See Gruzinski, *Images at War*, 30–61.

8 Curtin, *The Rise and Fall of the Plantation Complex*, 82–83.

9 Foucault, *The Order of Things*, 1–16.

10 Kathleen Wilson, *The Island Race*, 155.

11 See Drescher, *Abolition*, 147.

12 On surrogation, see Roach, *Cities of the Dead*, 2–3.

13 Kantorowicz, *The King's Two Bodies*.

14 Mbembe, *De la postcolonie*, 48. See 39–93 for a full development of the concept of *commandement*.

15 Foucault, *"Society Must Be Defended,"* 25.

16 Schorsch, *Jews and Blacks in the Early Modern World*, 222.

17 Kathleen Wilson, *The Island Race*, 152.

18 Philip Gridley King to Sir Joseph Banks, Series 39.004 (8 May 1792), the Banks Collection, Mitchell and Dixson Collections at the State Library of New South Wales, available online at http://www.sl.nsw.gov.au/.

19 See Casid, *Sowing Empire*, 31.

20 Joel Weinstein, "Memory and Its Discontents," in Sullivan, *Continental Shifts*, 57–61.

21 Du Tertre, *Histoire générale des Antilles Habitées par les François*, 2:107.

22 Sloane, *A Voyage to the Islands*, 1:lvii.

23 Christopher L. Miller, *The French Atlantic Triangle*, 17–21.

24 Ibid., 419.

25 Grove, *Green Imperialism*, 68 and 276.

26 Moreno Fraginals, *The Sugar Mill*, 20.

27 Sloane, *A Voyage to the Islands*, xlv. Charles Leslie, *A New and Exact Account of Jamaica*, quoted by J. H. Galloway, "Tradition and Innovation in the American Sugar Industry," 336.

28 Stewart, *A View of the Past and Present State of the Island of Jamaica*, 61.

29 Ibid., 187.

30 Malenfant, *Des Colonies* (1814), quoted in Debien, *Les Esclaves aux Antilles Françaises*, 116.

31 [Browne], *The Natural History of Jamaica*, 25.

32 See E. P. Thompson's classic essay "Time, Work Discipline and Industrial Capitalism."

33 Bernard, *Mastery, Tyranny and Desire*, 45–47.

34 For details of the different tasks in the ranks of oversight, see Debien, *Les Esclaves aux Antilles Françaises*, 105–34; and Bassett, *The Plantation Overseer*.

35 Craton and Walvin, *A Jamaican Plantation*, 105–6.

36 The Great Gang was the largest and undertook the heaviest labor, whereas the Second Gang mostly comprised women, and the Third children. James, *The Black Jacobins*, 86.

37 James H. Hammond, "Plantation Manual" [1844], quoted in Tadman, *Speculators and Slaves*, xxxvi.

38 Letter of 1776, quoted in Craton, *Testing the Chains*, 172. For further details on the Hanover plan, see ibid., 172–79.

39 Conley, *The Self-Made Map*, 1. See also Jacob, *The Sovereign Map*, especially chapter 4, "The Cartographic Image," 269–360.

40 See Buisseret, *Monarchs, Ministers and Maps*.

41 Jacob, *The Sovereign Map*, xv.

42 Ibid., 11.

43 For a comparison with similar processes of colonization in Australia, see Terry Smith, "Visual Regimes of Colonization."

44 On the development of the land survey, see Dubbini, *Geography of the Gaze*, 38–39.

45 Quoted in Zandvliet, *Mapping for Money*, 202.

46 Reproduced in Craton and Walvin, *A Jamaican Plantation*, 28.

47 Quoted in Higman, *Jamaica Surveyed*, 20.

48 Nathaniel Wilson, "Outline of the Flora of Jamaica."

49 Higman, *Jamaica Surveyed*, 49–59.

50 Ibid., 78.

51 Zandvliet, *Mapping for Money*, 203.

52 Hennigsen, *Dansk Vestindien I Gamle Billeder.*

53 Du Tertre, *Histoire générale des Antilles Habitées par les François*, 122.

54 Galloway, "Tradition and Innovation in the American Sugar Industry," 346.

55 Quoted in Marin, *The Portrait of the King*, 174.

56 For a full account of Brunias's work, see Tobin, *Picturing Imperial Power*, 139–73. On Grasset de Saint-Sauveur, see Lise, *Droits de l'homme et Abolition d'esclavage*, 21 et seq.

57 See Kathleen Wilson, "The Performance of Freedom."

58 Raynal, *Histoire des Deux Indes*, quoted in Aravamudan, "Trop(icaliz)ing the Enlightenment," 54. Aravamudan includes (and translates) these important lines, which are usually deleted from citations of the passage.

59 Casid, *Sowing Empire*, 31.

60 [Browne], *A Natural History of Jamaica*, 167; Hughes, *The Natural History of Barbados*, 171.

61 See Casid, *Sowing Empire*, 198.

62 Worthy Park took over "580 remote acres of the Cocoree" for slave gardens in 1787 (Craton and Walvin, *A Jamaican Plantation*, 105). Stewart noted that the 1787 law was "not so strictly attended to as it should be" (*A View of the Past and Present State of the Island of Jamaica*, 64).

63 Higman, *Jamaica Surveyed*, 80–83. For the individual plantation, see 84.

64 Foucault, *The Order of Things*, 163n3.

65 Ibid., 133.

66 Ibid., 128–29.

67 Ford, "People as Property," 14.

68 Braude, "The Sons of Noah and the Construction of Ethnic and Geographical Identities in the Medieval and Early Modern Periods," 137–38.

69 For more on the casta paintings, see the full and interesting account by Ilona Katzew, *Casta Painting: Images of Race in Eighteenth Century Mexico.*

70 [Browne], *The Natural History of Jamaica*, 265 and 421.

71 Long, *History of Jamaica*, 3:120.

72 [Browne], *The Natural History of Jamaica*, 173, 175, and 270.

73 Long, *A History of Jamaica*, 3:779.

74 "Letter of 1758," quoted in Fick, *The Making of Haiti*, 67.

75 On Sloane, see Kriz, "Curiosities, Commodities and Transplanted Bodies in Hans Sloane's 'Natural History of Jamaica.'"

76 Hughes, *The Natural History of Barbados*, 8.

77 Quoted in Pluchon, *Vaudou, sorciers, empoisonneurs de Saint-Domingue à Haïti*, 197.

78 Quoted in Richard Dunn, *Sugar and Slaves*, 239.

79 Sala-Molins, *Le Code Noir, ou le calvaire de Canaan*, 90. The full text of the code in its 1685 and 1725 versions is included along with commentary.

80 "Code Noir, ou Receuil d'Edits, Déclarations et Arrêts, Concernant la Discipline et le Commerce des Esclaves Nègres des Isles de l'Amérique Française" (1685), reprinted in *Le Code Noir et autres textes de lois sur l'esclavage*, 9. Both preamble and title were omitted from Edward Long's translation (*A History of Jamaica*, 3:921). See Dayan, "Codes of Law and Bodies of Color," 285.

81 Sala-Molins, *Le Code Noir, ou le calvaire de Canaan*, 104.

82 Glissant, *Poetics of Relation*, 61 and 190–91.

83 Wilfred S. Samuel, *A Review of the Jewish Colonists in Barbados in the Year 1680*, 23.

84 Raynal, *A Philosophical and Political History of the Settlements and Trade of the Europeans in the East and West Indies*, 5:37.

85 Cited in Judah, "The Jews Tribute in Jamaica: Extracted from the Journals of the House of Assembly In Jamaica," 153.

86 Cundall, *Governors of Jamaica in the First Half of the Eighteenth Century*, 198.

87 The details of Makandal's career are summarized by Fick in *The Making of Haiti*, 60–72. Many documents relevant to the case are reprinted by Pierre Pluchon in *Vaudou, sorciers, empoissoniers de Saint-Domingue à Haïti*, although as the somewhat sensationalist title suggests, his interpretations are questionable.

88 Report of Jacques Courtin (1758), quoted in Pluchon, *Vaudou, sorciers, empoissoniers de Sainte-Domingue à Haïti*, 210.

89 Métraux, *Haiti*, 60.

90 Fick, *The Making of Haiti*, 62.

91 Ibid., 71 and 257.

92 James, *The Black Jacobins*, 87. Fick quotes the Kreyol: "Couté la liberté li palé nan coeur nous tous" (*The Making of Haiti*, 93).

93 Moreau de St Mery, *Description topographique, physique, civile, politique et historique de la partie française de l'isle Saint-Domingue*, 2:631.

94 Dayan, *Haiti, History and the Gods*, 31.

95 Edouard Duval-Carrié, *La Voix des Sans-Voix* (private collection, 1994), reprinted in Consentino, *Sacred Arts of Haitian Vodou*, 262.

96 McClellan and Regourd, "The Colonial Machine," 35. See passim for further details.

97 McClellan, *Colonialism and Science*, 144–45.

98 Dutrône la Couture, *Précis sur la canne*.

99 Barré de Saint-Venant, *Des Colonies Modernes sous la Zone Torride et particulièrement de celle de Saint-Domingue*, 393.

100 Dutrône la Couture, *Précis sur la canne*, x and 152.

101 Ibid., xxv.

102 The boilers were named as running from *Grande* to *Propre*, *Flambeau*, *Sirop*, and finally *Batterie* (ibid., 137–39). The chain of sugar readiness was described as running from *perlé* to *lissé*, *à la plume*, and *faire la Goutte* to *faire le fil* (ibid., 177–79).

103 Ibid., 177–83.

104 Here French colonial practice appears to be different from the English one of delegating authority to the drivers.

105 Ibid., 31.

106 For instance, Moreno Fraginals gives dates of 1780 and 1789 for its first use, both dates appearing in the same book, *The Sugar Mill*, on pages 35 and 160n63, respectively.

107 Descourtilz, *Voyage d'un naturaliste en Haiti*, 54.

108 Stewart, *A View of the Past and Present State of the Island of Jamaica*, 65–67.

109 Vattel, *Le Droit des Gens*, 36–37.

110 Dutrône la Couture, *Précis sur la canne*, 328.

111 Maurel, *Cahiers de Doléances de la colonie de Saint-Domingue pour les Etats-Généraux de 1789*, 11.

112 "Cahier des Doléances de la Colonie de Saint-Domingue, à présenter au Roy dans l'Assemblée des Etats-Généraux de la Nation, par MM. les députés de cette colonie" (1789), reprinted in Maurel, *Cahiers de Doléances de la colonie de Saint-Domingue pour les Etats-Généraux de 1789*, 263. See 263–82 for the full details.

113 "Plan Proposé par la Colonie pour la formation des Assemblées Coloniales, Assemblées Provinciales, et de comités intermédiaires permanens tant dans la colonie qu'à Paris" (1789), reprinted in Maurel, *Cahiers de Doléances de la colonie de Saint-Domingue pour les Etats-Généraux de 1789*, 283.

114 Pétion, *Discours sur les Troubles de Saint-Domingue*, 16.

115 "Cahiers de Doléances de la Chambre d'Agriculture du Cap" (1789), reprinted in Maurel, *Cahiers de Doléance de la colonie de Saint-Domingue pour les Etats-Généraux de 1789*, 305.

TWO. THE MODERN IMAGINARY

1 See in particular James, *The Black Jacobins*; Trouillot, "An Unthinkable History"; and Buck-Morss, "Hegel and Haiti."

2 Trouillot, "An Unthinkable History," 89.

3 Many thousands of prints circulated during the French Revolution, known to

us now through collections at the Bibliothèque Nationale, the Musée Carnavalet, and other institutions, available in a five-volume collection, published under the editorship of the distinguished historian Michel Vovelle, *La révolution française: Images et recit 1789-1799*. See the online prints archive, "Imaging the French Revolution," available at http://chnm.gmu.edu/.

4 Censer and Hunt, "Imaging the French Revolution."

5 Christopher L. Miller, *The French Atlantic Triangle*, 58.

6 Quoted in Antoine de Baecque's "'Le choc des opinions'," in his *L'an 1 des droits de l'homme*, 14.

7 Paine, *The Rights of Man*, 130.

8 See Derrida, *Archive Fever*.

9 Freud, *The Interpretation of Dreams*, esp. 383–413 (quotation on 402; reference to overdetermination, 389; condensation in dream-work, 753–54).

10 Foucault, *"Society Must Be Defended,"* 218.

11 Foucault, *The History of Sexuality*, 135–37.

12 Desmoulins, quoted in Reichardt, "Light against Darkness," 118.

13 *Faits et idées sur Saint-Domingue, relativement à la revolution actuelle.*

14 Condorcet, "Fragment de Justification" (1793), in *Oeuvres*, 1:576.

15 Reinhardt, "French Caribbean Slaves Forge Their Own Ideal of Liberty in 1789," 29. The anonymous manuscript letters are accepted by historians as genuine, although some suggest that the authors may have been free people of color.

16 See Christopher L. Miller, *The French Atlantic Triangle*, 109–41.

17 "Motion Faite par M. Vincent Ogé, jeune, à l'Assemblée des COLONS, Habitans de S-Domingue, à l'Hôtel de Massiac, Place des Victoires," 2.

18 Vincent Ogé, "Letter" to the Provincial Assembly of the North, Sainte-Domingue, in Dubois and Garrigus, *Slave Revolution in the Caribbean*, 77.

19 Rancière, *Short Voyages to the Land of the People*.

20 Hobbes, *De Cive*, chap. 12, section 8, quoted in Virno, *A Grammar of the Multitude*, 23.

21 Freud observed of those of his contemporaries hostile to the crowd, like Gustave Le Bon, "The characteristics of revolutionary groups, and especially those of the great French Revolution, have unmistakably influenced their descriptions" (*The Standard Edition of the Works of Sigmund Freud*, 26).

22 Quoted in Césaire, *Toussaint L'Ouverture*, 171.

23 The text reads: "Tout homme a la très sûre propriété de sa personne, de toutes ses facultés personnelles, physiques et intellectuelles, de tout ce qu'il possedait lors de son association, et de ce qu'il acquiert ensuite," in *Project de déclaration des droits naturels civils et politiques de l'homme fondés sur des principes évidents et des vérités incontestables par un paysan*, reprinted in Baecque, *L'an I des droits de l'homme*, 306. See also the proposal by the revolutionary leader Sièyes, which offered "tout

homme est propriétaire de sa personne" (ibid., 72), and another, by Target, giving each ownership of "la vie de l'homme, son corps, sa liberté" (ibid., 81).

24 De Boislandry, *Divers articles proposés pour entrer dans la déclaration des droits* (Versailles, August 1789), reprinted in Baecque, *L'an 1 des droits de l'homme*, 285.

25 Quoted in Baecque, *L'an 1 des droits de l'homme*, 101.

26 Baecque, "'Le choc des opinions,'" 20.

27 Fisher, *Liberty and Freedom*, 42.

28 Claude Niquet Le Jeune, "Declaration des droits de l'homme et du citoyen" (1789, musée Carnavalet, Paris), reprinted in Vovelle, *La révolution française*, 2:299.

29 In the Salon of 1789 Le Barbier had shown a drawing of Harné—one of the first to storm the Bastille, who had arrested its governor, de Launay—an example of the new vernacular hero. Pupil, "Le dévouement du chevalier Desilles et l'affaire de Nancy en 1790," 83.

30 Collection Henin, vol. 119, no. 10428, Bibliothèque Nationale, Paris.

31 Demange, *Images de la Révolution*, 9.

32 Maurel, *Cahiers de doléance*, 63.

33 Speech given to the National Assembly by the deputies from Saint-Domingue, 3 November 1791, translated as *A Particular Account of the Commencement and Progress of the Insurrection of the Negroes in St. Domingo* (London: J. Sewell, 1792), 20.

34 Quoted in Fick, *The Making of Haiti*, 111.

35 Félix Carteau, *Soirées bermudiennes* (1802), quoted in Dubois, *A Colony of Citizens*, 105.

36 Benot, *La révolution française et la fin des colonies 1789-1794*, 39.

37 Sonthonax, "Decree of General Liberty" (1793), in Dubois and Garrigus, *Slave Revolution in the Caribbean*, 123.

38 Dahomay, "L'Esclave et le droit," 40.

39 Cited by Dorigny and Gainot, *La Société des Amis des Noirs*, 243n43.

40 Spivak, "Righting Wrongs," 525.

41 Bayart, *The State in Africa*, xvii. To those worried about anachronism, I point to Bayart's conclusion, where he suggests that Paul Bois's classic study of peasants in the French Revolution, *Paysans de l'Ouest*, is an "excellent methodological introduction to the study of Africa" (265). And vice-versa.

42 MacGaffey, "Aesthetics and Politics of Violence in Central Africa," 70.

43 Soboul, *The Parisian Sans-Culottes and the French Revolution*, 55–66.

44 Shaw, *Memories of the Slave Trade*, 211.

45 Ibid., 223.

46 Rediker, *The Slave Ship*, 82 and 97.

47 Christopher L. Miller, *The French Atlantic Triangle*, 77.

48 See Roberts, "Images of Popular Violence in the French Revolution."

49 See the extensive study by Darcy Grimaldo Grigsby in her *Extremities*, 9–63. See also Crow, *Emulation*, 119.

50 Janes, "Beheadings," 25.

51 From "Notes on Medusa's Head," in Freud, *Standard Edition of the Complete Psychological Works of Sigmund Freud*, 18:273–74.

52 Pinel, *A Treatise on Insanity*, 82 and 89.

53 Ibid., 66.

54 Foucault, *A History of Madness*, 460.

55 Ibid., 378.

56 Pinel, *A Treatise on Insanity*, 69, 144, 226–28.

57 Ibid., 73; Foucault, *A History of Madness*, 436.

58 Freud, *The Interpretation of Dreams*, 88.

59 Ibid., 638.

60 Foucault, *A History of Madness*, 480.

61 Descourtilz, *Voyage d'un naturaliste en Haiti*, 55.

62 A demand made by Jean-François (see Fick, *The Making of Haiti*, 114).

63 James, *The Black Jacobins*, 106. Blackburn, *The Overthrow of Colonial Slavery*, 194.

64 Trouillot, "An Unthinkable History."

65 Fick, *The Making of Haiti*, 116; she translates *bout à blancs* as "end to the whites."

66 Moreau de Saint Mery, *Description topographique de l'isle de Saint-Domingue*, 1:433–36.

67 Higman, *Jamaica Surveyed*, 269–76.

68 Descourtilz, *Voyage d'un naturaliste en Haiti*, 125.

69 Charles-A. Alexandre, "Parisian Women Protest via Taxation Populaire in February, 1792," 115.

70 Mathiez, *La Vie Chère et le mouvement social sous la Terreur*, 32.

71 "Police Reports on the Journées of February, 1793," 134.

72 Ibid., 139.

73 Albert Soboul, *The Parisian Sans-Culottes and the French Revolution*, 55–66.

74 Ibid., 56.

75 Mathiez, *La vie chère et le mouvement social sous la Terreur*, 40–42.

76 Soboul, *The Parisian Sans-Culottes and the French Revolution*, 67.

77 Lacerte, "The Evolution of Land and Labor in the Haitian Revolution," 458–59.

78 Respectively, Bourdon, *Rapport de Leonard Bourdon au nom de la commission d'Instruction Publique*, 8; quoted and translated by Michael J. Sydenham in his *Léonard Bourdon*, 223. On David's painting, see Clark, "Painting in the Year Two."

79 Rancière, *The Ignorant Schoolmaster*, 17.

80 Quoted in Geggus, *The Impact of the Haitian Revolution in the Atlantic World*, x.

81 Sydenham, *Léonard Bourdon*, 224. See 223–33 for full details.

82 Bourdon, *Recueil des action héroïques et civiques des Republicains Francais*, 3 and 6.

83 Bourdon, *Recueil des action héroïques et civiques des Republicains Francais*, no. 3.

84 Thibaudeau, *Recueil des action héroïques et civiques des Republicains Francais*, no 5.

85 Sonthonax (19 August 1794), quoted by Dubois, *A Colony of Citizens*, 167.

86 See Vovelle, *Marat*, 210–24.

87 Reprinted in Vovelle, *La révolution française*, 2:296.

88 Reichardt, "Light against Darkness," 124. Soboul documented at least fifty-two members of the *comités civils* of the Paris sections that worked in the arts (*The Parisian Sans-Culottes and the French Revolution*, 46). On Allais, see Roux, *Inventaire du Fonds Français*, 117–51.

89 Detournelle, *Journal de la Société Populaire et Républicaine des Arts*, 1–4. See Mirzoeff, "Revolution, Representation, Equality."

90 Berthaut, *Les ingenieurs géographes militaires*, 1:126–38.

91 Descourtilz, *Voyage d'un naturaliste en Haiti*, 166.

92 Joan Dayan, *Haiti, History and the Gods*, 3.

93 Jean Fouchard, *Plaisirs de Saint-Domingue*, 43.

94 Rainsford, *An Historical Account of the Black Empire of Hayti*, 222.

95 Joan Dayan, *Haiti, History and the Gods*, 186.

96 Fischer, *Modernity Disavowed*, 210–12.

97 Aravamudan, *Tropicopolitans*, 322.

98 The painting of Toussaint is reproduced in Consentino "It's All for You, Sen Jak!," 252.

99 Joan Dayan, *Haiti, History and the Gods*, 72; she also makes the comparison of *lwa* and *loi* here.

100 Rainsford, *An Historical Account of the Black Empire of Hayti*, 223.

101 Lillian B. Miller, *The Selected Papers of Charles Willson Peale and His Family*, 5:321.

102 Brigham, *Public Culture in the Early Republic*, 71; Peale, "Letter" (17 December 1805), in Lillian B. Miller, *The Selected Papers of Charles Willson Peale and His Family*, 2:916.

103 "Toussaint L'Ouverture to his Brothers and Sisters in Varettes" (22 March 1795), in Nesbitt, *Toussaint L'Ouverture*, 13–15.

104 Quoted in Césaire, *Toussaint L'Ouverture*, 268.

105 Fick, *The Making of Haiti*, 207–8. On the central place of war to the eighteenth-century state, see Brewer, *The Sinews of Power*, and Kathleen Wilson, *The Sense of the People*, 180–204.

106 The full constitution is reprinted by Madiou, *Histoire d'Haiti*, 11:539–55.

107 Madiou, *Histoire d'Haiti*, 144–46. Incidentally, James's startling comment that "Toussaint favoured the whites against the Mulattoes" (*The Black Jacobins*, 277) reworks Madiou's less incendiary comment that "Toussaint wanted [Haiti] to become independent by the union of Black and the white colonist" (*Histoire d'Haiti*, 144). See Paul B. Miller, "Enlightened Hesitations."

108 Toussaint L'Ouverture, "Proclamation" (25 November 1801), in Nesbitt, *Toussaint L'Ouverture*, 66–67.

109 Dubois, *Avengers of the New World*, 248.

110 Pinel, *A Treatise on Insanity*, 157.

111 James, *The Black Jacobins*, 284, see 276–88; Césaire, *Toussaint L'Ouverture*, 273–75.

112 Scott, *Conscripts of Modernity*, 162–65 (on Hamlet) and 203–6 (on Moïse).

113 Diana Taylor, *The Archive and the Repertoire*, 14–15.

114 See the remarkable photographic essay by Claire Garoutte and Anneke Wambaugh, *Crossing the Water: A Photographic Path to the Afro-Cuban Spirit World*, esp. fig. 99, pp. 113–14.

115 For full details, see Mirzoeff, "Aboriginality."

116 Horner, *The French Reconaissance*, 24–25.

117 Carter, "Looking for Baudin," 18.

118 Ryan, *The Aboriginal Tasmanians*, 16–17.

119 L-F Jauffret, "Considerations to serve in the choice of objects that may assist in the formation of the Special Museum of the *Société des Observateurs de l'Homme*, requested of the Society by Captain Baudin," appendix 8, in Baudin, *The Journals of Post-Captain Nicolas Baudin*, 594–96.

120 Plomley, *The Baudin Expedition*, 89.

121 James, *The Black Jacobins*, 277.

122 Feldman, *Formations of Violence*, 5.

PUERTO RICAN COUNTERPOINT I

1 Hartup, with Benítez, "The 'Grand Manner' in Puerto Rican Painting," 5. On *coartacion*, see Figueroa, *Sugar, Slavery and Freedom in Nineteenth Century Puerto Rico*, 84–85 and 226–27n8.

2 Sibylle Fischer has pointed out that, in 1791, a correspondent to the Havana newspaper *Papel Periódico* attributed faults in church frescoes to "some blacks . . . recently arrived from Angola" (quoted in Fischer, *Modernity Disavowed*, 61).

3 René Taylor, *José Campeche y su tiempo*, 160 and 160n1.

4 See Sullivan, "The Black Hand."

5 Gruzinski, *Images at War*, 211.

6 The painting text reads: "Juan Pantaleón hijo legítimo de Luis de Avilés y de Martina de Luna Alvarado. Vecinos labradores de la Villa de/ Coamo en la Isla de San Juan Bautista de Puerto Rico. Nació el día 2 de julio de 1806, y conducido por sus padres a esta Capital/ le confirió el Sacramento de la Confirmación el 6 de abril de 1808 el Ilmo. Sr. Obispo Diocno D. D. Juan Alejo de Arizmendi por cuya orden/ se hizo esta copia cogida del natural. José Campeche."

7 Taylor, *José Campeche*, 211.

8 Moreno Vega, "Espiritismo in the Puerto Rican Community."

9 Quoted in Houlberg, "Magique Marasa," 269. The tohosu are all water spirits, whose worship continues today in West Africa. On disabled children as tohosu, see Blier, "Vodun," 64.

10 For full details, see Childs, "'A Black French General Arrived to Conquer the Island.'"

11 Quoted in Fischer, *Modernity Disavowed*, 41.

12 Ibid., 43.

THREE. VISUALITY

1 Carlyle, *The French Revolution*, 3:319.

2 Clausewitz, *On War*, 109.

3 Ibid.

4 Ibid., 112.

5 Ibid., 192.

6 Carlyle would later write of Clausewitz: "a truly able man, of strong judgment, clear utterance,—tho' highly metaphysical (lost frequently in definitions, theoretic hair-splittings); a visible contemporary of Kant. Except Lloyd; much more, except Napoleon, and Fred[eric]k himself in the best moments, he is the cleverest man I have heard speak of War" (letter to Lord Ashburton, 23 January 1856, *The Carlyle Letters Online*, at http://carlyleletters.dukejournals .org/).

7 Clausewitz, *On War*, 87. Foucault, *"Society Must Be Defended,"* 48.

8 Immanuel Kant, "What Is Enlightening?" (1784), reprinted in Eliot and Stern, *The Age of Enlightenment*, 250–55.

9 Tocqueville, *Democracy in America*, 60 and 15.

10 Foucault, *"Society Must Be Defended,"* 229–32.

11 Berthaut, *Les ingenieurs géographes militaires*, 1:124.

12 Ibid., 1:286. See Godlweska, "Resisting the Cartographic Imperative."

13 Berthaut, *Les ingenieurs geographes*, 1:125.

14 Ibid., 1:292.

15 Ibid., 1:281–85.

16 Siegfried, "Naked History."

17 Makdisi, *Romantic Imperialism*, 156–72, especially his figure of Blake's map of the world (168).

18 W. J. T. Mitchell, "Chaosthetics," 453.

19 Thompson, *Witness against the Beast*, 225.

20 Gerrard Winstanley, "A Letter to the Lord Fairfax" (1649), reprinted in Sabine, *The Works of Gerrard Winstanley*, 190. See the discussion in Hill, *Winstanley*, 35–42.

21 Winstanley, "The True Leveller's Standard Advanced" (1649), reprinted in Hill, *Winstanley*, 77.

22 Ibid., 84.

23 Hill, *The World Turned Upside Down*, 106.

24 Thomas Carlyle, "Chartism" (1839), in Carlyle, *Critical and Miscellaneous Essays 4*, 157.

25 Ibid., 122–23.

26 Carlyle, *The French Revolution*, 1:15.

27 Ibid., 1:211.

28 Morris, "Heroes and Hero-Worship in Charlotte Bronte's *Shirley*," 287.

29 Rancière, *The Philosopher and His Poor*, 25 and 48.

30 Benbow, *Grand National Holiday and Congress of the Productive Classes*, 3–4. See also Rüter, "William Benbow's Grand National Holiday and Congress of the Productive Classes." Benbow's pamphlet retained its original page numbers.

31 Benbow, "William Benbow's Grand National Holiday and Congress of the Productive Classes," 8.

32 Hill, *Winstanley*, 41. Hill had long argued for this notion (see Manning, *The Far Left in the English Revolution 1640-1660*, 63–93).

33 Quoted in Manning, *The Far Left in the English Revolution 1640-1660*, 65–66.

34 Linebaugh and Rediker, *The Many-Headed Hydra*, 290–300.

35 On Spence, see Chase, *The People's Farm*, chaps. 2–3.

36 Robert Wedderburn, "The Horrors of Slavery" (1822), in Wedderburn, *The Horrors of Slavery and Other Writings by Robert Wedderburn*, 44–45.

37 Wedderburn, "The Axe Laid to the Root" (1817), in Wedderburn, *The Horrors of Slavery and Other Writings by Robert Wedderburn*, 81–82.

38 Ibid., 86.

39 Ibid., 105–8.

40 Rüter, "William Benbow's Grand National Holiday and Congress of the Productive Classes," 225. See also Prothero, "William Benbow and the Concept of the 'General Strike.'"

41 Jenkins, *The General Strike of 1842*, 21.

42 Ibid., 32.

43 Plotz, "Crowd Power," 88.

44 Friedrich Engels, "The Condition of the Working Class in England" (1845), in Marx and Engels, *Marx and Engels 1844-1845*, 518.

45 Ibid., 578n.

46 Ibid., 581. On Carlyle's influence on Marx and Engels, see Stedman Jones, "The Redemptive Power of Violence?"

47 Quoted in Plotz, "Crowd Power," 97.

48 Carlyle, "Model Prisons," 2.

49 Carlyle, "Chartism" (1839), in Carlyle, *Critical and Miscellaneous Essays 4*, 234–38.

50 Ibid., 197.

51 Ibid., 201.

52 Ibid., 214.

53 Carlyle, "Model Prisons," 14.

54 Semple, *Bentham's Prison*, 132.

55 Foucault, *The Order of Things*, 219.

56 Thierry, *Lettres sur l'histoire de France*, 10.

57 Thierry, "Sur l'antipathie de race qui divise la nation française" (1820), in Thierry, *Lettres sur l'histoire de France*, 483; quoted in Foucault, *"Society Must Be Defended,"* 226.

58 Thierry, *Essai sur l'histoire de la formation et des progrès du Tiers Etat*, 4.

59 Thierry, *Lettres sur l'histoire de France*, 2.

60 Ibid., 11.

61 Stedman Jones, "The Redemptive Power of Violence?," 8–9.

62 Quotations from Ranke in this paragraph are taken from Docker and Curthoys, *Is History Fiction?*, 56–57.

63 Simmons, *Reversing the Conquest*, 94–95.

64 Carlyle, *Past and Present*. See also Rigney, "The Untenanted Places of the Past"; and Schoch, "'We Do Nothing but Enact History.'"

65 Schoch, "'We Do Nothing But Enact History,'" 29.

66 Ibid., 38. On the idea of the whole, see Rigney, "The Untenanted Places of the Past," 344.

67 See Doane, *The Emergence of Cinematic Time*.

68 Lavally, *Carlyle and the Idea of the Modern*, 12.

69 Foucault, *The Order of Things*, 227. On the visual turn of history, see W. J. T. Mitchell, *Picture Theory*, 20.

70 Crary, "Modernizing Vision." See also Crary, *Techniques of the Observer*.

71 Quoted in Smajic, "The Trouble with Ghost-seeing," 1115.

72 Carlyle, *The French Revolution*, 1:212.

73 Smajic, "The Trouble with Ghost-seeing," 1118.

74 Carlyle, *The French Revolution*, 1:189.

75 Carlyle, "Goethe."

76 Carlyle, *On Heroes, Hero-Worship and the Heroic in History*. Subsequent page references appear in the text.

77 John Williams, *A Narrative of Missionary Enterprises in the South Sea Islands*, 2, quoted in Hilliard, *God's Gentlemen*, 2.

78 Kathleen Wilson, *The Island Race*. See also Levine, *Prostitution, Race and Politics*, 258–59.

79 Rigney, "The Untenanted Places of the Past," 351.

80 Crary, *Techniques of the Observer*.

81 Plotz, "Crowd Power," 95.

82 Carlyle, "Model Prisons," 16.

83 Ibid., 42.

84 Carlyle, "Occasional Discourse on the Nigger Question."

85 Carlyle, "Occasional Discourse on the Nigger Question," 295.

86 See Holt, *The Problem of Freedom*.

87 Ibid., 298.

88 Carlyle, "Occasional Discourse on the Nigger Question," 306. On the Demerara rebellion, see da Costa, *Crowns of Glory, Tears of Blood*.

89 Catherine Hall, *Civilizing Subjects*, 353. See also her analysis of the interplay of race and colonial masculinity in *Occasional Discourse*, 347–53.

90 Hall, *Civilizing Subjects*, 23.

91 Holt, *The Problem of Freedom*, 305–6.

92 Arnold, *Culture and Anarchy*, 55–57.

93 Tylor, *Primitive Culture*, 16.

94 Ibid., 22–23.

95 Darwin, *The Descent of Man*, 181–84.

96 Heffer, *Moral Desperado*, 208.

97 See Morris, "Heroes and Hero-Worship in Charlotte Bronte's *Shirley*," 285–307.

98 Painter, *Sojourner Truth*, 1–3.

99 Gilbert, *The Narrative of Sojourner Truth*, 31.

100 Hartman, *Scenes of Subjection*, 115–24.

101 Greenberg, *Honor and Slavery*, 66.

102 Brooks, *Bodies in Dissent*, 158–60.

103 Painter, *Sojourner Truth*, 139.

104 Halberstam, *Female Masculinity*.

105 On racial difference, see Kathleen Wilson, *The Island Race*, 177–89. On white notions of beauty, see Dyer, *White*. On the revolutionary figure of Liberty, see Pointon, *Naked Authority*.

106 Brooks, *Bodies in Dissent*, 160.

107 Spivak, *A Critique of Colonial Reason*, 290–91 and 294.

108 Harris, *Carlyle and Emerson*, 186n60.

109 W. B. Yeats, *Autobiographies* (1927), and Vincent van Gogh, *Letters to His Brother* (1883), quoted in Carlyle, *On Heroes*, lxiv.

110 For a full account, see Mirzoeff, "Disorientalism."

111 Lewis and Smith, *Oscar Wilde Discovers America*, 225.

112 Blanchard, *Oscar Wilde's America*, 33.

113 Lewis and Smith, *Oscar Wilde Discovers America*, 157.

114 O'Toole, "Venus in Blue Jeans," 80.

115 Lewis and Smith, *Wilde Discovers America*, 372.

116 Zamir, *Dark Voices*, 23–67. See also David Levering Lewis, *W. E. B. Du Bois: Biography of a Race*, 115–16.

117 Gilroy, *The Black Atlantic*, 87–93.

118 Du Bois, *W. E. B. Du Bois*, 811–14. All references to this speech are from these pages.

119 Emerson, *Representative Men*, 13.

120 Zamir, *Dark Voices*, 65.

121 Du Bois, *W. E. B. Du Bois*, 412.

122 Ibid., 847 and 842.

123 Zamir, *Dark Voices*, 65.

124 Du Bois, *The Souls of Black Folk*, 5.

FOUR. ABOLITION REALISM

1 Benjamin, "Paris, the Capital of the Nineteenth Century," 32. Trong Hiep Nguyen's book is preserved in the Bibliothèque Nationale, where Benjamin must have read it, but it is not listed in WorldCat or other online catalogs.

2 Benjamin, *The Arcades Project*, 518.

3 Quoted and translated in Hulme, *Colonial Encounters*, 266. One wonders whether Benjamin omitted the telling last sentence of the passage for reasons of space or because twentieth-century European Marxisms no longer used the colonial model after the Russian Revolution of 1917.

4 Froude, *The British in the West Indies*, 89.

5 Quoted in Hall, *Slave Society in the Danish West Indies*, 119.

6 Paiewonsky, "Special Edition," 12.

7 Hall, *Slave Society in the Danish West Indies*, 5 and 133.

8 Hansen, *Islands of Slaves*, 429.

9 Drescher, *Abolition*, 169.

10 *St. Thomae Tidende*, 20 November 1848.

11 *St. Thomae Tidende*, 17 May 1848.

12 *St. Thomae Tidende*, 26 June 1847.

13 *St. Thomae Tidende*, 17 July and 28 August 1847.

14 *St. Thomae Tidende*, 25 September 1847.

15 Hansen, *Islands of Slaves*, 370.

16 *Saint Croix Avis*, 18 July 1848.

17 Paiewonsky, "Special Edition," 14.

18 Ibid.

19 *St. Thomae Tidende*, 5 August 1848.

20 See Drescher, *Abolition*, 280.

21 *Saint Croix Avis*, 21 September 1848.

22 "Provisional Act to regulate the relations between the proprietors of landed estates and the rural population of free laborers," *Saint Croix Avis*, 29 January 1849. See also regulations published 2, 4, and 29 January 1849.

23 *Saint Croix Avis*, 14 June 1849.

24 Karl Marx, *The Eighteenth Brumaire of Louis Bonaparte*, esp. 125–32 on the peasantry and 73–76 on the lumpenproletariat.

25 Brettell and Zukowski, *Camille Pissarro in the Caribbean*, 22 and 39.

26 Cohen, *Through the Sands of Time*, 12–13, 38.

27 Blyden, "The Jewish Question (1898)," 209.

28 Respectively, Brettell, "Camille Pissarro and St. Thomas," 16; Carlos Ledezma, "Chronological Reading of Camille Pissarro's Political Landscape," 26.

29 Walcott, *Tiepolo's Hound*, 16.

30 Matos-Rodriguez, "Street Vendors, Pedlars, Shop-Owners and Domestics."

31 Quoted and translated in Hall, *Slave Society in the Danish West Indies*, 226.

32 Benjamin, *Arcades*, 128. Taken from a speech delivered by Haussmann in 1864.

33 See the remarks of the Comte de Ludre, *Le Correspondant*, 25 June 1883, and Carey Taylor, *Carlyle et la pensee latine*, 8:119–21.

34 Napoleon, *Analysis of the Sugar Question*, 2:82–83.

35 Agamben, *State of Exception*, 4 and 12.

36 Napoleon, *Analysis of the Sugar Question*, 88.

37 Karl Marx, *The Eighteenth Brumaire of Louis Bonaparte*, 146.

38 Susie King Taylor, *Reminiscences of My Life in Camp* (Boston, 1902), reprinted in *Collected Black Women's Narratives*, 12.

39 W. E. B. Du Bois, *Black Reconstruction in America*, 67.

40 Horan, *Timothy O' Sullivan*, 34–35.

41 J. Paul Getty Museum, Los Angeles, catalogue number 84.XM.484.39, reprinted in Jackie Napolean Wilson, *Hidden Witness*, n.p.

42 See Bolster, "Strange Familiarity."

43 Quoted in Bolster and Anderson, *Soldiers, Sailors, Slaves and Ships*, 81.

44 W. E. B. Du Bois, *Black Reconstruction in America*, 390. Subsequent page references appear in the text.

45 See Foner, *Reconstruction*, 106–8, 164–74, 402–9.

46 Manthorne, "Plantation Pictures in the Americas," 345.

47 Achille Mbembe, *On the Postcolony*, 14.

48 See Jennings, "On the Banks of a New Lethe."

49 Cardoze's novel *Lina, histoire vraie* was published in 1860. On Oller, see Lloyd, "Camille Pissarro and Francisco Oller."

50 Pissarro to Oller, 14 December 1865, reprinted in Venegas, *Francisco Oller*, 224. Translations by the author, unless specified. These letters were not included in the Pissarro correspondence, being located in Oller's papers.

51 Ibid., 126.

52 Vollard, *Paul Cézanne*, 28. Art historians dispute the dating for formalist reasons, due to Cézanne's use of the palette knife, already begun in 1865, and to the purported resemblance to the "dusky seducer" in *The Rape* (1867). The latter

is quite invisible to me, but even if it is there, it has no deciding authority. See Gowing et al., *Cézanne*, 130.

53 Quoted and translated by Joachim Pissarro, *Pioneering Modern Painting*, 37. All references to this letter come from this source.

54 Quoted and translated in DeLue, "Pissarro, Landscape, Vision, and Tradition," 720. I have benefitted from DeLue's important emphasis on Zola's understanding of Pissarro.

55 Quoted and translated in Athanassoglou-Kalmyer, "An Artistic and Political Manifesto for Cézanne," 485.

56 Quoted and translated in DeLue, "Pissarro, Landscape, Vision, and Tradition," 726.

57 Quoted and translated by Joachim Pissarro, *Pioneering Modern Painting*, 37.

58 Ibid.

59 T. J. Clark, "We Field-Women."

60 Quoted and translated by Joachim Pissarro, *Pioneering Modern Painting*, 38. There is a question as to whether Cézanne meant by "1870" the way in which Pissarro had been painting up until 1870, around 1870 specifically, or the decade of the 1870s as a whole. I have taken the first meaning to be most likely, because 1871 was such a radical break in French history that any date prior to it would have been taken as referring to the earlier period.

61 Quoted and translated in Peter Mitchell, *Jean Baptiste Antoine Guillemet 1841–1918*, 11.

62 See Elderfield, *Manet and the Execution of Maximilian* for full details.

63 Elderfield, *Manet and the Execution of Maximilian*, 104–5.

64 Karl Marx, *Capital*, 271n3.

65 Elderfield, *Manet and the Execution of Maximilian*, 137.

66 Manet, letter dated February 1849, *Lettres du Siège de Paris, précédés des Lettres de voyage à Rio de Janeiro*, 23.

67 See Wilson-Bareau with Degener, *Manet and the American Civil War*, which nonetheless does not mention slavery.

68 G. Randon in *Le Journal Amusante*, 29 June 1867, reprinted in Armstrong, *Manet Manette*, 12.

69 Quoted and translated by Delgado Mercado, "The Drama of Style in the Work of Francisco Oller," 69.

70 Haydee Venegas, "Oller Chronology," 133.

71 See Luis A. Figueroa, *Sugar, Slavery, and Freedom in Nineteenth-Century Puerto Rico*, 48–49 for figures; 113–17 for the Moret Law, 115.

72 Elaine Scarry, *The Body in Pain*.

73 See the reprinted catalog in *Salons of the Refusés* (London: Garland, 1981), n.p.

74 Brown, "Degas and *A Cotton Office in New Orleans*."

75 Foner, *Reconstruction*, 262–64.

76 Ibid., 551; Lemann, *Redemption*, 76–78.

77 Quoted and translated in Ross, *The Emergence of Social Space*, 59.

78 See Katz, *From Appomattox to Montmartre*, esp. 85–117.

79 Drescher, "Servile Insurrection and John Brown's Body in Europe," 522–23. Drescher misspells Vesinier's name throughout.

80 Marx and Lenin, *The Civil War in France*, 77.

81 "Paris au pouvoir des nègres," quoted by Ross, *The Emergence of Social Space*, 149.

82 Brecht, *The Days of the Commune*, ii.

83 Quoted in Lefebvre, *La Proclamation de la Commune*, 188.

84 Lissagaray, *History of the Paris Commune of 1871*, 83.

85 Lefebvre, *La Proclamation de la Commune*, 362.

86 Quoted by Badiou, "The Paris Commune," 261.

87 Jules Claretie, *Histoire de la révolution* (1872), quoted by Lefebvre, *La Proclamation de la Commune*, 25.

88 Ross, *The Emergence of Social Space*, 38.

89 Lissagaray, *History of the Paris Commune of 1871*, on the Prussian entry, 55; and the elections, 105.

90 Badiou, "The Paris Commune," 272.

91 Dittmar, *Iconographie de la Commune de Paris de 1871*, 357. No sources are supplied by Dittmar for his photographs.

PUERTO RICAN COUNTERPOINT II

1 See Katherine Manthorne, "Plantation Pictures in the Americas."

2 Cubano Iguina, *Rituals of Violence in Nineteenth-Century Puerto Rico*, 136–37.

3 Cézanne, *Letters*, 242–43.

4 Roger Marx, "Salon de 1895."

5 The current budgetary crisis in Puerto Rico has restricted access to the painting and made it impossible to have new photographs taken for this book, which I regret.

6 Moreno Vega, "Espiritismo in the Puerto Rican Community," 348–50.

7 Quoted and translated in Delgado Mercado, "The Drama of Style in the Work of Francisco Oller," 50.

8 Soto-Crespo, "'The Pains of Memory,'" 450. Soto-Crespo's piece has many strengths, and I cite it only because it is recent and in a major refereed journal.

FIVE. IMPERIAL VISUALITY

1 Clearly, there is an implied need to consider the related and contrasting work of Catholic missionaries, especially in South America, for the syncretic visual work of Catholicism leads in interestingly different directions.

2 Dunch, "Beyond Cultural Imperialism," 318. See also van der Veer, *Conversion to Modernities*.

3 Comaroff and Comaroff, *Of Revelation and Revolution*, 1:35; on Carlyle, 1:52–53.

4 John Williams, *A Narrative of Missionary Enterprises in the South Sea Islands*, 30–34.

5 Foucault, *Discipline and Punish*, 30.

6 H. Williams, "Diary," 514.

7 In Aotearoa New Zealand it is now conventional not to italicize the words in te reo, or Maori, because it is a bicultural society.

8 See Binney, "Christianity and the Maoris to 1840."

9 Quoted in Binney, "Whatever Happened to Poor Mr Yate?," 113.

10 Yate, *An Account of New Zealand*, 247.

11 Quoted in Binney, "Christianity and the Maoris to 1840," 158. This essay clearly outlines the process being described here.

12 Comaroff and Comaroff, *Of Revelation and Revolution*, 1:8 and passim.

13 See Ormond Wilson, "Papahurihia: First Maori Prophet."

14 Quoted in Elsmore, *Mana from Heaven*, 40.

15 Binney, "Papahurihia," 325.

16 Froude is quoted in Markus, *J. Anthony Froude*, 268. Woon (1836) is quoted in Ormond Wilson, "Papahurihia," 477.

17 Quoted in Eric Ramsden, *Marsden and the Missions*, 160.

18 See Rosenthal, *Not Strictly Kosher*, 16. Gluckman, *Identity and Involvement*, 75–76.

19 Darwin, *The Voyage of the Beagle*, 38.

20 Turner, "Sovereignty, or the Art of Being Native," 87.

21 See Binney, *Redemption Songs*.

22 See Elsmore, *Mana from Heaven*, 37–49; Binney "Papahurihia, Penetana."

23 See "Flags" and "Untitled," in Smithyman, *Atua Wera*, 45–46.

24 These flags can be seen today in Te Papa, the national museum of Aotearoa New Zealand. Unfortunately it was not possible to obtain permission from the relevant *iwi* to reproduce them here.

25 Binney, *Redemption Songs*, plates following 198.

26 Quoted in Moore, *New Guinea*, 133.

27 Servant, *Customs and Habits of the New Zealanders 1838-42*, 56–57.

28 William Williams, "Diary," 515, entry for 17 March.

29 See Rosenfeld, *The Island Broken in Two Halves*, 51–52.

30 Letters published in Yate, *An Account of New Zealand*, 253 and 259. See 249–281 for more such accounts.

31 *Report for the Select Committee of the House of Lords*, 87.

32 *Annals of the Diocese of New Zealand*.

33 *Report for the Select Committee of the House of Lords*, 88.

34 Orange, *The Treaty of Waitangi*, 25–26.

35 *Report for the Select Committee of the House of Lords*, 133.

36 Ibid., 243 and 263.

37 Walker, *Nga Pepa A Ranginui*, 52–53.

38 See Durie, *Te Mana te Kawanatanga*, 1–2.

39 Walker, *Nga Pepa A Ranginui*, 53.

40 Brookfield, *Waitangi and Indigenous Rights*, 103.

41 See ibid., 99–106, for a summary of the different positions.

42 Durie, *Te Mana Te Kawanatanga*, 1–6.

43 McHugh, *The Maori Magna Carta*, 9.

44 Quoted in McHugh, "Tales of Constitutional Origin and Crown Sovereignty in New Zealand," 77.

45 Quoted in McHugh, *The Maori Magna Carta*, 88.

46 Boast, "Recognising Multi-textualism," 556.

47 Evans, *The Victorian Age*, 360; Newton, *A Hundred Years of the British Empire*, 206–7; and Trevelyan, *British History in the Nineteenth Century and After*, 410. Cited by Willy, "The Call to Imperialism in Conrad's 'Youth,'" 40n3.

48 Quoted in Waldo Hilary Dunn, *James Anthony Froude*, 1:73.

49 Froude, *The British in the West Indies*, 3. For a partisan account favorable to Froude, see Waldo Hilary Dunn, *James Anthony Froude*, 1:251–60.

50 Froude, *Oceana*, 241. Froude lost the job when his controversial novel *Nemesis of Faith* was published—rather different from his fantasy of living off the land (Waldo Hilary Dunn, *James Anthony Froude*, 1:131 and 1:137).

51 Froude, *Oceana*, 86. See Young, *The Idea of British Ethnicity*, 215–19.

52 Froude, *Oceana*, 180.

53 Froude, *The British in the West Indies*, 347.

54 Quoted in Faith Smith, *Creole Recitations*, x. See 38–40 for Thomas's education and passim for the intellectual context of his work.

55 Ibid., 99.

56 John Jacob Thomas, *Froudacity*, 96–97.

57 James, "The West Indian Intellectual," 27.

58 Although this chapter does not take this path, it would be perfectly possible to expand this brief paragraph into a detailed exegesis of a similar pattern of imperial visuality and countervisuality in the Caribbean to that described here in the South Pacific.

59 Froude, *Oceana*, 312.

60 Froude, *The British in the West Indies*, 360.

61 Froude, *Julius Caesar*.

62 Froude, *Oceana*, 9. Subsequent references by page number appear in the text.

63 For full details of the Melanesian mission, see Hilliard, *God's Gentlemen*.

64 See Anderson, *Imagined Communities*, 24.

65 Hilliard, *God's Gentlemen*, 68. See 65–68 for the full account.

66 Codrington, "Religious Beliefs and Practices in Melanesia," 266–67.

67 Codrington, manuscript letter dated 11 September 1870, in possession of the Melanesian Mission, Watford, U.K.; viewed on microfilm at the Mitchell Library of the State Library of New South Wales.

68 Codrington, manuscript letter dated 15 September 1871, in possession of the Melanesian Mission, Watford, U.K.; viewed on microfilm at the Mitchell Library of the State Library of New South Wales.

69 Hilliard, *God's Gentlemen*, 61. See 59–61 for the full account.

70 See Knauft, *From Primitive to Postcolonial in Melanesia and Anthropology*.

71 Codrington, "Religious Beliefs and Practices in Melanesia," 262.

72 Ibid., 312.

73 Codrington, *The Melanesians*, 118. For a parallel case, in which anthropologists attributed a Supreme Being to the Maori, see Simpson, "Io as Supreme Being."

74 Codrington, "Religious Beliefs and Practices in Melanesia," 315–16.

75 Porter, *The Rise of Statistical Thinking*.

76 Lennard J. Davis, "Constructing Normalcy," 23–49.

77 Quoted in Porter, *The Rise of Statistical Thinking*, 16.

78 Galton, *Hereditary Genius*, 24.

79 Quoted in Lake and Reynolds, *Drawing the Global Color Line*, 2.

80 Hilliard, *God's Gentlemen*, 191.

81 Agamben, *State of Exception*, 51.

82 Keesing, "Rethinking Mana," 138.

83 Agamben, *State of Exception*, 4.

84 Durkheim, *The Elementary Forms of Religious Life*, 58–59.

85 Ibid., 196. See Lévy-Bruhl, *The "Soul" of the Primitive*, 16–20, for an elaboration of these ideas in French anthropology.

86 Durkheim, *The Elementary Forms of Religious Life*, 212–13.

87 Tylor, *Primitive Culture*, 9.

88 Marett, *Anthropology and the Classics*. Fowler, "The Original Meaning of the Word *Sacer*." The *homo sacer* was a person who, although sacred, could be killed with impunity, but not sacrificed. Agamben has influentially compared *homo sacer* to the Jew in the Nazi concentration camp. His methods of analogy and inference are directly derived from the interface of classics and anthropology being discussed here. He describes Lévi-Strauss's characterization of mana as the excess of the signifying function over signifieds and adds: "Somewhat analogous remarks could be made with reference to the use and function of the concepts of the sacred and the taboo in the discourse of the social sciences between 1890 and 1940" (Agamben, *Homo Sacer*, 80).

89 Fowler, "The Original Meaning of the Word *Sacer*," 22, referencing Marett, *The Threshold of Religion*, 90–92.

90 See Jennings Rose, *Ancient Roman Religion*, 12–14, where Codrington is extensively quoted.

91 Lévi-Strauss, *Introduction to the Work of Marcel Mauss*, 55–56.

92 Ibid., 62.

93 Dumézil, *Archaic Roman Religion*, 31.

94 See Beard, *The Roman Triumph*.

95 Raphael Samuel, "British Marxist Historians," 5.

96 O'Brien, *The Rise, Progress and Phases of Human Slavery*, 307–10.

97 Charles Kerr, "Publisher's Note," in Osborne, *The Ancient Lowly*, 1:iii.

98 "Working Men's Party: Their Platform," *New York Times*, 9 October 1871. "City and Suburban News," *New York Times*, 25 January 1874.

99 "Obituary: C. Osbourne Ward," *New York Times*, 21 March 1902.

100 Ward, *The Ancient Lowly*, 1:151–204.

101 Ward, *Ancient Lowly*, 1:ix.

102 Ward, *Ancient Lowly*, 1:427.

103 Harley, *Syndicalism*, 14.

104 Quoted in Raphael Samuel, "British Marxist Historians," 6.

105 Pelloutier, *L'Art et la Révolte*, 5.

106 Fernand Pelloutier, "La musée du travail" (1898), reprinted in Juillard, *Fernand Pelloutier et les origines du syndicalisme d'action directe*, 92–97.

107 Pelloutier, *L'Art et la Révolte*, 18.

108 Luxemburg, *The Mass Strike*, 47.

109 Rae, "The Eight Hours' Day in Australia," 528.

110 Friederich Engels, "Preface to the Communist Manifesto, May 1, 1890," available at the Marxists Internet Archive, http://www.marxists.org/.

111 Huberman and Minns, "The Times They Are Not Changin,'" 545, table 1.

112 See Gines, "Divisionism, Neo-Impressionism, Socialism."

113 Alexander Trachtenberg, *The History of May Day* (1932), available at the Marxists Internet Archive, http://www.marxists.org/.

114 Briand, *La Grève Générale et la Révolution*.

115 *La Grève Générale*, 13 January 1894.

116 *La Grève Générale*, 3d annee no. 1, 1 March 1899.

117 Luxemburg, *The Mass Strike*, 42.

118 Ibid., 66.

119 Ibid., 67.

120 Berth, *Les Nouveaux aspects du Socialisme*, 60–61.

121 Sorel, *Reflections on Violence*, 238–44.

122 Ibid., 25–29.

123 Ibid., 118.

124 Ibid., 121.

125 Bergson, *Essai sur les données immédiates de la conscience* (Paris, 1889), quoted in Sorel, *Reflections on Violence*, 26.

126 See Thiec, "Gustave Le Bon, prophète de l'irrationalisme de masse."

127 Gordon W. Allport, quoted by Robert K. Merton in the introduction to Le Bon, *The Crowd*, v. The French title of Le Bon's work was *Psychologie des Foules*, but it has become known as *The Crowd* in English.

128 Le Bon, *The Crowd*, 16–17.

129 Ibid., 41.

130 Ibid., 55.

131 Ibid., 54.

132 See, for Germany, Buck-Morss, "Aesthetics and Anaesthetics," 38; and for Italy, Falasca-Zamponi, *Fascist Spectacle*.

133 Buck-Morss, "Aesthetics and Anaesthetics," 10.

134 Drumont, *La France Juive*, 436 and 529. On Barrès and Carlyle, see Carey Taylor, *Carlyle et la pensée latine*, 330–32.

135 Fornelli, *Tommaso Carlyle*, 19.

136 Licciardelli, *Benito Mussolini e Tommasso Carlyle*, 32.

137 James Ellis Baker, "Carlyle Rules the Reich," *Saturday Review of Literature*, 25 November 1933, 291.

138 Liselott Eckloff, *Bild und Wirklichkeit bei Thomas Carlyle* (Konigsberg and Berlin: Ost- Europa-Verlag, 1936).

139 Quoted in Falasca-Zamponi, *Fascist Spectacle*, 21.

SIX. ANTIFASCIST NEOREALISMS

1 Mbembe, "Necropolitics."

2 Benjamin, "The Work of Art in the Age of its Technological Reproducibility," 122.

3 Benjamin, "Critique of Violence," 243.

4 For a concise summary of this historiography, see Lewis, *W. E. B. Du Bois: The Fight for Equality and the American Century*, 352–56.

5 See especially Du Bois, *Black Reconstruction in America*, 711–29.

6 Gramsci, *Prison Notebooks*, 53.

7 Gramsci, *The Antonio Gramsci Reader*, 37.

8 Gramsci, *Selections from Political Writings*, 260.

9 Gramsci, *The Antonio Gramsci Reader*, 269.

10 Ibid., 272.

11 Du Bois, *Black Reconstruction in America*, 382.

12 Gramsci, *Selections from Political Writings*, 15.

13 Urbinati, "The Souths of Antonio Gramsci and the Concept of Hegemony," 140–41.

14 Gramsci, *Selections from the Prison Notebooks*, 88.

15 Gramsci, *Selections from Cultural Writings*, 98.

16 Du Bois, *Black Reconstruction in America*, 707.

17 Mignolo, "The Geopolitics of Knowledge and the Colonial Difference," 66.

18 Quoted in Logan, "Education in Haiti," 414.

19 Bellegarde, *Ecrivains Haitiens*, 38–39.

20 Lespinasse, *Histoire des affranchis de Saint-Domingue*, 20–21.

21 Du Bois, "A Chronicle of Race Relations."

22 John Crowe Ransom, "Reconstructed but Unregenerate" (1930), in [Ransom et al.], *I'll Take My Stand*, 15.

23 Gramsci, *The Southern Question*, 33.

24 Ibid., 71.

25 Ibid., 59.

26 Sillanpoa, "Pasolini's Gramsci," 133n34.

27 Agamben, *State of Exception*, 23.

28 See Shepard, *The Invention of Decolonization*, and Le Sueur, *Uncivil War*.

29 Fanon, *The Wretched of the Earth*, 48n7.

30 Horne, *A Savage War of Peace*, 62.

31 Quoted in Le Sueur, *Uncivil War*, 300.

32 Albert Memmi, *Portrait du colonisé* (1957), quoted in Ramdani, "L'Algérie, un différend," 10.

33 I use *post-colonial* to mean "after the colony" and *postcolonial* to mean the "rethinking of the colonial."

34 Abbas, *L'indépendance confisquée*.

35 Le Sueur, *Uncivil War*, 299 and 320.

36 Fanon, *The Wretched of the Earth*, 2.

37 Ibid., 4.

38 Ibid., 3.

39 Mbembe, *On the Postcolony*, 175.

40 Mbembe, "Necropolitics," 26.

41 Quoted and translated in Vergès, "Creole Skin, Black Mask," 580.

42 Beauvoir, *The Second Sex*, 281.

43 Vergès, "Creole Skin, Black Mask," 589–90.

44 Lacan, *The Other Side of Psychoanalysis*, 92. See also Cherki, *Frantz Fanon*, 21.

45 See Bulhan, *Frantz Fanon and the Psychology of Oppression*, 71–73.

46 See Clemens and Grigg, *Jacques Lacan and the Other Side of Psychoanalysis*, wherein sixteen essays on the seminar let this passage pass without comment.

47 Deleuze and Guattari, *Anti-Oedipus*, 169.

48 See especially Greg Thomas, *The Sexual Demon of Colonial Power*, 76–103.

49 Ngũgĩ wa Thiong'o, *Decolonizing the Mind*.

50 Stora, *Algeria 1830-2000*, 52.

51 Barthes, *Mythologies*, 116.

52 Ibid., 148n25.

53 Horne, *A Savage War of Peace*, 135.

54 Feldman, "Political Terror and the Technologies of Memory," 60.

55 Quoted by Khanna, *Algeria Cuts*, 107. For more on the films produced from 1911–54, see Kenz, *L'Odysée des Cinémathèques*, 73.

56 *The Cinema in Algeria*, 9–14. Kenz, *L'Odysée des Cinémathèques*, 79.

57 Vautier, *Camera citoyenne*, 142.

58 Cherki, *Frantz Fanon*, 103. Vautier, *Camera citoyenne*, 146–47.

59 Mohamed Bensalah, "Tébessa: Premiers journées cinématographiques," *El Watan*, 17 April 2008.

60 *The Cinema in Algeria*, 13. Vautier, *Camera citoyenne*, 165–66.

61 Macey, *Frantz Fanon*, 321.

62 See *Racconti di bambini d'Algeria*. Discussed by Cherki, *Frantz Fanon*, 128. The originals are said to be with the Red Crescent in Tunis. There are references to a French translation, but I have not been able to locate it.

63 *Racconti di bambini d'Algeria*, drawings from 10–14, testimony cited from 47–55.

64 See Boudjedra, *Naissance du cinéma algérien*, 40.

65 Connelly, *A Diplomatic Revolution*, 138–39.

66 Macey, *Frantz Fanon*, 146–52.

67 *Manuel alphabétique de psychiatrie* (1952), quoted in Cherki, *Frantz Fanon*, 65.

68 Keller, *Colonial Madness*, 152.

69 As Foucault worked in Tunis, during the 1960s, it is not impossible that he was aware of Fanon's work.

70 Fanon, *Rencontre de la société et de la psychiatrie*, 2. See Keller, *Colonial Madness*, 171.

71 Fanon, *Rencontre de la société et de la psychiatrie*, 3.

72 Ibid., 8–9. Macey, *Frantz Fanon*, 326.

73 Greg Thomas, *The Sexual Demon of Colonial Power*, 77.

74 Cherki, *Frantz Fanon*, 56.

75 Quoted in Kenz, *L'Odysée des Cinémathèques*, 146.

76 Vautier, *Cinema citoyenne*, 179–88.

77 Khanna, *Algeria Cuts*, 107.

78 Ibid., 108.

79 Alleg, *La Question*, 65.

80 Le Sueur, *Uncivil War*, 293.

81 Hayles, *How We Became Post-Human*, 89.

82 See Stora, *Imaginaires de guerre*, 135.

83 Boudjedra, *Naissance du cinema algérien*, 25.

84 Khanna, *Algeria Cuts*, 132.

85 Djebar, *The Women of Algiers*, 151.

86 Ross, *May '68 and Its Afterlives*, 26.

87 Mignolo, "The Geopolitics of Knowledge and the Colonial Difference," 63.

88 Porton, "Collective Guilt and Individual Responsibility," 50–51.

89 Austin, "Drawing Trauma."

90 Quoted and translated in Macey, *Frantz Fanon*, 351.

91 See Gilroy, "Shooting Crabs in a Barrel."

92 Fanon, *The Wretched of the Earth*, 199–201.

93 Ibid., 183.

94 Austin, "Drawing Trauma," 135.

95 Durand, "Eija-Liisa Ahtila," 24.

96 Fanon, *Black Skin, White Masks*, 36.

97 Wideman, *Fanon*, 99. Further page references appear in the text.

98 Derrida, *Specters of Marx*, 14.

99 Keller, *Colonial Madness*, 223–26.

100 Fanon, *The Wretched of the Earth*, 82.

101 Cited in Kacem, *La psychose française*, 13.

102 Ibid., 15 and 56–62.

103 Ibid., 16–19.

104 Quoted in Coquery-Vidrovitch, *Enjeux politiques de l'histoire coloniale*, 11.

105 See my blog, at http://nicholasmirzoeff.com/RTL, for ongoing thoughts about these developments.

NOTES TO MEXICAN-SPANISH COUNTERPOINT

1 Paul Julian Smith, "*Pan's Labyrinth*."

2 Kim Edwards, "Alice's Little Sister: Exploring *Pan's Labyrinth*."

3 Respectively, quoted in Urbinati, "The Souths of Antonio Gramsci and the Concept of Hegemony," 142; Gramsci, *The Southern Question*, 59.

4 Urbinati, "The Souths of Antonio Gramsci and the Concept of Hegemony," 145.

SEVEN. GLOBAL COUNTERINSURGENCY

1 Roper, "Global Counterinsurgency," 101.

2 Sewall, "A Radical Field Manual," xxv.

3 Mbembe, "Necropolitics," 14.

4 Michael Hoffman, "New Reaper Sensors Offer Bigger Picture," 16 February 2009, available at the *Air Force Times* website, http://www.airforcetimes.com/.

5 Pynchon, *Gravity's Rainbow*, 1.

6 Quoted in "Troops Begin Combat Operations in New Orleans," *Army Times*, 2 September 2005, which itself is quoted in "Al-Cajun? *Army Times* calls NOLA Katrina Victims 'the Insurgency,'" posted by Xeni Jardin, on 3 September 2005, at the boingboing website, http://www.boingboing.net/. The link to the *Army Times* provided in the boingboing post generates the message "The story you are looking for cannot be found."

7 Brinkley, *The Great Deluge*, 412.

8 Ginger Thompson and Mark Mazzetti, "U.S. Drones Fight Mexican Drug Trade," *New York Times*, 16 March 2011.

9 Paul Lewis, "CCTV in the Sky: Police Plan to Use Military-Style Spy Drones," *Guardian*, 23 January 2010.

10 Joseph L. Flatley, "UK Police Drone Grounded for Flying Without a License," 16 February 2010, http://www.engadget.com/.

11 On global civil war, see Arendt, *On Revolution*. On the new state of permanent war, see Retort, *Afflicted Powers*, 78.

12 National Security Council Resolution 68, quoted by Paul Edwards, *The Closed World*, 12; for a thorough account, see 10–12.

13 Pease, "Hiroshima, the Vietnam Veterans War Memorial, and the Gulf War," 563.

14 Derrida, "No Apocalypse, Not Now (Full Speed Ahead, Seven Missiles, Seven Missives)," 23.

15 Vickers, "The Revolution in Military Affairs and Military Capabilities," 30.

16 Williams and Lind, "Can We Afford a Revolution in Military Affairs?," 2.

17 See U.S. Department of Defense, "DoD Releases Fiscal 2010 Budget Proposal," news release no. 304–09, 7 May 2009, available at the website for the U.S. Department of Defense, http://www.defense.gov/.

18 See Pantelogiannis, "RMA."

19 Arquilla and Ronfeldt, *The Advent of Netwar*, vii.

20 Ibid., 5.

21 Murphy, *Are We Rome?*, 83.

22 Weizman, *Hollow Land*, 187–200.

23 Chandarasekaran, *Imperial Life in the Emerald City*, 133–36.

24 See the report "Sociological Skills Used in the Capture of Saddam Hussein," by Victoria Hougham, available at the American Sociological Association's online journal *Footnotes* (July–August 2005), http://www.asanet.org/.

25 Danner, "Iraq."

26 Gregory, *The Colonial Present*, 211–13.

27 For an annotated selection of military video, see Jennifer Terry, design by Raegan Kelly, "Killer Entertainments," available at the online journal *Vectors*, http://www.vectorsjournal.org/. For insurgent videos, see the Internet Archive, http://www.archive.org/, under "Iraq War: Non-English Language Videos," such as the video "IED Attack in Samara [*sic*]," which purports to document an attack on U.S. forces in Samarra, but could easily be staged.

28 Karen J. Hall, "Photos for Access: War Pornography and U.S. Practices of Power," paper presented at the Society for Cinema and Media Studies Annual Conference, Vancouver, 2006. My thanks to Professor Hall for sharing her work.

29 Payne, "Waging Communication War."

30 Suskind, "Faith, Certainty and the Presidency of George W. Bush."

31 Arquilla, "The End of War as We Knew It?" This essay marks an effort by the leading theorist of information war to reframe COIN in his paradigm.

32 McElvey, "The Cult of Counterinsurgency," 21.

33 Kilcullen, "Countering Global Insurgency."

34 *Field Manual 3-24: Counterinsurgency* (Washington: Headquarters Department of the Army, 2006); republished, in 2007, as *The U.S. Army Marine Corps Counterinsurgency Field Manual.*

35 Sewall is "a member of the Obama-Biden Transition Project's Agency Review Working Group responsible for the national security agencies" (see "Working Group Members" for the National Security Policy Working Group, available at the Change.gov website, http://change.gov/).

36 Sarah Sewall, "A Radical Field Manual," xxv.

37 Gray, *Recognizing and Understanding Revolutionary Change in Warfare*, 19–23.

38 Alexander Galloway, *Gaming*, 63.

39 Weizman, *Hollow Land*, 262.

40 Ricks, *Fiasco*, 152.

41 Lawrence, *Secret Despatches from Arabia*, 153–60.

42 Tylor, *Primitive Culture*, 1.

43 *Small Wars Manual*, 1.

44 Burton and Nagl, "Learning as We Go," 311.

45 Reid, *The Biopolitics of the War on Terror.*

46 Coll, "War by Other Means."

47 Gregory, "The Rush to the Intimate." This important essay provides a close reading of counterinsurgency that is similar to mine, but phrased more in the language of geography and anthropology.

48 Niva, "Walling Off Iraq."

49 Hilla Dayan, "Regimes of Separation," 285.

50 William J. Broad, "Inside the Black Budget," *New York Times*, 1 April 2008.

51 Brendan O'Neill, "Watching You Watching Me," *New Statesman*, 6 October 2006.

52 Quoted by Eyal Weizman, "Thantato-tactics," in Ophir et al., *The Power of Inclusive Exclusion*, 565.

53 David Kilcullen, "Death from Above, Outrage Down Below," *New York Times*, 16 May 2009.

54 Greg Miller, "Increased U.S. Drone Strikes in Pakistan Killing Few High-Value Militants," *Washington Post*, 21 February 2011.

55 Derek Gregory, "American Military Imaginaries," 68.

56 Ibid., 75.

57 Blog post by Starbuck, "The T. X. Hammes PowerPoint Challenge (Essay

Contest)," 24 July 2009, available at the *Small Wars Journal* website, http:// smallwarsjournal.com/.

58 T. X. Hammes, "Dumb Dumb Bullets," *Armed Forces Journal*, July 2009, http:// www.armedforcesjournal.com/.

59 Elisabeth Bumiller, "We Have Met the Enemy and He Is Powerpoint," *New York Times*, 26 April 2010.

60 Riverbend, "End of Another Year . . . ," blog post, 29 December 2006, *Baghdad Burning*, http://www.riverbendblog.blogspot.com/. In July 2007, "Riverbend" herself left Iraq for Syria.

61 "Rising to the Humanitarian Challenge in Iraq," *Briefing Paper no. 105*, Oxfam/ NGO Coordination Committee in Iraq, 2007.

62 O'Hanlon and Campbell, *Iraq Index*, 3.

63 Central Intelligence Agency, "The World Factbook," available in the "Library" section of the CIA website, https://www.cia.gov/.

64 Foucault, "*Society Must Be Defended*," 16.

65 Mackinlay and al-Baddawy, *Rethinking Counterinsurgency*, 41.

66 Ibid., 56.

67 Costa and Philip, *Tactical Biopolitics*.

68 Bataille, quoted in Mbembe, "Necropolitics," 38.

69 This is the name of a Media Commons project that I edit. See http://media commons.futureofthebook.org/the-new-everyday/about/.

Abbas, Ferhat. *L'indépendance confisquée, 1962–1978*. Paris: Flammarion, 1984.

Agamben, Giorgio. *Homo Sacer: Sovereign Power and Bare Life*. Translated by Daniel Heller-Roazen. Stanford: Stanford University Press, 1998.

———. *State of Exception*. Chicago: University of Chicago Press, 2005.

Alleg, Henri. *La Question*. 1958–61. Paris: La Minuit, 2008.

Anderson, Benedict. *Imagined Communities: Reflections on the Origin and Spread of Nationalism*. Revised and extended edition. New York: Verso, 2006.

Annals of the Diocese of New Zealand. London: Society for Promoting Christian Knowledge, 1847.

Antliff, Mark. "The Jew as Anti-Artist: Georges Sorel, Anti-Semitism, and the Aesthetics of Class Consciousness." *Oxford Art Journal* 20, no. 1 (1997): 50–67.

Alexandre, Charles-A. "Parisian Women Protest via Taxation Populaire in February, 1792." *Women in Revolutionary Paris 1789–1795*, ed. and trans. Darline Gay Levy, Harriet Branson Applewhite, Mary Durham Johnson, 115–18. Urbana: University of Illinois Press, 1979.

Appadurai, Arjun. "Grassroots Globalization and the Research Imagination." *Globalization*, ed. Arjun Appadurai, 1–21. Durham: Duke University Press, 2001.

Aravamudan, Srinivas. *Tropicopolitans: Colonialism and Agency 1688–1804*. Durham: Duke University Press, 1999.

———. "Trop(icaliz)ing the Enlightenment." *Diacritics* 23, no. 3 (autumn 1993): 48–68.

Arendt, Hannah. *On Revolution*. New York: Viking, 1963.

Armstrong, Carol. *Manet Manette*. New Haven: Yale University Press, 2002.

Arnold, Matthew. *Culture and Anarchy*. 1869. Edited by Samuel Lipman. New Haven: Yale University Press, 1994.

Arquilla, John. "The End of War as We Knew It? Insurgency, Counterinsurgency and Lessons from the Forgotten History of Early Terror Networks." *Third World Quarterly* 28, no. 2 (March 2007): 369–86.

Arquilla, John, and David Ronfeldt. *The Advent of Netwar*. Washington: National Defense Research Institute, 1996.

Athanassoglou-Kallmyer, Nina. "An Artistic and Political Manifesto for Cézanne." *Art Bulletin* 72, no. 3 (September 1990): 482–92.

Austin, Guy. "Drawing Trauma: Visual Testimony in *Caché* and *J'ai huit ans*." *Screen* 48, no. 4 (winter 2007): 534–35.

Azoulay, Ariella. *The Civil Contract of Photography*. Translated by Rela Mazali and Ruvik Danieli. New York: Zone, 2008.

Badiou, Alain. "The Paris Commune: A Political Declaration on Politics." *Polemics*, 257–90. Translated by Steve Corcoran. New York: Verso, 2006.

Baecque, Antoine de. "'Le choc des opinions.'" *L'an 1 des droits de l'homme*, Antoine de Baecque, Wolfang Schmale, and Michel Vovelle. Paris: Presses du CNRS, 1988.

Barré de Saint-Venant, Juan. *Des Colonies Modernes sous la Zone Torride et particulièrement de celle de Saint-Domingue*. Paris: Brochot, 1802.

Barrell, John. *Imagining the King's Death: Figures of Treason, Fantasies of Regicide, 1793–96*. New York: Oxford University Press, 2000.

Barrenechea, Francisco J., et al. *Campeche, Oller, Rodón: Tres siglos de pintura Puertorriqueña / Campeche, Oller, Redon: Three Centuries of Puerto Rican Painting*. San Juan: Instituto de Cultura Puertorriqueña, 1992.

Barthes, Roland. *Mythologies*. New York: Noonday, 1972.

Bassett, John S. *The Plantation Overseer*. Portland: Smith College, 1925.

Baudelaire, Charles. "Salon de 1859." *Curiosités esthéthiques*, ed. Henri Lemaître, 305–96. Paris: Bordas, 1990.

Baudin, Nicolas. *The Journals of Post-Captain Nicolas Baudin, Commander-in-Chief of the Corvettes Géographe and Naturaliste assigned by order of the Government to a voyage of discovery*. Trans. Christine Cornell. Adelaide: Libraries Board of South Australia, 1974.

Bayart, Jean-François. *The State in Africa: The Politics of the Belly*. Translated by Mary Harper, Christopher Harrison, and Elizabeth Harrison. London: Longman, 1993.

Beard, Mary. *The Roman Triumph*. Cambridge: Harvard University Press, 2007.

Beauvoir, Simone de. *The Second Sex*. 1952. Edited and translated by H. M. Parshley. New York: Alfred A. Knopf, 1993.

Bellegarde, Dantès. *Ecrivains Haitiens: Notices biographiques et pages choisis*. Port-au-Prince, Haiti: Editions Deschamps, 1950.

Beller, Jonathan L. *The Cinematic Mode of Production: Attention Economy and the Society*

of the Spectacle. Hanover: Dartmouth College Press / University Press of New England, 2006.

Benbow, William. *Grand National Holiday and Congress of the Productive Classes*. London: n.p., 1832.

Benjamin, Walter. *The Arcades Project*. Translated by Howard Eiland and Kevin McLaughlin. Cambridge: Belknap Press of Harvard University Press, 1999.

———. "Critique of Violence." 1921. *Selected Writings, Volume 1: 1913-1926*, 236–52. Edited by Marcus Bullock and Michael W. Jennings. Cambridge: Belknap Press of Harvard University Press, 1996.

———. "Paris, the Capital of the Nineteenth Century." *Selected Writings, Volume 3: 1935-1938*, 32–49. Edited by Howard Eiland and Michael Jennings. Translated by Edmund Jephcott, Howard Eiland, et al. Cambridge: Belknap Press of Harvard University Press, 2002.

———. "The Work of Art in the Age of Its Technological Reproducibility." *Selected Writings, Volume 3: 1935-38*, 101–34. Edited by Howard Eiland and Michael Jennings. Translated by Edmund Jephcott, Howard Eiland, et al. Cambridge: Belknap Press of Harvard University Press, 2002.

Benot, Yves. *La révolution française et la fin des colonies 1789-1794*. 2nd edition. Paris: La Découverte, 2004.

Bernard, Trevor. *Mastery, Tyranny and Desire: Thomas Thistlewood and His Slaves in the Anglo-Jamaican World*. Chapel Hill: University of North Carolina Press, 2004.

Berry, Mary Frances. "'Reckless Eyeballing': The Matt Ingram Case and the Denial of African American Sexual Freedom." *African American History* 93, no. 2 (2008): 223–34.

Berth, Edouard. *Les Nouveaux aspects du Socialisme*. Paris: Marcel Rivière, 1908.

Berthaut, Colonel [H. M. A.]. *Les ingenieurs geographes militaires, 1624-1831: Etude Historique*. 2 vols. Paris: Imprimerie du service geographique, 1902.

Binney, Judith. "Christianity and the Maoris to 1840: A Comment." *New Zealand Journal of History* 3, no. 2 (October 1969): 143–65.

———. "Papahurihia: Some Thoughts on Interpretation." *Journal of the Polynesian Society* 75, no. 3 (September 1966): 321–31.

———. "Papahurihia, Penetana." *The Dictionary of New Zealand Biography, Volume 1: 1769-1869*, 329–31. Wellington: Allen and Unwin / Department of Internal Affairs, n.d.

———. *Redemption Songs: A Life of Te Kooti Arikirangi Te Turuki*. Auckland: University of Auckland Press, 1995.

———. "Whatever Happened to Poor Mr. Yate? An Exercise in Voyeurism." *New Zealand Journal of History* 9, no. 2 (October 1975): 113–25.

Blackburn, Robin. *The Overthrow of Colonial Slavery (1776-1848)*. London: Verso, 1988.

Blanchard, Mary Warner. *Oscar Wilde's America: Counterculture in the Gilded Age*. New Haven: Yale University Press, 1998.

Blier, Suzanne Preston. "Vodun: West African Roots of Vodou." *Sacred Arts of Haitian Vodou*, ed. Donald Consentino, 68–77. Los Angeles: UCLA Fowler Museum of Cultural History, 1995.

Blyden, Edward Wilmot. "The Jewish Question (1898)." *Black Spokesman*, ed. Hollis R. Lynch. London: Frank Cass, 1971.

Boast, R. P. "Recognising Multi-textualism: Rethinking New Zealand's Legal History." *Victoria University of Wellington Law Review* 37, no. 4 (2006): 547–82.

Bois, Paul. *Paysans de l'Ouest: Des structures économiques et socials aux options politiques depuis l'époque révolutionnaire dans la Sarthe*. Paris: Flammarion, 1971.

Bolster, W. Jeffrey. "Strange Familiarity: The Civil War Photographs of Henry P. Moore." *Soldiers, Sailors, Slaves and Ships: The Civil War Photographs of Henry P. Moore*, by W. Jeffrey Bolster and Hilary Anderson, 9–20. Concord: New Hampshire Historical Society, 1999.

Bolster, W. Jeffrey, and Hilary Anderson. *Soldiers, Sailors, Slaves and Ships: The Civil War Photographs of Henry P. Moore*. Concord: New Hampshire Historical Society, 1999.

Boudjedra, Rachid. *Naissance du cinema algérien*. Paris: Maspero, 1971.

Bourdon, Léonard. *Rapport de Leonard Bourdon au nom de la commission d'Instruction Publique, Prononce le premier Août*. Paris: n.p., 1793.

———. *Recueil des Action Héroïques et Civiques des Républicains Francais, no 1, presentés à la Convention Nationale au nom de son Comité d'Instruction Publique*. Paris: Convention Nationale, 27 Frimaire an II [1794].

Braude, Benjamin. "The Sons of Noah and the Construction of Ethnic and Geographical Identities in the Medieval and Early Modern Periods." *William and Mary Quarterly* 54, no. 1, 3rd series (January 1997): 103–42.

Brecht, Bertolt. *The Days of the Commune*. Translated by Clive Barker and Arno Reinfrank. London: Eyre Methuen, 1978.

Brettell, Richard R. "Camille Pissarro and St. Thomas: The Story of an Exhibition." *Camille Pissarro in the Caribbean, 1850–1855: Drawings from the Collection at Olana*, by Richard R. Brettell and Karen Zukowski. St Thomas, U.S. Virgin Islands: Hebrew Congregation of St Thomas, 1996.

Brettell, Richard R., and Karen Zukowski. *Camille Pissarro in the Caribbean, 1850–1855: Drawings from the Collection at Olana*. St Thomas, U.S. Virgin Islands: Hebrew Congregation of St Thomas, 1996.

Brewer, John. *The Sinews of Power*. New York: Knopf, 1989.

Briand, Aristide. *La Grève Générale et la révolution*. La Brochure Mensuelle no. 12. Paris: Bidault, 1932.

Brigham, David R. *Public Culture in the Early Republic: Peale's Museum and Its Audience*. Washington: Smithsonian University Press, 1995.

Brinkley, Douglas. *The Great Deluge: Hurricane Katrina, New Orleans, and the Mississippi Gulf Coast*. New York: William Morrow, 2006.

Brookfield, F. M. *Waitangi and Indigenous Rights: Revolution, Law and Legitimation*. Auckland: Auckland University Press, 1999.

Brooks, Daphne A. *Bodies in Dissent: Spectacular Performances of Race and Freedom, 1850–1910*. Durham: Duke University Press, 2006.

Brown, Marilyn R. "Degas and *A Cotton Office in New Orleans*." *Burlington Magazine* 130, no. 1020 (March 1988): 216–21.

[Browne, Patrick]. *The Natural History of Jamaica*. London: n.p., 1765; reprint, New York: Arno Press, 1972.

Buck-Morss, Susan. "Aesthetics and Anaesthetics." *October* 62, no. 2 (1992): 3–41.

———. "Hegel and Haiti." *Critical Inquiry* 26, no. 4 (2000): 821–65.

Buisseret, David, ed. *Monarchs, Ministers and Maps: The Emergence of Cartography as a Tool of Government in Early Modern Europe*. Chicago: University of Chicago Press, 1992.

Bulhan, Hussein Addilahi. *Frantz Fanon and the Psychology of Oppression*. New York: Plenum Press, 1985.

Burton, Brian, and John Nagl. "Learning as We Go: The U.S. Army Adapts to Counterinsurgency in Iraq, July 2004–December 2006." *Small Wars and Insurgencies* 19, no. 3 (September 2008): 303–27.

Callwell, Charles E. *Small Wars: A Tactical Handbook for Imperial Soldiers*. London: Stationary Office, 1890.

Carey Taylor, Alan. *Carlyle et la pensée latine: Thèse pour le doctorat ès letters présentée à la faculté de l'université de Paris*. Paris: Boivin, 1937.

Carlos Ledezma, Juan. "Chronological Reading of Camille Pissarro's Political Landscape." *Camille Pissarro: The Venezuelan Period, 1852–1854*. New York: Venezuelan Center, 1997.

Carlyle, Thomas. *Critical and Miscellaneous Essays 4*. Edited by H. D. Traill. Vol. 29 of *The Centenary Edition: The Works of Thomas Carlyle*. London: Chapman and Hall, 1899.

———. *The French Revolution*. 3 vols. London: Chapman and Hall, 1896.

———. "Goethe." *Critical and Miscellaneous Essays*, 1:172–223. 7 vols. London: n.p., 1872.

———. "Model Prisons." March 1850. *Latter-Day Pamphlets*, 59–106. London: Chapman Hall, 1855.

———. "Occasional Discourse on the Nigger Question." 1853. *Critical and Miscellaneous Essays*, 18:461–94. *Critical Memorial Edition of the Works of Thomas Carlyle*. Boston: Dana Estes, 1869.

———. *On Heroes, Hero Worship and the Heroic in History*. 1841. Vol. 2 of *The Norman and Charlotte Strouse Edition of the Writings of Thomas Carlyle*, ed. Michael K. Goldberg. Berkeley: University of California Press, 1993.

———. *Past and Present*. London: n.p., 1843.

Carter, Paul. "Looking for Baudin." *Terre Napoléon through French Eyes*, 21–34. Sydney: Pot Still Press for the Museum of Sydney, 1999.

Casarino, Cesare, and Antonio Negri. *In Praise of the Common: A Conversation on Philosophy and Politics*. Minneapolis: University of Minnesota Press, 2008.

Casid, Jill. *Sowing Empire: Landscape and Colonization*. Minneapolis: University of Minnesota Press, 2005.

Censer, Jack, and Lynn Hunt. "Imaging the French Revolution: Depictions of the French Revolutionary Crowd." *American Historical Review* 110, no. 1 (February 2005): 38–45.

Césaire, Aimé. *Toussaint L'Ouverture: La Révolution Française et le problème colonial*. 1961. Paris: Présence Africaine, 1981.

Cézanne, Paul. *Letters*. Edited by John Rewald. Translated by Seymour Hacker. New York: Hacker Art Books, 1984.

Chakrabarty, Dipesh. *Provincializing Europe: Postcolonial Thought and Historical Difference*. Princeton: Princeton University Press, 2000.

Chandarasekaran, Rajiv. *Imperial Life in the Emerald City: Inside Iraq's Green Zone*. New York: Knopf, 2006.

Chase, Malcolm. *The People's Farm: English Radical Agrarianism 1775-1840*. Oxford: Oxford University Press, 1988.

Cherki, Alice. *Frantz Fanon: A Portrait*. Translated by Nadia Benabid. Ithaca: Cornell University Press, 2006.

Childs, Matt D. "'A Black French General Arrived to Conquer the Island': Images of the Haitian Revolution in Cuba's 1812 Aponte Rebellion." *The Impact of the Haitian Revolution in the Atlantic World*, David P. Geggus, 134–56. Columbia: University of South Carolina Press, 2001.

The Cinema in Algeria: Film Production 1957-1973. Algiers: Ministry of Information and Culture, [1974].

Clark, T. J. "Painting in the Year Two." In "National Cultures before Nationalism," special issue, *Representations*, no. 47 (summer 1994): 13–63.

———. "We Field-Women." *Farewell to an Idea: Episodes from a History of Modernism*, 55–138. New Haven: Yale University Press, 1999.

Clausewitz, Karl von. *On War*. 1832. Edited and translated by Michael Howard and Peter Paret. Princeton: Princeton University Press, 1976.

Clemens, Justin, and Russell Grigg, eds. *Jacques Lacan and the Other Side of Psychoanalysis: Reflections on Seminar XVII*. Durham: Duke University Press, 2006.

Le Code Noir et autres textes de lois sur l'esclavage. Paris: Editions Sepia, 2006.

Codrington, Robert Henry. *The Melanesians*. Oxford: Clarendon, 1891.

———. "Religious Beliefs and Practices in Melanesia." *Journal of the Anthropological Institute of Great Britain and Ireland* 10 (1881): 261–316.

Cohen, Judah M. *Through the Sands of Time: A History of the Jewish Community of St. Thomas, U.S. Virgin Islands*. Hanover: Brandeis University Press / University Press of New England, 2004.

Coll, Steve. "War by Other Means." *New Yorker*, 24 May 2010, 50–52.

Collected Black Women's Narratives. The Schomberg Library of Nineteenth-Century Black Women Writers. New York: Oxford University Press, 1988.

Comaroff, Jean, and John Comaroff. *Of Revelation and Revolution: Christianity, Colonialism, and Consciousness in South Africa.* 2 vols. Chicago: University of Chicago Press, 1991–97.

Condorcet, Marquis de [Jean-Antoine-Nicolas de Caritat]. *Oeuvres de Condorcet,* ed. A. Condorcet O'Connor and M. F. Arago. 12 vols. Paris: Firmin Didot, 1847–49.

Conley, Tom. *The Self-Made Map: Cartographic Writing in Early Modern France.* Minneapolis: University of Minnesota Press, 1996.

Connelly, Matthew James. *A Diplomatic Revolution: Algeria's Fight for Independence and the Origins of the Post Cold War Era.* Oxford: Oxford University Press, 2002.

Consentino, Donald J. "It's All for You, Sen Jak!" *Sacred Arts of Haitian Vodou,* ed. Donald Consentino, 242–65. Los Angeles: UCLA Fowler Museum, 1995.

———, ed. *Sacred Arts of Haitian Vodou.* Los Angeles: UCLA Fowler Museum of Cultural History, 1995.

Coquery-Vidrovitch, Catherine. *Enjeux politiques de l'histoire coloniale.* Marseille: Agone, 2009.

Costa, Beatriz da, and Kavita Philip, eds. *Tactical Biopolitics: Art, Activism, and Technoscience.* Cambridge: MIT Press, 2008.

Crary, Jonathan. "Modernizing Vision." *Vision and Visuality,* ed. Hal Foster, 29–50. Seattle: Bay Press, 1988.

———. *Techniques of the Observer.* Cambridge: MIT Press, 1991.

Craton, Michael. *Testing the Chains: Resistance to Slavery in the British West Indies.* Ithaca: Cornell University Press, 1982.

Craton, Michael, and James Walvin. *A Jamaican Plantation: The History of Worthy Park, 1670-1970.* London: W. H. Allen, 1970.

Crow, Thomas E. *Emulation: David, Drouais, and Girodet in the Art of Revolutionary France.* New Haven: Yale University Press, 2006.

Cubano Iguina, Astrid. *Rituals of Violence in Nineteenth-Century Puerto Rico: Individual Conflict, Gender and the Law.* Gainesville: University of Florida Press, 2006.

Cundall, Frank. *Governors of Jamaica in the First Half of the Eighteenth Century.* London: West India Committee, 1937.

Curtin, Philip D. *The Rise and Fall of the Plantation Complex.* 2nd edition. New York: Cambridge University Press, 1998.

Da Costa, Emilia Viotti. *Crowns of Glory, Tears of Blood: The Demerara Slave Rebellion of 1823.* New York: Oxford University Press, 1994.

Dahomay, Jacky. "L'Esclave et le droit: Les légitimations d'une insurrection." *Les abolitions de l'esclavage de L. F. Sonthonax à V. Schœlcher 1793, 1794, 1848,* ed. Michel Dorigny. Paris: Presses Universitaires de Vincennes / Editions UNESCO, 1995.

Danner, Mark. "Iraq: The War of the Imagination." *New York Review of Books* 53, no. 20 (21 December 2006).

Darwin, Charles. *The Descent of Man*. London: John Murray, 1871.

———. *The Voyage of the Beagle*. 1839. New York: Modern Library, 2001.

Davis, Lennard. "Constructing Normalcy," 23–49. *Enforcing Normalcy: Disability, Deafness, and the Body*. New York: Verso, 1995.

Dayan, Hilla. "Regimes of Separation: Israel/Palestine and the Shadow of Apartheid." *The Power of Inclusive Exclusion: Anatomy of Israeli Rule in the Occupied Palestinian Territories*, ed. Adi Ophir, Michal Gavoni, and Sari Hanafi, 281–322. New York: Zone, 2009.

Dayan, Joan. "Codes of Law and Bodies of Color." *New Literary History* 26, no. 2 (1995): 283–308.

———. *Haiti, History and the Gods*. Berkeley: University of California Press, 1995.

Debien, Gabriel. *Les Esclaves aux Antilles Françaises (xviième-xviiième siècles)*. Basse-Terre: Société d'Histoire de la Guadaloupe and Société d'Histoire de Martinique, 1974.

Deleuze, Gilles. "Postscript on the Societies of Control." *October* 59 (winter 1992): 5–10.

Deleuze, Gilles, and Felix Guattari. *Anti-Oedipus: Capitalism and Schizophrenia*. Minneapolis: University of Minnesota Press, 1983.

Delgado Mercado, Osiris. "The Drama of Style in the Work of Francisco Oller." *Campeche, Oller, Rodón: Tres Siglos de Pintura Puertorriqueña / Campeche, Oller, Redon: Three Centuries of Puerto Rican Painting*, by Francisco J. Barrenechea et al. San Juan: Instituto de Cultura Puertorriqueña, 1992.

DeLue, Rachael Ziady. "Pissarro, Landscape, Vision, and Tradition." *Art Bulletin* 80, no. 4 (December 1998): 718–36.

Demange, Françoise. *Images de la Révolution: L'imagerie populaire orléanaise à l'époque révolutionnaire*. Orléans: Musée des Beaux-Arts, 1989.

Derian, James der. *Virtuous War: Mapping the Military-Industrial-Media-Entertainment Network*. 2nd edition. London: Routledge, 2009.

Derrida, Jacques. *Archive Fever: A Freudian Impression*. Translated by Eric Prenowitz. Chicago: University of Chicago Press, 1996.

———. *Droit de regards*. Paris: Editions de Minuit, 1985.

———. "Force of Law: The 'Mystical Foundation of Authority.'" Translated by Mary Quaintance. *Cardozo Law Review* 11 (1989–90): 920–1046.

———. "No Apocalypse, Not Now (Full Speed Ahead, Seven Missiles, Seven Missives)." Translated by Catherine Porter and Philip Lewis. "Nuclear Criticism." *Diacritics* 14, no. 2 (summer 1984): 20–31.

———. *Of Grammatology*. Translated by Gayatri Chakravorty Spivak. Baltimore: Johns Hopkins University Press, 1976.

———. *Right of Inspection*. Translated by David Wills. Photographs by Marie-Françoise Plissart. New York: Monacelli, 1998.

————. *Specters of Marx: The State of the Debt, the Work of Mourning, and the New International.* Translated by Peggy Kamuf. New York: Routledge, 1994.

Descourtilz, Michel-Etienne. *Voyage d'un naturaliste en Haiti, 1799-1803.* 1809. Edited by Jacques Boullanger. Abridged from 3 vols. Paris: Plon, 1935.

Detournelle, Athanase. *Journal de la Société Populaire et Républicaine des Arts.* Paris: 1794.

Dittmar, Gérald. *Iconographie de la Commune de Paris de 1871.* Paris: Editions Dittmar, 2005.

Djebar, Assia. *The Women of Algiers in their Apartment.* Trans. Marjolijn de Jager. Charlottesville: University of Virginia Press, 1992.

Doane, Mary Ann. *The Emergence of Cinematic Time: Modernity, Contingency, the Archive.* Cambridge: Harvard University Press, 2002.

Docherty, Thomas. *Aesthetic Democracy.* Stanford: Stanford University Press, 2006.

Docker, John, and Ann Curthoys. *Is History Fiction?* Ann Arbor: University of Michigan Press, 2005.

Dorigny, Michel, ed. *Les abolitions de l'esclavage de L. F. Sonthonax à V. Schœlcher 1793, 1794, 1848.* Paris: Presses Universitaires de Vincennes / Editions UNESCO, 1995.

Dorigny, Marcel, and Bernard Gainot. *La Société des Amis des Noirs: 1788-1799: Contribution à l'histoire de l'abolition de l'esclavage.* Paris: Editions UNESCO, 1998.

Drescher, Seymour. *Abolition: A History of Slavery and Antislavery.* New York: Cambridge University Press, 2009.

————. "Servile Insurrection and John Brown's Body in Europe." *Journal of American History* 80, no. 2 (September 1993): 499–524.

Drumont, Eduoard. *La France Juive.* Paris: n.p., 1886.

Dubbini, Renzo. *Geography of the Gaze.* Chicago: University of Chicago Press, 2002.

Dubois, Laurent. *Avengers of the New World: The Story of the Haitian Revolution.* Cambridge: Harvard University Press, 2004.

————. *A Colony of Citizens: Revolution and Slave Emancipation in the French Caribbean.* Chapel Hill: University of North Carolina Press, 2004.

Dubois, Laurent, and John D. Garrigus, eds. *Slave Revolution in the Caribbean, 1789-1804.* London: Palgrave MacMillan, 2006.

Du Bois, W. E. B. *Black Reconstruction in America, 1860-1880: An Essay toward a History of the Part which Black Folk Played in the Attempt to Reconstruct Democracy in America.* New York: Russell and Russell, 1935.

————. "A Chronicle of Race Relations." *Phylon* 3, no. 1 (1st quarter 1942): 76–77.

————. *The Souls of Black Folk.* New York: Penguin, 1989.

————. *W. E. B. Du Bois: Writings.* New York: Library of America, 1986.

Dumézil, Georges. *Archaic Roman Religion.* 1966. Vol. 1. Translated by Philip Krapp. Baltimore: Johns Hopkins University Press, 1970.

Dunch, Ryan. "Beyond Cultural Imperialism." *History and Theory* 41 (October 2002): 301–25.

Dunn, Richard. *Sugar and Slaves: The Rise of a Planter Class in the English West Indies, 1624-1713*. Chapel Hill: University of North Carolina Press, 1974.

Dunn, Waldo Hilary. *James Anthony Froude: A Biography, 1818-56*. 2 vols. Oxford: Clarendon, 1961.

Durand, Regis. "Eija-Liisa Ahtila: Les mots, la mort, l'espace, le temps." *Art News* (Paris), no. 342 (2008): 24-30.

Durie, M. H. *Te Mana te Kawanatanga: The Politics of Maori Self-Determination*. Auckland: Oxford University Press, 1998.

Durkheim, Emile. *The Elementary Forms of Religious Life*. 1912. Translated and introduced by Karen E. Fields. New York: Free Press, 1995.

Du Tertre, Jean-Baptiste. *Histoire générale des Antilles Habitées par les François*. 4 vols. Paris: Thomas Iolly, 1667.

Dutrône la Couture, Jacques-François. *Précis sur la canne et sur les moyens d'en extraire le sel essentiel, suivi de plusieurs mémoires sur le sucre, sur le vin de canne, sur l'indigo, sur les habitations et sur l'état actuel de Saint-Domingue*. Paris: Debure, 1791.

Dutt, R. Palme. "The British Empire." *Labour Monthly* 5, no. 4 (October 1923).

Dyer, Richard. *White*. London: Routledge, 1997.

Eckloff, Liselott. *Bild und Wirklichkeit bei Thomas Carlyle*. Konigsberg: Ost-Europa-Verlag, 1936.

Edwards, Kim. "Alice's Little Sister: Exploring *Pan's Labyrinth*." *Screen Education* 40 (2008): 141–46.

Edwards, Paul. *The Closed World: Computers and the Politics of Discourse in Cold War America*. Cambridge: MIT Press, 1996.

Elderfield, John. *Manet and the Execution of Maximilian*. New York: Museum of Modern Art, 2006.

Eliot, Simon, and Beverly Stern, eds. *The Age of Enlightenment*. Vol. 2. Milton Keynes: Open University, 1979.

Elsmore, Bronwyn. *Mana from Heaven: A Century of Maori Prophets in New Zealand*. Tauranga: Moana, 1989.

Emerson, Ralph Waldo. *Representative Men: Seven Lectures*. Vol. 4 of *The Collected Works of Ralph Waldo Emerson*. Text established by Douglas Emory Wilson. Cambridge: Belknap Press, 1987.

Evans, R. I. *The Victorian Age: 1815-1914*. London: Edward Arnold, 1950.

Eudell, Demetrius L. *Political Languages of Emancipation in the British Caribbean and the U.S. South*. Chapel Hill: University of North Carolina Press, 2002.

Faits et idées sur Saint-Domingue, relativement à la revolution actuelle. Paris: n.p., 1789.

Falasca-Zamponi, Simonetta. *Fascist Spectacle: The Aesthetics of Power in Mussolini's Italy*. Berkeley: University of California Press, 1997.

Fanon, Frantz. *Black Skin, White Masks*. Translated by Charles Lam Markman. New York: Grove, 1968.

————. *Rencontre de la société et de la psychiatrie: Notes de cours, Tunis 1959-60*. Edited by Mme Lilia Bensalem. Tunis: Université d'Oran: CRIDSSH, n.d.

————. *The Wretched of the Earth*. Translated by Richard Philcox. New York: Grove, 1994.

Feldman, Allen. *Formations of Violence: The Narrative of the Body and Political Terror in Northern Ireland*. Chicago: University of Chicago Press, 1991.

————. "Political Terror and the Technologies of Memory: Excuse, Sacrifice, Commodification, and Actuarial Moralities." *Radical History Review* 85 (2003): 58–73.

Fick, Carolyn. *The Making of Haiti: The Saint-Domingue Revolution from Below*. Knoxville: University of Tennessee Press, 1990.

Figueroa, Luis A. *Sugar, Slavery, and Freedom in Nineteenth-Century Puerto Rico*. San Juan: University of Puerto Rico Press, 2005.

Fischer, Sibylle. *Modernity Disavowed: Haiti and the Cultures of Slavery in the Age of Revolution*. Durham: Duke University Press, 2004.

Fisher, David Hackett. *Liberty and Freedom: A Visual History of America's Founding Ideas*. Oxford: Oxford University Press, 2005.

Foner, Eric. *Reconstruction: America's Unfinished Revolution, 1863-1877*. New York: Harper and Row, 1988.

Ford, Charles. "People as Property." *Oxford Art Journal* 25, no. 1 (2002): 3–16.

Fornelli, Guido. *Tommaso Carlyle*. Rome: A. F. Formíggini, 1921.

Foster, Hal, ed. *Vision and Visuality*. Seattle: Bay Press, 1988.

Foucault, Michel. *Discipline and Punish: The Birth of the Prison*. Translated by Alan Sheridan. London: Penguin, 1977.

————. *A History of Madness*. Translated by Jonathan Murphy and Jean Khalfa. New York: Routledge, 2006.

————. *The History of Sexuality: An Introduction*. Translated by Robert Hurley. New York: Vintage, 1978.

————. *The Order of Things: An Archaeology of the Human Sciences*. London: Tavistock, 1970.

————. *Security, Territory, Population: Lectures at the Collège de France, 1977-1978*. Translated by Graham Burchell. New York: Palgrave, 2007.

————. *"Society Must Be Defended": Lectures at the Collège de France 1975-76*. Translated by David Macey. New York: Picador, 2003.

Fouchard, Jean. *Plaisirs de Saint-Domingue: Notes sur la vie sociale, littéraire et artistique*. Port-au-Prince, Haiti: Editions Henri Deschamps, 1988.

Fowler, W. Warde. "The Original Meaning of the Word *Sacer*." 1911. *Roman Essays and Interpretations*, 15–23. Oxford: Clarendon, 1920.

Freud, Sigmund. *The Interpretation of Dreams*. 1900. Translated by James Strachey. Edited by Angela Richards. Harmondsworth: Pelican, 1976.

————. *The Standard Edition of the Complete Psychological Works of Sigmund Freud*. Translated by James Strachey. 24 vols. London: Hogarth, 1953.

Froude, James Anthony. *The British in the West Indies, or the Bow of Ulysses*. London: Longmans, Green, 1888.

———. *Julius Caesar: A Sketch*. London: n.p., 1879.

———. *Oceana: Or, England and Her Colonies*. 1886. New York: Charles Scribner, 1888.

Galloway, Alexander, *Gaming*. Durham: Duke University Press, 2007.

Galloway, J. H. "Tradition and Innovation in the American Sugar Industry, c. 1500–1800: An Explanation." *Annals of the Association of American Geographers* 75, no. 3 (September 1985): 334–51.

Galton, Francis. *Hereditary Genius*. 1869. London: MacMillan, 1892.

Garoutte, Claire, and Anneke Wambaugh. *Crossing the Water: A Photographic Path to the Afro-Cuban Spirit World*. Durham: Duke University Press, 2007.

Geggus, David P. *The Impact of the Haitian Revolution in the Atlantic World*. Columbia: University of South Carolina Press, 2001.

Gilbert, Olive. *The Narrative of Sojourner Truth*. Edited by Margaret Washington. New York: Vintage Classics, 1993.

Gilroy, Paul. *The Black Atlantic: Modernity and Double-Consciousness*. Cambridge: Harvard University Press, 1993.

———. "Shooting Crabs in a Barrel." *Screen* 48, no. 2 (summer 2002): 233–35.

Gines, Giovanna. "Divisionism, Neo-Impressionism, Socialism." *Divisionism/Neo-Impressionism: Arcadia and Anarchy*, ed. Vivian Green, 29–31. New York: Guggenheim Museum, 2007.

Glissant, Edouard. *Poetics of Relation*. Translated by Betsy Wing. Ann Arbor: University of Michigan Press, 1997.

Gluckman, Ann, ed. *Identity and Involvement: Auckland Jewry, Past and Present*. Palmerston North, New Zealand: Dunmore, 1990.

Godlweska, Anne. "Resisting the Cartographic Imperative: Giuseppe Bagetti's Landscapes of War." *Journal of Historical Geography* 29, no. 1 (2003): 22–50.

Gowing, Lawrence, et al. *Cézanne: The Early Years 1859-1872*. New York: Harry N. Abrams, 1988.

Gramsci, Antonio. *The Antonio Gramsci Reader*. Edited by David Forgacs. New York: New York University Press, 2000.

———. *Prison Notebooks*. Vol. 2. Edited and translated by Joseph A. Buttigieg. New York: Columbia University Press, 1996.

———. *Selections from Cultural Writings*. Edited by David Forgacs and Geoffrey Nowell-Smith. Translated by William Boelhower. Cambridge: Harvard University Press, 1985.

———. *Selections from Political Writings (1921-1926)*. Edited and translated by Quintin Hoare. New York: International Publishers, 1978.

———. *Selections from the Prison Notebooks*. London: Lawrence and Wishart, 1971.

———. *The Southern Question*. 1926. Translated by Pasquale Verdicchio. Toronto: Guernica Editions, 2005.

Gray, Colin S. *Recognizing and Understanding Revolutionary Change in Warfare: The Sovereignty of Context*. Carlisle, Penn.: Strategic Studies Institute, 2006.

Green, Vivian, ed. *Divisionism/Neo-Impressionism: Arcadia and Anarchy*. New York: Guggenheim Museum, 2007.

Greenberg, Karen J., and Joshua L. Dratel, eds. *The Torture Papers: The Road to Abu Ghraib*. New York: Cambridge University Press, 2004.

Greenberg, Kenneth S. *Honor and Slavery: Lies, Duels, Noses, Masks, Dressing as a Woman, Gifts, Strangers, Humanitarianism, Death, Slave Rebellions, The Proslavery Argument, Baseball, Hunting, and Gambling in the Old South*. Princeton: Princeton University Press, 1996.

Gregory, Derek. "American Military Imaginaries: The Visual Economies of Globalizing War." *Globalization, Violence and the Visual Culture of Cities*, ed. Christoph Linder, 67–84. New York: Routledge, 2010.

———. *The Colonial Present: Afghanistan, Palestine, Iraq*. Oxford: Blackwell, 2004.

———. "The Rush to the Intimate: Counterinsurgency and the Cultural Turn." *Radical Philosophy* 150 (July–August 2008), http://www.radicalphilosophy.com/.

Grierson, Herbert. *Carlyle and Hitler*. Cambridge: Cambridge University Press, 1933.

Grigsby, Darcy Grimaldo. *Extremities: Painting Empire in Post-Revolutionary France*. New Haven: Yale University Press, 1998.

Grove, Richard H. *Green Imperialism: Colonial Expansion, Tropical Island Edens and the Origins of Environmentalism*. Cambridge: Cambridge University Press, 1995.

Gruzinski, Serge. *Images at War: Mexico from Columbus to Blade Runner (1492–2019)*. Translated by Heather Maclean. Durham: Duke University Press, 2001.

Halberstam, Judith. *Female Masculinity*. Durham: Duke University Press, 1998.

Hall, Catherine. *Civilizing Subjects: Metropole and Colony in the English Imagination, 1830–1867*. Chicago: University of Chicago Press, 2002.

Hall, Neville A. T. *Slave Society in the Danish West Indies: St. Thomas, St. John and St. Croix*. Edited by B. W. Higman. Baltimore: Johns Hopkins University Press, 1992.

Halpin, Edward, Philippa Trevorrow, David Webb, and Steve Wright, eds. *Cyberwar, Netwar and the Revolution in Military Affairs*. New York: Palgrave MacMillan, 2006.

Hansen, Thorkild. *Islands of Slaves*. Translated by Kari Dako. Accra, Ghana: Sub-Saharan Publishers, 2004.

Hardt, Michael, and Antonio Negri. *Commonwealth*. Cambridge: Belknap Press, 2009.

Harley, J. H. *Syndicalism*. London: T. C. and E. C. Jack, 1912.

Harris, Kenneth Marc. *Carlyle and Emerson: Their Long Debate*. Cambridge: Harvard University Press, 1978.

Hartman, Saidiya V. *Scenes of Subjection: Terror, Slavery and Self-Making in Nineteenth-Century America*. Oxford: Oxford University Press, 1997.

Hartup, Cheryl D., ed. *Mi Puerto Rico: Master Painters of the Island 1782-1952*. Ponce: Museo de Arte de Ponce, 2006.

Hartup, Cheryl D., with Marimar Benítez. "The 'Grand Manner' in Puerto Rican Painting: A Tradition of Excellence." *Mi Puerto Rico: Master Painters of the Island 1782-1952*, ed. Cheryl D. Hartup, 1-36. Ponce: Museo de Arte de Ponce, 2006.

Haug, Wolfgang Fritz. "Philosophizing with Marx, Gramsci and Brecht." *Boundary 2* 34, no. 3 (2007): 143-60.

Hayles, N. Katherine. *How We Became Post-Human: Virtual Bodies in Cybernetics, Literature and Informatics*. Chicago: University of Chicago Press, 1999.

Heffer, Simon. *Moral Desperado: A Life of Thomas Carlyle*. London: Weidenfeld and Nicolson, 1995.

Hennigsen, Henning. *Dansk Vestindien I Gamle Billeder*. Copenhagen: Royal Museum of Copenhagen, 1967.

Higman, Barry. *Jamaica Surveyed: Plantation Maps and Plans of the Eighteenth and Nineteenth Centuries*. Kingston: Institute of Jamaica Publications, 1988.

Hill, Christopher. *Winstanley: The Law of Freedom and Other Writings*. Harmondsworth: Penguin, 1973.

———. *The World Turned Upside Down: Radical Ideas during the English Revolution*. New York: Viking, 1973.

Hilliard, David. *God's Gentlemen: A History of the Melanesian Mission, 1849-1942*. St Lucia, Queensland: University of Queensland Press, 1978.

Holt, Thomas. *The Problem of Freedom: Race, Labor and Politics in Jamaica and Britain, 1832-1938*. Baltimore: Johns Hopkins University Press, 1992.

Horan, James D. *Timothy O' Sullivan: America's Forgotten Photographer*. New York: Bonanza, 1966.

Horne, Alistair. *A Savage War of Peace: Algeria 1954-1962*. New York: New York Review of Books, 2006.

Horner, Frank. *The French Reconnaissance: Baudin in Australia 1801-1803*. Melbourne: Melbourne University Press, 1987.

Houlberg, Marilyn. "Magique Marasa: The Ritual Cosmos of Twins and Other Sacred Children." *Sacred Arts of Haitian Vodou*, ed. Donald Consentino, 267-84. Los Angeles: UCLA Fowler Museum of Cultural History, 1995.

Huberman, Michael, and Chris Minns. "The Times They Are Not Changin': Days and Hours of Work in Old and New Worlds, 1870-2000." *Explorations in Economic History* 44 (2007): 538-67.

Hughes, Griffith. *The Natural History of Barbados*. 1750. New York: Arno Press, 1972.

Hulme, Peter. *Colonial Encounters: Europe and the Native Caribbean*. New York: Methuen, 1986.

Jacob, Christian. *The Sovereign Map: Theoretical Approaches in Cartography throughout History*. Translated by Tom Conley. Chicago: University of Chicago Press, 2006.

James, C. L. R. *The Black Jacobins: Toussaint L'Ouverture and the San Domingo Revolution*. 1963. 2nd edition. New York: Vintage, 1989.

———. "The West Indian Intellectual." Introduction to *Froudacity: West Indian Fables by James Anthony Froude*, John Jacob Thomas, 23–48. London: New Beacon, 1969.

Janes, Regina. "Beheadings." *Representations* 35 (summer 1991): 21–51.

Jenkins, Mick. *The General Strike of 1842*. London: Lawrence and Wishart, 1982.

Jennings, Michael. "On the Banks of a New Lethe: Commodification and Experience in Benjamin's Baudelaire Book." *boundary 2* 30, no. 1 (2003): 89–104.

Jennings Rose, Hubert. *Ancient Roman Religion*. London: Hutchinson's, 1948.

Jones, Amelia. *Irrational Modernism: A Neurasthenic History of New York Dada*. Cambridge: MIT Press, 2004.

Judah, George Fortunatus. "The Jews Tribute in Jamaica: Extracted from the Journals of the House of Assembly in Jamaica." *Publication of the American Jewish Historical Society*, no. 18 (1909).

Juillard, Jacques. *Fernand Pelloutier et les origines du syndicalisme d'action directe*. Paris: Seuil, 1971.

Kacem, Mehdi Belhaj. *La psychose française: Les banlieues: Le ban de la République*. Paris: Gallimard, 2006.

Kaddish, Doris Y., ed. *Slavery in the Francophone World: Distant Voices, Forgotten Acts, Forged Identities*. Athens: University of Georgia Press, 2000.

Kantorowicz, Ernst. *The King's Two Bodies: A Study in Medieval Political Theology*. Princeton: Princeton University Press, 1957.

Kaplan, Amy, and Donald E. Pease, eds. *Cultures of United States Imperialism*. Durham: Duke University Press, 1993.

Katz, Philip M. *From Appomattox to Montmartre: Americans and the Paris Commune*. Cambridge: Harvard University Press, 1998.

Katzew, Ilona. *Casta Painting: Images of Race in Eighteenth Century Mexico*. New Haven: Yale University Press, 2004.

Keesing, Roger. "Rethinking Mana." Fortieth Anniversary Issue, 1944–1984, *Journal of Anthropological Research* 40, no. 1 (spring 1984): 137–56.

Keller, Richard C. *Colonial Madness: Psychiatry in French North Africa*. Chicago: University of Chicago Press, 2007.

Kenz, Nadia El. *L'Odysée des Cinémathèques: La Cinémathèque algérienne*. Roubia, Algeria: Editions ANEP, 2003.

Khanna, Ranjana. *Algeria Cuts: Women and Representation, 1830 to the Present*. Stanford: Stanford University Press, 2008.

Kilcullen, David. "Countering Global Insurgency." *Journal of Strategic Studies* 8, no. 4 (August 2006): 597–617.

Knauft, Bruce M. *From Primitive to Postcolonial in Melanesia and Anthropology*. Ann Arbor: University of Michigan Press, 1999.

Kriz, Kay Dian. "Curiosities, Commodities and Transplanted Bodies in Hans

Sloane's 'Natural History of Jamaica.'" *William and Mary Quarterly* 57, no. 1, 3rd series (January 2000): 35–78.

———. *Slavery, Sugar and the Culture of Refinement*. New Haven: Yale University Press, 2008.

Kriz, Kay Dian, and Geoff Quilley. *An Economy of Colour: Visual culture and the Atlantic World, 1660-1830*. New York: Manchester University Press, 2003.

Lacan, Jacques. *The Other Side of Psychoanalysis (The Seminar of Jacques Lacan Book 17)*. Edited by Jacques-Alan Miller. Translated by Russell Grigg. New York: Norton, 2007.

Lacerte, Robert K. "The Evolution of Land and Labor in the Haitian Revolution, 1791–1820," *Americas* 34, no. 4 (April 1978): 449–59.

Lake, Marilyn, and Henry Reynolds. *Drawing the Global Color Line: White Men's Countries and the International Challenge of Racial Equality*. New York: Cambridge, 2008.

Lavally, Albert J. *Carlyle and the Idea of the Modern: Studies in Carlyle's Prophetic Literature and Its Relation to Blake, Nietzsche, Marx and Others*. New Haven: Yale University Press, 1968.

Lawrence, T. E. *Secret Despatches from Arabia: And Other Writings*. Edited and introduced by Malcolm Brown. London: Bellew, 1991.

Le Bon, Gustave. *The Crowd: A Study of the Popular Mind*. Introduction by Robert K. Merton. New York: Penguin, 1960.

Lefebvre, Georges. *La Proclamation de la Commune, 26 mars 1871*. Paris: Gallimard, 1965.

Lemann, Nicholas. *Redemption: The Last Battle of the Civil War*. New York: Farrar, Strauss and Giroux, 2006.

Lespinasse, Beauvais. *Histoire des affranchis de Saint-Domingue*. Vol. 1. Paris: Joseph Kugelman, 1882.

Le Sueur, James D. *Uncivil War: Intellectuals and Identity Politics during the Decolonization of Algeria*. 2nd edition. Lincoln: University of Nebraska Press, 2005.

Levine, Philippa. *Prostitution, Race and Politics: Policing Venereal Disease in the British Empire*. New York: Routledge, 2003.

Lévi-Strauss, Claude. *Introduction to the Work of Marcel Mauss*. 1950. Translated by Felicity Baker. London: Routledge and Kegan Paul, 1987.

Lévy-Bruhl, Lucien. *The "Soul" of the Primitive*. 1928. Translated by Lillian A. Claire. New York: Frederick A. Praeger, 1966.

Lewis, David Levering. *W. E. B. Du Bois: Biography of a Race, 1868-1919*. New York: Henry Holt, 1993.

———. *W. E. B. Du Bois: The Fight for Equality and the American Century, 1919-1963*. New York: Henry Holt, 2000.

Lewis, Lloyd, and Henry Justin Smith. *Oscar Wilde Discovers America (1882)*. New York: Harcourt Brace, 1936.

Licciardelli, G. *Benito Mussolini e Tommasso Carlyle: La nuova aristocrazia*. Milan: n.p., 1931.

Linder, Christoph. ed. *Globalization, Violence and the Visual Culture of Cities*. New York: Routledge, 2010.

Linebaugh, Peter, and Marcus Rediker. *The Many-Headed Hydra: Sailors, Slaves, Commoners, and the Hidden History of the Revolutionary Atlantic*. Boston: Beacon, 2000.

Lise, Claude, ed. *Droits de l'homme et Abolition d'esclavage: Exposition organisée par les Archives départmentales de la Martinique*. Fort-de-France, Martinique: Archives départmentales, 1998.

Lissagaray, Prosper. *History of the Paris Commune of 1871*. 1876. Translated by Eleanor Marx. London: New Park, 1976.

Lloyd, Christopher. "Camille Pissarro and Francisco Oller." *Francisco Oller: Un realista des Impressionismo / Francisco Oller: A Realist-Impressionist*, by Haydée Venegas, 89–101. New York: Museo del Barrio, 1983.

Logan, Rayford W. "Education in Haiti." *Journal of Negro History* 15, no. 4 (October 1930): 414.

Long, Edward. *A History of Jamaica*. 1774. Edited by George Metcalf. 3 vols. London: Frank Cass, 1970.

Lotringer, Sylvere, ed. *Autonomia: Post-Political Politics*. 1979. Los Angeles: Semiotexte, 2007.

Lotringer, Sylvere, and Christian Marazzi. "The Return of Politics." *Autonomia: Post-Political Politics*, ed. Sylvere Lotringer, 8–23. Los Angeles: Semiotexte, 2007.

Luxemburg, Rosa. *The Mass Strike: The Political Party and the Trade Unions*. 1906. Translated by Patrick Lavin. New York: Harper and Row, 1971.

Lyotard, Jean-François. *La guerre des Algériens: Ecrits 1956-1963*. Paris: Galilée, 1989.

Macey, David. *Frantz Fanon: A Life*. London: Granta, 2000.

MacGaffey, Wyatt. "Aesthetics and Politics of Violence in Central Africa." *African Cultural Studies* 13, no. 1 (June 2000): 63–75.

Mackinlay, John, and Alison al-Baddawy. *Rethinking Counterinsurgency*. Vol. 5 of RAND Counterinsurgency Study. Santa Monica: RAND National Defense Research Institute, 2007.

Madiou, Thomas. *Histoire d'Haiti*. 3 vols. Haiti: Port-au-Prince, 1947–48.

Makdisi, Saree. *Romantic Imperialism: Universal Empire and the Culture of Modernity*. Cambridge: Cambridge University Press, 1998.

Maldonado Torres, Nelson. *Against War: Views from the Underside of Modernity*. Durham: Duke University Press, 2008.

Manet, Edouard. *Lettres du Siège de Paris, précédés des Lettres de voyage à Rio de Janeiro*. Edited by Arnauld Le Brusq. Vendôme: Editions de l'Amateur, 1996.

Manning, Brian. *The Far Left in the English Revolution 1640-1660*. London: Bookmarks, 1999.

Manthorne, Katherine. "Plantation Pictures in the Americas, circa 1880: Land, Power, and Resistance." *Nepantla* 2, no. 2 (2001): 343–49.

Marett, R. R., ed. *Anthropology and the Classics*. Oxford: Clarendon, 1908.

————. *The Threshold of Religion*. Oxford: Clarendon, 1909.

Marin, Louis. *The Portrait of the King*. Translated by Martha M. Houle. Minneapolis: University of Minnesota Press, 1988.

Markus, Julia. *J. Anthony Froude: The Last Undiscovered Great Victorian*. New York: Scribner, 2005.

Marx, Karl. *Capital*. Translated by Ben Fowkes. Harmondsworth: Penguin, 1977.

————. *The Civil War in France: The Paris Commune*. 2nd edition. New York: International Publishers, 1993.

————. *The Eighteenth Brumaire of Louis Bonaparte*. 1852. Reprinted in *Surveys from Exile: Political Writings*. New York: Vintage, 1974.

Marx, Karl, and Friedrich Engels. *Marx and Engels 1844-1845*. Vol. 4 of *Collected Works of Karl Marx and Friedrich Engels*. London: Lawrence and Wishart, 1975.

Marx, Karl, and V. I. Lenin. *The Civil War in France: The Paris Commune*. 2nd edition. New York: International Publishers, 1993.

Marx, Roger. "Salon de 1895." *Gazette des Beaux-Arts* 14, series 3 (August 1895): 442.

Mathiez, Albert. *La Vie Chère et le mouvement social sous la Terreur*. Paris: Payot, 1927.

Matos-Rodriguez, Felix V. "Street Vendors, Pedlars, Shop-Owners and Domestics: Some Aspects of Women's Economic Roles in Nineteenth-Century San Juan, Puerto Rico." *Engendering History: Caribbean Women in Historical Perspective*, ed. Verene Shepherd, Bridget Brereton, and Barbara Bailey, 176–93. Kingston, Jamaica: Ian Randle, 1995.

Maurel, Blanche, ed. *Cahiers de Doléances de la colonie de Saint-Domingue pour les Etats-Généraux de 1789*. Paris: Ernest Leroux, 1933.

Mbembe, Achille. *De la postcolonie: Essai sur l'imagination politique dans l'Afrique contemporaine*. Paris: Editions Karthala, 2000.

————. "Necropolitics." Translated by Libby Meintjes. *Public Culture* 15, no. 1: 11–40.

————. *On the Postcolony*. Translated by A. M. Berrett et al. Berkeley: University of California Press, 2002.

McClellan, James E. *Colonialism and Science: Saint-Domingue in the Old Regime*. Baltimore: Johns Hopkins University Press, 1992.

McClellan, James E., and François Regourd. "The Colonial Machine: French Science and Colonization in the Ancien Régime." In "Nature and Empire: Science and the Colonial Enterprise." *Osiris* 15, 2nd series (2000): 31–50.

McElvey, Tara. "The Cult of Counterinsurgency." *American Prospect* 19, no. 11 (November 2008): 21.

McHugh, Paul. *The Maori Magna Carta: New Zealand Law and the Treaty of Waitangi*. Auckland: Oxford University Press, 1991.

————. "Tales of Constitutional Origin and Crown Sovereignty in New Zealand." In "Liberal Democracy and Tribal Peoples: Group Rights in Aotearoa/New Zealand." *University of Toronto Law Journal* 52, no. 1 (winter 2002): 69–100.

Métraux, Alfred. *Haiti: Black Peasants and Voodoo*. Translated by Peter Lengyel. New York: Universe Books, 1960.

Mignolo, Walter D. "Delinking: The Rhetoric of Modernity, The Logic of Coloniality and the Grammar of Decoloniality." *Cultural Studies* 21, nos. 2–3 (March–May 2007): 449–514.

———. "The Geopolitics of Knowledge and the Colonial Difference." *South Atlantic Quarterly* 101, no. 2 (winter 2002): 57–96.

Miller, Christopher L. *The French Atlantic Triangle: Literature and Culture of the Slave Trade*. Durham: Duke University Press, 2008.

Miller, Lillian B., ed. *The Selected Papers of Charles Willson Peale and His Family*. 5 vols. New Haven: Yale University Press, 2000.

Miller, Paul B. "Enlightened Hesitations: Black Masses and Tragic Heroes in C. L. R. James's *The Black Jacobins*." *Modern Language Notes* 116, no. 5 (December 2001): 1069–90.

Mirzoeff, Nicholas. "Aboriginality: Gesture, Encounter and Visual Culture." *Migrating Images*, ed. Petra Stegman, 25–35. Berlin: Haus der Kulturen der Welt, 2004.

———. "Disorientalism: Minority and Visuality in Imperial London." *TDR* 51 (summer 2006): 52–69.

———. "On Visuality." *Journal of Visual Culture* 5, no. 1 (April 2006): 53–80.

———. "Revolution, Representation, Equality: Gender, Genre, and Emulation in the Académie Royale de Peinture et Sculpture, 1785–93." *Eighteenth-Century Studies* 31, no. 2 (1997–98): 153–74.

———. *Watching Babylon: The War in Iraq and Global Visual Culture*. London: Routledge, 2005.

The Missionary Register. London: L. B. Seeley, 1834–46.

Mitchell, Peter. *Jean Baptiste Antoine Guillemet 1841-1918*. London: John Mitchell and Son, 1981.

Mitchell, Timothy. "The Stage of Modernity." *Questions of Modernity*, ed. Timothy Mitchell, 1–20. Minneapolis: University of Minnesota Press, 2000.

Mitchell, W. J. T. "Chaosthetics: Blake's Sense of Form." In "William Blake: Images and Texts." *Huntington Library Quarterly* 58, nos. 3–4 (1995): 441–58.

———. *Picture Theory*. Chicago: University of Chicago Press, 2004.

———. *What Do Pictures Want? The Lives and Loves of Images*. Chicago: University of Chicago Press, 2005.

Moore, Clive. *New Guinea: Crossing Boundaries and History*. Honolulu: University of Hawai'i, 2003.

Moraña, Mabel, Enrique Dussel, and Carlos A. Jáuregui. "Colonialism and Its Replicants." *Coloniality at Large: Latin America and the Postcolonial Debate*, ed. Mabel Moraña, Enrique Dussel, and Carlos A. Jáuregui, 1–22. Durham: Duke University Press, 2008.

Moreau de Saint Mery. *Description topographique de l'isle de Saint-Domingue*. 3 vols. Paris: n.p., 1797.

Moreno Fraginals, Manuel. *The Sugar Mill: The Socioeconomic Complex of Sugar in Cuba, 1760-1860*. Translated by Cedric Belfrage. New York: Monthly Review Press, 1976.

Moreno Vega, Marta. "Espiritismo in the Puerto Rican Community: A New World Recreation with the Elements of Kongo Ancestor Worship." *Journal of Black Studies* 29, no. 3 (January 1999): 325–53.

Morris, Pam. "Heroes and Hero-Worship in Charlotte Bronte's *Shirley*." *Nineteenth-Century Literature* 54, no. 3 (1999): 285–307.

"Motion Faite par M. Vincent Ogé, jeune, à l'Assemblée des COLONS, Habitans de S-Domingue, à l'Hôtel de Massiac, Place des Victoires." 1789. *La Révolte des Noires et des Creoles*, Vol. 11, *La Révolution française et l'abolition de l'esclavage*. Paris: Editions d'Histoire Sociale, n.d.

Murphy, Cullen. *Are We Rome? The Fall of an Empire and the Fate of America*. New York: Houghton Mifflin, 2007.

Napoleon, Louis. *Analysis of the Sugar Question*. 1842. Reprinted in *The Political and Historical Works of Louis Napoleon Bonaparte*. 5 vols. 1852; reprint, New York: Howard Fertig, 1972.

Nealon, Jeffrey T. *Foucault beyond Foucault: Power and Its Intensification since 1984*. Stanford: Stanford University Press, 2008.

Negri, Antonio. *Time for Revolution*. Translated by Matteo Mandarini. New York: Continuum, 2003.

Nesbitt, Nick, ed. *Toussaint L'Ouverture: The Haitian Revolution*. Introduction by Jean-Bertrand Aristide. New York: Verso, 2008.

Newton, A. P. *A Hundred Years of the British Empire*. London: Duckworth, 1940.

Ngũgĩ wa Thiong'o. *Decolonizing the Mind: The Politics of Language in African Literature*. London: James Curry, 1981.

Niva, Steve. "Walling Off Iraq: Israel's Imprint on U.S. Counterinsurgency Doctrine." *Middle East Policy* 15, no. 3 (fall 2008): 67–79.

O'Brien, James Bronterre. *The Rise, Progress and Phases of Human Slavery*. London: n.p., 1885.

O'Hanlon, Michael E., and Jason H. Campbell, eds. *Iraq Index: Tracking Variables of Reconstruction and Security in Post-Saddam Iraq*. Washington: Saban Center for Middle East Policy, Brookings Institute, February 2009.

Oliver, Kelly. "The Look of Love." *Hypatia* 16, no. 3 (summer 2001): 56–78.

Ophir, Adi, Michal Gavoni, and Sari Hanafi, eds. *The Power of Inclusive Exclusion: Anatomy of Israeli Rule in the Occupied Palestinian Territories*. New York: Zone, 2009.

Orange, Claudia. *The Treaty of Waitangi*. Wellington: Bridget Williams Books, 1997.

Orwell, George. *1984*. New York: Signet, 1990.

Osborne, C. Ward. *The Ancient Lowly: A History of the Ancient Working People from the*

Earliest Known Period to the Adoption of Christianity by Constantine. 2 vols. Chicago: Charles H. Kerr Co-Operative, 1907.

O'Toole, Fintan. "Venus in Blue Jeans: Oscar Wilde, Jesse James, Crime and Fame." *Wilde the Irishman*, ed. Jerusha McCormack, 71–81. New Haven: Yale University Press, 1998.

Paiewonsky, Michael, ed. Special edition, *St. Thomas Historical Journal* (2003).

Paine, Thomas. *The Rights of Man.* Reprinted in *Thomas Paine Political Writings*, ed. Bruce Kuklick. Cambridge: Cambridge University Press, 1987.

Painter, Nell Irvin. *Sojourner Truth: A Life, A Symbol.* New York: W. W. Norton, 1996.

Pantelogiannis, Famourious. "RMA: The Russian Way." *Cyberwar, Netwar and the Revolution in Military Affairs*, ed. Edward Halpin, Philippa Trevorrow, David Webb, and Steve Wright, 157–59. New York: Palgrave MacMillan, 2006.

Parks, Lisa. *Cultures in Orbit: Satellites and the Televisual.* Durham: Duke University Press, 2005.

Paton, Diana. *No Bond but the Law: Punishment, Race, and Gender in Jamaican State Formation, 1780–1870.* Durham: Duke University Press, 2004.

Payne, Kenneth. "Waging Communication War." *Parameters* 38, no. 2 (summer 2008): 48–49.

Pease, Donald E. "Hiroshima, the Vietnam Veterans War Memorial, and the Gulf War." *Cultures of United States Imperialism*, ed. Amy Kaplan and Donald E. Pease, 557–80. Durham: Duke University Press, 1993.

Pelloutier, Fernand. *L'Art et la Révolte: Conférence prononcé le 30 mai 1896.* Edited by Jean-Pierre Lecercle. Paris: Editions Place d'Armes, 2002.

Pétion, J. *Discours sur les Troubles de Saint-Domingue.* Paris: 14 October 1790.

Petraeus, General David. *FM 3-24 Counterinsurgency.* Washington: Headquarters Department of the Army, 2006.

Pfaltzgraff Jr., Robert L., and Richard H. Shultz Jr., eds. *War in the Information Age: New Challenges for U.S. Security Policy.* Washington: Brassey's, 1997.

Pinel, Philippe de. *A Treatise on Insanity.* Translated by D. D. Davis. Sheffield: Cadell and Davis, 1806.

Pissarro, Joachim. *Cézanne and Pissarro: Pioneering Modern Painting, 1865–1885.* New York: Museum of Modern Art, 2006.

Plomley, N. J. B. *The Baudin Expedition and the Tasmanian Aborigines 1802.* Hobart: Blubber Head Press, 1983.

Plonowksa Ziarek, Ewa. "Bare Life on Strike: Notes on the Politics of Race and Gender." *South Atlantic Quarterly* 107, no. 1 (winter 2008): 89–105.

Plotz, John. "Crowd Power: Chartism, Thomas Carlyle and the Victorian Public Sphere." *Representations* 70 (Spring 2000): 87–114.

Pluchon, Pierre. *Vaudou, sorciers, empoisonneurs de Saint-Domingue à Haïti.* Paris: Editions Karthala, 1987.

Pointon, Marcia. *Naked Authority: The Body in Western Art 1830-1908*. Cambridge: Cambridge University Press, 1990.

"Police Reports on the Journées of February, 1793." *Women in Revolutionary Paris 1789-1795*, ed. and trans. Darline Gay Levy, Harriet Branson Applewhite, Mary Durham Johnson, 133–43. Urbana: University of Illinois Press, 1979.

Porter, Theodore M. *The Rise of Statistical Thinking 1820-1900*. Princeton: Princeton University Press, 1986.

Porton, Richard. "Collective Guilt and Individual Responsibility: An Interview with Michael Haneke." *Cineaste* 31, no. 1 (winter 2005): 50–51.

Prothero, Iorwerth. "William Benbow and the Concept of the 'General Strike.'" *Past and Present* 63 (May 1974): 132–71.

Pupil, François. "Le dévouement du chevalier Desilles et l'affaire de Nancy en 1790: Essai de catalogue iconographique." *Le Pays Lorrain*, no. 2 (1976): 73–110.

Pursell Jr., Carroll W., ed. *The Military-Industrial Complex*. New York: Harper and Row, 1972.

Pynchon, Thomas. *Gravity's Rainbow*. 1973. New York: Penguin, 1987.

Racconti di bambini d'Algeria: Testimonianze e desegni di bambini profughi in Tunisia, Libia e Marocco. Translated by Giovanni Pirelli. Turin: Giulio Einaudi, 1962.

Rae, John. "The Eight Hours' Day in Australia." *Economic Journal* 1, no. 3 (September 1891): 528.

Rainsford, Marcus. *An Historical Account of the Black Empire of Hayti: Comprehending a View of the Principal Transactions in the Revolution of Saint Domingo; With Its Antient and Modern State*. London: J. Cundee, 1805.

Ramdani, Mohammed. "L'Algérie, un différend." Introduction to *La guerre des Algériens: Ecrits 1956-1963*, by Jean-François Lyotard, 9–32. Paris: Galilée, 1989.

Ramsden, Eric. *Marsden and the Missions: Prelude to Waitangi*. Dunedin: A. H. and A. W. Reed, 1936.

Rancière, Jacques. *Aux bords de la politique*. Paris: Gallimard, 1998.

———. *The Future of the Image*. Translated by Gregory Elliott. New York: Verso, 2007.

———. *Hatred of Democracy*. Translated by Steve Corcoran. New York: Verso, 2006.

———. *The Ignorant Schoolmaster: Five Lessons in Intellectual Emancipation*. Translated and with an introduction by Kristen Ross. Stanford: Stanford University Press, 1991.

———. "Introducing Disagreement." Translated by Steven Corcoran. *Angelaki* 9, no. 3 (December 2004): 3–9.

———. *The Philosopher and His Poor*. Edited and with an introduction by Andrew Parker. Translated by John Drury, Corinne Oster, and Andrew Parker. Durham: Duke University Press, 2004.

———. *Politics and Aesthetics*. Translated by Gabriel Rockhill. New York: Continuum, 2004.

————. *Short Voyages to the Land of the People*. Translated by James B. Sewnson. Stanford: Stanford University Press, 2003.

————. "Ten Theses on Politics." Translated by Davide Panagia, Rachel Bowlby, and Jacques Rancière. *Theory and Event* 5, no. 3 (2001).

[Ransom, John Crowe, et al.] *I'll Take My Stand: The South and the Agrarian Tradition, by Twelve Southerners*. 1930. New introduction by Susan V. Donaldson. Baton Rouge: Louisiana University Press, 2006.

Raynal, Abbé. *A Philosophical and Political History of the Settlements and Trade of the Europeans in the East and West Indies*. 6 vols. Edinburgh: Mundell and Son, 1804.

Rediker, Marcus. *The Slave Ship: A Human History*. New York: Viking, 2007.

Reichardt, Rolf. "Light against Darkness: The Visual Representations of a Central Enlightenment Concept." In "Practices of Enlightenment," special issue, *Representations*, no. 61 (winter 1998): 95–148.

Reid, Julian. *The Biopolitics of the War on Terror: Life Struggles, Liberal Modernity, and the Defence of Logistical Societies*. New York: Palgrave, 2006.

Reinhardt, Catherine. "French Caribbean Slaves Forge Their Own Ideal of Liberty in 1789." *Slavery in the Francophone World: Distant Voices, Forgotten Acts, Forged Identities*, ed. Doris Y. Kaddish, 19–38. Athens: University of Georgia Press, 2000.

Report for the Select Committee of the House of Lords Appointed to Inquire into the Present State of the Islands of New Zealand. London: House of Commons, 1838.

Retort. *Afflicted Powers: Capital and Spectacle in a New Age of War*. New York: Verso, 2005.

Ricks, Thomas. *Fiasco: The American Military Adventure in Iraq, 2003 to 2005*. New York: Penguin, 2007.

Rigney, Ann. "The Untenanted Places of the Past: Thomas Carlyle and the Varieties of Historical Ignorance." *History and Theory* 35, no. 3 (October 1996): 338–57.

Rishell, Joseph J., and Suzanne Stratton-Pruitt. *The Arts in Latin America 1492-1820*. Philadelphia: Philadelphia Museum of Art, 2006.

Roach, Joseph. *Cities of the Dead: Circum-Atlantic Performance*. New York: Columbia University Press, 1996.

Roberts, Warren. "Images of Popular Violence in the French Revolution: Evidence for the Historian?" http://chnm.gmu.edu/revolution/imaging/essays.html.

Ronel, Avital. *The Test Drive*. Urbana: University of Illinois Press, 2005.

Roper, Col. Daniel S. "Global Counterinsurgency: Strategic Clarity for the Long War." *Parameters* 38, no. 3 (autumn 2008): 92–108.

Rosenfeld, Jean A. *The Island Broken in Two Halves: Land and Renewal Movements among the Maori of New Zealand*. University Park: Pennsylvania State University Press, 1999.

Rosenthal, Odeda. *Not Strictly Kosher: Pioneer Jews in New Zealand*. North Bergen, N.J.: Bookmart, 1988.

Ross, Kristin. *The Emergence of Social Space: Rimbaud and the Paris Commune*. Minneapolis: University of Minnesota Press, 1988.

———. *May '68 and Its Afterlives*. Chicago: University of Chicago Press, 2002.

Roux, Marcel. *Inventaire du Fonds Français: Graveurs du dix-huitième siècle*. Paris: Bibliothèque Nationale, 1930.

Rüter, A. J. C. "William Benbow's Grand National Holiday and Congress of the Productive Classes." *International Review for Social History* 1 (1936): 217–36.

Ryan, Lyndall. *The Aboriginal Tasmanians*. St Lucia: University of Queensland Press, 1981.

Sabine, George H., ed. *The Works of Gerrard Winstanley*. Ithaca: Cornell University Press, 1941.

Said, Edward. *Orientalism*. New York: Viking, 1978.

Sala-Molins, Louis. *Dark Side of the Light: Slavery and the French Enlightenment*. Translated by John Conteh Morgan. Minneapolis: University of Minnesota Press, 2006.

———. *Le Code Noir, ou le calvaire de Canaan*. Paris: Presses Universitaires de France, 1987.

Samuel, Raphael. "British Marxist Historians, 1880–1980, Part 1." *New Left Review* 1, no. 120 (March–April 1980): 21–96.

Samuel, Wilfred S. *A Review of the Jewish Colonists in Barbados in the Year 1680*. London: Purnell and Sons, 1936.

Scarry, Elaine. *The Body in Pain: The Making and Unmaking of the World*. New York: Oxford University Press, 1985.

Scheider, Jane, ed. *Italy's "Southern Question": Orientalism in One Country*. New York: Berg, 1998.

Schoch, Richard W. "'We Do Nothing but Enact History': Thomas Carlyle Stages the Past." *Nineteenth-Century Literature* 54, no. 1 (June 1999): 27–52.

Schorsch, Jonathan. *Jews and Blacks in the Early Modern World*. Cambridge: Cambridge University Press, 2004.

Scott, David. *Conscripts of Modernity: The Tragedy of Colonial Enlightenment*. Durham: Duke University Press, 2004.

Seeley, J. R. *The Expansion of England: Two Courses of Lectures*. 1883. New York: Cosimo, 2005.

Semple, Janet. *Bentham's Prison: A Study of the Panopticon Penitentiary*. Oxford: Clarendon, 1993.

Servant, C. *Customs and Habits of the New Zealanders 1838–42*. Translated by J. Glasgow. Edited by D. R. Simmons. London: A. H. and A. W. Reed, 1973.

Sewall, Sarah. "A Radical Field Manual: Introduction to the University of Chicago Press Edition." *U.S. Army Marine Corps Counterinsurgency Field Manual*, xxi-xlv. Chicago: University of Chicago Press, 2007.

Shaw, Rosalind. *Memories of the Slave Trade: Ritual and Historical Imagination in Sierra Leone.* Chicago: University of Chicago Press, 2002.

Shepard, Todd. *The Invention of Decolonization: The Algerian War and the Remaking of France.* Ithaca: Cornell University Press, 2006.

Shepherd, Verene, Bridget Brereton, and Barbara Bailey, eds. *Engendering History: Caribbean Women in Historical Perspective.* Kingston: Ian Randle, 1995.

Siegfried, Susan Locke. "Naked History: The Rhetoric of Military Painting in Post-revolutionary France." *Art Bulletin* 75, no. 2 (June 1993): 235–58.

Sillanpoa, Wallace P. "Pasolini's Gramsci." *Modern Language Notes* 96, no. 1 (January 1981): 120–37.

Simmons, Clare A. *Reversing the Conquest: History and Myth in Nineteenth-Century British Literature.* New Brunswick: Rutgers University Press, 1990.

Simpson, Jane. "Io as Supreme Being: Intellectual Colonization of the Maori?" *History of Religions* 78, no. 1 (August 1997): 50–85.

Sloane, Hans. *A Voyage to the Islands Madera, Barbados, Nieves, S. Christophers and Jamaica, with the Natural History of the Herbs, and Trees, Four Footed Beasts, Fishes, Birds, Insects, Reptiles etc. of the last of these Islands.* 2 vols. London: n.p., 1707.

Smajic, Srdjan. "The Trouble with Ghost-seeing: Vision, Ideology, and Genre in the Victorian Ghost Story." *ELH* 70, no. 4 (winter 2003): 1107–35.

Small Wars Manual: United States Marine Corps 1940. Washington: U.S. Government Printing Office, 1940.

Smith, Faith. *Creole Recitations: John Jacob Thomas and Colonial Formation in the Late Nineteenth Century Caribbean.* Charlottesville: University of Virginia Press, 2002.

Smith, Paul Julian. "Pan's Labyrinth." *Film Quarterly* 60 (summer 2007): 4–8.

Smith, Terry. *Making the Modern: Industry, Art and Design in America.* Chicago: University of Chicago Press, 1993.

———. "Visual Regimes of Colonization: Aboriginal Seeing and European Vision in Australia." *The Visual Culture Reader*, 2nd edition., ed. Nicholas Mirzoeff, 483–94. London: Routledge, 2002.

Smith, Terry, Okwui Enwezor, and Nancy Condee, eds. *Antinomies of Art and Culture: Modernity, Postmodernity, Contemporaneity.* Durham: Duke University Press, 2008.

Smithyman, Kendrick. *Atua Wera.* Auckland: University of Auckland Press, 1997.

Soboul, Albert. *The Parisian Sans-Culottes and the French Revolution, 1793-4.* Translated by Gwynne Lewis. Oxford: Clarendon, 1964.

Sorel, Georges. *Reflections on Violence.* 1906. Edited and translated by Jeremy Jennings. Cambridge: Cambridge University Press, 1999.

Soto-Crespo, Ramón E. "'The Pains of Memory': Mourning the Nation in Puerto Rican Art and Literature." *Modern Language Notes* 117, no. 2 (2002): 449–80.

Spivak, Gayatri Chakravorty. *A Critique of Postcolonial Reason: Toward a History of the Vanishing Present.* Cambridge: Harvard University Press, 1999.

————. "Righting Wrongs." *South Atlantic Quarterly* 103, nos. 2–3 (winter 2004): 523–81.

Stedman Jones, Gareth. "The Redemptive Power of Violence? Carlyle, Marx and Dickens." *History Workshop Journal*, no. 65 (2008): 11–14.

Stewart, John. *A View of the Past and Present State of the Island of Jamaica*. 1823. New York: Negro Universities Press, 1969.

Stoler, Ann Laura. *Race and the Education of Desire: Foucault's* History of Sexuality *and the Colonial Order of Things*. Durham: Duke University Press, 1995.

Stoll, Steven. "Toward a Second Haitian Revolution." *Harper's* 320, no. 1919 (April 2010): 7–10.

Stora, Benjamin. *Algeria 1830-2000: A Short History*. Translated by Jane Marie Todd. Ithaca: Cornell University Press, 2001.

————. *Imaginaires de guerre: Algérie-Viêtnam, en France et aux Etats-Unis*. Paris: La Découverte, 1997.

Sturken, Marita, and Lisa Cartwright. *Practices of Looking*. New York: Oxford University Press, 2009.

Sullivan, Edward J. "The Black Hand: Notes on the African Presence in the Visual Arts of Brazil and the Caribbean." *The Arts in Latin America, 1492-1820*, curated by Joseph J. Rishel and Suzanne Stratton-Pruitt, 42–44. Philadelphia: Philadelphia Museum of Art, 2006.

————, ed. *Continental Shifts: The Art of Edouard Duval Carrié*. Miami: American Art Corporation, 2007.

Suskind, Ron. "Faith, Certainty and the Presidency of George W. Bush." *New York Times Magazine*, 17 October 2004.

Sydenham, Michael J. *Léonard Bourdon: The Career of a Revolutionary, 1754-1807*. Waterloo, Ontario: Wilfred Laurier University Press, 1999.

Tadman, Michael. *Speculators and Slaves: Masters, Traders, and Slaves in the Old South*. 2nd edition. Madison: University of Wisconsin Press, 1996.

Taylor, Diana. *The Archive and the Repertoire: Performing Cultural Memory in the Americas*. Durham: Duke University Press, 2003.

Taylor, René, ed. *José Campeche y su tiempo / José Campeche and His Time*. Ponce: Museo de Arte de Ponce, 1988.

Taylor, Timothy. "Believing the Ancients: Quantitative and Qualitative Dimensions of Slavery and the Slave Trade in Later Prehistoric Eurasia." In "The Archaeology of Slavery." *World Archaeology* 33, no. 1 (June 2001): 27–43.

Thibaudeau, A. C. *Recueil des action heroiques et civiques des Republicans Francais*. Paris: Convention Nationale, n.d., 1794.

Thiec, Yvon J. "Gustave Le Bon, prophète de l'irrationalisme de masse." In "Sociologies Françaises au Tournant du Siècle: Les concurrents du groupe durkheimen." *Revue Française de Sociologie* 22, no. 3 (July–September 1981): 409–28.

Thierry, Augustin. *Essai sur l'histoire de la formation et des progrès du Tiers Etat.* 2nd edition. Paris: Garnier Frères, 1867.

———. *Lettres sur l'histoire de France: Dix ans d'études historiques.* Paris: Furne, Jouvet et Cie, 1866.

Thomas, Greg. *The Sexual Demon of Colonial Power: Pan-African Embodiment and Erotic Schemes of Empire.* Bloomington: Indiana University Press: 2007.

Thomas, John Jacob. *Froudacity: West Indian Fables by James Anthony Froude.* 1889. London: New Beacon, 1969.

Thompson, E. P. "Time, Work Discipline and Industrial Capitalism." Reprinted in *Beyond the Body Proper: Reading the Anthropology of Material Life,* ed. Margaret Lock and Judith Farquhar, 494–511. Durham: Duke University Press, 2007.

———. *Witness against the Beast: William Blake and the Moral Law.* New York: New Press, 1993.

Tobin, Beth Fowkes. *Picturing Imperial Power: Colonial Subjects in Eighteenth-Century British Painting.* Durham: Duke University Press, 1999.

Tocqueville, Alexis de. *Democracy in America.* Translated by J. P. Mayer. New York: Harper Perennial, 1966.

Trevelyan, G. M. *British History in the Nineteenth Century and After: 1782-1919.* 1922. 2nd edition. London: Longmans, Green, 1947.

Trouillot, Michel-Rolph. "An Unthinkable History." *Silencing the Past: Power and the Production of History,* 70–107. Boston: Beacon, 1995.

Turner, Stephen. "Sovereignty, or the Art of Being Native." *Cultural Critique,* no. 51 (spring 2002): 74–100.

Tylor, Edward B. *Primitive Culture.* Vol. 1. London: John Murray, 1871.

Urbinati, Nadia. "The Souths of Antonio Gramsci and the Concept of Hegemony." *Italy's "Southern Question": Orientalism in One Country,* ed. Jane Scheider, 135–56. New York: Berg, 1998.

The U.S. Army Marine Corps Counterinsurgency Field Manual. Chicago: University of Chicago Press, 2007.

Vattel, Emmerich de. *Le Droit des Gens.* 1758. Translated by Charles G. Fenwick. 1902; reprint, New York: Oceana Publications / Windy and Sons, 1964.

Vautier, René. *Camera citoyenne: Mémoires.* Paris: Editions Apogée, 1998.

Veer, Peter van der, ed. *Conversion to Modernities: The Globalization of Christianity.* London: Routledge, 1995.

Venegas, Haydée. *Francisco Oller: Un realista des Impressionismo / Francisco Oller: A Realist-Impressionist.* New York: Museo del Barrio, 1983.

———. "Oller Chronology." *Campeche, Oller, Rodón: Tres Siglos de Pintura Puertorriqueña / Campeche, Oller, Redon: Three Centuries of Puerto Rican Painting,* by Francisco J. Barrenechea et al. San Juan: Instituto de Cultura Puertorriqueña, 1992.

Vergès, François. "Creole Skin, Black Mask: Fanon and Disavowal." *Critical Inquiry* 23, no. 3 (spring 1997): 578–95.

Viano, Maurizio. "The Left According to the Ashes of Gramsci." *Social Text* 18 (winter 1987–88): 51–60.

Vickers, Michael J. "The Revolution in Military Affairs and Military Capabilities." *War in the Information Age: New Challenges for U.S. Security Policy*, ed. Robert L. Pfaltzgraff Jr. and Richard H. Shultz Jr., 30–34. Washington: Brassey's, 1997.

Villarejo, Amy. *Lesbian Rule: Cultural Criticism and the Value of Desire*. Durham: Duke University Press, 2003.

Virno, Paolo. *A Grammar of the Multitude*. Translated by Isabella Bertoletti et al. New York: Semiotext(e): 2004.

Vollard, Ambroise. *Paul Cézanne*. Translated by Harold Van Doren. New York: Crown, 1937.

Vovelle, Michel, ed. *Marat: Textes choisis*. Paris: Editions Sociales, 1975.

———. *La révolution française: Images et recit 1789-1799*. 5 vols. Paris: Messidor / Livre Club Diderot, 1986.

Wagenvoort, H. *Roman Dynamism: Studies in Ancient Roman Thought, Language and Custom*. Oxford: Basil Blackwell, 1947.

Walcott, Derek. *Tiepolo's Hound*. New York: Farrar, Strauss and Giroux, 2000.

Walker, Ranganui. *Nga Pepa A Ranginui: The Walker Papers*. Auckland: Penguin, 1996.

Wedderburn, Robert. *The Horrors of Slavery and Other Writings by Robert Wedderburn*. Edited by Iain McCalman. New York: Markus Weiner, 1991.

Weizman, Eyal. *Hollow Land: Israel's Architecture of Occupation*. New York: Verso, 2006.

Whatling, Clare. *Screen Dreams: Fantasizing Lesbians in Film*. Manchester: Manchester University Press, 1997.

Wideman, John Edgar. *Fanon*. Boston: Houghton Mifflin, 2008.

Williams, Cindy, and Jennifer M. Lind. "Can We Afford a Revolution in Military Affairs?" *Breakthroughs* (spring 1999): 3–8.

Williams, Eric. *Capitalism and Slavery*. 1944. Chapel Hill: University of North Carolina Press, 1994.

Williams, H. "Diary." *The Missionary Register for 1834*. London: L. B. Seeley, 1834.

Williams, John. *A Narrative of Missionary Enterprises in the South Sea Islands*. 1837. Rarotonga, Cook Islands: n.p., 1998.

Williams, Raymond. *Culture and Society, 1780-1950*. New York: Columbia University Press, 1958.

Willy, Todd G. "The Call to Imperialism in Conrad's 'Youth': An Historical Reconstruction." *Journal of Modern Literature* 8, no. 1 (1980): 39–50.

Wilson, Jackie Napoleon. *Hidden Witness: African-American Images from the Dawn of Photography to the Civil War*. New York: Saint Martin's, 1999.

Wilson, Kathleen. *The Island Race: Englishness, Empire and Gender in the Eighteenth Century*. New York: Routledge, 2003.

———. "The Performance of Freedom: Maroons and the Colonial Order in

Eighteenth-Century Jamaica and the Atlantic Sound." *William and Mary Quarterly*, 66, no. 1, 3rd series (January 2009): 45–86.

———. *The Sense of the People: Politics, Culture and Imperialism in England, 1715-1785*. Cambridge: Cambridge University Press, 1995.

Wilson, Nathaniel. "Outline of the Flora of Jamaica." Appendix 2 in *Reports on the Geology of Jamaica*, by James Sawkins, 285–91. London: Longmans, Green, 1869.

Wilson, Ormond. "Papahurihia: First Maori Prophet." *Journal of the Polynesian Society* 74, no. 4 (December 1965): 473–83.

Wilson-Bareau, Juliet, with David C. Degener. *Manet and the American Civil War: The Battle of the U.S.S. Kearsage and C.S.S. Alabama*. New Haven: Yale University Press, 2003.

Yate, William. *An Account of New Zealand and of the Church Missionary Society's Mission in the Northern Island*. 1835. Introduction by Judith Binney. Shannon, Ireland: Irish University Press, 1977.

Yoo, John. "Memorandum for William J. Haynes II, General Counsel for the Department of Defense. Re: Military Interrogation of Unlawful Combatants Held Outside the United States." Office of the Deputy Assistant Attorney General, U.S. Department of Justice. 14 March 2003.

Young, Robert J. C. *The Idea of British Ethnicity*. Malden: Blackwell, 2008.

Žižek, Slavoj. *Enjoy Your Symptom! Jacques Lacan in Hollywood and Out*. New York: Routledge, 2001.

Zamir, Shamoon. *Dark Voices: W. E. B. Du Bois and American Thought, 1888-1903*. Chicago: University of Chicago Press, 1995.

Zandvliet, Kees. *Mapping for Money: Maps, Plans and Topographic Paintings and Their Role in Dutch Overseas Expansion during the Sixteenth and Seventeenth Centuries*. Amsterdam: Batavian Lion International, 2002.

Numbers in italics indicate illustrations

Bush, George H. W., 294
Bush, George W., 218, 286, 292–94, 302–5

Caché (Haneke), 257–60
Caesar, Julius, 212–13
Caesarism, 24, 32, 196–98, 209, 212–13, 223–24, 228–29, 234–42, 276
Cai Guo Qiang, *Nothing to See Here*, 282–83
Cairo, 241, 269–70, 309
California, 303
Callwell, Charles E., *Small Wars*, 297
Campeche y Jordan, José, 31, 117–22, *119, pl. 4*
Capital (Marx), 172, 179
Caravaggio, Michelangelo Merisi da, *The Supper at Emmaus*, 193–95, *194*
Carlyle, Thomas, xiii–xiv, 3, 12, 139, 280; abolition of slavery and, 147; *Chartism*, 135–38; on condition of England, 130, 212; on Dante, 141; Engels on, 135; fascism and, 130, 230; *The French Revolution*, 13, 131–33; Haiti and, 13; *Latter-Day Pamphlets*, 143–46; *Occasional Discourse*, 143–45; *On Heroes and Hero Worship*, 140–43, 199, 209, 217–19; Paris Commune and, 183; syndicalism and, 223; visuality and, 141
carnival, 60–61
Casid, Jill, 62
Casta painting, 63–64
Catherin, Louis, 204
Censer, Jack, 79
Central Intelligence Agency (CIA), 307
Centre Audio-Visuel, 251; ciné-pops at, 251–52
Cézanne, Paul, 177, 179, 188; *The Negro Scipio*, 174–75, *175*
Chakrabarty, Dipesh, 22–23
chaos, 16, 123, 167, 193; in Carlyle, 138–

44; counterinsurgency and, 280–82, 304–5
Charby, Jacques, 251
Charles I, 52, *54*, 289
Charles I at the Hunt (Van Dyck), 52, *54*
Chartism, 132–36, 143–44, 226, 276
Chartism (Carlyle), 135–38
Chiarelli, Peter, 299, *299*
Chile, 18, 241
Christianity, 16, 50, 92, 196–99, 204–6, 213, 217, 221
Chute en Masse, La (Dupuis), 43
cinema, 39, 147, 238, 272–80, 288; in Algeria, 251–56, 264–67; colonial, 233, 246; digital-era, 260, 271; postcolonial, 257–67
cinematic mode of production, 23
classics, 219–20; historical materialism and, 221
classification, visuality and, 3–4, 11, 14, 18, 21, 33, 146, 151–54, 197, 216, 268–69, 278–80, 285
Clausewitz, Karl von, 3, 12, 124–25, 236, 277–79; Carlyle on, 324n6; *On War*, 37, 227
closed-circuit television (CCTV), 20, 302
Coalition Provisional Authority (Iraq), 286
Code Noir (1685), 11, 49, 66, 317n80
Codrington, Robert Henry, 213–14, 217–19; *The Melanesians*, 215–16
Cold War, 278, 282–83, 307
Comaroff, Jean, 199–200
Comaroff, John L., 199–200
command, control, communications, intelligence (C3I), 284
Commune, Paris, 31, 183, 185–87, 270; slavery and, 184
complex, 3, 5; Freud and, 9–10; imperial, 13–18; military-industrial, 8, 18–22; plantation, 10–13, 49
condensation, of images, 79, 92

Iraq, xiv, 8, 19, 26, 33, 239; metrics for, 307; war in, 279–82, 285–307
Iraqi Media Network, 287–88
Ireland, 208–9; compared to Jamaica, 144; compared to South, 151; famine in, 158; Northern, 245
Islam, 7, 67, 92, 217, 233, 241, 256, 265–66, 304; global, 307; Sunni, 305
Israel, 21, 285, 296, 301–3

Jacob, Christian, 58
Jacotot, Joseph, 104
J'ai huit ans (Maurice Audin Committee), 246–50, *248*, 260
Jamaica, 8, 13, 33, 55–62, 71, 100–101, 133–34, 183, 276; Morant Bay uprising in, 143–46, 208
James, C. L. R., 56, 81, 99, 112, 211, 223
Jews, 7, 27, 224; in Caribbean, 51, 54, 67, 158, 162; Carlyle and, 140, 201; Maori self-fashioning as, 32, 192, 197, 200–205; Nazis and, 231; Sartre and, 243
Jospin, Lionel, 207
Joyce, James, xiii
Jubilee, 31; Jewish origins of, 133

Kacem, Mehdi Belhaj, 267
Kant, Immanuel, 125
Katrina (hurricane), 291, 309; counter-insurgency response to, 280–81
kawanatanga, 206–8
Keesing, Roger, 218
Keller, Robert, 265
Kilcullen, David, 303
Kipling, Rudyard, 15
Kongo, 68, 94, 107–9, 120–21, 189
Kororareka, 203, *203*

Lacan, Jacques, 9–10, 17, 243, 251
Lake, Marilyn, 216
Lantern, 84, *85*
La Roche, Mme, 79, 110

Las Meninas (Velazquez), 49, 51
Latter-Day Pamphlets (Carlyle), 143–46
law, 7–8, 10, 14, 275, 278, 282; *Brown v. Board of Education*, 4; colonial, 208–9, 240, 244; force of, 49, 57, 60, 65–67, 70, 75–76, 215–17; of the gaze, 276; Moret, 181; Roman, 165, 167, 220; slavery and, 11, 51, 63; Tablets of, 88, 91–92, 129–30, 196; *Wi Parata v. Bishop of Wellington*, 208–9
Lawes, William, 203
Lawrence, T. E., 33, 298
Le Barbier, Jean-Jacques-François, 88–91
Le Bon, Gustave, 228–29, 319n21
Lee, Spike, 281
Lenin, V. I., 19, 112, 226
Le Peletier, Michel, 103–4
Le Pen, Jean-Marie, 267
Lévi-Strauss, Claude, 16, 217, 220
Libya, 268–69
Linnaeus, Carl, 62
Livy, 7
Locke, Susan, 126
London, 14, 51, 132–33, 140–41, 199, 203–5, 211, 215, 302; Blake on, 127
Longoni, Emilio, *May 1*, 45, 225–26
Louis XVI, 87, 289
Louverture, Toussaint, 12, 62, 99, 104; Carlyle and, 211; crisis of 1801 and, 110–13; print of, *42*, 107–10, 122
Luxemburg, Rosa, 27; on general strike, 224–26

Makandal, Brigitte, 68
Makandal, François, 11, 30, 57, 61, 120, 317n87; portrait of, 69; revolt led by, 67–70. *See also* Maroons
Maldonando Torres, Nelson, 6
mana, 16–17, 32, 196–97, 206–8, 213–21, 229
Manet, Edouard, 31; *Execution of Maximilian*, 179–81, *180*; slavery and, 179–80

Polack, Joel, 44, 205

police, 183, 248, 258–60, 276, 282–83;
Algerian revolution and, 241–42, 263;
in Britain, 302; colonial, 8–10, 75,
211; in Egypt, 269–70; fascism and,
17, 233–38; in Iraq, 290; Paris Com-
mune and, 186; plantation and, 161–
64, 170, 179; in Rancière, 1; in Saint-
Domingue, 65, 75, 111; in Tunisia,
268–69

Pontecorvo, Gillo, 33, 46, 234, 241,
252–56, 266

pornography, Iraq war and, 290–91

Porot, Albert, 250

Powell, Colin, 294

PowerPoint, 304–5, *304, 306*

Prendergast, Sir James, 208–9

primitive, 27, 91, 250, 275; civilized
and, 10, 14–18, 24, 79, 196–97, 213–21;
communism, 200, 228–29

proletariat, derived from *proles*, 221

Proudhon, Pierre-Paul, 227

psychiatry, 265; colonial, 250. *See also*
Fanon, Frantz

Puerto Rico, 117–22, 160, 188–94

Pynchon, Thomas, 280

Quetelet, Adolphe, 216

Rachedi, Ahmed, 251

Rachida (Bachir), 264–67, *264, pl. 10*

Rancière, Jacques, 4–5, 7, 15, 25, 77, 132,
146, 186, 282, 308

Ranke, Leopold von, 138

Raynal, Abbé, 61–62

realism, 5, 8, 25, 135, 142, 147, 190, 261–
62; abolition, 26, 32–33, 44, 58, 90,
155–87, 189, 195; nuclear, 284; in *Pan's
Labyrinth*, 275; as revolutionary, 35,
96–97, 122. *See also* neorealism

Red Detachment of Women, The (Xie), 252

Reed, Brian J., 288

Reflections on Violence (Sorel), 227–28

Regourd, François, 70

Rendition (Hood), 253

Representative Men (Emerson), xvi

Revolution: American, 287; in Egypt
and Tunisia, 239–40, 265, 268–69; in
Military Affairs, 33, 277, 282–84. *See
also* Algeria; France; Haiti

Reynolds, Henry, 216

rights, 1, 24–30, 65–67, 77–92, 102–3,
106, 115, 130, 132–34, 206–9, 240, 242,
263, 301–2; general strike and, 226–
27; property, 198–99

Rights of Man (Paine), 82, 106, 139

right to look, 1–6, 25–26, 29, 34, 114,
129, 157, 232, 241, 249, 261; aboli-
tion and, 165–72, 215; in Algeria, 232,
241; *Caché* and, 260; education and,
157, 266; general strike as, 221, 228;
negated by fascism, 231; *Pan's Laby-
rinth* and, 276; in Saint-Domingue,
69; Sojourner Truth and, 148–50;
sustainability and, 78, 157

Rimbaud, Arthur, 183, 259

Riverbend (pseud.), 305

Rivet, 260

Robespierre, Maximilien, 286

Rolling Stone (magazine), 305

Ronfeldt, David, 285

Roper, Daniel S., 277–78

Rose, H. J., 219

Ross, Kristin, 186, 257, 312n13

Ross, Ruth, 206

Royal Anthropological Society, 215

Rumsfeld, Donald, 286, 293–94

Saadi, Yacef, 252; *Battle of Algiers* and,
252–55

Sadr, Moqtada al-, 290

Said, Edward, 13

St. Croix, 59–62, 157–62

Saint-Domingue, 11, 30–31, 42, 50,

Nicholas Mirzoeff is professor of media, culture, and communication at New York University. He is the author of *An Introduction to Visual Culture* (1999; second edition, 2009); *Watching Babylon: The War in Iraq and Global Visual Culture* (2005); *Bodyscape: Art, Modernity, and the Ideal Figure* (1995); *Silent Poetry: Deafness, Sign, and Visual Culture in Modern France* (1995), and the editor of *The Visual Culture Reader* (1998; third edition, 2012); *Diaspora and Visual Culture: Representing Africans and Jews* (2000). He is a contributing editor of Media Commons, and a member of the *Social Text* collective.

Library of Congress Cataloging-in-Publication Data
Mirzoeff, Nicholas, 1962–
The right to look : a counterhistory of visuality / Nicholas Mirzoeff.
p. cm.
Includes bibliographical references and index.
ISBN 978-0-8223-4895-5 (cloth : alk. paper)
ISBN 978-0-8223-4918-1 (pbk. : alk. paper)
1. Mass media and world politics. 2. Communication and culture—Political aspects. 3. Mass media—Political aspects. 4. Visual communication—Political aspects. I. Title.
P96.W62M57 2011
302.2′22—dc23 2011027508